EVERYTHING
KEEPS
DISSOLVING

ABOUT THIS BOOK'S TITLE:
Around the time of the first Coil Royal Festival Hall performance in April 2000, John Balance was speaking to the musician, journalist, and Sentrax Corporation label boss, John Everall, who was undergoing his own struggles with alcohol and mental health challenges. 'EVERYTHING KEEPS DISSOLVING', said Everall, a phrase which clearly resonated with Balance, who used it as the title of the recording of the extended drone piece performed at the Royal Festival Hall, and at Sonar in Barcelona the same year.

Everything Keeps Dissolving: Conversations with Coil
by Nick Soulsby

First published by Strange Attractor Press 2023
Text © The Authors

Cover by Tihana Šare
Design by Tihana Šare, layout by Maïa Gaffney-Hyde
Typeset in Aichel, Acuta and Komet

ISBN 9781913689438

Strange Attractor Press
BM SAP, London,
WC1N 3XX, UK
www.strangeattractor.co.uk

Distributed by The MIT Press, Cambridge, Massachusetts.
And London, England.

EVERYTHING KEEPS DISSOLVING

Conversations with Coil

Nick Soulsby

Black Sunrise
(1983-1985)

The Dark Age of Love
(1986-1988)

CCXI 'It Could Be to Kill The Audience!'
Maurizio Pustianaz, *Maelzel*, February-May 1986

CCXIX 'Having Been Corrupted it's Uphill From There On'
Alexander Oey, *The Sound of Progress*, 2nd and 3rd July 1986

CCXXXIX 'Circles Of Mania, Pestilence and Temptations'
Vittore Baroni, *Rockerilla* (#79), March 1987

CCXLVII 'The Dark Side Of Sampling'
Mark Dery, *Keyboard* Magazine, Summer 1987

CCLV 'We Avoid Comparisons and Contrasts, We Isolate Ourselves...'
John Balance, Unpublished Letter, 1st October 1988

Clothed in Useful Illusions
(1989-1992)

CCLXVII 'A Naked Man, Hung on His Cross, Sacrificing His Body'
Roy Mantel and Petur Van Den Berg, *Opscene*, April-May 1991

CCLXXXI 'You Let The Future Leak Through'
Justin Mitchell & John Eden, 16th May 1991

CCCVII 'We do Dance Music for The Head'
Tony Dickie, *Compulsion*, 18th October, 1992

Born Again Pagans
(1994-1997)

CCCXXXV 'In The Talking Shop'
Edwin Brienen, *Opscene*, August-September 1994

CCCXLVII 'Wrapping Around Reznor, Hellraiser, Burroughs,
and Spirituality'
Jessica Wing, *Boing Boing*, 1994

The Key to Joy
(1998–2002)

A Complete Derangement of The Senses
(2003-2004)

List of Illustrations

A number of individuals have kindly contributed original artwork by John Balance, as well as rare photography to this volume. I, and Strange Attractor Press, are delighted to showcase these pieces here interleaving the conversations within this volume.

XXXII, XC, CLXVIII, CCX, CCLXVI, CCCXXXIV, CDXXXVI, DXL, DLXXIV: John Balance sketches contributed to *The JudasJesus* (Rolf Vasellari, Black Sheep Press, 1988). Included by kind permission of Rolf Vasellari

XXII-XXIII: Zos Kia On Stage at the Berlin Atonal Festival, 3rd December 1983 (from left to right: John Gosling, John Balance, Min Kent). Included by kind permission of Guido Huebner

CCCLXXIV: John Balance collage contributed to *Janus Head* zine (Vittore Baroni/Jacques Juin, Mur Mur, 1981). Included by kind permission of Vittore Baroni

LVI, CIV, CXII, CXLVI, CLXVI-CLVII, CCVIII, CCXXXVIII, CCLIV, CCLXIV, CCLXXX, CCCXXXII, CDXXII, DXVI, DXXX, DXXXVIII, DLXIV, DLXXVIII : Credit to Mark Lally, 1985-1988

List of Illustrations

LXXVIII-LXXIX: Loplop Feeds Fish to the Wicked collage by John Balance, 1981 (Private gift). Taken from the collection, and included by kind permission, of Cultural Amnesia

LXX (front), CDXXIV (back): John Balance collage A3 poster included with *The Men With The Deadly Dreams* compilation (White Stains Tapes, 1981). Taken from the collection, and included by kind permission, of Cultural Amnesia

LXXX (front), CDLXIV (back), LV (inside): Early computer generated image designed by John Balance with assistance from Peter Christopherson. *Sinclair's Luck* album by Cultural Amnesia (Hearsay And Heresy, 1983). Taken from the collection, and included by kind permission, of Cultural Amnesia

X (front), CDXLIV (back): 'Original ART (ha!)' 23.IV.86. Included by kind permission, of Maurizio Pustianaz

DII: Envelope art sent to Anthony Blokdijk and included by kind permission

CCVII: Autographed record sent to Anthony Blokdijk and included by kind permission

CCXXXVII: Coil dinner, film stills, included by kind permission, of Alexander Oey

Introduction

Nick Soulsby

Significant time immersed in the voices of Coil has provided various thoughts perhaps worth sharing.

Remembrance of childhood is not neutral: we sift and discard masses of material from the 5,475 days lived out by age 16, choosing what to present to others, what is recalled but hidden from others' sight, and what goes entirely unrecalled. In Balance's case, he was uncharacteristically discreet regarding the backdrop of his childhood. Divorce was not without social stigma in 60s Britain, nor is parental separation a nothing to any child. Later statements that he sometimes slept in a dog basket and would bite the ankles of his mum's suitors do not suggest it was easy. Remarriage and an armed forces stepfather led to a peripatetic upbringing including nine schools before age 11. Seeing Coil perform in 2004, I recall Balance on stage recounting a startling tale in which his stepfather held him over the edge of one of the Ruhr dams, then hit him for crying about it. While indicating pressure over behaviour deemed effeminate, Balance's recollection spoke also to his defiance of a repressed and regimented vision of male identity.

Instead of dwelling on his family, however, Balance spent his adulthood recounting tales such as his birth in the grounds of an asylum for shellshocked soldiers; his worship of the moon from age seven; of an extreme bout of measles resulting in three weeks lying in a dark room: '...the sort of "shamanic type" illnesses that they say happen in people's lives which change your perception of the world forever.' Of taking magic mushrooms, age 11; of writing to Alex Sanders, 'King Of The Witches', at 12; of dabbling teachers sharing occult practices; of sexual activity with other pupils; of a letter from the headmaster stating he was 'obsessed with the occult and could he desist from astral projecting into other people's heads.' A CV used as press material in Coil's early days mentioned 'psychiatric treatment after attempting to push a piano down three flights of stairs and strangling the son of a United Nations diplomat... Seduced by a 70-year-old cook... scandal with son of famous Disney actor... Brush with police after placing five pigs' heads face up in the public lavatories.'

While doubtlessly delighting in spinning eyebrow-raising yarns, the stories Balance presented should not be interpreted as mere disturbance. Rather, this was his tale of liberation, a rite of passage, in which finding himself in magick and finding himself as a gay man were entwined. In Balance's telling, ill health and delinquency were symptoms that fell away once the twin stars of his being were inwardly accepted and externally realised.

The joy of self-identification did not, of course, mean full resolution. While stage names might be unexceptional, it's hard to think of an artist as defined by multiplicity as the man who went by Geff, Geoffrey, John, Jhonn; Burton, Rushton, Balance; Legion, Coil, Frater Coil O*, Eden 2, Absolom, Rufus Pool, Otto Avery, Louise Weasel, Jenny De'Ath; Zos Kia, ELpH, Eskaton, Black Light District, Time Machines... His claim to have been treated for schizophrenia as a child was unlikely and regurgitated pop culture's mistaken use of schizophrenia as a synonym for dissociative identity disorder, but pointed to his belief that he

was, and should be thought of as, multiple souls coexisting in cycles of harmony/disharmony. This refusal of singularity was at the heart of Coil as seen in their manifesto: 'Coil is amorphous... in constant change... Dreamcycles in perpetual motion.' The manifesto indeed represented that philosophy given that, across ten times I'm aware it was reprinted, not once was the text identical. Coil's whole set-up rejected the singular as well as simple 'balance' too. Intended to feature a shifting cast of collaborators and to coexist with Psychic TV, Coil morphed into a duo but always incorporated at least one other party thus breaking easy back-forth duality.

Coil stood in contrast to most bands, where the norm is to get comfy and then tweak a formula, by making fundamental tectonic shifts every one or two records, every three to five years. Transmutation and the confounding of expectation was critical to their methodology: *Scatology* applied the magickal philosophy that every occult symbol should be interpretable on multiple levels. *Love's Secret Domain* involved a process of 'folding in' every sound to render sources vague though still present, then they inaugurated 'sidereal sound' — sounds turned 'inside out.' 2000 to 2004, the process enacted in the studio became public derangement on stage with material warping on a nightly basis, everything iterated, nothing definitive. Coil, in a remarkable feat of will, rejected stability or a consistent identity in favour of continuous renewal.

Christopherson's childhood appears far more steady than Balance's... But then, it's hard to know. Even when not away working, Christopherson tended to shy away from interviews, often occupying himself elsewhere, or remaining in the background. His discreet nature is visible in the way his collaboration with one natural possessor of the spotlight, Genesis P-Orridge, was replaced by another in Balance. Balance claimed that Christopherson, despite misgivings, was so determined not to provoke trouble within Psychic TV that it was only Balance's decision to leave that forced Christopherson to speak up and

act. Charming and affable at all times, Christopherson was the quintessentially clubbable child of an English academic in his ability to talk volubly about intellectual topics — such as his deep antithesis toward Christianity — while placing a smiling 'mustn't grumble' gloss over more personal emotions. In a couple of interviews, seeing an interviewer's discomfort with homosexuality, he would comfort and reassure them that they didn't need to be gay to enjoy or comprehend Coil's art.

When Balance's problems forced Christopherson more into the spotlight, he proved an adept PR face, honest, but discreetly eliding the challenges within Coil to talk gear or stage setup instead. In many ways, Balance was his perfect emotional match: one helplessly exposed, the other quite repressed.[1] Awareness of this gap between public and private faces was critical to Christopherson's work which delighted in poking at society's squeamishness. Appropriately, he lived a double life for most of two decades: entrepreneurial video director by day, esoteric musical force (and sexual adventurer for a time) by night. His nickname — Sleazy — resulted from what he described in Simon Ford's *Wreckers Of Civilisation* as a taste for 'using the body as an object of fetishistic exploration...' His inclinations rubbed up against an ever more stifling cultural climate in which he witnessed P-Orridge charged for 'obscene' mail-art; the hysterical condemnation of Coum Transmissions' *Prostitution* show; and police raids on Throbbing Gristle's studio.

+ + +

Hostile officialdom was a perturbing presence throughout Coil's first decade. Balance spoke of being subject to police stop-and-search; of a friend's flat searched for drug paraphernalia; of being arrested at a gay rights protest; of fear of the police leading

1 After 2004, in Balance's absence, Christopherson's work moved noticeably toward a more genteel end of the spectrum in the absence of someone to help him access less polite emotion.

to the cessation of Psychic TV and Coil's exploration of cults. The 1987 Operation Spanner prosecutions of various friends of Coil — for consensual sadomasochistic acts — heightened tension, then everything erupted in 1992 when a documentary made false allegations of child abuse against P-Orridge. P-Orridge and family fled into exile after the police raided their home and confiscated their archives. Coil described being so scared they sanitised their home of anything that might arouse police suspicion and spent several years expecting the front door to be kicked in.

This was not the only existential threat to Balance and Christopherson. Both participated enthusiastically in the libertinage of London's gay scene, only to be slammed brutally into the burgeoning devastation of AIDS. Personally escaping infection brought limited relief as they witnessed friends succumbing. Madonna's tour manager, Martin Burgoyne, died on his 23rd birthday in 1986 with Balance musing: 'you start to dwell on it, y'know? Especially if you've had sex with him.' Balance still sounded angry in 1995 over the death of Eddie Cairns, the cover artist for the 'Tainted Love' single: 'I think it was Hammersmith Council who dealt with Eddie's body... men in bloody Dalek suits wrapped the body in numerous sheets of plastic and didn't know how to deal with the body.' Their friend Leigh Bowery would die, aged 33, in December 1994. Meanwhile their long association with Derek Jarman was lived in the shadow of his HIV diagnosis in December 1986, until his death in February 1994.

Coil reflected the shock also felt by the wider gay community, with *Scatology*'s nod toward niche pleasures giving way to *Horse Rotorvator*'s explicit grappling with death as a lived experience. A UK resident in their 20s might experience an elderly relative's demise, a further few an untimely loss from disease or misadventure; it's truly exceptional to have significant numbers of young friends die. In 1986, Balance was 24, Christopherson was 31: their peak years of sensual exploration were derailed by risk, sickness and death. The terror of those times is underappreciated.

Beyond AIDS lay further trauma. 'Ostia (The Death Of Pasolini)' was a simultaneous tribute to the murdered film director; to a friend, Wayne, who jumped from the Dover cliffs; and to another friend, Leon, whose cause of death Coil left undisclosed. Again, in 1992, a voicemail recounting someone's suicide, '...he threw himself off a cliff...' was the basis of the haunting 'Who'll Fall'. The recording was revisited for 1993's 'Is Suicide A Solution?' with a cover image taken from the window of a Coil fan who leapt from said window to his death. Their other 1993 single was 'Themes For Derek Jarman's Blue', a film visually portraying blindness arising from AIDS.

Described as their 'dance' album, 1991's *Love's Secret Domain* was no testament to Second Summer of Love joyousness. Instead of relief from the numbing drumbeat of death, from emotional baggage, from the policeman's shadow, Coil's third album ushered in personal cataclysm. In a vast release of tension, Coil spent much of 1988-1992 immersed in the hedonistic relief of Ecstasy and other drugs, Christopherson stating 'the main reason for that was I think we were struggling to find a kind of intimacy that didn't involve sexual contact — a consequence of AIDS.' The resulting album opened with 'Disco Hospital' — a metaphor as pointed as Coil's take on 'Tainted Love' — then dwelt on the intertwining of death and love, a soundtrack to desperation not delight. The chemically-induced fallout of these years was so severe it propelled Stephen Thrower from the group, while Balance collapsed on occasions both public and private, before lapsing into alcoholism.[2] Marking the seriousness of this moment, 'Eskaton' became a permanent

2 There's one further possibility. Aspects of Balance's magickal pursuits encouraged the loss of personal identity as a step to greater knowledge. Balance made a point in the 80s of disparaging magickians he felt were too public in their work, stating that real forward motion should be achieved in private. It makes it hard not to wonder if this series of collapses, in which Balance described having forgotten his name and identity altogether, were in some ways aimed for, the visible outcome of private pursuits and intentions, even if the consequences were in no way predicted or desired.

Coil label imprint. Eschatology — the study of the world's end — tied together *Horse Rotorvator*'s explicit theme with a wordplay on *Scatology*. This loop indicated that Coil were attempting to begin anew, that their past was linked to but distinct from their future. They lived now in the 'last days,' somewhere amid the apocalypse.

Balance and Christopherson sought workable ways to continue but Coil, for a time, was too bloodied an entity to be the vehicle. Practically speaking, the name Coil existed from 1994 to 1998 almost entirely as an archive, a host for alternate identities, or a remixer of others' work. A tentative step forward involved standing in direct opposition to their former self: 1994's Coil vs. The Eskaton and Coil vs. ELpH singles. This led to the even more radical idea of shedding Coil's damaged husk and splintering their activity into new, unsullied personas: Wormsine, Black Light District, Time Machines, ELpH, Eskaton. 1995-1999 reads as an escape attempt: seeking refuge in a 'black light district,' the opposite of a red light district's dangerous carnality; channelling alien entities to extirpate their own voices; escaping time altogether; rejecting Mars and the sun in favour of the feminine moon; leaving London's dense metropolis in the east for the seaside of Weston-Super-Mare in the far west.

A mooted album title Coil had rejected ten years prior, *Funeral Music For Princess Diana*, seemed eerily prescient in 1997. It's real significance, however, was as a mirror. Across their first decade, Coil tried to find ways to live amid trauma, then in the aftermath tried shedding their identity to find the renewal that redefinition of the self had given Balance as a young man. The final phase of their existence felt like a surrender. Tales of Balance's frightening battle with alcohol were not products of a scandal-hungry media: Coil was the source. Alongside their candid interviews and on-stage acknowledgement of issues, by 2000 they were selling a blood-smeared 'Trauma' edition of *Musick To Play In The Dark 2*, then Balance performed in a straightjacket in 2004. Coil were not virgins. They understood the public's appetite for salacious

consumption, that the media was a delivery mechanism for perusing human pain, and they colluded in the same symbiotic relationship that ended Diana. While Christopherson gave every appearance of being ready to settle into being a musical elder statesman, Balance seemed harrowed by the prospect that he had no way out of his role as a public avatar of pain.

+ + +

Reading hundreds of Coil interviews, a further tragi-comedy became clear. Coil repeatedly explained that their lived experience as gay men was the creative force underpinning their work... Only to be faced with a blank absence of response. Ossian Brown plainly stated in his book *Haunted Air* that: 'Coil were the first resolutely queer group...' This echoed a statement by Balance in a mid-90s interview: 'for a long time we were the most out on a limb or experimental gay group, for sure, in England...' Balance then shrewdly pointed out that people were more comfortable pretending 'gay music' only existed as a ghetto of flamboyant disco, something safe, soft and ignorable. It isn't that anyone denied that Christopherson, Balance, Thrower, Brown or Thighpaulsandra were gay. Their gay identity was simply deemed ephemeral, not worth engaging with, something to be brushed aside in favour of declaring Coil to be a 'magick' or 'drug' band. Somehow, in stark contrast to Coil's homosexuality, those definitions aroused no discomfort or debate, they were easier for our dominant heterosexual culture to swallow.

To a large degree this was down to discomfort with the topic of sex, or a desire not to typecast queer individuals, rather than being the result of untoward motives. The effect, however, was a persistent refusal to acknowledge the creative impact of queerness within Coil. There was no 'outing' of Coil, nor a celebratory coming out, because they were calmly and contentedly gay in a way public figures were not meant to be. Their music featured

Introduction

neither the de-gendered lyricism nor the acceptable wink of campness that came with Freddie Mercury or Elton John or much of what was accepted as gay music. Balance and Christopherson rejected the demand that they either embrace performative homosexuality, or remain discreet and closeted.

In the 80s, with grotesque homophobia daily fodder for British tabloids, it was perhaps unsurprising that early interviews averted their gaze from Coil's homosexuality. This was usually done either by quoting the 'accumulation of male sexual energy' phrase from the *How To Destroy Angels* liner-notes without comment on its overtly queer significance, or by making reference to sexual extremity as a veiled euphemism meaning gay sex. Such squeamishness extended across Coil's entire career. Their treatment mimicked that of William S. Burroughs.[3] Audiences were unable to honestly face works suffused with gay life, gay fantasy, and queer identities beyond the restrictive effeminacy imposed by polite society. Burroughs was only assimilated as a countercultural icon once all the ejaculating penises had been greyed out and he had been redrawn as a sexless old man, a druggy guru figure void of sensuality. Portrayals of Coil similarly presented 'acceptable' rebelliousness — occultism, apocalypse, narcotics, sonic experimentation — as the definitive means through which to understand their work, with homosexuality given short shrift. While ink was splashed describing how those other elements played out as an influence on Coil's work, not one article or interview grappled with the fact that Coil's music was suffused with their queerness.

In 1984, asked to differentiate Psychic TV and Coil, Balance pinpointed: 'we have no female members and Psychic TV did have and had a very definite feminine/lunar side. We are conscious of our sexual position. We choose male dynamic subjects given the choice...' The group's first EP was not just a magickal exercise,

3 I wholeheartedly recommend *Queer Burroughs* by Jamie Russell to any and all readers.

it was gay sex magick; *Scatology*, while metaphorically complex, acknowledged a sexual interest Christopherson enacted in a gay context; Coil's first video was an AIDS parable accompanying a single raising money for the Terrence Higgins Trust and they would contribute to a John Giorno compilation funding AIDS research. There's even selective blindness when it comes to the cosmology in which Coil positioned themselves: Aleister Crowley, Austin Osman Spare, William S. Burroughs, Pier Paolo Pasolini — these were all gay or bisexual men. Without denying other interests, sexuality was a critical bond between Coil and the icons with whom they wished to be associated.

In their film-related work too, homosexuality framed their productive relationships with Derek Jarman; the extreme BDSM imagery Coil's pornography collection contributed to *Hellraiser*; the film adaptation of Dennis Cooper's novel *Frisk*; their soundtrack to Britain's first explicit video sex guide for the gay community, *The Gay Man's Guide To Safer Sex* (again raising money for the Terrence Higgins Trust). *Sara Dale's Sensual Massage* was exceptional: a Coil soundtrack not tied to a gay film-maker or writer!

Even a glance at Coil's music makes it hard to deny the inspirational force provided by homosexuality. Without delving into the numerous homoerotic phrases, or lines addressed to lovers one should assume were male, just glance at the titles: 'AYOR', 'Backwards', 'The Sewage Worker's Birthday Party', 'Slur', 'The Halliwell Hammers', 'The Anal Staircase', 'Protection', 'Queens Of The Circulating Library', 'Sex With Sun Ra', 'The Gimp'...*Love's Secret Domain*'s cover art came replete with an ejaculating penis at its centre, while the title track's video saw Balance perform amid youthful male go-go dancers — a vision of Coil surrounded by homoerotic life and resolutely focused on homosexuality.[4] Coil were so overt they declared gender their

4 There's a further, rarely noted, penis descending like a meteor into the *Astral Disaster* artwork.

career's overarching structure, male and female phases in which they personified both genders. While private in their day-to-day lives and having no wish to become political figures, they still attended gay rights protests; received callouts in gay zines such as *JDs* and *Homocore*; gave interviews to *Pink Paper* and *Square Peg*. Even their clubgoing is portrayed in a deceptive light if one does not acknowledge much of it was in queer venues.[5]

Coil's final albums emerged as *Black Antlers* and *The Ape Of Naples*, joke names for imaginary gay pornos. Their final song, 'Going Up' has been wrapped up in a spine-tingling legend that says Coil converted a 70s sitcom theme reciting department store goods into a hymn to the transcendence of the physical — an inspiringly magickal vision of death. Being blind to homosexuality again makes this interpretation faulty. Claiming the song for Coil was no more a foreshadowing than *Funeral Music For Princess Diana*, heterosexual audiences are just more comfortable seeing death than they are gay iconography. Burroughs spent his career eviscerating the cliché that gay men were supposed to be politely effeminate, therefore funny to onlookers and submissive to the dominant order. By contrast, the sitcom to which 'Going Up' was the theme turgidly reiterated that cliché. For Coil, choosing to restage the song was not about future death, it was about shedding the past, about Mr. Humphries' freedom to rise above his subjugated 70s state, about Coil's own transcendence of the musical and personal limits imposed on what gay musicians and gay lives could be. Coil's career did not end by dwelling on death, it ended on a celebration of 20 years of uncompromising queer creativity opposing and escaping the past. A true history of Coil, one respectful of their queerness, is sorely overdue.

5 Stephen Thrower stated in a 2021 interview with Mark Pilkington: '...the gay press hardly ever paid any attention to Coil. It really was the cliché of, if you're making disco bunny or house music then you might get covered in the gay press, but if you're not doing something that appeals to that rather superficial aesthetic... they didn't even deign to glance at you.' Ultimately, Coil remained outsiders with an individualistic vision of what gay identity could be.

+ + +

A sad irony of Throbbing Gristle's legacy was that, in holding a mirror to the worst of society, they ushered in less discerning scavengers happy to revel in abuse. It's underappreciated – often wilfully forgotten – how violent Britain was during the 70s and 80s. On into the Coil years, Christopherson and Balance were living in the paradoxical outcome of World War Two's victory over Nazism, with the right wing having turned that victory into a myth of absolute national righteousness absolving them of any need to reflect on clear currents of Fascism within British society. Blinded by one-dimensional triumphalism, violence was justified against anyone who, by mere fact of their existence, was deemed a social outsider: people of colour, Jews, women, homosexuals, punks, squatters, miners, travellers, peace campaigners... The adoption of Swastikas by the punk generation was a direct challenge to their parents' moral corruption, one intended to turn the 'little Hitlers' puce with rage. Throbbing Gristle were even more radical, with Christopherson pointing out that 'tolerance of – even encouragement of – minorities has always been a very central and clear part of Throbbing Gristle theory.'

Unfortunately, as had happened in the 60s with the American counterculture, the open-minded and fluid communities that formed around radical causes in the U.K. attracted jackals alive to the scent of profit at others' expense; while acquiring a degree of power brought certain participants' latent authoritarianism to the surface. For some, the anarchy slogans and fight against oppression became the warped grotesquery of libertarianism. By the mid-80s, the community around Coil contained a number of bad faith actors, cosplay Fascists, edgelords, and outright Nazis. Coil responded by establishing both spiritual and physical separation from such grim figures, ever increasing hermetic isolation, with Christopherson later describing one such case: '... we fell out because of Boyd's increasingly racist public image. It

wasn't because of political or social correctness. For us it was just common sense. Anyone who singles out a particular portion of any population for criticism just because they fit into a certain category – whether it be gay, or black, or Jewish, or even female – to us was, and is, simply moronic.' Opponents of the mainstream, rejected by the gay scene, Coil also became outsiders in opposition to other outsiders.

Later in Coil's career, Balance was unyielding in his position: 'everyone has an equal right to survive – the total opposite of Fascism.' However, continued openness to valid lines of non-mainstream inquiry did lead to occasional, and unintentional, proximity to latter-day Fascism's fellow travellers. One such example was Balance's 2004 interview with the journal *TYR*. The conversation is one of the most hopeful of the final years of his life and I'm very pleased to include it here, but I'm diametrically at odds with certain of *TYR*'s other contributors peddling racism veiled in talk of national or cultural pride, whitewashing the well-attested antisemitism and supremacism of various historical movements and figures, or espousing Fascism under euphemisms such as 'radical traditionalism', all to give pseudo-historical/pseudo-scientific justification for the familiar reactionary, anti-democratic, and racist banalities of the far right.

Such beliefs are the opposite of those Coil lived and gave voice to. Coil were on the receiving end of authoritarian power, the threat of oppression, and the reality of bigotry throughout their existence. They countered it with the radical nature of their work but also by adopting a stance of philosophical, spiritual and intellectual opposition. On the one hand, this meant Balance's pagan belief in the universal oneness of all mankind and nature – 'everything is sacred and everything has a soul... I've found it works and no one is ever going to persuade me any other way. Everything is sacred. That totally eliminates Fascism or racism... ' – and, on the other hand, Christopherson's plain-spoken honesty – 'Do I think bands who flirt with Nazi or Fascist imagery should

be held responsible if they encourage people to abuse others, even inadvertently? Yes I do! If you give someone directions, you are in part responsible if they, or someone else, gets hurt as a consequence of what you tell them. Encouraging anyone to think that Nazi or Fascist beliefs or behaviour toward others are okay (even by INaction) is NOT okay.'

+ + +

A further misconception regarding Coil is the belief that they were prone to abandoning projects. While the *Rumoured, Announced, Unreleased, Abandoned* page on Brainwashed lists 75 entries 1983-2004, almost all are discarded names or formats for music that did in fact emerge. It seems the duo rarely forgot anything. *Black Light District*, for example, originated as a Boyd Rice title on the Bethel compilation released by Balance in 1983; became the title for acid house tunes made with Drew McDowall 1988-1989; morphed into part of a comic book concept, *Underground*, in the early 90s; before emerging as an alternate group identity in 1996.

In fact, there's a fair case to be made that Balance consistently worked to time scales beyond normal attention spans. At school in the late 70s, his first group, Stabmental, gave two performances: 'Non-Appearance One' and 'Non-Appearance With A Little Girl'. Both times, the band prepared the sounds, set the stage — then didn't turn up. In that context, it's no accident that Stabmental recorded an album which was never released; nor that it was titled *Hidden Fears* which by their very nature are potent, while remaining imaginary. Coincidentally or not, Coil's first performance, scheduled to take place at the Equinox Event on 21 June 1983, was cancelled. Balance turned up anyway and did 'something' outside, meaning Coil was inaugurated with an indeterminate non-appearance/appearance. That August, Coil properly took to a stage to perform the pointedly titled 'Silence And Secrecy'. Strobes, amplified cicadas, frankincense... But no

actual performance. Balance described it as 'extended tension' with the audience complicit in imagining fulfilment that would never come. A clue lies in the blatant, yet subtle, borrowing from the language of movies where the sound of insects is a prompt indicating the wait for something about to happen.

A supposedly 'lost' release, *The Sound Of Music* compilation, was first mentioned in 1985 and still spoken of a decade later. Far from being forgotten, the content became *The Angelic Conversation* LP and parts of the *Unnatural History II* and *III* compilations. In discussion at the time, Balance made the point: 'I don't know what order these things are coming out in. Or what form they will take. Or if they will even come out in this dimension...' That final statement is crucial. Far from being glib, Balance should be taken at his word given it is consistent with, and a continuous thread to, the earliest motivation visible in his work. The audience's projections onto his announcements, their wait for resolution, were already musical/magickal experiences regardless of whether they manifested physically. Coil's most famous non-arrival, *Backwards* — for the appropriately named Nothing Records — appeared after Balance's death with Christopherson saying, 'all those tracks that had been unfinished for reasons that were not clear to me, suddenly could be, and for the first time made sense.' How far ahead could Balance see? His career both began and ended present, yet invisible.

+ + +

One thing to bear in mind while reading this volume is how obscure Coil were for much of their career. The mid-80s mainstream was relatively hospitable with Biba Kopf, Don Watson and others giving them space in the music weeklies, but it was the burgeoning fanzine network that gave the most extensive coverage. Balance kept up a vigorous campaign of in-person and letter-based interviews, with Christopherson joining in around work, but that enthusiasm

ebbed and Coil apparently gave up on interviews across 1988, 1989, and most of 1990. Similarly, the British press showed little interest in Coil during the guitar-centric years of Madchester, Grunge and Britpop with most coverage appearing in continental media. The absence of label promotional backing, along with Balance's struggles, caused periodic silences after 1992 with Coil's mailing list being the main source of news. It was only with the rise of electronica influenced by Coil, *The Wire*'s turn toward 'adventures in modern music,' plus the rise of online journalism allowing longer interviews, that Coil's status was renewed. Touring boosted coverage still further though many publications rightly felt that audiences would know little of Coil, making it not uncommon to see their career or discography recapped at the start of interviews. The inaccessibility of most of Coil's pre-internet interviews meant journalists often displayed significant unfamiliarity, or ran through standard-issue 'touring band' or 'getting to know you' questions, occasionally enlivened by genuine enthusiasts.

The deaths of John Balance and Peter Christopherson stand in stark contrast, but neither was sweet. To loved ones, each was a sadness song, a unique pain I have no wish for anyone to relive. The only humane response to death is empathy and it is that emotion that led to the approach chosen for this book. Rejecting the intrusion of biography, perhaps we could still commune with the honoured dead? Creating this anthology of interviews allowed Balance and Christopherson to share their story as they chose to tell it: Coil as a living breathing entity. A desire was to blend functional accounts with more expansive conversations, allowing the reader to encounter the departed in all their wit, wisdom, mischief, fire and sweetness.

+ + +

I do not readily attribute life's coincidences to mystical roots... However... While creating this book, benevolent serendipity came

with such regularity that it felt like friendly hands pushing me forward. I count ten occasions when locked doors at bedtime would open spontaneously by morning. I'd go to bed stumped and each time I awoke to emails in which, without prompting or knowledge of my challenges, individuals simply appeared bearing answers to questions and conundrums. One night, Balance grumbled on a tape about being 'ripped off' by a book, but didn't identify the volume in question. The next morning, John Coulthart emailed me and, despite us never having spoken before, spontaneously explained it all to me out-of-the-blue. Another night, I surrendered abjectly having failed to identify the person behind a pseudonym from the mid-80s. The next day, mid-conversation, Gary Levermore suddenly said 'I used to do some music writing under the name...' and turned out to be precisely the person I was looking for! On one occasion, I despaired of finding any interviews from 1988-1989, only for Claus Laufenburg to pop up and hand me an unreleased letter the following day. On another, I realised I had no clue how to track down anything Coil did on their PR trip to Germany in 1987... Then an email from Graf Haufen arrived that same day with a link to a German fanzine archive.

On two occasions it felt overtly like someone saying hello. On 28 March 2021 I delved into Jeremy Reed and Karolina Urbaniak's beautiful book *Altered Balance* for the first time after it had sat on the shelf for months. I realised I'd opened the book at a letter from Balance dated 28 March 2000 — which felt like kind best wishes given it's my birthday, and also because 28 March 2000 was the date I received my first Coil album. Another night I was transcribing a letter from Balance to Mr. Mark Lally and sat pondering how much of it I might use. Turning to the next page, I was faced with a handwritten exhortation from Balance: '*I hope you can reprint most if not all because I think I've written some important things here...*' Who was I to argue? Even the connection to Strange Attractor Press was serendipitous. I was looking to buy

a book and the email response was from Mark Pilkington who had interviewed Coil in 2001. I explained why that delighted me and he suggested we talk... This book was the result.

A further motivation was that, in spite of Coil's enduring critical reputation, the biographical bibliography is slim. The essential work remains David Keenan's *England's Hidden Reverse* (also the accompanying booklet *Furfur*). Personal reminiscences and original letters feature in Jeremy Reed and Karolina Urbaniak's *Altered Balance, The Abrahadabra Letters* by Anthony Blokdijk and Zoe Dewitt's *Nekrophile Records 1983-1990*. In terms of analysis, I heartily recommend the scholarship of Phil Barrington and Dr. Hayes Hampton, while Cormac Pentecost's zine *Man Is The Animal* is a quality compendium of Coil considerations. There's also Edward Pandemonium's *Twilight Language*, a helpful guide to Coil's references. Beyond that, various volumes cover Coil visually, specifically: Ruth Bayer's *Coil: Camera Light Oblivion*, and Timeless Editions' *The Universe Is A Haunted House; Peter Christopherson Photography*; and *Bright Lights And Cats With No Mouths: The Art Of John Balance Collected*.

At this point, I must bow respectfully to Kiefer Gorena and the team at the amazing Live Coil Archive: a stunning and comprehensive record of Coil's existence as a live entity, a real labour of love. I would encourage anyone with memories, memorabilia, or recordings to get in touch and consider contributing to the LCA. I owe many thanks, as ever, to so many people for their kindness — life's most undervalued quality. To name but a few, thank you to Isabel Atherton, Mark Pilkington, Richard Rupenus, Oscar Smit, Simon Dell, Annie Marie Nyvold, to Hans at FromTheArchives, and — always — to the LiveNirvana fan community for showing me what could be achieved through DIY passion.

Black
Sunrise

1983–1985

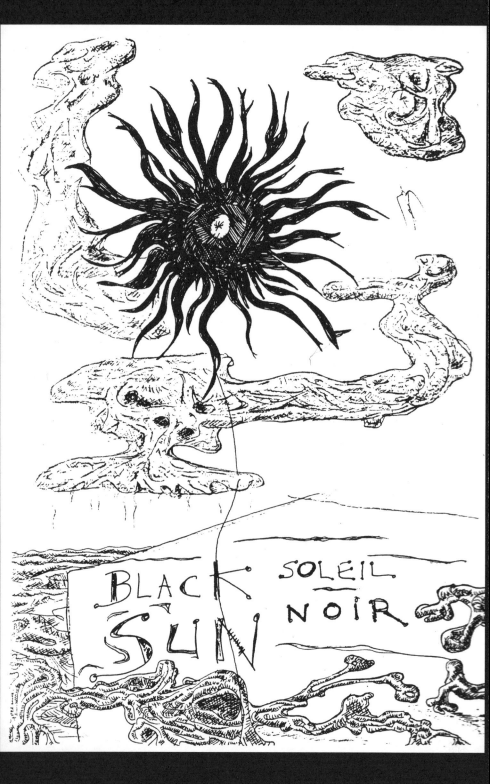

BLACK SUN

SOLEIL NOIR

'Psychic TV Split' / 'The Fetish For Shit'

Abstract #3 and #4, 1984

Gary Levermore

I began corresponding with Geff Rushton in 1982 while co-editing a short-lived fanzine and immersing myself in the post-industrial DIY cassette culture boom. Geff was the editor of a magazine with similar musical leanings, *Stabmental*, and encouraged my early endeavours, while also sending me tapes of artists and compilation projects he was involved with.

We first met at a Final Academy night in Brixton in October 1982, and then again in Portobello Road a few months later when I was taking my own *Rising From The Red Sand* tape compilations to the Rough Trade warehouse. 'You must pop round for dinner,' he said, an offer I failed to follow up. Shortly after, I would also regret not including what was purported to be the first ever Coil recording on a follow-up volume of *RFTRS*.

'Homage To Sewage' appeared on *Life At The Top*, a compilation on my Third Mind label that also included issue 4 of *Abstract* fanzine, edited by Rob Deacon (who would soon start Sweatbox Records.) Rob had interviewed Geff and Sleazy for a Psychic TV feature in issue 3, but the duo left to concentrate on Coil and Rob

had endured the wrath of Genesis P-Orridge for publishing it. Rob included Gen's letter along with his own pithy response in issue 4, as well as a new Coil interview. Rob and I worked together again a decade later on his Deviant imprint and we joked about this period, but any further opportunity to reminisce was gone when he died tragically in a boating accident in 2007 at the age of 42.

I interviewed Geff for *Grim Humour* magazine when *Horse Rotorvator* was released, while I recall an enthusiastic conversation a couple of years later after being given a cassette of demos entitled *The Side Effects Of Life*. I thought it contained the best music they had recorded to that point and tried to sign it, but the tracks were re-worked as *Love's Secret Domain*.

I have a fond memory of John from the launch event for *England's Hidden Reverse* in 2003, when we sat down for an hour and discussed the past and Kate Bush. The next and final time I saw him was at Throbbing Gristle's reunion at The Astoria in May 2004. He could be seen sitting cross-legged at the front of the stage enjoying the show.

With Red Sand PR, I recently had the honour of handling publicity for an official reissue of *A Guide For Beginners: The Voice Of Silver/A Guide For Finishers: A Hair Of Gold*. It rekindled old memories while reinforcing my opinion that they were one of the finest British groups of the last four decades.

Glinting eyes blink in unison, razorlike claws scratch at the opaque glass, its confine and home for the rest of its life. The rat is intrigued by the intrusion of these two newcomers into its claustrophobic existence.

A cup of tea is politely offered and accepted by the eager pair, anticipation? After four months of letters, phone calls and impractical arrangements there was room for little else. Unnerved? The peaceful engulfing atmosphere and calm exterior did little to mask the brooding intensity and impassioned fervour that Sleazy and Jeff hold for their beliefs.

The quieter half of (now officially defunct) Psychic TV have been cornered and captured but now does the hunter become the game?

Their beliefs, fact or fiction, they could be accused of starting their own religion, but Sleazy succinctly denies this: 'No, religion is fundamentally to do with the glorification of a God, of one sort or another. I don't want to set us up as preachers. I don't know if Gen would want to do that or not, but I'm very cautious about labelling the Temple in that way at all.'

Warily treading an extremely controversial path I continue: how did the manifestation with Thee Temple ov Psychick Youth begin?

'Well, between the time we ended Throbbing Gristle and began Psychic TV we weren't really looking at music as an outlet for what we were doing in terms of our ideas. We wanted to explore ourselves and one of the outlets that we did was the idea of writing things and developing ideas that were to do with how people saw themselves and behaved in society. For want of a better name we called it Thee Temple ov Psychick Youth, just in order to identify it, make it visible.'

Jeff defines the Temple as not having a tangible existence — the mind is the temple, the body its enclosure. Close links with

Buddhism spring to mind but are not substantiated, actually denied. Those who do not remember the past are condemned to repeat it, but does the Temple really hold such power or is it just an elaborate farce? You must decide.

Holophonic sound, gimmick or necessity? How did they discover it in the first place?

'Well, the guy we use as an engineer, Ken Thomas, works at 'Jacobs' and he knew we were into creating pictures from sound. He happened to see a demonstration by Zuccarelli who was, at the time, working with [Paul] McCartney, and he told us that he'd heard this amazing thing where you see things moving around with sound.'

'It still seems like you are using it as, less a part of the music, more a showcase for its effect.'

Jeff retorts, 'everything was recorded holophonically but things like the dog barking and the crackling flames stand out more because they are sound effects rather than music.'

My fears were not laid to rest, why was Dreams Less Sweet recorded in a church?

'And also in caves, because the nature of the device picks up the atmosphere of the place as well as the sound, if recorded in a studio it would be dead, but recorded in a place that has ambience, not only acoustic, but the ambience of things that have happened there in the past. That's why we recorded it in a church and also the Hellfire Caves in West Wycombe which used to be used for many different rituals and stuff like that.' Recalls Sleazy.

There is an amusing ambiguity in this statement, I muse to myself. Whereas Psychic TV admit to another's religious ceremony leaving an aura, an intensity of atmosphere in such caves, no other religion would admit to or believe that they could ever create the same. Slightly disillusioned by this lack of commitment I continue, determined to delve deeper. Why did they want to play at a mental hospital?

'Well, we wanted to play at Prestwich Mental Hospital but unfortunately, at the last moment, the "born again Christians"

in Manchester decided that we would be a dangerous influence upon the patients, they even picketed the town hall,' recalls Jeff.

This small piece of information rather turns the comment previously on its head. The God-fearing community, by picketing and banning Psychic TV, clearly admit that they are scared of their effect. My faith is restored as we continue, but for how long? Why did they want to play there?

Sleazy shuffles, coughs and offers an explanation. 'Mental patients very often are more open to new ideas than people who have been through the mill of everyday life. They are more naïve, more aware of things going on, and it would have been interesting for us and, I think, for them.'

False gesture or factual observation? Jeff's explanation for the ban's reason is unleashed on the unexpecting interviewer: 'I mean, Nico played there but I should think to patients only and not the public.'

Again, my support for the Temple shows hairline fractures appearing at its base. White night shirts mixing with army greens and Dr. Martens! Am I narrow minded or is it my truest belief that the public should be the patients in many cases?

'Do you think they believed then that you would stir up the patients whereas Nico wouldn't really threaten them?'

Sleazy corrects me: 'Not threaten them, get them to think.'

Due to this excursion, Psychic TV have now been banned from entering Manchester, an almost medieval act on the authorities' part. (Fade to cries of 'Free speech! Free speech!')

Jeff continues, apparently the Mancunian council had heard their particular brand of malevolent mood music prior to the gig: 'They heard "In The Nursery", they liked the idea of playing music like that, but the officials didn't like the idea of the public coming in and seeing what was going on. I mean, there is a total regime in mental hospitals, more than just keeping disorderly people under discipline. It is like a playground filled with people who don't know how to defend themselves.'

'How did you get the idea behind "In The Nursery"?' (A particularly effective bludgeoning cacophony of sound aided by P-Orridge's vocal discord.)

'It is the heart of the Temple,' explains Geff. 'It doesn't exist, yet it does exist, because we've got rooms called the "Nursery." It's a word that implies a lot of things: childhood, learning, games of all sorts, sexual and otherwise. One of the ideas that we had at the time was that there should be a place in which one is sheltered from the outside world and in which one can really expose your inner feelings and emotions, that is the "Nursery."'

The red light dims, click, tape ends... TDK C90 Side 2: 'So what is the philosophy behind "Terminus"?' A compilation video tape containing Psychic TV's video for the epic 'Terminus' has been released on DoubleVision. An extraordinary film (and I do not use the word lightly) featuring several people committing strange masochistic acts in slow motion. 'Is it for real?'

'I'm not telling,' retorts Sleazy as one particularly violent act of self-castration appears on the screen. Interesting, but Sleazy's wry smile gives the game away. I'd been well and truly had, or had I?

Again, I felt lost, the need for sensationalism in a video, shock tactics no less, was to me a pointless exercise, narrowing their chances of public awareness or acceptance of their beliefs.

If you are part of that small amount of people (apparently about 250,000 Throbbing Gristle/Psychic TV records have been sold) who wish to discover more about the aims and philosophy of the Psychick ones, an introductory booklet can be obtained by writing to Some Bizzare, 17 St. Anne's Court, London, W1 for a meagre £2.30. Copyright existing, and also my general unwillingness to report any information contained within its 23 pages, prohibits me from using any extracts, suffice to say that it leads to intriguing late-night reading for the more open minded among us.

Harking back to the early days: 'do you think Throbbing Gristle became so infamous due to word of mouth alone?'

'Yeah, I think so, I think once people heard us they saw something was going on. When we started to do Throbbing Gristle there were no independent record labels, I mean, we were the first. All the groups that were around then were playing things like Yes and Genesis and even the punk thing, that was obviously new when it started was, well you know, three chords now you can have a band, sort of thing. I mean, why do you have to learn three chords?'

Earlier Sleazy had said that the fundamental philosophy of the group has always been that you do things the way you want to do them, regardless of what convention tells you to do. By denying the necessity and the cataclysmic effects that 'punk' had at that time is to coin a phrase 'like cutting your head off to spite your face.' That first sentence, the FIRST sentence Sleazy uttered on the tape must be repeated: 'those who do not remember the past are condemned to repeat it.'

Change subject before stagnation sets in... 'Where did your obsessions with Charles Manson and the Reverend Jim Jones come from?'

'Well, I don't think we're obsessed with Manson and Jim Jones, but they are interesting examples of control process. That is to say how people on a small and quite noticeable scale, surrender their intelligence at will to the bidding of a single man. That's interesting because it's a model of what everyone does in the real world. They surrender their will to the social system. Working in a factory, a bank, a record company and so on.'

'So, you are trying to analyse why people do things like that?'

'Correct! Including us.' Agrees Sleazy.

'Have you found an escape?' The ultimate question in a penultimate interview.

'We don't want an escape, we want a way of confronting it creatively, making use of what there is. We say that you don't have to go along with what's there, you can create your own reality, your own system and you can integrate with it.'

XXXIX

'Would you ever try to spread your philosophy on a wide scale?' According to Sleazy apparently not: 'It's up to the individual! I'm really not interested in having a little street of followers who just do everything the way I do, cut their hair the way I do and think the way I do.'

A sound point from a man of reason. Discover your own 'temple.' Living up to your own principles and moral standards should be an equally challenging task as someone else's. The tug of war between their proposed logical self-discovery and the blatant public duping is going their way again. I persevere but am suddenly side tracked by Marc Almond (he gets everywhere!). Apparently a rather barrier-breaking book is in the proverbial pipeline.

Jeff reveals: 'I'm writing a book with him about male prostitutes in contemporary London. We still have to contact a few people to interview. It'll be a series of 10, of different rent boys, of which there are quite a few variations, an insight into what they do, with comment from us.'

Sleazy jokingly jibes in: 'I think we should give them a rating out of 10.' They laugh, so do I, pensively. The ultimate question for 1984 had been asked, now for the question of 1981, why did Throbbing Gristle split ranks?

Voices lower, remembering the past, a painful task: 'Personality clash.' Apparently Cosey and Gen had been lovers for some time and when they ceased to be, 'it became impossible to work together until we split in an amicable way. If you have a partnership that is growing then it adjusts to the circumstances, it's really only when people get fed up with others they move on.'

Moving on to the present a new project has apparently been formed, a coalition between Jeff and Sleazy: 'We are working under the name "Coil" at the moment and Jeff has been working under the name Current 93 which has been released on Les Disques du Crépuscule.' The first recording by the freshly formed 'Coil' has already been released on Dave Henderson's

The Elephant Table Album.[1] Meanwhile Gen has been working on a German film project by Klaus Maeck called *Decoder* with William Burroughs and Christiane F, apparently about psychological soundwaves. Plain to see that it is these new commitments which have led to the reported split of the group.

Anyway, back to the more mundane issue of musical preference, and Sleazy's taste in music?

'It's mostly Tibetan or New Guinea music, there are various sorts of ethnic shops where you can buy these things. There's a guy called Dave Tibet, who we've lost track of recently, who was a sort of Tibetan scholar. He introduced us to the Tibetan human thighbone, which produced the sound on the free LP with *Force The Hand Of Chance*. When you play them, it supposedly evokes the spirit of the person it belonged to.'

The owner of the thighbone can only be one of three things: a virgin girl, a murderer, or someone who died very violently. Although the album purports to have 23 thighbones playing at once, it is revealed to be only several such items multitracked together.

'We recorded the album to be a soundtrack for a video,' explains Sleazy: 'but unfortunately the law changed recently, just around the time it was finished and then it became impossible to sell.' Realising what law had been altered, I inquired as to whether it had been classed as a 'video nasty.' 'It certainly could be prosecuted under those laws. We've sent all our copies away and stored them abroad, we have no desire either to break the law or go to prison!'

Again, the distinctive use of 'shock tactics.' Please don't misunderstand my meaning and intention. Psychic TV were, and

1 's Is For Sleep'. Meanwhile 'LAShTAL' was the title track of Current 93's second EP, originally recorded in 1982 and released in January 1984, with Balance participating as part of a Crowleyan magickal ritual. David Tibet confirms he reconnected with Balance: '...once he had also left Psychic TV. Then we first worked together on *In Menstrual Night* and on the split-album *Nightmare Culture*, although I did thank him on *Nature Unveiled* and *Dogs Blood Rising*.'

Coil will be, a force to be reckoned with on a musical and mystical front. The pathway is still not clear, many questions must still be raised, the group's intent defined.

Less of an interview, more a preview of what is to come. The group split once, and now twice, it becomes, poetically speaking, like the Medusa. Sever one head and two more will grow. To question is the only way to define the aims of this, the level-headed half of Psychic TV. Now we wait for the next instalment from Throbbing Gristle's offspring.

Seek, question, and search through the many ambiguities of this interview and draw your own conclusions!

Abstract #4 Letters
23rd June 1984
To ABSTRACT:

E have just been handed a copy of your magazine Issue #3 which purports to contain an interview with Psychic TV, yet no members of Psychic TV are interviewed, no photos of anyone in Psychic TV are used. You therefore must realise that legally speaking you could be sued into thee annals of your own stupidity.

On glancing through this so-called article on Psychic TV we see many lies and misrepresentations. It is a basic law of journalism that before reporting opinions you check your facts and also give those slandered and presented a right of reply. We have tried to be fair to thee ego of Sleazy and Geff by allowing them to give thee impression they left Psychic TV when, in fact, they were instructed to leave, we have cassette tapes of this conversation.

We don't expect Coil to refuse to benefit by their previous connection with our work, butter to say they are Psychic TV and leave an underlying impression they were Psychic TV as its heart is to slanderously misrepresent Psychic TV. And to ask Geff to give you explanations of pieces of music and lyrics which were written by me in private is disgraceful.

Abstract #3, July 1984

Firstly, we want an apology, secondly we want a guarantee that you will indeed print a reply, thirdly you'd better get in touch, those expelled from Psychic TV and Thee Temple by all those still in it may seem level headed butter that does not mean they are per se honest, right or committed or that they are US. We want your explanation return of post or further action will be taken. We cannot allow thee public to be given such grossly dishonest versions of our history or to be told that nothing to do with us are us or can explain us. Do you realise what you have done, or how much harm it can do?
Yours disgustedly,
Genesis P Orridge.

Abstract 3 was compiled during Jan/Feb of '84, Sleazy and Geff assured us they were part of Psychic TV. At the end of February, while the magazine was at the printers, the major press announced that they had left the group. Four months after the multitude have bought it, you are handed a copy: these facts would seem to have some bearing on your accusations. We will, however, ask to see you, not as redemption for any supposed crime, but to convince us that you are being 'per se honest.'
Ed.

'The Fetish For Shit'
(Abstract #4, July 1984)

Following our feature on Psychic TV last issue, the half we'd interviewed — Geff and Sleazy — parted company with the band to pursue their own ideals in 'Coil.' At the time, we concluded that more talk was needed to tidy loose ends and explain incomplete ideas. As with this issue we are able to compile a more complete feature, with an audible, as well as printed insight, it seemed perfect to return for some questioning before the confusion had settled.

With the last article we managed to disturb both camps. One, because our report displayed a half-hearted belief in what was

said and the other, because we supposedly misled the public by reporting that Coil was part of Psychic TV, at that time we believe they were.

We approached Coil with both these accusations in mind, armed with questions and tactics which should supposedly crush any ambiguities and force to the surface any pitfalls or truth in their statements and beliefs.

Offering tea, Sleazy explained that they didn't want to talk about Psychic TV, naturally enough wanting to pursue new avenues, but does that mean that everything's changed, even their attitude toward music?

PETER CHRISTOPHERSON: We don't feel we've changed our philosophy or approach to life, just our approach to music.

ROB DEACON: How would you describe this new approach?

PC: ...Perverse. Not only in the sense of whatever we enjoy, we don't particularly enjoy mainstream music, but then we also don't enjoy much that isn't mainstream, banging pots etc. It's a question of finding a particular kind of music that's moving and entertaining for us. Also perverse in that after all these years we still can't play the instruments properly, so it's a question of making the kind of sounds we want, by whatever means we can, that get us as close as we can to expressing what we've got in our heads.

RD: What ideas have you got in your head?

PC: Basically all the ideas that we've managed to successfully bring into being are on the album. Sometimes you have an idea that doesn't work or an idea that you can't make work because you're not clever enough.

RD: Would you be hesitant to ask someone else to help in that situation, even if you knew that they could create what you want?

PC: Well it depends a lot where they come from and whether we think we can express in our words, to them, something that will end up having them interpret it the way we want. We couldn't use professional musicians who we had no contact with. It's much more important, the kind of person they are, rather than their technique and ability.

RD: So would they necessarily have to conform to your ideas?

PC: They don't have to believe the things we believe, it's just that we're more likely to select people who are naturally sympathetic to our ways and views in life, rather than select the kind of radical lesbian midwife who might not actually sympathise with our views.

Stephen Thrower, a member from Possession, has recently been sympathizing with Coil's needs, perhaps injecting a new direction or inspiration into the ideas. Where does their inspiration come from?

PC: A lot of our inspiration at the moment is coming not from personalities, such as Manson and Jones, as it has done before. It's coming more from ideas about specific concepts, even though our album is not a concept album.

RD: Can you give us some idea of what these specific concepts involve?

PC: The album is called *Scatology*. The dictionary definition of which is something like 'an obsession with base material,' which is really an obsession with shit.

Geff moves forward in his chair, from his previously silent viewpoint.

JOHN BALANCE: More specifically shit, it's actually an obsession with obscenity, with animal and human fetishism. The ideas around which some of the songs are based, some can be taken on face value, some are going a bit deeper into the idea of people either finding value in things that have been thought

not to have any face value or thought of as repulsive. Or even more deeply as an actual chemical way where people transmit base matter into gold or into things which are highly valuable.

RD: Have you got a fetish for shit, Sleazy?

PC: No comment! Yes, I have in fact.

(Geff practically leaps from his chair.)

JB: No I haven't! Make sure you get that in print. I'm only interested in turning base matter into gold.

RD: How exactly do you do that Geff?

JB: Alchemy never meant it literally, they meant transforming like an allotropy.

RD: There was a literal side to it where people did try to transmute lead into gold, but aren't you talking about changing something that's base, something that you don't want, into something good that you do want?

PC: I've hoped it's worked on lots of different levels at once, so you can take it at the banal level of people being into shit, or on a more philosophical level about finding value in things that appear horrible.

RD: The track 'Homage To Sewage' which appears on our album *Life At The Top*, is that meant along these lines? Worshipping base matter — sewage?

PC: Yes, that was one of the very first things that we did when we were developing the line of thought and this technique of playing.

It's an attempt to assemble sound sources in a way that actually has, in the beginning, no musical form. A lot of groups over the past few years have just played tapes as backing to whatever music it is they're doing, in order to give

'I think people in themselves are actually very strong and anything you can do to build up that strength and independence must be good. Like with faith healing, if you could use that amount of psychic direction and power actually to get people to cure their own verrucae and cancers, I'm sure a lot of interesting and useful things could be done like that. But there isn't really the motivation for people that are in control of these techniques, they're all feathering their own nests.'

it a more filmic quality or make it more interesting. What we were trying to do was to use a lot of things that might be insignificant under the track and actually make them into the music itself. I think there are about six or seven different sounds that are completely non-musical in their origination, that we've tried to weave together into a musical form.

The impression that we wanted to give at the beginning of working out this idea, was trying to possibly take things that might be — in their unedited form — disgusting, and actually elevate them to something which isn't really revolting at all, but very musical and rhythmic.

RD: With Throbbing Gristle and Psychic TV, I felt that you were always making music to test the public's reaction, whether it was the effect a certain sound or image would have on the individual or — in live circumstances — the effect it would have on a crowd. Was this part of your aim and have you now carried this thinking into Coil?

PC: We're both very interested in how people react today, but the reason for its being is not as a test of someone's reactions; that sounds like it's not actually a serious piece — if the reason for its composition is just to do a number on somebody — but that's not the case with any of the things that we've done. Obviously, if people write in and say 'I experienced an ecstatic transformation listening to your record,' then that's very interesting and you write back to them and say, 'oh really, how did this happen, what did you feel, and I did too,' or whatever. Or if they happen to say 'my mum heard your record through the bedroom door and immediately threw up,' that's also quite interesting because it's more experience as a result of your music. But I don't feel it's a number we're doing on people. I don't recall Psychic TV ever being that calculated, although

Gen might have said that we were. I'm not really interested at all in the manipulation of people for its own sake, there again I can't comment on Psychic TV's position in that. I'm obviously not interested in people having the same kind of haircut as us or the same clothes.

RD: But at times, when Throbbing Gristle and Psychic TV played live, weren't there certain ways that you were trying to manipulate people for some sort of reaction?

PC: When Throbbing Gristle played live we were always interested in actual physical reactions to the song and that responded quite clearly, it stated the objectives. Over the period of the gigs that Throbbing Gristle played we found out basically what you could do and what you couldn't do with that kind of equipment and that kind of volume. But since then it's not really been such a direct experiment.

RD: In 1976 you did the *Prostitution* exhibition at the ICA. Being such a controversial subject at the time with also the punk thing happening, surely the aim there was to create some public response?

PC: I don't think so at all. We were just doing things that we were interested in at the time and quite by accident we suddenly realised how different our ideas were, or in fact not different at all, because the papers in fact thought it was all a jolly interesting and an easier way to sell papers.

(Geff again leans forward and interrupts.)

JB: I think you were playing around with people's expectations. You did that to test boundaries in the sense that you knew people would be interested if it would expose their hypocrisies, and I'm sure Gen and you lot were all aware of that, so in that sense you did, and we still do.

XLIX

PC: To some extent I think you take some people's expectations into account when you do things, certainly with record covers and stuff. We'll try and do something that, when somebody might see the record cover first, we'll try to do something new and a bit different or interesting for them, rather than just being a nice design. That was what I always intended to do with any of the Throbbing Gristle or Psychic TV covers that I was involved with. To a certain extent you are aware of people's expectations and I know I'm repeating myself, but you're not trying to trick them, you're just trying to make it more interesting.

RD: When you started using the Manson imagery, were you just trying to make it more interesting? Are you still interested in him? Or was that a Psychic TV fetish?

PC: Well, intellectually yes, we are still interested in him, but none of the music we're making at the moment actually features him as an inspiration in the way that some of the Psychic TV stuff did. We're certainly not obsessed with Manson or Jim Jones. They are characters who are interesting in what they did, but so too are a lot of other characters.

JB: They are useful symbols, but they're being done to death at the moment by 400 Blows and SPK... Anyone. It's becoming rather a cliché.

PC: Basically all you can do is gather data on it at surface level, and over a period of time you begin to appreciate what strange little skills those people had, and if possible try to avoid being influenced by those skills when they're being exhibited by other people: whether it's Margaret Thatcher or your next door neighbour. I think that what Jones and Manson and all those people did is something that should be avoided rather than something which should be encouraged — but the technique with which he manipulated people was incredible.

RD: Don't you think what he did, which as far as I can see was reconditioned his followers making them think that they were right to kill all those people, don't you think that the technique he used could be used for good, positively, rather than negatively?

PC: Anybody's viewpoint being imposed on someone else is wrong, whatever it is.

RD: But you could do it without imposing your viewpoint on other people. If you take people out on their own and ask them, without criticism — and that's what stops most people speaking out for themselves — ask them what they think and what they want to do and get them to utilise that control in their life, then they could learn to apply it.

PC: I think that's possible but very rarely happens. I've never seen that. There are various courses that are supposed to give you new confidence and make you double your income and all this. *Excogises* (sic) is a very good example of this, where they do basically what you're saying only they actually, at the same time, promote their company ideals and so on. They have people working for the company using those self-motivational techniques and these people all have big smiles on their faces and say they're having a wonderful time and do jolly well for the company. It's just I don't think it's the way people operate. I agree, I think people in themselves are actually very strong and anything you can do to build up that strength and independence must be good. Like with faith healing, if you could use that amount of psychic direction and power actually to get people to cure their own verrucae and cancers, I'm sure a lot of interesting and useful things could be done like that. But there isn't really the motivation for people that are in control of these techniques, they're all feathering their own nests. I think, to some extent, that was another reason why we left Psychic TV, was that the trappings of this

thing we're discussing were taking on those overtones, which we didn't like.

RD: Were you all exploiting this kind of control with Thee Temple Ov Psychick Youth?

PC: Not in any serious way I don't think, it's just that the trappings were the same. I think that any organisation that encourages people to look the same, rather than different, at the very least is boring and may lead onto things that are even more unpleasant.

RD: So, are you actually saying that the 'guidelines' laid down in the *Introduction To The Temple* such as 'you should write magazines and give them 23 pages,' these guidelines were not your ideas?

PC: Well, no, a lot of the actual material that was covered in that pamphlet and the book were an attempt to lay out a lot of things we've been talking about just now, the way that people can be manipulated and how one should leave aside dogma and become independent and more able to deal with things alone. But unfortunately that in itself, over the months, became dogma. The words actually became more important than the ideas, or at least that's the way it appeared to me. But certainly I'm still behind a lot of what we wrote.

Back to the band in question, Coil, and Sleazy's interest in video. He actually owns a video company producing commercials and promo videos, including the latest from Barry Gibb.

PC: It's interesting because it's completely different from anything I've experienced before. It's a very good way of learning the techniques, not only of manipulating people (I thought we'd questioned all the contradictions!) but also of making films. Because, just as we've always made music with a particular

image or vision in mind, I would also like to be able to make films in the same way, because films obviously appeal to a much wider audience and it's easier to get ideas across much quicker: as they say 'a picture paints a thousand words.'

RD: Do you intend doing videos for Coil in the same vein as 'Terminus', the masochistic Psychic TV offering?

PC: In theory, yes, but in practice I haven't had the chance. We have actually had a number of requests from people putting out compilation video tape things and although we'd like to do things in that area and be seen by the public, up to now I haven't had the time. We're still quite friendly with Stevo and he had a cable programme on American TV which is supposed to reach 35 million people every month, for which we've been asked to do a film for, so we will be doing something imminently. It's just, maybe I'm being a snob, but I have a high expectation of ourselves, so we don't think it would be sufficient to do a 'super imposition' of lots of marching feet, weird images, and sweaty bodies because I don't think that's very interesting. The thing is you're bombarded with images on the TV and a lot of people, as a result, think that if you just bombard people with more images, or images of a particular nature, then that is actually sufficient to make an entertaining video and I don't think that's the case.

RD: So what would you do that would be entertaining?

PC: Well, you'll see when I do it. I think it's more likely to be a proper film and I'm sure the story, if there is one, is likely to tell a very different tale from those that you've seen already.

Sleazy is equally vague about his plans for touring.

PC: We haven't actually figured out quite what it is that we'd do that would be worthy of being called 'live' and interesting but,

at the same time, would be good enough to reach our sort of standards. I was never happy with what we did with Psychic TV live, it was very sub-Throbbing Gristle-ish as far as I was concerned and I'm not really interested in doing that again. I need to do something new and making a noise isn't new at all.

Sleazy refusing to expand further on any appearances which may be made, squeezes the conversation dry but not without first explaining why.

PC: Our energy is not put into talking so it's possibly true that in interviews with us we are likely to be less forthcoming than a lot of people are. Hopefully we are a little more literate than some bands who say, 'yeah, we had a really great time on tour screwing lots of people,' because we've possibly got more interesting things to say.

And they've got some interesting things to question, but until their next contradiction I'm satisfied they're being 'per se honest'.

'Paradise Lies In The Shadow Of Swords'

They're Coming To Take Me Away Ha Ha, Summer 1984

Mark Lally

The early 80s was a moment when the gap between bands and fans was the smallest it's ever been. In 1979, at 12 years old, I bought my first NME and listened to John Peel; I started visiting Probe Records in Liverpool and was served by Pete Burns; then the Wild Planet column in *Sounds* turned me onto even weirder stuff. As a consequence, it didn't feel at all intimidating to write to Crass — or strange to hear back. That openness was at the core of DIY culture, the belief that you had permission to make things happen...

...So I did. Age 16, I wound up on a Government Youth Training Scheme print and design course. My fanzine became the project I undertook to successfully complete the course. *They're Coming To Take Me Away Ha Ha*, came out in summer 1984 and I'm still proud of the quality and the breadth I achieved with some core determination and those YTS skills.

I wrote to quite a lot of underground artists including Psychic TV. I sent a couple of letters in late '83 and Geff was handling the post. He really respected fanzine culture given he'd started out

with *Stabmental* so he recognised the passion I had. When the Coil/Psychic TV split came, it was natural we kept talking and wound up doing an interview.

People underestimate how hard it was to scratch below the surface of pop music back then. If you weren't *Top Of The Pops* material then you'd never get more than a sarcastic half-page in the press. That's where the zines came in: this network of people with their own projects and connections, with a commitment to evangelising new culture, they were ideal for esoteric artists who were smart enough to engage like Geff and Peter did.

We stayed in touch after that. I started a cassette label, Frux, on £25 a week Giro cheques — later supplemented by college grants. I wound up releasing three compilations featuring artists like Nurse With Wound, Muslimgauze, We Be Echo, Bene Gesserit, and DDAA. I also issued The New Blockaders' *Epater Les Bourgois* and *Salute*, the latter a split with Organum. It was only when I got proper distribution for the *Let The Pigeons In* LP that low sales meant I couldn't continue.

Coil allowed me to do photo portraits of them in 1985 and 1988. After that we lost contact as I left the music scene behind: better to burn out AND to fade away. But I've always thought fondly of that time and how much could be accomplished if you put your mind to it — it's why I called one compilation *Born Out Of Dreams*.

'Paganism is merely truthful
examination of the mind, instincts
— everything is fragmented — as
is the natural order.'

Interview
2.II.84[1]

Dear Mark,

Yes, you can interview both me and Sleazy. I really don't know when will be OK, but one of thee dates you mentioned will be I'm sure... What about though? Psychic TV and/or Coil? I will have just recorded a Coil LP then — called *Set And Reset* — and I can go on about that.

Performance art — no, I don't usually feel pain. But I feel totally and utterly wrecked afterward and for thee next few daze. It's a purge. You're baring everything — body and soul — literally. Pain is a state of mind. I went to thee dentist today, something I absolutely hate, but if I thought about other things while he was drilling then the pain went away. Well, it was still there obviously but I was translating it differently.

Coil have done several strange live appearances — performance art and so on. Marc Almond, Joan d'Arc and myself did a piece called 'How To Destroy Angels' at the Air Gallery in London last August... I did a piece with Sleazy called 'Silence And Secrecy' which was an exercise in extended tension due to using extremely amplified insect noises and violin. A small section is released on the Austrian cassette. The whole point of that performance was that it was not possible to capture the atmosphere on tape because I was using out of phase strobes and also perfumes to make the observer more of a participant in the whole thing.

Saluti

1 Lally's first letter arrived at Some Bizzare during Psychic TV's tour in late 1983. Balance responded in late December saying 'We have been away in Berlin, New York, Iceland... We are still interested in being interviewed... Please get in touch if you're still interested — also in my own solo project called Coil.' The performance art discussion in this subsequent letter relates to Balance's involvement in Psychic TV's notorious *First Transmission* VHS. The final paragraph is from an undated letter.

Geff Legion
16.2.84
ERA MAXIMUS

Dearest Mark L.

...we are eager to talk to people. There's no point in doing things if one doesn't discuss them.

...You probably know Sleazy and I have left now and it was for similar reasons to why David 93 left. He had fewer ties and so it was easier for him to go. With Sleazy it was much harder and it was only when he lost interest in the actual material being produced that he decided to leave. I left because it would have been very hard for me to stay without Sleazy and, anyway, I had found things getting too autocratic and one-lined for my liking. Things were being taken as representative of the whole of Psychic TV, when it was just Genesis' own personal view. It's a very complicated, delicate situation. I still respect Genesis and the overall and underlying Psychic TV/Temple ov Psychick Youth concepts but because we all hold such strong views, when these views change you find yourself at odds all of a sudden. It's just two different paths to the top of a similar (never identical) mountain.

How did you get involved with Psychic TV? I read the right signs, did the right things: i.e., pretended to be in awe, submissive and pale. Psychic TV draws in a willing victim and I slowly began to change the shape and helped improve what was a growing thing. Gen and Sleazy did start the ideas — or rather proposed a new manifestation of things which have existed since early Throbbing Gristle days... I still believe we uncovered a huge amount of hidden information, but both Sleazy and I now feel we should establish a different alternative to what Genesis personally believes. His views are absolutely valid — so are ours. We just don't want, or need, to refer to each other so closely anymore. Natural growth, change and hopefully fruition on both sides.

Mark Lally

Prestwich gig?[2] I suggested we play in a mental home originally, because I thought it was good to play to people who have 'open' perceptions... there are areas of human consciousness which are present when you are young, or so-called 'mad', and we were interested in playing to people who may still have this open facility... I've been treated for schizophrenia as a child, so I have a small grasp of what actually does go on, my experience was minimal but I managed to see what a fucking terrible system it all is; open to maltreatment, abuse and everything...

Death? No, I'm not scared. On things like LSD trips you realise that everything dies — or rather changes. Everything is part of an ordered disorder. I'm scared of pain, that's entirely different though. Death is a constant, the only thing man can be sure of. So it's a good measuring aid. I think I have to get on and do things now rather than waste time so, in that sense, it's a friend, a stimulus.

'Ubu Noir' — Surrealist collage. *Ubu Roi* is Jarry's Dada violent film about a dictator king — very savage and obscene. 'Ubu Noir' turns it into something new with the same sound. It's black, savage and surrealistic.

'Cyclic' — Everything has been already and will be again. Everything goes in cycles: birth→death→birth. The seasons power the rise and fall of an engine or an empire. Reincarnation. Life cycles from frogs to spiral galaxies. A statement of grinding inevitability.

'Ergot' — LSD was found to be related to ergot rye mould, a fungus which grows on wheat heads. It caused St Anthony's Fire in the Middle Ages, when people made bread from diseased wheat it caused blindness, insanity, violent religious visions, humming sensations in hands and feet — your hands eventually fell off — uncontrollable urges to dance, murder and kill yourself... A nice

2　Psychic TV's second live performance was to take place at Prestwich Mental Hospital on 4th November 1983. The hospital governor intervened citing 'concern for the welfare of the inmates' after calls from concerned relatives. The show was moved to the Manchester Ritz on Sunday 6th.

little tale. It ties in with the theme of poisons which the LP will have in it. I like the sound of the word too.

'The Tenderness Of Wolves' — About appearance and reality in relationships — jealousy and backstabbing. About how the urge to survive takes over beyond the individual's control. It's a virus inside. There is a book called *The Selfish Gene*, which says our genes just use the body to make sure they survive and the outer shell is left to compensate for this rather callous situation, so people say things and then act against what they promised and so on: the origins of selfishness and jealousy. It implies that there is very rarely any tenderness in anyone, despite what they would make out.

...It's very hard to create an atmosphere; to recreate an experience like a car crash live — almost impossible. You have to translate thee experience and present it another way, hopefully preserving the feelings you had. You have to put someone in a car and crash it to get them to feel what you did...

Please keep in touch,

Saluti.

Legion.

3.III.84

ERA MAXIMUS

Dear Mark,

...Coil is confusing. So what! Life is. This could be intentional... Coil is me and who I work with — but Sleazy is a full time member now so it's whoever thee both of us work with. We are recording an LP next week using a Fairlight synth.

Saluti

14.V.84

BLACK SUN RISING

Dear Mark,

...I'm glad you like the Coil tape, especially the tracks you mentioned. There is the idea of releasing a full-length version of 'Silence And Secrecy' re-recorded as opposed to a live version... (*The song*) 'Truth' — Manson is talking! It's from the speech he made to the court from which the jury were excluded and was later published as *Your Children* by Charles Manson, a small rare pamphlet in the U.S.A. Psychic TV have done what I consider to be a mean, dirty underhand move by including the Manson piece on the Sordide Sentimental record just out by Psychic TV. It had, however, been released since October '83 on the *Transparent* tape so anyone would know which came first. Of course, I don't have exclusive rights to the Manson speech — but it's a bit of a liberty.[3]

Soundtracks — yes, Derek Jarman has approached us but I'm not prepared to say anymore until we've actually completed something concrete. He is a friend of ours and we have discussed several possibilities.

The working title for the Coil LP is *The Erotic Form of Hatred*, but we'll probably change it as we usually do. No label due to release it — we may even do it ourselves. 'Set And Reset' became 'How To Destroy Angels' but the title will be used again elsewhere.[4]

3　Balance's declaration refers to the recording date of 'Truth', October 8th. The album itself wasn't released until 23rd February 1984. In a letter from February, Balance refers to it as 'a Live in Berlin cassette which is coming out soon...' making clear he still didn't know what it was called. He subsequently confirmed on 3rd March that he had copies for sale.

4　In a further exchange with Lally, Balance mentioned 'How To Destroy Angels'/ 'Absolute Elsewhere' saying of the B-side 'It has had some very confused reactions, which is nice. I stick by it, it is pure and as we intended which is always a good thing. We could have easily done a weird rhythm track to keep people's attentions, →

What you wrote about drugs at school, etc. was disgusting. Smack is a plague of epic proportions — foul and insidious. I sincerely hope I never gave you the impression we take drugs on that level. NEVER. I believe people should know the facts and, if they do take them, do so in circumstances whereby they are beneficial. I don't understand why people take smack... Inbuilt death wishes I suppose. Who am I to preach? I believe in scientific exploration of your own mind — sounds pretentious — so don't quote me on that. I don't believe there should be controls on what people do to their minds/bodies, but it's their responsibility.

Why am I a pagan? Because † is fuck all use. It provides a crutch, a passing of responsibility to the church, your earthly business to the priests, and your conscience/soul to a dated and contradictory bastard of a deity. God structure is a macro-version of puerile social hierarchy. It all leads to no person having responsibility for themselves and they therefore are totally wide open to manipulation by others — basics of control systems — manipulated by guilt, fear of God, hell, and imposed moral structure which causes conflict and problems with true 'will' nature. Paganism is merely truthful examination of the mind, instincts — everything is fragmented — as is the natural order. There are no gods except those you create yourself and man is his own master. Of course, 'pagan' means 'godless' to people who 'have' god. My beliefs are godless so that's what I meant. My real beliefs are extremely complicated.

Saluti.

Coil.

→ but that was not what it was about. It's uncomfortable, not because there are extreme noises, but because it's very hard to follow, you have to involve yourself.'

21.V.84

Dear Mark,

I can't give you a rough mix copy of the mini-LP really. We are remixing it all this coming weekend so I can send you one at the beginning of next week which will be the finished thing near enough. We have decided to call the record *Scatology* — which you'll have to look up in a dictionary if you don't know what it means. I hope the cassette will be arriving in time. So the track-listing (revised) for the LP is now:

1. 'Panic' (not done yet, with Jim Thirlwell — Foetus On Your Breath)
2. 'Cathedral In Flames'
3. 'Ubu Noir'
4. untitled as yet
5. retitled — used to be 'Homage To Sewage' so call it that for the moment.
6. 'The Wheel'
7. 'The Sewage Worker's Birthday Party'

As usual, I reserve the right to change everything totally but this is close to what it will be.

Saluti.

Coil.

23:6:84[5]

Dear Mark,

I will be brief as to what this letter is about. I must have a copy of what you intend to print and publish in your magazine regarding Coil and us leaving Psychic TV. The reasons being that we are in a situation whereby we have decided it is better to be very precise and careful about what we say. What we wrote

5 Note the corresponding date of P-Orridge's letter to *Abstract*...

earlier was a while ago and situations have changed since then. What was said then might now mean different things and be interpreted in new ways. It is essential that you do not publish anything until we have seen it and approved of it. Failure to do so can be embarrassing for us and dangerous for you. Please send down what you intend to print as soon as possible and on no account send any copies out until we say. This is to ensure that all are seen in a reasonable light. I'm sorry to have to spring this on you and it will probably be the case that all would have been OK anyway, but we must be sure as relationships with old Psychic TV members are sensitive at thee moment and there is no point inflaming things. Act ASAP.

Saluti.

John Balance

27.6.84

Dear Mark,

I am sorry to cause all the bother. The reason for the panic and paranoia was that Genesis had said that we had been slagging him off too much and that he thought it was unfair. We hadn't been and I think we probably should have but still, at this point in time it is probably best to concentrate on what we are doing and not on what people think went on before. That is past.

Your article, though brief, is OK... I do want you to change the title 'An Antidote For When People Become Poisons.' That is a sneaky sensationalist trick... The 'people' referred to were no one in particular and especially not anyone we were working with at the time. I don't like the deliberate colouring you intended the positioning and inclusion to have. Also, please change the order of the last paragraph round so it comes before the bit on paganism. We don't want to end on a piece talking about Genesis because it makes us seem obsessive. I want to establish our own identify and not keep going on about the past. Although I admit

that in the proper circumstances I would be interested in that too. I am very sorry that this happened, but it was best for both of us. I was upset at your attitude of aggression (i.e., 'I don't think that Genesis will ever talk to you again when he reads the piece,' etc.) We can't live that way. We still have to talk to him and pretend that nothing particular has happened, because otherwise life for both of us would become intolerable as we work in close areas and they still overlap from time to time.

Regards,
John Balance

15/7/84
TRAP THEM AND KILL THEM

Dear Mark,

OK, so all the changes are for the best. Of course, people read things that they want to see into facts and stories — truth is totally subjective. Two people never see the same thing. EVER.

You were right in associating 'The Tenderness Of Wolves' with relationships/GPO, etc. but at this stage it's much easier to be subtle and forget details. We, as I pointed out, have to still deal with him/Psychic TV. People always (I'm not meaning you in particular) sensationalise and personalise a story once told — I do — but the area you had entered was too painful to let pass at the time. I'm glad you're able to change it anyway. I was frantic for three days in case you'd already printed something terrible.

25.7.84
BLACK SUN RISING

Dearest Mark,

They're Coming... is very good. I'm very pleased with the Coil and Psychic TV pieces. They have mistakes in but disinformation, always a good thing... We have still not completed the *Scatology* LP. We did a track called 'Restless Day' for the animal liberation in the end.[6] We were doing one called 'Godhead=Deathead' for it but in the end we wanted that for our LP. So tracks now included are: 'Lock', 'Godhead=Deathead', 'Homage To Sewage', 'The Tenderness Of Wolves', 'Ubu Noir', 'Cathedral In Flames', 'The Sewage Worker's Birthday Party', 'Panic', I want to do 'Baptism Of Fire' as well.

Saluti John Balance

6 *Devastate To Liberate,* supporting the Animal Liberation Front, wouldn't be
 released until late 1985.

'Not Knowing What Is And Is Not Knowing, I Knew Not'

Interchange #2, 1984

John Hirschhorn-Smith

When punk broke in 1976 I was 14 but, being brought up in a middle-class area of London, could scarcely detect its presence. I didn't much care for the music, but its counter-culture attitude resonated with my sense of alienation. Fanzines, John Peel, and various 'enlightened' press articles made me aware of bands like The Human League, Virgin Prunes and Throbbing Gristle.

Moving to Newcastle in 1980, I discovered a lively scene: Metgumbnerbone, The New Blockaders, Zoviet France and — although I didn't know him at the time — David Tibet, all lived inside ten minutes of my flat. Dropping out of university, I became a fully-fledged member of this incestuous group where everyone seemed to have 'a project' and the seed of *Interchange*, planted in London, bore fruit in this fertile climate.

The early issues were entirely self-produced and nearly everything was done via mail. The first issue contained a long Nurse With Wound interview and I printed 230 copies, of course! Incredibly, despite looking (and reading) execrably, it sold out and the many nice letters I received inspired me to produce a second issue.

John Hirschhorn-Smith

I was on the original Industrial Records mailing list and, when Throbbing Gristle broke up, I joined Thee Temple Ov Psychick Youth. Geff Rushton was my 'correspondent' within TOPY headquarters (although we may have corresponded during his *Stabmental* days) and, when TOPY imploded I decided that Coil was, by far, the more interesting project. Thus it was a no-brainer to involve them in *Interchange*.

The eventual article was constructed partly via letters, and also an interview conducted at the Coil house in Chiswick, a huge Victorian pile. John's snake had died so we delayed the interview by a day to allow him to mourn. We sat on the floor of a largely empty spare room and chatted for a few hours over tea and biscuits. I didn't see the rest of the house but Sleazy did pop his head around the door to say hello.

This was our only meeting and I found John a gentle, shy, and reserved soul. I got the sense that Coil was far more John's project than Sleazy's but much of our chat was not about Coil *per se*, but rather about art and artists generally. Before I left, he kindly gave me various issues of *Stabmental* to complete my collection and we kept in sporadic touch for a few years. Eventually, as I moved further from the music scene, our contact lapsed, something I regret as his name sometimes appeared in the context of other interests.

(Note: all issues of Interchange *are available for free via John's Side Real Press website).*

'Marc did vocals and John and I did a scenario of degradation, stripping naked, painting our bodies, shitting on the floor, degrading our bodies — but really extreme, it's things the people who turned up always say they are into but far more extreme...'

Interview
'Not Knowing What Is And Is Not Knowing, I Knew Not.'
Hassan I Sabbah

Coil is a multi-sensory project organised around Psychic TV collaborator Geff Rushton.

Similarities can obviously be drawn between the activities of Coil and Psychic TV in that both are working in multimedia on both a physical and mental plane. Due to the extremeness of the images, [Hermann] Nitsch similarities are also apparent, again this being both visual and ideologically i.e.,:

> ...a rediscovery of the ego, in a state of intoxication provoked by the search for being... catharsis through fear and compassion directly encountering the unconscious and reality.[1]

> Coil. Who has the nerve to dream, create and kill, while the whole moves and every part stands still. Our rationale is the irrational. Hallucination is the truth our graves are dug with. Coil is compulsion, urge and construction. Dead letters fall from our shedding skins. Kabbala and Khaos. Thanatos and Thelema. Archangels and Antichrists. Open and close. Truth and deliberation. Traps and disorientation.[2]

There are also links with Throbbing Gristle in that things are done 'en masse' which overall have little meaning compared to the total experience but when looked at separately have very particular roles.

Coil itself is very fluid in terms of personnel — performances have a loose framework which is used as a basis for improvisation, Geff working

1 'Nitsch — A Modern Ritual' Katie Tsiakma — *Studio Int* '75
2 An excerpt from the Coil Manifesto.

with people who have either expressed an interest in the project or else people who he feels could have a useful contribution to make.

JOHN BALANCE: There have been two performances as Coil — we interpret the idea in relation to the place and people we expect to be playing to.

JOHN HIRSCHHORN-SMITH: How do these performances come about?

JB: People just ask us to do them — it seems to work quite naturally — like I'll be working on the Psychic Television project or something and see a space in time coming up, and by the time I've reached it I'll be wanting to do something on my own and someone will want Coil to do something...

...One performance was at the Air Gallery. I knew what type of people to expect because of the other people performing so I used the performance as a counter attack to the other happenings. We called the piece 'How To Destroy Angels' and I worked with Marc Almond and another person called John Gosling. The piece was both a study of human degradation and personal relationships as well as a parody of fine art which appealed to Marc as he is very interested in relationships as well as being totally different to Marc And The Mambas and something he used to do before Soft Cell.

Marc did vocals and John and I did a scenario of degradation, stripping naked, painting our bodies, shitting on the floor, degrading our bodies — but really extreme, it's things the people who turned up always say they are into but far more extreme — I think Marc found it more over the top than he expected — people were wandering around complaining about the smell and things...

JS: Like Z'EV. He used just metal sheets and things when he played in London a few years ago — all untreated — and the audience

didn't know what to make of it, even though Throbbing Gristle and Cabaret Voltaire were playing and they were seen to be 'avant garde'/'industrial' etc.

JB: It's funny you should mention Z'EV as Coil works in roughly the same way. Z'EV's interested in language breakdown and uses Alchemy and Kabbala — he's Jewish so he uses the Kabbala as a matter of course... Coil and Z'EV are interested in Konstructivism (NOT the Glenn Michael Wallis thing!)[3], structuralism and finding the hidden meaning of things. Throbbing Gristle were chaotic, but behind it is a hidden structure, structures composed of chaos— find the structures and use them...

Coil are Archangels of Khaos — the price we pay for existence is eternal warfare. There is a hidden coil of strength, dormant beneath the sediment of convention. Dreams lead us under the surface, over the edge, to the delirium state. Unchanged. Past impositions and false universals. Reassembling into our order.

There was another performance at Brixton Ritzy — this was based on the idea of the nothingness of the universe. It sounds pretentious but it's based on the idea that instead of there being something incredibly interesting at the centre of the universe — the essential fact is that there is nothing at all — the ultimate state is nothingness — in magickal terms this is absolute enlightenment — crossing the Abyss.

Another aspect we had was smell — the Ritzy has a really high stage which I thought was a bit like a church, so I used Frankincense because I wanted a high church smell.

We then had out of phase strobes, and I found that after I had got off stage to go to the mixing desk I found it really difficult to get back on again as the stage was going up and down, the

3 A reference to industrial band Konstruktivits.

cricket noises were as loud as we could get them as well... but really, nothing happened — I tried to get an atmosphere of unfulfillment... suspended unease.

It's so many things at once. That's why I chose the name COIL as it represents so many things:

> *Coil is a hidden universal. A code. A key for which the whole does not exist. Is non-existent. In silence and secrecy. A spell. A serpents* ShT *round a female cycle.*[4] *A whirlwind. A double helix.* DNA. *Electricity and elementals. A tonal noise and brutal poetry.*

There have been a few audio releases as Coil. Although some items may have been influenced by live performance, each recorded item has been done in such a way that it will stand up without other aid.

Geff Rushton also works under the name John Balance: 'not to confuse — but to distinguish between projects' — and is closely involved with both Cultural Amnesia, who have material available on the Datenverarbeitung label in Germany, and David Tibet's Current 93 whose debut disc has just been released on a subsidiary of Les Disques Du Crépuscule.[5]

4 'ShT' is an occult formula especially associated with Crowley's magickal system. Among various connections it refers to the Egyptian god Set and is equivalent to 31 in the tarot.

5 Cultural Amnesia was a trio originating at the same school as John Balance. He effectively became their manager, arranging contacts; contributing lyrics; producing artwork and promos; and releasing a number of their early works. Various compilations emerged in the 2000s.

FOR GERARD

Lop Lop feeds fish to the wicked.

1/8

sinclairs luck
by
cultural amnesia

'Cathedral In Flames'

Rockerilla, 2nd October 1984

Vittore Baroni

Strangely, a cassette of my noise/plunderphonic project Lieutenant Murnau made its way to Geff Rushton and he reviewed it in a 1980 issue of *Stabmental* — it would be some time before I had a chance to return the favour.

I found John's address in the *Industrial News Bulletin* and, being active at the time as a writer for Italian rock monthly *Rockerilla* and as a producer of mail art, zines, cassettes, etc., we started exchanging material and keeping in touch. In his long letters, always handwritten in his beautiful, almost ornate, calligraphy, John would request information, photocopies, text from books, on topics he was researching. It's why my name appears in the thank you list of *Horse Rotorvator*: I supplied John with details of the life of Pasolini, including the fact that Ostia was known colloquially as 'the sea of Rome,' a phrase he incorporated into the lyrics of 'Ostia.'

I arranged three Coil interviews to appear in *Rockerilla* between 1985-1991, always coinciding with the release of a new album. As was common in pre-internet times, and given John was

such a charming and eloquent writer of letters, I conducted the first two interviews through the post. He answered in detail and also added handwritten lyrics, photos, and other supplementary material to entice and illuminate. For the third, I took advantage of a trip to London to interview him at Threshold House, though unfortunately Peter was away working.

I continued to write about Coil in the years that followed and was, of course, dismayed at news of John's serious problems with alcohol. Surely no one could have imagined such a sad, premature end to his earthly existence? From what I heard and observed, John's presence within any musical endeavour always implied constructive and fruitful collaboration, that he was the glue binding many projects together with his mild, calm, loved, and respected character. To cite one small anecdote, I once interviewed Diamanda Galás and, at first, she was keeping a reserved distance. By chance I mentioned my friendship with John and she instantly opened up and audibly relaxed: 'Oh I love John Balance!' She declared. Peter knew full well that John emanated this powerful aura of positivity, and that's why he gladly left so much of the task of press relations to John, especially in the early years of the group.

Note: the original letter below was quoted in Rockerilla *(issue 55, March 1985).*

'What do you think of Pope
Giovanni Paolo II?'

'Is he the Antichrist, do you mean?'

Interview

Dearest Vittore,

The reason I have not been in touch for so long is because it has been immensely difficult to answer your questions. I don't like to have to do written statements. Ideally I like to do an interview and do it in several parts. I will attempt to do an answer thing though as I think it's important. People like Genesis have had many years of practice at such things and so have the edge over the naïve likes of me.

How are things anyway? I hope that you are well and that things are progressing as you wish them to. Coil have been doing little recently but there will be a burst of releases near to x-mas. The questions:

VITTORE BARONI: Both Psychic TV and Coil claim that their music should not be considered 'entertainment', do you think that there is a difference in the attitude of the two groups?

JOHN BALANCE: A trick question. Of course there is, but I think that the difference is one of methods and personalities which is, of course, why we both opted to leave Psychic TV. And, on this point, can I just clarify that despite published reports from Genesis that say the contrary, we left of our own accord and were not asked to leave. We simply found that we couldn't work under the demands of GPO. There was a lot of bad feeling and paranoia on everyone's part and I hope that now both parties can get on with their particular modes of activity.

There are many similarities in the way both groups work, but also fundamental differences. I can't speak on their behalf, but the enemies we are attacking — control, laziness, blind acceptance — are the same and we both have ideal and disciplined guidelines by which we live our lives. The literature of Psychic TV says a lot but basically it is the striving of the

individual to make an impression on things and to change them for the better. It sounds naïve and simplistic, but then the most complex and multifaceted things and ideas are always deceptively simple.

Regarding 'pathetic art-groupies' and how/what sort of audience we are aiming to reach... I am interested in reaching anyone who can share, experience, and benefit hopefully from our music and ideas. We have an indefinable mission. We are NOT preachers with the divine law. Coil wish to create the delirium state where things are disorganised into a glorious ecstasy. The quality of the observer/listener will determine whatever they get out of it. We will perform for whomever wishes to experience. There are superficial levels to what we do, we DO want to be pure entertainment on one level, but we want and attempt to couple this with a serious core. Nothing will be what it seems. It will be information and chaos, art and language. We are not interested in preaching other gospels. We believe in ourselves and so should other people. As we said in Psychic TV, we are merely catalysts, 'we wish to give people back to themselves.'

Regarding *How To Destroy Angels*, the 'Angels' side is an attempt to create a music which the listener can use as an aid to sexual magick, as we are all male in Coil with '...accumulation of male sexual energy' (as it says on the sleeve). This has had us called misogynistic by certain people, but it is merely that we chose to do a piece of music that was masculine and Martian in content. We have a feminine side. We are gay and accept both the male and female side to the character, this is natural to us, but on the record we were accentuating the active and strident, positive side to the situation. The title is ambiguous. I meant several things, one is that one might be capable of releasing such power that the forces would be enough to

destroy angels. It could mean a loss of innocence. It could be the destruction of fallen angels. There are all sorts of things that lead from discussion of the method of destruction.

The 'Absolute Elsewhere' side is to do with absolute negatives. Absolute Elsewhere is the region of space that is beyond the boundaries of the imaginable universe. One can only define it by referring to what it isn't because the mind cannot accept the concept. Once it IS accepted it is then no longer Absolute Elsewhere because it has become comprehensible.

We wanted to have a pure shiny mirror surface, but the first pressing was a noisy mixture of about one hundred different record surfaces, which was nice but not what we had originally intended. The second pressing had the surface we had intended. I like the idea of having a black mirror, as the mirror is a traditional gateway to inner-space and astral travel and clairvoyant states. And several people have attempted to use it as such which I like the idea of a lot. One of the reasons why the record only had one side was to separate it from normal record releases. It was intended as a tool first and as an entertaining piece of music second. The having only one side strengthened that idea in my mind.

VB: Do you think, musically speaking, that the work of Coil, Nurse With Wound, Current 93, etc. should be considered in the popular music tradition of Rock 'n' Roll, as a combination of improvised music with magickal and alchemical theories, or rather as religious music — under what category would you file it in a music shop?

JB: I can only really speak for us. I know that Nurse With Wound try to be filed as classical, and have the United Dairies releases pressed on classical quality vinyl which is more expensive. With Coil, it would depend on the particular release. Some

of the recorded material, especially on the LP, is highly structured and tight and could not be called improvised by any stretch of the imagination. I wouldn't really care what it was filed under as long as it was available.

VB: What do you think of power electronics groups?

JB: Not a lot really. Early live Coil often came close to this area, but only because we were working with simple structures and loud volumes. I respect confrontational tactics as long as they remain combined with intelligent thought processes and something very personal. There are a lot of groups who copy early Throbbing Gristle, which had a really strong sense of the humorous and the personal, but are themselves totally devoid of any redeeming qualities. I can excuse any amount of noise and assault as long as I'm aware of there being something behind the pose. I'm far more interested in 'why' and 'what' than the surface considerations. I can admire the stance and perhaps the need for Whitehouse, etc. but certainly not the content.

VB: 'LAShTAL'... In what circumstances was it recorded?

JB: I can't really describe the circumstances, but they were special and, yes, they did have an effect. I don't think that the magickal essence of such a ritual can be carried to its full extent on vinyl. There needs to be a combination of mental preparation and process that can only occur in the flesh, and that ALL that is on the record is an echo. Not much danger there. All we hope for is a transmission of some part of the experiences that we underwent. No more. It was seriously conceived though.

VB: Do you have any relationship with existing magician or occult organisations?

JB: As little as possible. Groups like the OTO are highly organised and, as such, are very restricting. We don't really need to have contact with any such organisation. We have friends who have, of course, but for the most part such activities are best and most potently and purely perused as an individual or with select partners. Throughout history it has been the individual vision and genius that has burned most brightly: Dali, Nietzsche, Van Gogh, Austin Osman Spare, Max Ernst, etc. Of course, in order to achieve and create, these people have teamed up and collaborated with others and the 'Third Mind' process enables headway to be made, but I believe that dreams and delirium and privately conceived and experienced states of mind are what matter in the long run. The greatest truths and breakthroughs cannot be translated to other people, but the method by which to attain these states possibly can. The handing round of psychic keys and clues.

VB: What do you think of Pope Giovanni Paolo II?

JB: Is he the Antichrist, do you mean? I like to hear all these theories and ways in which he is supposed to fulfil Biblical prophesies. David Tibet is a bit obsessed with this so perhaps you should ask him about it in more detail. I like the theory that the assassination attempt was organised by people who thought he was the Antichrist, high powered Masonic groups. It's all possible. That's also why they killed the last Pope, because he would have fulfilled the prophesies. I don't claim to know very much about all this, but I'm interested. There is a book called *The Broken Cross* which deals with this in detail. I'm sure whether he is or not doesn't really matter because we are living in the age of Horus, the age of Thelema, and there is change of cataclysmic magnitude on the way. A cosmic shakeup to get rid of the shit and start again. All we can do is cause enough chaos and confusion to help it all along.

VB: Do you have any plans for video, etc.?

JB: I have described some of the vinyl releases, I forgot to include the Italian single 'The Sewage Worker's Birthday Party' which is with *FREE* magazine on Industrie Discographische, in December I believe.[1] We will be doing video releases but until we actually get around to them I can't really say much. At the moment I am working on a video piece that will be co-released with a piece by Current 93 on MIMORT Records.

1 *Free* was Paolo Cesaretti's zine during the early-to-mid 80s and often had a 7" attached. The Coil release in question was ultimately cancelled.

'Chaos, Change and Turmoil.'

The Feverish, 1984-1985

Will I. Stasch

In 1982, Psychic TV's debut album *Force The Hand Of Chance* had a huge impact on me, my partner (now wife) Rose, and friends we lived with at the time. The double LP offered more than sweet melodies, noise and ritual music, it was also a key to unlocking many interesting topics. So, of course, we made our way to the Berlin Atonal Festival in 1983 to witness an outstanding Psychic TV performance. A further intense highlight was Zos Kia, a project John also played in.

This is where the idea of publishing a fanzine was born. It was my impression that there was very little information on these groups, that their ideas and background were not readily available to the public. My intention was not to write about them, but to give them a platform and the ability to present themselves. That's how *The Feverish* started.

Naturally John was among the people I contacted first. He liked the idea and was very supportive from the beginning. I also remember how exciting it felt to be in direct contact with the people behind the music that meant so much to me, to

receive first-hand information and in some cases to become friends with them. The feedback on the first issue was mostly positive and it encouraged me to continue publishing more over the next few years.

John and I were in constant contact. Not only did he contribute to *The Feverish*, but we also exchanged information, thoughts, and ideas on music and magic in our letters. In addition, he sent me a copy of *Scatology* and many other gifts. Coil's music, for me, remains absolutely unique, endlessly fascinating, and persistently stimulating.

Sometime in the late 80s-early 90s I finally met him in London at a Current 93 concert. He was exactly the friendly and open-minded guy I expected him to be! Fortunately I kept all of John's many letters, the seasonal cards he and Sleazy would send to me, the records, the badges... And last, but not least, many fine memories. I'm glad that I can now share the interview and information John gave to me.

Editor's Note: The material below was excerpted across three issues of The Feverish, *No. 1 (1984), No. 3 (1985) and No. 4 (1985).*

'In Mexico we saw
beautiful wax effigies —
absolutely gore soaked,
blood drenched images of
Jesus, etc. — they were
really brilliant!'

Will I. Stasch

Interview

JOHN BALANCE: Can I just say that these are your questions answered a second time. I wrote one set of replies, cynical and rather damning in the extreme — but once all that was out of my system I was able to answer more creatively. With more insight — I hope!

WILL I. STASCH: You once told me that Peter and you are influenced by the work of Spare, Levi and Crowley, also the Kabbalah and other things like this. Can you please tell me more about this?

JB: Yes, we are very much influenced by these people and the theories and ideas that they presented and have come to represent. Many, many complex areas present themselves. A few pointers as to why, perhaps, we feel affiliated in some way to certain aspects of these personalities. But we must say it is fundamentally the tradition, and the body of knowledge that these people reveal that is the most important part of it all.

Crowley — the concept of the true will — finding and following the higher self — the discovery of one's 'guardian angel', perhaps a separate entity, more likely a personalisation/manifestation of what could be described as an 'over-self', certainly possessing higher knowledge — fundamental and profound knowledge. Crowley is important because he lived his dreams, his whole life was a quest for perfection, for experience and answers! Everything in his life had a profound, spiritual meaning. He found a reason, a purpose, for every thought and action. A supreme justification for continued and ever experienced existence. What more could you ask for! Regardless of whether one believes in the message of Thelema, of the age of Crowleyanity, one can respect the completeness and fullness of Crowley's life. He at least tried to put into concrete forms his innermost wishes, his beliefs — what he called his 'true will.'

I personally believe that the age of Horus — of Thelema — will occur. But that in between will be chaos, change and turmoil. A state of confusion and transition. A violent and bloody bird. The descriptions afforded by *The Book Of The Law* are not peaceful and idyllic, but strife-ridden, hard and ruthless. One can go into ancient theories about the cycles of the ages, etc. but it is true that both the Age of Kali and the 'last' age — the final cycle of the Aztec system — are calculated about now. So no wonder the signs are beginning to manifest themselves. I think that we (Coil) should, and we as individuals, attempt to relate to all this and you can't help but be wholly involved. One should attempt to generate chaos and confusion, help bring down the old order in order to speed on the advent of the New. The longer the old thrashes painfully about the worse it will be for everyone now! Open the Bloodgate! LET IT COME DOWN!

The Kabbalah is a huge body of work and the more you study it, the more you realise this fact: you absorb it and use it, incorporate it into every aspect of life. You suddenly notice that apparently random events and circumstances, juxtapositions of objects and happenings, suddenly make complete sense — become part of an organised chaos (see end!) You realise that people long ago knew that an underlying system of correspondences and parallels existed. To study it, provides insight and a certain power. Each symbol is a potent and potentially dangerous — if misused/misapplied — source of personal power. It can enrich and it can possibly unBalance. Each power used must have a purpose, an earth, like an immense psychic lightning bolt. With NO purpose, no earth, there is a danger of damage. The force must have a form. The energy must flow to somewhere. To risk sounding very 'hippy', you realise subtle and profound correspondences between the personal — microcosmic — universe, oneself, and the universe — the macrocosmic — everything else. The

Norse western tradition of Runes is very similar. It too is a map, a lattice of pathways and correspondences, which have personal and universal importance. We usually can't help but incorporate what we have observed into our music — into the lyrics — in numerous ways, embedded fragments, clues, etc.

Spare — Austin Osman Spare represents to me a man who travelled in psychic regions which have rarely been so systematically and brilliantly traversed and subsequently documented. I like him because he is in an ancient Briton tradition of Magick, which can be traced back to the druids and further. But his artistic abilities set him apart in this respect. I like his drawings regardless of their content. But I find the content overwhelmingly important. He systemised and personalised the psychic process. Preferring to do that as opposed to having probably social fame and wealth, at the likely expense of his occult studies. Crowley referred to him as a 'black brother' — which meant he had become a victim to the temptations and side effects of his occult studies, the surface manifestations, etc. But regardless of that, he is an important figure. Certain Surrealists have attempted to explore similar inner-astral regions but, as far as I know, none were so precise — so scientific or illuminating and inspirational as Spare was.

Ralph Chubb — a lesser, but still quite interesting character that we have come across. We personally find him interesting, of human interest, not necessarily so profound as certain contemporaries. He lived on the edge of the New Forest in England and founded a cult of GANYMEDE, of youth-worship. Not paedophilia — but perhaps the spiritual equivalent of that! He did limited edition booklets of poems and woodcuts. He was closely in touch with the spirit of Blake. Chubb was a brilliant, pioneering eccentric — typically English — a valuable rarity!

WIS: 'How To Destroy Angels' and a lot of the *Scatology* songs seem to be parts of rituals. How much did magick influence your work in the past, and will influence it in the future?

JB: 'How To Destroy Angels' was ritual-ised. Every aspect of that piece of music was produced according to predetermined and mathematically and Kabbalastically determined guidelines. Then we recorded it and the element of chance, tempered by our preconditioned states of mind, came into play. It was based around MARS. There are male aspects — metals, specifically iron and steel; five huge gongs, five small gongs — five being the number of MARS. The colour of the cover is in accordance also. We produced special bullroarers, ritually used instruments exclusively used in tribal male initiation rites all over the world, especially Australia, New Guinea and with South American Indians' culture. The bullroarer is a long flat piece of magically marked and incised wood, whirled round the head on a long rope. This spins very fast and makes an intense, penetrating whirring sound. We made our own and personalised them. We recorded at an appropriate time and for 17 minutes, another Martian number. These are the details and so on, but one can illustrate the complex workings that go on to achieve a stated, specific aim. It must be correct. Not necessarily to any laws laid down, etc., but it must be right for the group, for the individual. Any ritual can be constructed in any way. The belief and the sanctity that you can bring to those beliefs, whatever they are, is what triggers whatever psychic process and makes the ordinary act transcend the barrier of its ordinariness into something else entirely, something magickal. Just as the X-ian host is presumed, it changed into the body of CHRIST in the X-ian communion. It probably doesn't physically change, but for them, the believers in the congregation, it does become the body of Xst, and the wine, the blood, etc. Tales of Cannibal Apocalypse!

On *Scatology*, for instance, I see 'Solar Lodge' as some sort of incantation, a spell, if you interpret certain innocuous phrases as you possibly can, as deep and meaningful statements (this is not the way I wrote it particularly). It's an evocation of a certain magickal energy — one that we have defined and described — that we have tapped into, opened up a gate of energy!

WIS: What does the 'Black Sun' stand for?

JB: The Black Sun can be seen as the alchemical 'Sol Niger' — the secondary chaotic state — the stage before the putrifacto stage. It can represent many things, depending on one's interpretation. The Black Sun is the sun at night, in its most magickal and mysterious aspect. As it travels through the underworld, through the psychic regions — Hades — whatever. In Japanese mythology it is represented as a horse and rider, into the depths, like Orpheus. The Aztecs would sacrifice humans to ensure the return of the sun the next day. The 'Sol Niger' in the underworld, the realm of the dead, the place of decay: *putrifacto*, the necessary breakdown of matter — a natural part of the inevitable and illusive transition of base material into gold. The alchemists' quest represented as a physical change. The Sun In Eclipse.

One can go as deep, or a short way into it, as one wishes. All this information was given to us after we had done the song. The Black Sun was merely a symbol of chaos to me. The blind spot left on the eye after you have stared into the sun for too long, obsessive behaviour. Black Sun = Soleil Noir = Shadow Sun.

We recently did a co-performance with Kristine Ambrosia, Eric Love, Monte Cazazza and Fakir Musafar in California. We did our half here in London. To quote from Kristine's transcript: '*KAGE HOSHI — Shadow Star Ritual — extract from*

K. Ambrosia's notes: this quest to the underworld began with a large rotating pyramid upon which Kristine was suspended upside down for ten minutes while a drum was beat and horns were blown. As she slowly fell into a trance state, Monte Cazazza, Eric Love and Fakir Musafar circled her.[1] After she was brought down, they were suspended in her place, hanging upside down, chanting until the end of the performance. After the phase she was led over to a folding screen, which she painted while still in trance, using a small amount of blood with Indra ink and aniline dyes. Despite the apparent simplicity of the piece, the atmosphere in the room was almost unbearable in intensity. In judging the success of such works, the usual criterion was their magickal success. In this case, we felt the aesthetic and magickal to have linked as closely as might have dreamed possible.' (End!)[2]

So, the Black Sun has profound meaning for others, all in a long established and now reworked magickal current. A detailed and complete transcript of both parties' interpretations and results will be eventually published in *Another Room* magazine — U.S.A., before the end of the year.

WIS: How important is all this for your daily life?

JB: Intrinsic and completely! See above. See below! See Coil releases and interviews elsewhere.

WIS: Did the Christian religion also influence you in your thinking and work?

1 Kristine Ambrosia was a California-based artist, Fakir Musafar was a founding presence in Modern Primitivism, while artist and musician Monte Cazazza originated the phrase 'industrial music for industrial people' for Industrial Records while creating a substantial oeuvre in his own right.

2 These ritual events took place on 21st June and 26th June 1985 respectively, with a final ritual sometime afterwards to complete the cycle. A detailed account by Tim O'Neill for the *Gnosis* zine can be found on the Brainwashed web site.

JB: Yes, there are a few interesting areas left. Specifically the assimilation and Christianisation of ancient, pagan beliefs, i.e., building churches on ancient sites of worship in an attempt to suppress the currents of power already there, to pervert the established ancient orders. I am very interested in areas of crossover, i.e., Voodoo, Santería, and idol worship in Latin America; how Christian saints can represent ancient spirits, nature spirits, ancestral totems, etc.; how the true(!) X-ian spirits have become fetishized and idolised — the lives of the saints are psychoanalysts' nightmares. Representations of truly bizarre desires and stifled beliefs! Christ himself as an old god belonging to and representing the OSIRIS type myth. The Fisher King, the Corn God, the willing and necessary sacrificial item. There is a long, long tradition in Greek and Roman, and even earlier mythologies. The Holy Grail Parzival myth being the accepted culmination of all this, the archetype.

These aspects are interesting — along with some brilliant cathedrals and architectural structures. In Mexico we saw beautiful wax effigies — absolutely gore soaked, blood drenched images of Jesus, etc. — they were really brilliant! To reject the organised religion doesn't necessarily mean a rejection of the Spiritual. In fact, one begins to reject it because it no longer seems spiritual enough. The power is dying. It is in a degenerate stage, the beginning of an inevitable putrefaction in fact. The New Values apply and need applying. Rigorously! The Age of Horus, the Conquering Child, and so on. The Age of Thelema? That is an addition which is debatable.

So, succinctly, yes, x-ianity did affect us of course. It affects us at school, on television, in the courts of Law, in morality and accepted codes of behaviour, in the very condition of our personality. This next fact is unfortunate. The aspect of all-pervading insidious guilt: we are taught to identify with

C

Christ! The victim. The dominated. One has to ask is the human race naturally subservient? Always genetically willing to accept leadership? To give up or to negate responsibility? Perhaps it is! But the God system we have now reflects and strongly perpetuates these trends and with them personal development and growth is 'naturally' seen to be at odds with the whole universe, as it travels around the Body of Christ! Everything is automatically a sin. As we said on the LP and quoted: 'the word of sin is restriction.' People are indoctrinated to be led, to serve, to be similar to everyone else: conformity and subordination are positive virtues. So there is virtual stasis. Stagnation. With any reaction against this being evil, being subversive and, to our way of thinking, being essential to a survival of the true, whole spirit and a sense of belonging to oneself, rather than a decaying ancient, insidious state of mind!

WIS: You once wrote to me: 'we do feel, to a certain extent, that we have a mission.' Can you explain this?

JB: Our mission is to, in any small way possible, make each action count. To set a liberating example. Not to preach it, but to act, and explain, and justify each action. We always justify that precise statement with a reminder, that chaos and systematic disorientation of the senses is our desired goal. Because only after the shake-up can new order, realistic personalised order, be obtained. Like waking up after a 2,000 year old coma! It is bound to be a little uncomfortable, disorientating, and painful!

WIS: Is Coil planning to realise other projects apart from music?

JB: Other Coil projects apart from music?! A fanzine/research magazine from the U.K. is planning to compile a lot of our printed interviews and writing. I think this is a little premature maybe, but it will be next year so maybe there will be enough

by then. A flexi-disc is planned to be released as part of the package — along with a few other items, badges and so on.

We will be producing a *Live At Bar Maldoror* video cassette when we can manage to assimilate and organise all our various ideas about this. We desperately need funds for things like this. If we can't afford to do something well, we generally don't bother to do it. We don't like to compromise with a potentially good idea because of lack of money.

Apart from these (and an extended, specially written European version of the compilation of writings, etc. which is also in the future) there is no immediate revelation to divulge. We don't like to give long lists of things we want to attempt. Needless to say, these are numerous — we have ambitions, ideas overflowing. Creative boys!

I'd perhaps like to expand Force And Form with other people's releases.[3] But I really haven't come across anything that I would want to release, that I would want to endorse or sponsor in any way. I have a dislike for records, generally — it's a rather disheartening situation to be in. It's our fault we choose to release music as a vehicle for our ideas and interests yet, increasingly, I find them redundant and less potent than I imagine they once were. Revolutions or even simple changes rarely come in 7" or 12" picture disc form. Then again, one can always try. It's a dissemination of what we consider valuable information. The reason why I sit here 'til 3am in the morning writing all this is because I hope that someone may find something written of value. A trigger to the imagination. One has to hope.

As we said when we were in Psychic TV and will repeat now, we can only ever assume to be a stepping stone, a catalyst, a

3 The label set up by Coil for certain early releases distributed by Some Bizzare sub-label K.422.

part of an awakening process. It's not that we have illusive knowledge to impart, but we may be able to illustrate that the first step to self-control — regaining yourself — is the realisation that there is something wrong with the present situation, and to isolate and illustrate specific dangers. All manifestations of the all-pervasive cancer of CONTROL — to put it in 'post-industrial' terms (cynical tone noted!)

John Balance. London.

10.10.85 ev4. COIL
ADDITIONAL NOTE!
(Catastrophe Theory) of René Thom

The catastrophe theories as presented by the French biologist/ physician René Thom have some bearing on this point. Our next LP has been deeply influenced by what I've read regarding this subject. It proposes that events previously assumed to be totally uncontrolled and random have, in fact, got a basic calculable pattern to them. And that many shapes and patterns in nature are controlled by these 'minor catastrophic' events. The ways in which and where a wave breaks on a beach, for example, the shape of fjords, leaves, the folds of the human stomach, etc. are pre-determined by these stress/catastrophic events. Also it has implications in thought processes, social organisations, evolution and so on. Unfortunately his books are out of print, but I believe his previously discredited ideas are now being examined closely and are coming into scientific circulation again.

'The Tortured Artist Syndrome'

Overground #2, 1985

Martin Lacey

I was lucky enough to witness the early years of punk in London before making the move to Sheffield. Once I was up there, I became very involved in what was a very tightly-knit music scene. Punk fanzines were an essential part of the media because so much was going on that just wasn't covered. Someone had to make sure that local music, or particular communities of music, were getting exposure and I felt there was a need for something with the same relevance to Sheffield music that *Sniffin' Glue* had to punk. So, that's where *NMX* — *New Musical Excess* — started. The local music shops would take copies, or I'd just show up at gigs with a bag of them, and I've no idea how many were sold in the end but *NMX* wound up being pretty widely read. It was just this first attempt to spread the gospel about what was happening — Pulp's first ever interview and photo shoot, for example.

Overground was a different proposition. I'd moved back down to London and wanted to see if I could do something more professional, but it only lasted three episodes across three years. For a start, to print *NMX* we had bought a printing press and eventually wound up starting up our own independent

alternative print shop. That really took off and wound up so busy there wasn't as much time to go to gigs. Also, *Overground* was more generally about electronic and underground music so it had less of a focus, making it hard to find a market, and it was near impossible to compete with 'proper' magazines... In the end, it took so long to get the final issue prepared and printed that we gave it away for free. It was good to keep the social ties going with a lot of the bands we'd covered earlier, and it was great covering some of the rising powers — Coil, The Smiths, The Cure, Cabaret Voltaire — but it felt like skimming the surface compared to the intimacy *NMX* had.

It's been good in recent years being able to reappraise things: Cherry Red Records released a box-set called *Dreams To Fill The Vacuum* documenting the Sheffield scene and I contributed to the liner notes; and I kicked off SafetyPinMag.com really going back to my roots in punk rock but also focusing on making each physical issue into an artefact, something that can't just be replaced.

Editor's Note: Stephen Thrower makes his first appearance in this book. Mr. Andy Darlington has, very kindly, given permission to quote from an interview he conducted with Thrower for obscure fanzine *NE*:

> *I wrote to Sleazy about the end of 1983 when he was still in Psychic TV — but only JUST in... 'cos I wanted to know if he could get hold of any pornographic material on our 'shared interest.' Also because I sorta admired him for things he'd done. I thought we'd have very similar sorts of interests — and we do. I got a really open reply from him. I wrote to him a couple more times, and eventually he asked me to come down to London. He said 'come and spend a bit of time down here.' I went down once for a social visit, we got on really well and then, at the end of it, Sleazy said 'we're due to start recording*

the LP.' They'd heard the stuff I'd done with Possession and were interested in it and they just said, 'come into the studio with us for the sessions,' and it worked out very nicely. I played on five of the eleven tracks (on Scatology.) I played all the reed instruments, clarinet, guitar, drums and tubular bells. The track I worked on to the greatest extent was 'At The Heart Of It All', an instrumental featuring the clarinet very prominently. I virtually wrote it. Geff Rushton hit a patch where he didn't know which way to go, he said 'what shall we do next?,' so I kinda just picked up the reins for that track.

'We chose him [Jim Thirlwell] because of his manic reputation... He worked us up in the studio — coming in and kicking me to do the vocals — what I needed.'

Interview

MARTIN LACEY: How long have Coil been together?

JOHN BALANCE: I started doing cassettes when I was in Psychic TV, doing things they weren't — dreams and delirium, illness. I did a track when I was ill with flu — little hallucinations when in a fever — I worked out some lyrics when I was 'twixt world and nowhere else. Then when me and Sleazy left Psychic TV we decided to make more of it.

ML: Have you ambitions with the more ritualistic music?

JB: The first Psychic TV *Themes* album was intended as ritualistic, but ended up as a video accompaniment. *How To Destroy Angels* was made as a purely ritualistic piece, if people liked the sounds that was all right, but the first consideration was the mathematical and magical structure.

ML: There is a tradition of this sort of thing in performance art but not 'rock.'

JB: I know that Z'EV bases his performances on using certain metals — say tin on Friday — tying it in with the planets and chooses rhythms accordingly.

ML: What is the logo on the sleeve, 'Black Sun Rising'?

JB: We have a track called 'Solar Lodge', which in America is an offshoot of the Oriental Order of the Templars (OTO) who now publish Crowley. They use Chinese and Indian yoga...

ML: So it's more secular?

JB: But it is metaphysical, black magic as the Sun would have it. 'Solar Lodge' is a heavy version of it, blood sacrifices, Californian blood and Satan cults. Manson was supposed to have something to do with it. I did a song about it. 'Black

Sun' is a symbol for Coil, a surrealist symbol, out of the book of Maldoror, the negative of a photo... Positive/negativism, like Jim Thirlwell's theory that two negatives make a positive because of purging, it's a bit of that, and deliberate word play, ambiguity... Also Manson, off *White Album*, the song 'Blackbird', blacks rising and killing all the whites in a race war, he'd hide in a hole in the desert in Death Valley. There are references to that in the lyrics 'a hole in the ground, like a knife in the sand, Solar Lodge,' my imagination running riot with all these things.

ML: Also on the sleeve, 'The price of existence is eternal warfare...'

JB: It's from Crowley. It fits in with my personal philosophy — anything valuable has to come through struggle, against laziness and apathy, want to live on the edge.

STEPHEN THROWER: Nietzsche said live dangerously...

JB: Sounds like James Dean (laughs). Don't need to quote Nietzsche to have that attitude. Coil embrace chaos. That's partly what 'Panic' is about — 'the only thing to fear is fear itself, everything will be all right if you come out of the night,' — it's beyond saying 'don't be scared of things,' it's saying create a situation where fear is generated and use the vortex of negative energy to catapult yourself somewhere... Interesting. It fits in with what Coil is about, delirium not nightmare like H.P. Lovecraft. I have weird dreams (laughs). 'Ubu Noir' on the LP is based on the Ubu cycle by [Alfred] Jarry — absurdist, vicious — he used to induce hallucinations with ether, and drink himself to death... Because he liked the feeling... Bit like the way Blixa Bargeld works (laughs). Get inspired when near to death. Like Jim Thirlwell — unbelievable.

ML: Do you work in that way?

CX

JB: We stretch ourselves... The tortured artist syndrome (laughs). The studio is such a dead atmosphere, need to forget where you are to get into what you are doing.

ST: Obviously this is different for different people it's a lot of bull really — the tortured artist syndrome makes someone interesting when they're not (laughs).

ML: That's changing now as producers are becoming more important — a calm placid person that twiddles knobs.

JB: We had Jim Thirlwell — most frantic person I've ever met — a bottle of vodka a day — at least!

ST: With no visible impairment at all.

JB: We chose him because of his manic reputation. He worked us up in the studio — coming in and kicking me to do the vocals — what I needed. I never had to do them in Psychic TV so first time nerves and learning to communicate, like learning to talk, or ride a bicycle... A challenge.

ML: Will Coil work with film?

JB: Definitely. We've done the soundtrack for a Derek Jarman film *The Angelic Conversation* which will be premiered at the Berlin Film Festival in February 1985. It's full length — it's not surreal, like a ritual seduction that lasts 70 minutes.

ST: A 'cinema of small gestures.'

JB: We are going to Mexico soon and will do some filming and sound recording there for a music LP coming out called *The Sound Of Music* on LAYLAH, mostly instrumental.

'A Sick But Meaningful, Well Intentioned Joke'

ZigZag, 28th June 1985

Tom Vague

I interviewed Coil for *ZigZag* magazine in their flat at 14 Beverley Road, Chiswick. The article was in the September '85 issue. I was covering the post-punk-industrial music scene for *ZigZag* and my magazine *Vague* issue #18/19 'Control Data Manual: Conspiracy Theory and Programming Phenomena'. The previous issue #16/17 featured the other half of the original Psychic TV and the *Decoder* film. I also interviewed Chris and Cosey from Throbbing Gristle for #18/19. *Vague* fanzine began in the late 70s in the west country and became an annual journal in London in the early 80s when I was writing for *ZigZag* and *International Times*. I had previously been to Stamford Brook in the 60s to visit my great-aunties Madge and Doll.

'I think society is breaking down, all this trans-global village thing, it's the wrong direction, it's all spreading out. The centre will collapse if it's spreading outwards, in every respect, in information and basic communication with each other. We don't go round for tea with anyone anymore.'

Interview

TOM VAGUE: How do you account for you becoming acceptable — hip even — with *NME*, *Time Out*, etc., rather than Psychic TV who are doing the most mainstream things they've ever done?

JOHN BALANCE: It's just a typical media preconception. Early Psychic TV stuff was a bit close to the bone and they've still got that hanging over them. Gen's still got people at *NME* that don't like him personally. People don't really go beyond the surface. I suppose maybe because we've come clean people give us a chance again.

TV: Have you changed your attitude towards talking to people and explaining yourself?

JB: I think they just wouldn't listen before, to early Coil, but we didn't really go out of our way to do anything along those lines either. We wanted to wait until our album came out and we had something tangible to talk about, because we were really aware, after we left Psychic TV, that we could have gone really... We've split into two equal parts — these are our plans, we want to do so and so, deal with video and all that, but because of that things don't always turn out that way and we thought 'we'll leave it for a while and see how it develops' and actually get some product out and let that talk first. And, basically, because the album got good reviews and people wanted to follow it up with articles, which is the natural way really. But I do write to fanzines and say do you want to do something on us. We haven't got any press people working for us so I have to do that.

TV: There are certain myths that might put people off which you seem to play up intentionally...

JB: If that does put people off, we're probably not interested in that sort of people listening to it. It's that situation where it leaks out or filters out to people.

TV: Sleazy, do you totally separate your work on pop videos from Coil?

PETER CHRISTOPHERSON: It varies, it's separate in as much as the work that I do with Coil doesn't have any restrictions on it. We can do more or less whatever we like. With a pop video you're restricted to the tastes of your client, also the tastes of television and the broadcasters who control what's going on and what doesn't. So it's a much more limited market.

TV: Are the two sides in any way reconciled?

JB: It's two different activities really: product and creative messages — two separate forms of language.

PC: I think it is more or less separate. Pop music really is a fashion outlet. So people who are trained in it and good at it can do things that are popular for a time. Therefore I think most records that get into the charts are done specifically to get into the charts.

JB: They're done to a formula.

TV: Why did you do 'Tainted Love'?

PC: We did it because we wanted to. If we did it to get into the charts we'd have done it at the proper speed.

JB: I think it's possible!

PC: I think you're suffering under an illusion.

JB: Why we did 'Tainted Love': we did it because it's a good song and we put a new meaning to it, and we wanted to deflate the thing that supposedly makes Some Bizzare great and is an albatross around Marc Almond's neck. So we did everybody a favour by recording it but not just for parody's sake, it had a meaning behind it.

PC: And also it has a serious intent because we're donating the money to the Terrence Higgins Trust.

JB: Which is a sick but meaningful, well intentioned joke.

PC: I still think no matter that you might be optimistic and say 'maybe the songs that the Thompson Twins do, they do because they want to.' But I imagine they're done in order to get into the charts and make money. There's nothing wrong with that, it's just a different approach and the things that get into the charts do so because a large number of people buy them. And I don't personally have the same tastes as a large number of people and that's why we are — fortunately — able to do the records that we want and that's why they sound like they do.

JB: There's only one thing that we did that I could ever say was a pop song, called 'The Wheel' — it hasn't come out yet. That was supposed to be the first thing we ever did, and it was, but Stevo's taken two years to release it on a Some Bizzare compilation album. That's a pop song — it's like early Wire or something. It's much more poppy, and I did one vocal out of tune, Syd Barretty, and we just left it at that because we're not that interested in what will happen to it.

PC: We didn't do it as a pop song.

JB: It turned out like that. That was the only time I was conscious of that. It's not something we're interested in. Otherwise we'd be pursuing it in a totally different way. I don't know whether it's accident or design that *Scatology* sounds like it does.

PC: A long time ago, longer than I care to remember, in an interview when I was in Throbbing Gristle, I said basically something to the effect that if you're allowing your music to pay your rent, you're inevitably going to threaten its very

deepest foundations, because it's inevitable that you're going to compromise in some way, even if it's unconscious. And Coil does not rely on record sales or chart positions in order to be able to afford studio time.

JB: Consequently we really do what we want to do.

PC: Yeah. As it happens, *Scatology* has sold enough for a new album to be recorded. If we suddenly decided that we really had to go to Berlin to do the mixing, or if we really had to get a certain person to do the drums and he was in New York, then we could do it. So the music is unfettered by that desire to sell. I think it makes the music stronger and more individual and really more interesting. I think the reason the critics liked that album was because I think it was quite a good album. I felt much happier about *Scatology* than either of the Psychic TV albums, just because it was better and it was more successful in what we wanted to do and what we wanted to say and I think it was more interesting. The Psychic TV albums were sort of compromised for me, which was brought about by the circumstances of the time and the people we were working with.

JB: But that's part of being in a group. We'll start arguing among ourselves now.

PC: I'm not saying that you're wrong, I'm glad we did the Psychic TV albums like that but at the same time I thought *Scatology* was a better album and therefore I'm not surprised that...

JB: ...That's a bit of a fatuous thing to say, I meant obviously you were more pleased with it. I still think *Dreams Less Sweet* is valid for what it was and it was interesting at the time. Obviously you always think that the latest thing you've done is best, that's normal.

PC: I take your point. True. I take that back.

JB: We wanted to do the sound that is on the record. I always had, in the back of my mind, this three-point plan where we were going to introduce Coil gently, and then slowly get it harder and even more extreme and explore in a new way, without it being anything like Neubauten or SPK because that's been done before. We want to capture an audience and then educate them in a way to the sound.

PC: So, by our standards, *Scatology* is the most accessible! A lot of these post-industrial type groups, first of all, think 'we'll do a commercial album and then we'll get on *The Tube* or *O.R.S.*, or whatever it is, and we'll make metal-banging into commercial product', on the assumption that having done so they'll be able to go back to their roots subsequently.

TV: Do you think that's a myth?

PC: I don't know about a myth. I think it's a mistake, I think it's a terrible mistake. First of all, they don't know enough about being commercial. Even if they were successful, the moment they did something interesting and obscure again, everyone other than the people who like that anyway would get bored with them again.

JB: It just doesn't work like that.

PC: The only thing you can do is make more records of music that you really like — which is what we're trying to do. That's why he's doing a country 'n' western solo album!

TV: Could you expand on your interest in Dali?

JB: I could do for about three days! I'm obsessed by him at the moment, absolutely obsessed, there are good ideas behind him. I like his writing, his theories, he's very eclectic. He nicked

a load of stuff. I'm trying to work it out for myself why I'm interested in him at the moment. I suppose he transcended everything he set out to do... Like he transcended — almost eclipsed — all the Surrealists. And being rejected by them because of it, because of the politics — which is just a by-product by the way — just the fact that he actually makes his dreams concrete. He's the only one of those people who have really done that, like his whole house is exactly how he wants it. It's his subconscious actually made conscious. Apart from people like Gaudi the architect, who's Catalan as well so I'm convinced that that's some Catalan mentality that allows it for them. I just think people like that are incredible. He might have been an arrogant, selfish person, like his detractors always say he is, just by the fact that he makes his subconscious tangible. I'm trying to improve myself and go to places where you'll seek out things that interest you and put yourself through things. That's creating an environment for yourself to flourish in. It's the ideas of what you cultivate in your mind, in your house, in your immediate surroundings. It's only when you start digging down that you find there is so much there. You can get so paranoid about it but it is true you get words like 'control' and 'police state' and things, but it's getting far heavier. You sit here and think it doesn't affect you but me, because I wear black or something, if I walk up my own street I get stopped by the police who go through my pockets and look at my contact lens solution thinking it's liquid LSD.

PC: I don't think I want dodgy people walking around the street where I live. Like, would you want to live in a street that would have someone like you living in it?

TV: Is there a danger of desensitising people? I think we talked about this...

JB: Yeah, I remember that, I can't remember what we said though. These are such old subjects. I always find it goes back, almost entirely, to the strength of character of the person it's influencing. Realisation of those things, of outside influences, and things you never even dreamt of that are influencing you and enforcing themselves on you without you even realising at all. You can go one step further and find, if you push it, the fact that you're not allowed to do it anymore, like whatever you want in your own home. Like two cuttings in my scrapbook, one's a classic 'man kills wife, children, and next door neighbours after watching snuff horror movie,' and on the other page it's 'man kills because he read a passage out of the bible that told him to.' So that's two sides to the coin, I always think it's strength of character. It's how much you want to be affected, that's really it. I don't really know, it depends on the situation.

PC: I think, in general, there ought to be freedom of information, which is to say that people ought to be able to get hold of information about anything, even if there's a risk that a percentage of the population might be adversely affected by contact with it. That's not to say I think people should be forced to see it, or necessarily that things are heard or shown. There's a misconception that bands using horrible things are interesting, because I think that most of them are very boring, and so, if you say 'how can a group use images of torture chambers or concentration camps in their films?' My feeling is that they should be allowed to do so, and I would be against any move or message, from the government or from magazines, that have a political slant. They should not be prevented from doing so. I just personally wouldn't be very interested in watching such a performance because I've seen it all before and I don't care. I mean, I care about it, but I don't want to see it as part of entertainment.

JB: You wouldn't be reacting to it in a musical sense.

PC: I don't think that we should take a moral stand and say 'we must not display things that are horrible or violent,' because of the possible threat to the population, but at the same time, a lot of these things I'm not very interested in. I am personally interested in the subject matter of our album, and I don't think the way it was presented was done in a particularly shocking way. It was done much more from the point of view of sharing information and new experience that most people aren't likely to have come across, and also analysing some of the intellectual overtones and aspects of it that equally they might not have come across if they just read a porno magazine.

JB: Just realising that it could be said that we're desensitised to images of violence and, therefore, might be seen to be not caring. But, as Sleazy said, we do care! It's just that we don't want to watch things like that anymore particularly. It's not to say that we don't still support freedom of information.

PC: Because of the subject matter of the album, on the surface of it some people assume that we are trying to exploit disgust. That's not actually true at all. Some people have been put off, but those people we don't really care about.

JB: My mum didn't even know what it meant.

PC: I've heard that Japanese record companies, apparently, are not very keen to license it because Japanese society is much more conservative and so, unlike many groups, Coil is not very big in Japan. I don't know what the Japanese translation of *Scatology* is but it's a pretty heavy word.

TV: Would you say you test people?

PC: Fundamentally ourselves, I think we're testing ourselves particularly. If you say 'yes, we're testing people,' that sounds like it's an intentional thing.

JB: And that sounds like we've got the answer, which is never what we presume, that's just conning people.

PC: Even though that's not the intention, it happens by coincidence that people write in having heard the album and say 'what do you mean by this?' It suddenly occurred to me that maybe the album made them...

JB: That's an unconscious thing.

PC: That's an effect rather than a cause or motivation.

JB: We're just doing what we're interested in and presenting it in a way that we hope other people will find interesting and stimulating. Whether they throw up — which is very unlikely I would think — or go and look for some books, or write to us and say 'can you recommend some books?' I always think that's a very good reaction because that just makes us the catalyst for somebody to go and learn something, not that we've particularly got any exclusive knowledge to hand on.

TV: But surely the object is to search for some beauty in life, not subject yourself to the more repulsive side? ...Or is it?

JB: That's Oscar Wilde.

PC: I agree, but who's to say what's beautiful and what's repulsive? That's one of the things that the record's actually about: often you can find beauty, if you like, or ecstasy, or bliss, in things that are not conventionally considered to be so. And things like chocolate box, soft focus pornography of girls running through fields of corn, which are conventionally considered to be beautiful, I might think are disgusting.

JB: And there was an aspect to the title *Scatology* being alchemical in that it was turning base material, it's a kind of sick joke, shit into gold — which is the metaphysical chemical elevation of

lead into gold. It's just pointing out the fact that anything can represent anything to anybody depending on their viewpoint and their sensibility. So, what our culture calls the dark side of man's whatever, toilet habits or whatever — if you went to Borneo they don't think anything of it, or Mexico they make jokes and there's a sub-culture about it.

TV: So, what you're doing is going to these extremes to question what our culture takes as the unquestioned law...

JB: I don't think it's extreme really.

PC: I think, in general, what we do is a celebration of the things that we enjoy, whether they're silly things like shit, or whether they're important like spiritual things. The fact that we might find beauty and pleasure and fulfilment in different areas than the conventional ones, is one of the things that makes us interesting and possibly sets us apart from Go West, who seem to be completely, so deeply, entrenched in MOR music for the masses, that I think they have nothing whatsoever to say of any interest. I won't get to do a Go West video now! The norm is not something that has any value to me. I think deviation from the norm is, more or less, an essential ingredient for progress.

TV: Would you say that's the object of what you do, to get people to question what is the norm?

PC: No, because as we've said before the object of what we do is to make music that we like. It may be that as a by-product of it, as you say.

JB: It really is a conscious by-product. I mean, I'd say yes, I'm just interpreting it slightly differently. I do hope that we are provoking thought and expanding people's outlook and subconscious.

PC: Yes, I concur. Provoking thought is obviously a good thing, but I don't see that what we're doing is the manipulation of people for its own sake. So, I think that the norm is there's that example, a conventional point of view of what is acceptable, of what is nice, what is beautiful, what is the kind of music we want to listen to on Radio 1, things that in general reduce humanity to a stasis, not only to the lowest common denominator but also to no progress, to no movement, just to obsolescence. It's not exactly death, it's just a stasis.

JB: That's control. But would it be wrong to provoke somebody to question, to realise that, or to manipulate, knowing that you're doing that deliberately?

PC: No, it's just the word 'manipulate' has overtones of doing things to people against their will, which also will...

JB: In most ways? Personal or economic?

PC: I think that the news on television sometimes has the effect of manipulating people by presenting a view, usually what promotes the political view of the broadcasters, by the way it's edited.

JB: The controllers of the BBC are linked to the government.

PC: And I think that's also true of Go West, in a sense that they have a vested interest in promoting a certain type of music that does not advance anyone.

JB: It's a tranquilizer. You were going on about 'spectacular society' right?[1] It's that people think what they've got is the good life when it's just something created to keep the stasis there. You can take that so far as to almost have a Zen attitude, where it's just the quality of life, just the way you must almost be

1 Prior to the interview, Vague and Balance had discussed the Situationists' 'society of the spectacle'.

stimulated to think. You can appreciate something far more than you ever even thought possible, that would elevate life considerably and make things which we consider important now redundant. It would be because it came back to the personal level rather than having the spectacle where you have to consume rather than be involved with yourself.

PC: It's always better, in my opinion, to be a stimulant rather than a transmitter — and that's got nothing to do with drugs, and nothing to do with songs going 'blah, blah, blah' to themselves. It's got to do with being exciting and stimulating and interesting and most groups aren't like that in my experience.

JB: As most people in groups are creative people, they've got to get out a better viewpoint than other people's viewpoints which enable them to be like that. 90% of the groups don't know what they're doing particularly. It's like when people ask what the next entertainment boom will be? Will we get TVs that you can touch and feel and smell? And the same thing applies: 90% of the stuff broadcast on these machines is going to be as much rubbish as what's on Radio 1. The technology will move up but the content will remain static and boring. That's what control is: it's just a static society. Anyone who is on the boundaries — which, in some ways, is what we could be considered — pushes outwards and society tolerates it to a certain extent because some evolution is necessary. But if you go too far you get your wrists slapped, or you become a symbol like Boy George and get accepted back again, like some antibody in the bloodstream. It stays in there, but it gets consumed by something dealing with it. I mean, I think we do find strange things beautiful. That's not to say we have a deviant viewpoint.

PC: I think we have a deviant viewpoint. But the important thing for me is we're not saying that our viewpoint is the only one

particularly. It's just a viewpoint which is as true for me as Mary Whitehouse's is for her. Although I might disagree with her, I would not do anything to stop Mary Whitehouse holding her opinion. Just as I should hope, albeit a vain hope, that she would do nothing to stop me holding my opinion — which somebody like her doesn't do obviously, her life's devoted to imposing her opinion on other people.

JB: Karma will get her in the end. She'll come back as a slug in the next life... No! She's one in this life isn't she?

TV: I wanted to ask you about the Derek Jarman film *The Angelic Conversation...*

JB: I enjoyed it, I was quite surprised. I don't know when the film's going to be released anywhere. It got shown at Cannes. I think it's coming out in September and then we've got to do a soundtrack, that's the next big job. We'll probably release the soundtrack on record but it's quite a long film — 70 minutes in total. I'm a bit against releasing an album's worth of soundtrack because it's for the film and the film's very slow. Like some of it's on 75mm, so it's really big. Some of it sort of clicks across in patterns of light because it's so slowly done. So, to release that on an album would be spectacularly boring, so we're going to do an album called *The Sound Of Music* that'll be the best of the soundtracks that won't come out until someone offers us another soundtrack.

PC: It's very abstract, it doesn't have a story or anything.

JB: It has a sort of non-linear story...

PC: All the verbals are Shakespeare sonnets read by Judi Dench. It's not like *Raiders Of The Lost Ark...*

TV: I wanted to ask if you were much influenced by the Futurists in your work?

JB: That was really early Coil. There's a few good things about them, leaving the Fascism to one side. I just respect the way they went almost outside of their own time and how everyone got outraged...

TV: Test Department were certainly influenced by them.

JB: I can't really say because I wasn't around then. You really have to study how important they were at the time, not so much the Futurists, because I don't really know that much about them. But the Surrealists were considered extremely subversive. You just don't seem to get situations like that anymore. You don't get any subversives in the way that they were.

TV: Well, you're doing that.

JB: Not on such a high level, maybe it's just the nature of society now?

PC: I don't think that's true. Did they really outrage people that much? Factory workers and stuff probably never heard of the Futurists.

JB: No, you're wrong. The Surrealists actually organised practical workshops in Haiti or somewhere. André Breton would deliver a speech to the students and it ended up with the government stepping in and it led to a revolution there. That really did have a big influence because they really had a Communist revolutionary spirit. The early Surrealists sent letters around supporting the Soviet Union to the workers, them and the Situationists did have an effect. Everyone's alienated from everyone now, probably because there's more people around, everyone makes less impression on everyone else because of it. Spectacular society again: watching everyone else and not doing anything yourself, you're spreading yourself thinner.

PC: The classic experiment: if you put too many rats in a cage they'll always... First of all, they all become gay and then society starts breaking down.

JB: I think society is breaking down, all this trans-global village thing, it's the wrong direction, it's all spreading out. The centre will collapse if it's spreading outwards, in every respect, in information and basic communication with each other. We don't go round for tea with anyone anymore. It's so difficult to do anything like that, just to visit friends. There's distance and then there's social attitudes as well. I don't know which we dictated to the other, but it definitely does happen. I've never known any different.

PC: I quite like it though. I think we are anti-social in a sense, but I don't think we are any different from many people. I never understood alienation, I never wanted to be part of anything in the first place.

JB: Yeah, we say all of that but I am glad that I am outside of it. You come out with all those statements like 'I hate 90% of the human race,' but sometimes I really do mean that. We come out with those things, that we want to give some people information to help them in a way and give them the same sort of liberation that we think we've got ourselves, then you think 'fuck it! Why should I dictate my will?' It's just a transient sort of thing. Even if you think you've got some sort of inspiration, or something that makes it special, it dies away because you've got such overwhelming pressure from everything else to be mundane and everyday again. You have to say though, don't make it a mission or a cause, because I don't think most people are worth it. This is why we aren't that bothered about selling lots of records, because if we did we'd be in the situation where people would be saying 'give us more! Tell us more!' We'd rather do it for ourselves so

everything balances out and spreads as far as is natural... I got a bit lost there.

PC: We've done a record with Boyd Rice. It's not Coil, it's Boyd Rice and us — extreme.[2]

TV: And you've been working with Jim Thirlwell too? Foetus, Clint Ruin...

JB: He's doing the next album with us but that's in the planning stage. He's doing a new album of his own now — he's really busy. Then he's going on tour, sometime in the next couple of months we'll do some of the next album and he's going to produce it again.

TV: How did you come to meet him?

JB: Can't remember... Oh, Jim used to live in Gen's flat! In Martello Street.

PC: I didn't know him because of that, I knew him because of Stevo. The first time I ever heard about him was because Stevo played me this record and he said this guy lives in the same place as Gen.

JB: I met him through Claude Bessy, the Ikon bloke, he told us about this well-liked person who was going to be doing a record for Some Bizzare. I really respect his music. I wouldn't say we listen to it all the time, but the quality of it is really good. He's like a task master, he goes in doing that, forcing us to do things. He's very manic, he's very, very good. He's not over the top rock 'n' roll — no chance! He knows exactly what we're going to do.

2 These songs emerged under the band-name Sickness Of Snakes on the *Nightmare Culture* LP.

'The Magickal World Of Coil'

Square Peg #9, 1985

First mentioned to me by the very kind Mr. Michael Shankland, a copy of this magazine was located by the team at Manchester's Bishopsgate Institute, with Stephen Harwood providing an additional copy. Unfortunately, despite extensive efforts, I have been unable to locate the interviewer or original creator of the magazine.

'I'm not sure what image
people have of us...If anyone
comes up to me they say, "I
know all about you; you're into
black magic," they come out
with all these ridiculous things,
like we do blood rituals and
we have our genitalia pierced
thousands of times.'

Interview

SQUARE PEG: What was Throbbing Gristle about?

PETER CHRISTOPHERSON: It was the same as all of our music: we were trying to do music that we wanted to hear that was not readily available elsewhere. Although the music we do now is very different to the music we started off doing with Throbbing Gristle and also with Psychic TV. We've always tried to make records which at the same time expressed our needs and our feelings of what was missing and what was available in music.

SP: What was Psychic TV about?

JOHN BALANCE: It was a different camouflage for the same ideas and philosophies. When Throbbing Gristle split up it carried on, a different skin for the same animal. A different set of contrasting and confusing images to throw people off again. Throbbing Gristle has become 'established' in a way.

SP: To throw people off?

PC: At the surface. We've always believed in a number of ideas, some simple, some more complicated, but one of them is questioning what you are presented with by society: the strictures and principles — as well as the more mundane things like whether they like the music. The changing from Throbbing Gristle to Psychic TV and also the religious overtones that had was really just trying to find a different way of presenting the same fundamental ideas in a way that would be interesting to new people and also make them continue to think about what they were doing rather than just accepting blindly what people told them to do. At the time when we started the religious aspects of it, we were very careful to make it understood that we were not proposing other systems that would work in the same dogmatic, limiting way that systems

already worked in, but getting people to question their beliefs in those things. But I think that more recently perhaps, some of the claims that they are making have changed, and they're not what John and I believe in.

SP: Have Coil's ideas completely changed since then?

JB: They haven't completely changed; they've emphasised things that we want to emphasise, away from the commune mentality that I thought was developing. We do things on an individual level.

PC: I think that although sexuality isn't the main thing that we're about, the fact that we're both gay and the other people in that group weren't, was a natural division. We obviously felt that they were interested in their kind of imagery and their way of life which was very different to the one that we were interested in. Being in Coil has allowed us to exploit those interests much more honestly and purely than before. We didn't leave because we were gay, but because we felt they were doing things in the wrong way and in ways we weren't interested in.

JB: They were getting into the role of being a proper group.

PC: A proper group in terms of music, and also making more obvious, religious claims, and it being more a question of a leader and followers, which was one of the feelings we had about what Genesis was doing which we weren't interested in.

JB: We're still interested in sex magick and religious things, but it's distracting to go into things like that because it's not the be-all-and-end-all of what we do. I'm not sure what image people have of us; they seem to have an overlap of the image we had in Psychic TV. If anyone comes up to me they say, 'I know all about you; you're into black magic,' they come out

with all these ridiculous things, like we do blood rituals and we have our genitalia pierced thousands of times.

SP: But wasn't that the image you were communicating with things like the snuff videos you were using?

JB: Snuff videos!

PC: We never used any snuff videos. I think a lot of those claims have been exaggerated. Certainly I personally am interested in things that I find frightening to start with, and things that are difficult to watch, because they force me to examine certain things about myself and why it is that I'm afraid of those things. It's coming to terms with fear that ultimately leads people to be stronger and more fulfilled. It's important that you come to terms with being gay, for example, so that you know where you stand when you're sitting on the bus and somebody starts screaming at you. And therefore by the same token, I think that it's important that you come to terms with death and the more horrific side of life that one occasionally comes upon. So, it's true that to a certain extent I have always been interested in some of the things that are a bit heavy, but I'm not about to force that down other people's throats. It's just a personal interest of my own.

SP: What about the danger of desensitising yourself to things like violence?

JB: It depends on the person. Of course, you can. There is always the danger of that. It falls back on the character and strength of the people who are witnessing or involving themselves in things like that. Society is far more violent than anything we perpetrate in the name of 'art.'

PC: I think, in general, most violence is the result of frustration and the people that are the most violent characters are the

ones who have the most difficulty in accepting themselves on many different levels. That applies to anything. Like there was a kid in America who said, 'I murdered my mother because I saw somebody murdering their mother on TV.' I honestly think that's rubbish. I don't think there's a direct connection between pornography and violence, for example. It's true that you can be desensitised to it in the way that policemen or people who work in hospitals must be. But I don't think that doctors who work in casualty wards are any the less caring or humane in their attitude toward their patients just because they've seen blood for 20 years. I don't think there's a connection. We seem to have been talking a long time now about heavy imagery, whereas it's not particularly a part of what Coil does, it just happens to be something that we were associated with in the past.

SP: OK, one last question about the darker side of Coil: the claims of magick... Is that black or white magic?

JB: It depends on what newspaper you read. *The News Of the World* would call it 'Black Magic: Shock! Horror! Chicken Orgy With Six Defrocked Priests!' It's spelt with a K so that numerologically it adds up to 11, the number of sexual magick... Sexual magick is using the power of the orgasm to focus the will in order to make things happen. 'Any deliberate act is a magickal act,' that's what Aleister Crowley wrote. It's a system of living whereby you utilise and make the most of every possible aspect of your personality in your surroundings. It's just maximising your situation. It doesn't have to involve goats, sacred daggers, or circles at midnight on the Moor — although it can do. It just depends on how you go about it. Personally we don't do that sort of thing: we prefer to use music and more modern applications.

SP: You state that sex magick uses the power of the orgasm. Isn't the gutter press going to draw a parallel between that and sexual rituals that occur in black magic?

JB: Sexual rituals go on in the church, the Christian Church. And the more orthodox it gets, the more vicious and bizarre it gets. In Spain, there's a procession they have, 24 hours long, in which they get themselves into a trance, beating drums and scourging themselves with huge whips with pads and hooks on them which tear the flesh. They all have to be hospitalised afterward. And everyone knows about *The Devils of Loudun* and all these bizarre sexual things. It's just the sexual hysteria that the church generates. If you go somewhere like Spain, a Catholic country, you can see it coming to the surface.

SP: But why do you call that sexual ritual? Doesn't that say more about you than Catholicism?

JB: It says something about me, but it definitely says more about Catholicism, because it's definitely a sexual ritual. Nun hysteria is a sexual phenomenon... The Church has always been at the forefront of sexual repression.

The moment that Christianity came along, a hell of a lot of problems started because there was this cage of repression over every aspect of life. Neuroses and guilt have fucked up society ever since. Go to somewhere like New Guinea, for example, which is fucked up now because of missionaries, but before they had no sense of guilt. That's why people called the Pacific Islands 'paradise,' because the islanders have never had to feel guilty. Basically, they've never had a Christian influence. They've never felt indebted to Jesus because he died for them. They have no concept of sex as a dirty word, as a dirty institution, as a dirty act — because it isn't and shouldn't be to us. The gutter press always pick up on sex

because of the Christian morality that they see it in context with. It's the same with homosexuality, but everything is increased fivefold in its outrage value, because it's considered even more against nature.

PC: When, in fact, it's the opposite.

JB: Anything you feel instinctively is obviously natural. You have to take into consideration the bending and distorting aspects that living in this society have upon you. It's only when your natural feelings come into conflict with what's expected of you that the problems start.

SP: Is there a lighter side to Coil? Is there any humour?

JB: Oh, there's a lot of humour. Some of it may be considered a bit sick, but it is dry.

PC: I think it's possible to combine an element of sick humour with good intentions as well. For example, our 12" single is a remix of 'Panic', which is one of the tracks on the album, and the B-side is a version of 'Tainted Love'. All the profits from the record will be donated to the Terrence Higgins Trust. There are some people who would say that it is sick to make a record of 'Tainted Love' and donate the profits to an AIDS counselling service.

SP: And 'Panic'.

JB: I never thought of that!

PC: So, in a sense, that has a sick level to it, but also it is doing good work as well, assuming we make any profit but I assume we will. So, there is a self-conscious sense of humour in what we do and there are some fairly wry bits on the album as well, though they're not done in a way that is intended to be entertaining in a funny way. We've always had that slightly mischievous quality to our work, even in Throbbing Gristle.

Some people find music that's slow and dramatic depressing, but I personally don't. I've always found music like that uplifting. So, although there are darker sides to what we do, they're not intended to be heavy, they're intended to be interesting. Judging from the number of people who have written in there are certain people who find what we do very interesting and positive.

SP: There's no intended gimmick of perversity: in music, in sexuality, in philosophical thought?

JB: Well, who calls it perversity? It's called that by someone coming across it second-hand. We certainly don't intend it to be like that, but we're well aware that it might be seen like that. That's why we do interviews, that's why we'll go to lengths to explain our point of view. In a sense we are well aware that it's something that attracts people, but it certainly isn't something that we'd call a gimmick. Perversity is the wrong word; it's the way we are, the things that interest us. We want to explore further. We do gravitate toward the...

PC: ...Unusual. Yes, the keyword of what you said was 'gimmick,' because a gimmick implies that you are doing something in order to achieve an effect for someone else... None of what we do, although it is out of the ordinary in terms of images, is done for the purposes of achieving an effect for somebody else. All the things that we write music about or talk about are things that are intensely personal and strongly felt by us. For example, the album is called *Scatology* not in order to be outrageous but because the word encapsulated a lot of things we were interested in, both on a base and banal level and also on a complex intellectual level. If other people find those things perverse I hope they don't think the worse of us for it.

SP: Are you trying to achieve something avant garde?

PC: That implies that the purpose of doing it is to be ahead of everybody else. I don't think we are particularly. I think inevitably that happens if you have people who care about those things and think for themselves, then the people who don't think tend to follow those people.

SP: Is one of your aims to educate?

PC: It's not education in the sense of preaching or proselytising. But it's education in the sense that if we find out about something or a way of doing something, then to some extent we feel it's our responsibility to make that knowledge available to other people if they want it. Education should be sharing experiences people might not otherwise have had, in an attempt to enlarge their perception of experience. I think everyone should be educating everyone else.

SP: Have you written any love songs?

PC: Love is such a universal thing and I hope that more or less everyone would have felt it and experienced it and know what it is, that it doesn't provide for me very much new interest. It is something that is incredibly important, but it's important like food. Everybody needs it so it's not very interesting to write songs about it just as you don't write songs about chicken sandwiches. It's so fundamental.

SP: OK, let's talk about AIDS. Or do you not want to talk about it?

JB: I'm sick and tired of reading about it.

PC: No, I think the more information you have about it the better. Obviously it's boring when there are things in *The Sun* saying 'Prison Chaplain In AIDS Shock' because that's not helping.

SP: OK, how has AIDS affected you?

JB/PC: (together) Well, we're a lot less promiscuous!

JB: I think it's the same with everybody.

PC: The people that say it's nothing to worry about really are just failing to face the fact that it is something to worry about and something that everybody is going to have to deal with sooner or later. It's just that we, as gay people, happen to be the first. I think it's inevitable that everybody will become vastly less promiscuous and stop going out, or stop having sex with people. It's something they've just got to come to terms with.

JB: I think, on a more subtle level, it is actually changing social integration. People won't go out for a quick fuck basically and it may have the good effect that they'll relate to each other on a more permanent, personal level. The art of conversation may come back. But that's a pathetic small price. But what I think is pretty awful is that there may be a whole generation of people who are afraid to come out of the closet. They just don't want contact with gay people because they've been told that they'll immediately catch AIDS if they stand near them at the bus stop. There's a whole generation who may have a totally different viewpoint on coming out may never do that. As a consequence they'll end up fucked up mentally. And that's more destructive than the fact that they might die.

PC: I agree. In terms of the effect on people in general, the fear of catching AIDS preventing people from coming out is ultimately going to be more damaging than the disease itself.

JB: When a sizeable quantity of people we know in London start dying of it, which is quite likely to happen eventually, there's going to be a fuck of a lot of guilt and anger and fear going around. And retribution in a sense... Like I say, the shadow of guilt is coming back. Even though they say 'I don't believe the press, we shouldn't feel guilty, we should stand together,' they can't help but feel that there might be something like divine retribution.

PC: I don't think that at all.

JB: Well, I personally don't and a lot of people would say that they don't. But, subconsciously, I don't think they can help it. I'm aware that this is a Christian society and it's been said that it's divine retribution and that it's good that God is sorting out those dirty queers. Well, you can't help but have that rub onto you. I don't personally feel that as an influence but perhaps I've managed to get rid of it.

PC: I definitely don't feel any more guilt than I ever did. I never felt any guilt whatsoever actually. And I don't think that the people in my family or the people that love me feel anything but concern that I might die!

JB: This is what I mean by guilt, that's another factor. My mum keeps ringing me up and saying, 'we're worried about you, I've been crying all day. I've been reading in *The Mirror...*'

SP: Well, tell her to stop reading *The Mirror*!

JB: I do! I say, 'stop reading it and why don't you talk to me about it?' It's that sort of guilt that is bringing doubt into a lot of things.

PC: All the more reason to support everybody being open about the way they feel and about their sexuality, even in the face of these more increased odds. That's why it's even more important now — and this is going to sound very old fashioned — to promote gay liberation. To my way of thinking, the sex side of gay life, although it's the first motivation for coming out and leaving home, is really quite a small part and not necessarily a very important part of gay life. There's no reason why people shouldn't carry on being gay without going out to the pub and picking someone up every night.

SP: Well, what about using fear constructively, in this case to externalise your fear of AIDS?

PC: In terms of the music, inasmuch as that's our form of expression, we deal with it as best we can and in an interesting way; on the financial side we're trying to donate as much as we can to the right places. Also, in interviews, we're trying to express our views. So, yes, we are trying to externalise it as much as possible and trying to counteract the gutter press poison bullshit.

SP: Have you any true confessions?

PC: One of the reasons I started to do Throbbing Gristle was in order to have groupies. I'm sure it's the same for most people. Other people might say that this isn't the case, but there certainly is an aspect of that. I know Bronski Beat aren't complaining.

SP: What about sadomasochism and *Scatology*?

PC: As you might be able to tell from our album being called *Scatology*, there are S&M aspects to our personal lives. This refers to what I was saying before, inasmuch as one of the things that I find exciting to do are those things that are considered shocking or difficult or fearful, and that certainly includes things in the sexual area. I do get turned on very much by doing things because they are 'dirty,' both literally and metaphorically.

JB: I find the mythology of S&M, the ritualised power struggle, is always interesting because it's got very strong imagery. People always latch onto it.

PC: The problem with presenting it in public is that people usually make the mistake of assuming that it's about doing something to somebody against their will, whereas 99 times out of a hundred, it's not.

JB: You need perfect trust for it to happen, that's why it's so interesting.

PC: And the removal of responsibility. One of the things that's interesting for me, which ties in with what we were talking about in terms of AIDS is that, because my current proclivities are not orientated toward screwing so much as 'dirty' type things, I find myself interested in having physical relationships with people that are straight. For them, the sex side is not significant. Am I speaking too obliquely or is it obvious what I'm saying?

SP: Don't the politics of S&M enter into it? What about the view that S&M is the Fascistic control of one over another?

JB: There are far more insidious examples in social attitudes and media manipulation on people's values and consciousnesses than in an open ritualised display of an expression of sexuality.

PC: I think it's as bad for humanity and, in a relationship, for somebody to control the other and make them do things that they don't want because they're afraid of losing them, for example. That happens all the time. That, to me, is just as bad as sticking your cock in somebody's mouth even if they don't want it there. That's actually much more short-term and much less harmful. Obviously a Fascistic control of people as portrayed in the film *Salo*, for instance, is a terrible thing. To some extent, because we all have that streak in us that would take pleasure from being in that relationship in either role, it's because people can't come to terms with it and are not able to carry it out in a relatively harmless way, that it gets magnified. You have to find out what it is that you need and give yourself harmless excursions into it in order that it doesn't become repressed. Obviously, I don't think that anybody should do anything to anybody against their will. But there are all sorts of things that I would like people to do to me, which they might think that I wouldn't want but that actually would give me great pleasure. You have to find the opportunities.

JB: That's why you're telling *Square Peg* all about it!

SP: Do you find the anti-S&M argument irrelevant?

PC: There are obvious behavioural limits to what it is right for people to do. You shouldn't do anything to anybody that they don't want you to. But if you're in a situation where somebody wants to be pooed on, or something like that, if they want that, then I can't see any harm whatsoever in doing it.

JB: Personally, I think that people should put themselves through as much as possible in order to expand their knowledge and insight.

PC: Also, to some extent, there is the view that if you have the opportunity to try out these role models, in a safe environment, you learn a lot more about your own personality which makes you more able to handle difficult or confrontational experiences in real life. You accept the fact that you are prepared to give way to somebody else's view or that you aren't. The more you learn about yourself, the more you are able to become a fulfilled person in the outside world.

'An Obsession With Animal Lusts and Base Instincts'

Tape Delay, 1985

Charles Neal

I moved to London in 1983 with the original plan being to stay for six months so I could work on a film school resume with no distractions. Instead, I met a record store owner and he introduced me to the musicians, artists and writers who became friends to this day. I was into post-punk after a spell on college radio in North Carolina, but my mind was blown seeing Cabaret Voltaire in Sheffield: 23 TV sets on stage, stunning lighting and subversive music — amazing! A couple of months later, in January 1984, I was at the ICA for Einstürzende Neubauten's 20-minute set as they drilled a hole in the stage. A friend pointed out Stevo — owner of Some Bizzare — and I marched up to him, told him I was writing a book, and asked to interview him. He handed me a phone number and became my first interviewee.

The interviews that became *Tape Delay* extended across 1984-1986; all but one conducted in person. My goal was to create a book that allowed the artists to speak for themselves with rather minimal editing: for example, I kept Mark E. Smith's exclamations of 'y'know what I mean?' every other line. Throbbing Gristle was

an important reference point so I interviewed Chris and Cosey, then visited Hackney for three long conversations with the loquacious Genesis P-Orridge. Next, Geff and Sleazy left Psychic TV to form Coil, I wanted to discuss both projects with them.

I remember their house as rather large, but sparsely decorated, not a lot of furniture or visual art. We did the interview upstairs in a near-bare room with striped grey walls. At the time, decadent tales circulated of sexual encounters involving members of Psychic TV, Coil, and their collaborators, which — combined with the knowledge that ritualistic and recreational sex were very important to them — created an atmosphere that made me a touch uncomfortable.

Working at Record And Tape Exchange, one friend turned me onto Serious Art Forms who had begun publishing music books. Another introduced me to Jon Wozencroft who designed the book, Chris Bohn wrote the introduction, while Edwin Pouncey agreed to do various drawings. *Tape Delay* was published three times and sold around 10,000 copies. I was paid for the first two but given nothing for the third — welcome to the music business!

In the years since — while remaining dear friends with Michael Gira and bumping into Foetus, Cabaret Voltaire, and Lydia Lunch — I became a wine and spirits importer visiting producers in France then distributing their wines in the U.S. *Tape Delay* therefore stands as a work I am proud of, but also a memory of a specific time and place.

'Scatology, in the medical sense, is an obsession with human shit, or as the old fashioned dictionaries used to say, "an obsession with animal lusts and base instincts." So, it's a combination of those two.'

Interview

CHARLES NEAL: What is Coil?

PETER CHRISTOPHERSON: Loosely, it's what we do musically. We do other things apart from music but it is the term for our musical experiments. Although it's basically me and John, we do get other people to help as well. In that way, I suppose it's like Psychic TV regarding the set-up and collaborative aspects. Coil is also a code. A hidden universal. A key for which the whole does not exist, a spell, a spiral. A serpents ShT around a female cycle. A whirlwind in a double helix. Electricity and elementals, atonal noise and brutal poetry. A vehicle for obsessions. Kabbalah and Khaos. Thanatos and Thelema. Archangels and Antichrists. Truth and Deliberation. Traps and disorientation. Infantile disobedience.

CN: Where is the term Coil derived from?

JOHN BALANCE: I chose it on instinct and since then I've found that it actually means a noise. And there are things like the spiral, the electrical coil and contraception. The spiral is a repeating micro/macrocosmic form. From DNA to spiral galaxies. A primal symbol. It's a nice little word. The Black Sun that we use is a surrealist symbol from [Les Chants de] Maldoror by Isidore Ducasse. It has ten rays (two by five). Coil are essentially a duo and five is the number of the aeon of Horus — the present time. We have a private mythology completely in tune with symbols and signs of the present aeon. We don't believe that it should become an important part of our public image — as misinterpretation and unnecessary and incorrect replication would possibly occur. Silence and secrecy. After all, the image of Horus most appropriate to the new aeon is of a 'conquering child' with his fingers to his lips — the sign of silence.

CN: What is the significance behind the title of the album *Scatology*?

CL

PC: Scatology, in the medical sense, is an obsession with human shit, or as the old fashioned dictionaries used to say, 'an obsession with animal lusts and base instincts.' So, it's a combination of those two.

CN: Why do you feel that's important to incorporate in the title?

PC: In as much as *Scatology* is more to be listened to as entertainment, the titles of those records normally try to attract people in a slightly outrageous way and, at the same time, give some indication of the atmosphere of the record. I think it's a good title and a lot of the songs on the record refer, either in their lyric or in their moods, to the most base of man's instincts. It seemed quite appropriate. It's what Dali, in *The Unspeakable Confessions Of Salvador Dali*, calls 'the Humanism of the Arsehole.'

CN: What do you see as the importance behind a ritual?

PC: Most people's lives are basically devoid of anything that adds meaning. That sounds so patronising to say, but I just think that the fulfilment I get from doing things that have no immediate everyday need, while at the same time fulfilling other needs, certainly indicates to me that it would be interesting for other people to try them too. And you can only use yourself as an example for how you think other people should live — rather than saying in the way that religions do, 'you must do this,' or whatever.

CN: Is it important for the ritual to be designed by the person that practises it?

PC: I don't think so. Millions of people benefit from Catholic rituals...

JB: ...Or the Japanese Tea Rituals. It's the Zen philosophy that every movement means something. I think that way of living is far richer and it gives them an awareness of what and

CLI

where they are. But ritual in the West is monopolised by the church, especially in Europe and the United Kingdom. People carry out rituals all the time, the English parlour obsessions with table turning, clairvoyants, and wishing wells. All these exist and are practiced, but people seem to be somehow ashamed of them and would rather be represented by the church. I suppose that's because it's a rich organisation with ostentatious shows of power and wealth.

CN: How would something like the Japanese Tea Ritual differ from something that the church has organised?

PC: They're not at all different in what they achieve in the person. Where they differ is that the organised church has exploited its knowledge of ritual to control people and enhance their own political end. Certainly in this country in the last thousand years, the church has been a political machine that has done what it has for profit and for the advancement of the people in control. And I think it's a pity that the church leaders have exploited their position that way because it has fucked up a lot of people in Northern Ireland, the whole of South America, Spain and most of the Far East.

JB: To take a blatant example like the Aztecs, their whole society was controlled by priests who knew the language and knew the way to stop the sun from dying, and so they had complete control over every member of the population. If people didn't do certain things, they believed they'd die. The system was highly developed, very brutal and based on human sacrifice. But they believed if the gods didn't get their blood, then the sun would not rise and the world would end. And it's just the same here except it's far more insidious and hidden.

PC: All that you really need for your own rituals to be valid is a belief in their abilities. The only problem is that it's easy to

have self-doubt about what you're doing. And if you have a body of other people doing a ritual that somebody else has designed, then it's more easy to believe that it might have some power.

CN: Is it possible to use rituals for negative purposes, to bring out evil or destructive things?

JB: Oh yeah, but what's the point really? The Tibetan Bon-Po shaman priests still do this. They've been called the most powerful and evil Magickians that ever lived. I've got an LP of part of a malicious, destroying ritual. They go on for days and cause plague in a whole village. The energy and powers exist to be able to do that sort of thing, but what's the point?

PC: The gutter press, *National Enquirer*, sort of mentality use basically the same argument when dealing with more or less anything, whether it's a nuclear bomb or a ritual. Sexuality, for example, they frown on because it's a way of having a powerful experience. Not exploiting, but using the power of human nature to do something. And if it has a possible negative power, then they immediately say that the medium is at fault.

CN: Does the energy of the ritual come from within the person or can it be drawn from other sources?

JB: It doesn't really matter where it comes from. The point is it works, that power can be summoned, generated and you can harness, manipulate and channel it, so you never need to know where it comes from.

CN: Why do most people view a ritual or Magick as being evil?

PC: It's fear of the unknown. Basically it's because the church saw other people who were doing rituals as a threat to their control.

JB: They try to keep a monopoly so anything else is bad or evil and you get thrown into hell for it. It's Christian propaganda basically. England has strong pagan roots and the church has always attempted to stamp these out — originally by neutralising pagan temple sites and then building churches on the same sites, then by burning witches and religious persecutions. If they couldn't kill them, they used ridicule and fear tactics to deter people from the pagan heritage. The devil is only a Christian adaptation of a neutral nature deity; Pan, Cernos, the horned gods — which are phallic. The Christian church has never been very sexual, except where the pagan undercurrent has been allowed to emerge because it was too strong to suppress completely. The devil is a representation of pagan sexuality, which is why people are attracted to it even when seen as a Christian invention.

PC: At the moment we're sort of going through a right-wing backlash against the freedom of the 60s and 70s, certainly in terms of sex. And I wouldn't be surprised if in ten years' time there was a religious resurgence of interest in the church.

CN: Were the angels symbolic of a larger concept on *How To Destroy Angels?*

PC: All of what we do is symbolic on several different levels at once, so you can interpret angels as being a number of things, whether it's the controlling influence of the church, or whether it's an unnecessary desire to retain virginity.

JB: When I thought of the title, all these things went through me. It was a record to accumulate enough power to destroy theoretical angels — Christian gossamer angels don't seem hard to destroy. It was a curious matter-of-fact title, almost like a manual, a handbook you'd come across which could be the key to immense power and change.

CN: Do you think that Coil will vary to a large extent from Throbbing Gristle live?

PC: The trouble with playing live is that everything has to be done on the spot more or less. And nobody in Throbbing Gristle was a particularly great musician. Basically that narrows down your options as to what you can do live. You can rely very heavily on backing tapes, you can just do your best, or you can bring in other musicians. And none of those options are very acceptable to me. Just doing your best and trying to work out sounds that one could reproduce competently and that sounded interesting was really what Throbbing Gristle were doing. It got to the point where we couldn't go any further and that's one of the reasons why we split up. And the Psychic TV dates that we did in the summer and autumn of 1983 didn't really go any further than Throbbing Gristle had. We had Alex playing, who is a good musician in that he can play proper guitar, but jams even with good musicians tend to sound like what their influences are. And so a lot of Psychic TV stuff ended up sounding like The Velvet Underground, which didn't seem to me like it was advancing anything.

JB: Although the ideas were interesting live, it became more brutal and relied on the noise element while the ideas got swamped. I mean, it's alright for people who had heard the records before and knew what we were about and they got energy off it, but it wasn't much more than a sort of controlled noise with a cause behind it. Which on reflection seems pretty reasonable, but something wasn't right. Genesis would probably say it was our attitude.

PC: Well that's alright, but the reason why we haven't really done any live dates is because we haven't actually solved this problem of what to do. Certainly we could rely more on backing tapes in the way that a lot of groups do, but people really want

that sort of dense atmosphere and rely on that adrenalin rush and I don't know if you can get that from backing tapes.

CN: Is there such a thing as inaudible sound?

PC: Pardon? (Laughs) The theory of all that stuff is that if you actually play something at a lower level or backwards or in flashes on the screen it's absorbed by the subconscious mind which acts upon it immediately. But I've never had any information or evidence that it works. People say the Rolling Stones' album *Their Satanic Majesties Request* has reverse masking and it says 'come to Satan,' or something. I mean it's all bullshit, it doesn't work in my view.

JB: Records are very crude as far as recording and playback quality goes and there is no way that scientific experiments can be done in this medium. I think holophonics are far more interesting anyway. Stevo gets accused of doing a big hoax and so does Zuccarelli who developed the system.[1] With holophonics we were able to get atmospheric subliminals and record a particular feeling including the spatial limits of a room or a cave and the movements of people in it. But I remain very dubious about backmasking and inaudible sounds having profound but subtle effects.

PC: Coil are interested in subliminals of another kind — delirium subliminals. Atavistic glimpses of a grand chaos — surfacing in flashes of black light — in darkest Dali, Jarry, the Moomintrolls, the Virgin Prunes, in the face of Edith Sitwell, Boyd Rice's humour — emotional subliminals. Psychic information, partly deliberate, mostly instinctive.

CN: Do you think that ghost images in a visual picture have an effect on people?

1 Holophonics was a theory and recording system created by Argentine inventor Hugo Zuccarelli, and used on the PTV album *Dreams Less Sweet*.

JB: I think they possibly have more effect. Apparently *The Exorcist* originally had dead animals subliminally put in and they had to take them out. I mean there was a huge reaction about people being sick because it was the first high class splatter movie. It has more chance of having an effect if you see adverts many times — and they're not subliminal. If you see adverts for ice cream, next time you're in the shop, you go 'I'll have one of them,' because you've seen it on telly. It just works on a crass level like that.

PC: But there are lots of things that happen with films that could be exploited more, just things that you see in the background that you don't notice but are actually there.

JB: All of these subjects — subliminals, backmasking, cut-ups, the industrial group's subjects — culled from Burroughs' *The Job* and *The Electronic Revolution* have been done to death... And not very well. Sonic research is very hard to do properly on a Rough Trade advance or whatever. It maintains a pseudo-science, it has a wish-washy quality that I don't particularly want to be associated with. I'd rather be seen as a perverse noise unit with decidedly dubious musical leanings. I admire the intentions of all these groups, but the purity or scope of the possibilities are diminished by huge amounts in the translation to vinyl. Z'EV and NON seem to remain pure, as do Sonic Youth but they're coming from a different area as far as I can tell. In the end, the intentions alone can be appreciated: a golden conceptualists and dull records type of situation.

CN: Do you think that music is the best medium to get your ideas across to people?

PC: No, I think that film and television is by far the strongest because it's a way of really affecting all of us. If you could affect the senses of smell and touch as well, it would be stronger still.

CN: Is there a difference between chance and fate?

PC: I don't think there's such a thing as fate really. I don't think there's such a thing as chance either, but that's different. Fate implies a certain thing is bound to happen, but I don't think that's the case. To rely on logic, then obviously whatever's going to happen is going to happen. But, at the same time, the implication that it's out of your control is obviously rubbish. At any point you have a myriad of choices, whether it's running and jumping out of the window or not. Obviously, things happen as a result of circumstances that one could not possibly foresee and that is what one calls chance.

CN: In the studio, does the recording process differ much with how you've worked previously?

JB: With Coil we lay down the backbone ourselves and, if we want to, we collaborate with other people. With Psychic TV it was more of a jam, things spontaneously arose out of rehearsals.

PC: But all the Psychic TV records that we were involved in were fundamentally done in the same way that we do now, which is to set down a rhythm and just lay things on top of it as they seem appropriate.

CN: Do you think that you can change society through music?

PC: No, I don't think you can change anything with music particularly.

JB: But, then again, a group like Crass might say it's not necessarily their music, but the message that's coupled with it. We're very cautious about having one heavy message, but we do have a lifestyle and I do want to change a lot of things. We're obviously not like Ultravox where their album and the way they view life may be quite separate.

PC: I actually don't know any members of Ultravox personally, but my suspicion is that the content of their lyrics actually isn't very deep and doesn't concern very many of the things that I'm interested in. So that's one of the reasons I don't buy Ultravox records. Music is just an expression of the taste of the person that's doing it, and that is ultimately why you buy a record — whether it's Johnny Rotten or Captain Beefheart.

JB: If you hear a record you like and you suddenly find out that the people responsible do something that you're really against, then you probably won't listen to the record in the same light.

CN: But shouldn't music be judged on its own merit?

JB: I don't think it should just be the song. They should have a sense of realisation that people do tie the two things together.

PC: That's a very difficult question because, having been around 'the business' for a long while, I've met people whose music I've respected, but whom I discovered I didn't respect as people. And certainly that changed my perception of their music and their work.

CN: Do you think that is elitist in some ways?

PC: I think we are elitist. I know that I am a bit of a snob in some ways. I mean, we're talking about politics now and that is about how much self-respect you have and whether you think your opinion is actually better than somebody else's. And the important thing to remember is that one's own opinion is the best there is for you, but not necessarily somebody else. It has got to do with whether you are big-headed enough to think that your own opinions are the ones other people should hold. And I think that's very dangerous. I have certain very strong views about particular things that other people would certainly think were elitist, unusual, or unacceptable. But I only

hold those views for myself and I wouldn't necessarily expect other people to enjoy the things that I enjoy. And, likewise, I would expect them not to force me to live in the way that they do. Coincidentally we have touched upon a very common misconception which is that elitism is a bad thing. It's also an old misconception that it's important to do a particular kind of music at a particular time. I mean you can look back on certain songs as being 'classic' or completely different from anything else at the time, but it's all temporary. I think it's worse in America where people tend to accept commercial dogmas more readily. In England, the eccentric is part of the history of the country. There has always been the village idiot.

JB: Does that make us the village idiots?

PC: No, but there's the whole tradition — Oscar Wilde or Quentin Crisp or whatever — as being acceptable as the local weirdo in a sense. And the people that do that in America are far more out on a limb until they get some commercial success. I mean, New York is a cultural island relative to the Midwest where the people that do weird records have a difficult time. At least in England people are prepared to listen to something new with an open mind, so it's that much easier. It may be crazy, but I still have an optimistic hope that free thinkers will be allowed to continue to do so because most of them are not threatening to society even though society might feel that they are. That's why we're lucky in Britain in that we accept eccentrics and people that do things out of the ordinary as being a healthy and contributory part of society's existence.

JB: But you make it sound like it's idealistic and that all these things are allowed to happen. There are huge backlashes all the time against those who appear to deviate. But society needs the deviants in order to change. There's this thing, let them grow up so far and perpetuate some sort of change and

then beat them down again. It's as if society, like an organism, allows mutation in order to improve itself but keeps a tight rein on how much actually occurs.

CN: Sword imagery creeps into several Coil tracks. Is that simply a phallic symbol?

JB: We didn't mean it as a phallic symbol. If you get Freudian then it's definitely a phallic symbol but in magick it's not. The sound of the swords on 'How To Destroy Angels' represents Mars, as in martial, the god of spring and war, who cabalistically represents dynamic, positive change. The sword is a symbol of willpower.

PC: Although I certainly wouldn't describe us as militaristic, we recognise that man has an aggressive streak. I don't think the peace movement, for example, has got any real hope of succeeding. You have to recognise the nature of man, accept it, and use it.

JB: It's the way things happen isn't it? It's creative force is what we're aiming at, rather than militaristic, crass and obviously masculine, sexist type of things. Rough Trade actually said that the cover notes to *How To Destroy Angels* were misogynist, which I find ridiculous, just because it dealt with masculine qualities.

PC: They stocked the record and it sold out, but I don't think they were too happy about it, and they didn't put the poster up either because it was too extreme for them. In many ways, the people that are supposed to be spearheading the libertarian view are just as limited in their view as the gutter press and the more conservative elements.

JB: Their ideals often disagree with the practical way they work. They'll say, 'oh yes, we support free thinking and things,' but

when you actually bring a copy of it into the shop, they'll smash it if it disagrees with their personal sensibilities.

PC: You're bound to come into contact with hypocrisy when you step out the door really. The only thing you can do is to try and make sure it doesn't take place in your own home.

CN: What inspired 'The Sewage Worker's Birthday Party'?

PC: It came from a story of the same name in a magazine called *Mr. S&M*: a Scandinavian publication which is basically fetishistic in its content. It's an area I'm interested in anyway. We wanted to try and express it in musical form, and I'm personally quite pleased with the way it turned out. It's an interesting piece of music even if you don't know the original story and where it came from. I'd have liked to print it, but I don't think the people doing the covers would have actually accepted it.

CN: Does it seem strange doing dance music?

PC: When Throbbing Gristle did *20 Jazz Funk Greats*, it was the intention to do something that was more conventional in that form, but it wasn't totally successful because we didn't really know how to do it. We still don't know how to do it, it's just that we wanted to make some of the music a little more up-tempo, aggressive and rhythmic. But it's certainly not a considered attempt to do a dance record, because I think if we tried to do that it would be a disaster. I can't speak for the intentions of others, but I get the impression that The Art Of Noise were really a very considered attempt to do dance music in a way that would be artistic and fashionable. And it feels to me that the results are sterile and not very interesting.

JB: It all depends on what dance you're going to do. I think that The Birthday Party were dance music, but it wasn't the kind of thing that got played in discos very often.

CN: Do you think that anybody has added a great deal of depth to a song which is also very entertaining and commercial accepted?

PC: It's very hard because you don't know what people's reasons for doing the records were. 'Endless Sleep' by The Poppy Family, 'Tainted Love' by Gloria Jones, 'Seasons In The Sun' by Terry Jacks, and 'Emma' by Hot Chocolate — to name a few — seem to work on lots of different levels but I don't know whether that was the intention of them in the first place. I mean, from The Beatles onwards, some records have struck at exactly the right time for them to be amazingly successful and also interesting from some other philosophical or inspirational point of view — I think that's true for films as well. That's probably one of the most satisfying things for a creative person to do, because that spiritual or philosophical side stands or falls for what it is.

CN: What do you think about cults that develop around certain bands, such as the mimicking of haircuts and dress that became noticeable with Throbbing Gristle and Psychic TV?

JB: Thoughtless and crass mimicking of anything is worthless.

PC: It's one thing to dress a particular way and to meet other people that have, by their own route, arrived at similar conclusions. But to wear things because one's hero or idol happens to wear them is really weird and a bit unhealthy — and slightly distasteful. That whole thing of Marc Almond clones — even though Marc's terrific — it's the same with Bowie clones. It's ironic as well because, at the time we were in Psychic TV, one of the messages of the group was free thinking and independence from that kind of thing. I can't speak for what they're doing now because they're going their own way and I wish them well, but there's no way that I personally could continue to be a part of that.

CN: How important is image to Coil?

PC: We haven't established an image for Coil as such. Although we obviously have interests slightly apart from the norm, we haven't particularly gone out of our way to create an image. In many ways it works against us because that means when we do occasionally give interviews, people don't really know what to ask.

JB: We've got the added problem that we could easily rely on ex-Psychic TV and play up all the same things, but we make a conscious effort to play down those things even though some of the aspects we're still very much involved in. We're making a conscious effort to be isolationists. I think it might become our image in a way. I suppose some people might try and pick up on the fact that we're gay and associate us with that, like Bronski Beat who were only ever thought of in that context.

PC: It's a question of really not allowing ourselves to be reduced to two dimensional objects. Although sexuality is a fairly important part of what we do, it's by no means the only part and I don't see it as a restriction.

CN: Why are so many people scared away by some of the imagery that Throbbing Gristle and Psychic TV made use of, such as skulls?

PC: I think that it must be that we have a different threshold, a different interpretation upon imagery. I mean, it's a cliché to say this, but I've been at home and felt happier in fairly desolate and lonely sorts of places. And if people get scared by photos of the Berlin Wall or something like that, then I just can't perceive the life they lead and how they could find it scary, because it just seems natural to me. A vast proportion of what we do and the way that we live our lives would probably freak out the majority of civilised people, simply because it's out of the norm of their experience. It would certainly freak out my mum.

We don't have any wallpaper, we've got rat shit everywhere, it's just a completely different way of living. But the reason that people get frightened is because of their interpretation of those things, not because of the reality of them. It's easy for a person to interpret a photo of you holding a skull, but it doesn't necessarily mean that you are a devil worshipper or a necrophiliac. It's their interpretation which is at fault. If my mum was living here, after a while she would probably think it completely normal and would have a much more realistic scale to determine whether I was a nice person or not. It's a very dangerous thing that some of the newspapers and the media do because it's so easy for them and they're going to sell newspapers for being outrageous and saying 'Naughty Vicar' and 'VD Hospital' shit. But outrage has always been a commodity. Boy George, the Sex Pistols and everything are all manufactured, totally. But none of us, even Gen, has ever done anything really to make mileage out of being outrageous, it just comes naturally which is quite different I think. Although you see people on the subway with whom you feel you have absolutely nothing in common and possibly even dislike just because of the kind of people they are, I'd rather have nothing to do with them. I don't think it's even worth going to the effort of outraging them. I just wish they weren't there.

CN: Is there anything else that should be known about Coil?

PC: We have talked quite a lot about ritual and I'm not sure if that gives a true picture of what we do because, although it is a part of our lives, it's not something that we would particularly be interested in having a name for promoting amongst young people. Thee Temple Ov Psychick Youth was an attempt to bring ritual to other people. I wouldn't really want to be seen doing that still, because I don't feel it is my job to tell people how they should live. But if they want to ask me, that's fine.

'A Personalised Vision of The Apocalypse'

AbrAhAdAbrA, Late 1985-Early 1986

Anthony Blokdijk

I was too young to dive into punk during its heyday. Instead, in around 1980 at age fifteen, I became acquainted with Crass, initially through mail correspondence before meeting them at two of their concerts in The Netherlands. Rapidly disillusioned with punk, I became aware of Throbbing Gristle very shortly after they had 'terminated the mission.' This led to me becoming a member of Thee Temple Ov Psychick Youth — a relatively short-lived membership, several important members left the cult and so did I. Of more significance, however, I started an occultural fanzine called *AbrAhAdAbrA* with a couple of friends.

I stayed in contact with several ex-TOPY members, including David Tibet. It was David who offered me a place to stay at the Vauxhall squat he was living in and who asked me if I wanted to interview John Balance. I was already totally in love with the few recordings I'd heard on cassette so, on a Friday in 1984, I visited Threshold House. Oddly enough, in David's squat I met members of Crass again, namely Steve Ignorant and Gee Vaucher. We all

went for drinks in a transvestite bar. Years later I learned Steve regularly sold his wood carvings to John.

Sleazy was away in the U.S. so it was only John who received me. We became friends and pen pals thereafter. We bonded over a love of books: he'd look for Austin Osman Spare books in London, while I'd look for Dali paraphernalia in The Netherlands. From then on, I was a welcome guest at their home, usually bringing a bottle of Mescal (illegal in the U.K.). At one point we were working together to arrange the release of the Coil track 'For Us They Will', but the financing fell through. We did, however, collaborate successfully on a Dutch translation of Burroughs' *Electronic Revolution*, with John writing a foreword and Sleazy designing the cover.

Sadly, the last time I visited them was in 1988. Geff was in a manic state due to (and regarding) amphetamines, which resulted in me winding up pretty grumpy — there wasn't enough for me too, I shamefully have to admit.

Still, in the 21st century, I saw Coil on three occasions: The Hague (2002), then Amsterdam and Jesi (both 2004). I adored the shows but didn't want to get in touch. It took John's death for me to email Sleazy, a welcome reconnection which was cemented when I was able to meet him and we hugged after a SoiSong show in Amsterdam in 2008. Two years later, he passed, leaving me with nothing but fond memories of him and of John.

'People should be only concerned
with about ten people in their
immediate vicinity.'

Interview Late Afternoon

ANTHONY BLOKDIJK: I remember the first time that I did an interview, Steve was sort of a part-time member, are you a full-time member now?

STEPHEN THROWER: I am now, yeah. Fully integrated.

AB: Now there's three of you?

JOHN BALANCE: A trio.

ST: A rock 'n' roll trio!

JB: A power trio!

AB: And on *Horse Rotorvator*, there are some other people working on it as well. Marc Almond is singing again. On one of the last tracks on Side B, a Leonard Cohen song, he is singing for you.

JB: A little help from Marc Almond.

AB: It's difficult with these interviews, I know too much about Coil is the problem.

ST: Just make up all the boring stuff from what you know.

AB: It's what you have to do! (Laughs)

ST: Yeah, but we have to make up all the intelligent stuff as well.

JB: Difficult.

ST: There's nothing intelligent to say about music anyway.

AB: Who's on the album?

JB: We are. (Laughs)

ST: Oh dear. Jim Thirlwell.

JB: Foetus on your duvet.

ST: That's it isn't it?

AB: Some Mexican kid as well...

JB: Oh yeah, Alan Babylero, a 12-year-old beach bum from Acapulco. He's only 12, a young one, a young 'un. We exploited him, ripped him off, didn't give him a penny — yes we did, we gave him about four quid.[1]

AB: Is that his voice at the end of 'The Anal Staircase'? No, that's your voice... But before that there was someone else.

JB: The tape on 'The Anal Staircase' is this found source tape we got from America, this kid and his dad. It sounds like other things you see? It sounds like whatever your filthy mind wants it to sound like. He's enjoying it, whatever it is, it's not pain. That's it really, that's all we can say about the *Horse Rotorvator*.[2]

AB: What's this thing with horses then?

ST: *Ennui* has set in I'm afraid...

JB: What's that? Tiredness of the soul or something?

1 'Babylero' is a one-minute interlude on *Horse Rotorvator* which rips lines from 'Maria Isabel' by the Spanish group Los Payos.

2 In a letter dated 28th April 1987, Balance elaborates rather intriguingly: '"Rotor" is the motion of wheels, cogs, the mechanics of time, cyclic events, history repeating itself, the spiral, seasons, re-emergence, history, the return of the evil past, crop rotation, religions, ecstasies, etc. All circular wheels in motion, perpetual motion... The horse symbolises the dark night of the soul, the all-powerful, fundamental, unbridled nature. Sensual and forceful, the powerful unconscious depths. The all-devouring mother. Magna Mater, maybe seen as Fenrir, the all-devouring wolf in Norse mythology. The "horse power" as D.H. Lawrence wrote "splintering hooves that kick down the walls of the world."' As a sidebar, 'the return of the evil past' was a phrase Balance became enamoured of. He used it in an interview for a French LP compilation, *Stator*, again in a private letter dated 9th January 1986 to Tom Vague, and finally in unused lyrics entitled 'Gilded Sickness' in the *Gold Is The Metal* boxset.

ST: Yes, it's French for boredom.

JB: It's not boredom with the music, it's boredom with the fact of having to get it out. Don't start me off on that, I'll be worse.

ST: What was the question? About a horse.

JB: I hate horses actually, I despise the things.

ST: I like horses.

JB: They don't frighten me, they irritate me. I hate horsey things and horsey people...

ST: Oh horsey people are dreadful!

JB: ...In England. In Holland you don't really get horses do you? There's these horrible girls who go to gymkhanas — the word 'gymkhana' makes me quite ill. Do you know what a gymkhana is? It's a sort of event where teenage girls go to ride their horses, which mummy and daddy bought them... A sort of amateur horse trial. It's a very 'English' thing and it's very dreadful.

ST: Horses are alright.

JB: Steve likes them because they've got big dicks. The Horse Rotorvator is a sort of semi-apocalyptic thing where the Four Horsemen Of The Apocalypse kill their horses and make a machine to plough the Earth up out of their jawbones. So despite the fact that I dislike horses, it suddenly became relevant to me.

ST: It's like a personalised vision of the Apocalypse because it takes the traditional or mythological view of the Apocalypse and twists it through one of his dreams.

JB: I like the idea of the betrayal in it, the deceit, because everyone expects them to ride down from Heaven but they don't — they take the bus.

ST: They hitch-hike.

JB: They come on a tandem.

AB: I find it strange, getting back to the Apocalypse...

JB: You have to get back to it because it's coming! I really think it is. We're not particularly morbid about it, or gothic, anymore but we still use it because it's happening.

AB: The old Throbbing Gristle days were quite apocalyptic, after that Psychic TV started with a very optimistic view, now there's Coil...

ST: Many of the songs on the album are connected or are directly about death, but they're not particularly pessimistic about the idea. It's not viewed throughout the album as a bad thing, most of the songs are eulogies to death more than anything else, celebrations of aspects of death.

JB: Explorations.

AB: Sounds a bit like the last days of Rome as well.

JB: We've got a very good parallel between nowadays and the last days of Rome.

AB: That's from the situation in London at the moment?

ST: The situation in the world I think.

JB: The situation in the world, spreading. New York: the epicentre, the black heart. This was a double album and the second album which is now going to be released separately is called *The Dark Age Of Love*, which takes the aspect that sex now equates with death more closely than it has ever done, partly through AIDS but partly through the terminal quality of life. We've reached the nadir or the pinnacle of experiences and people are just going to go over the edge. It's a very nihilistic

lifestyle, even though people try to coat it with this luxury. We're more aware of the barbarism within us all than we ever have been really. It is the end-time, people are aware of it. With nuclear war and everything hanging over us, people think of final things all the time whereas before they had a future. We've got what we've got now and — I'm not saying there's 'no future' like a punk statement — but we're on the edge of something and we've either got to create, very actively and hard, we've got to create a new direction or we just ride out the crest of this final wave.[3]

AB: Is that what you do?

JB: I personally like to do that, yeah. Because I've got ulterior motives, you see? Magickal ulterior motives. I think you have to bring it down, bring down the old order — destructively — otherwise it remains and hangs around.

AB: Do you think there's anything after the destruction of the old order?

JB: There always has been before.

AB: And is there any way of avoiding threats like nuclear...

JB: I'm not sure you should avoid all these threats, I like to embrace them. Say fuck it! Let them nuke it. Nuclear war now.

AB: That's what I mean by 'is there anything after the old order,' because that's the end of the old order.

JB: To make it an old order you're assuming there will be something new.

ST: I think it's uninteresting, in a social sense, to think about it in that sort of framework: who cares? I guess there'll

3 In the interview accompanying the *Stator* LP compilation, Balance also stated: 'Our third album may be called *The Tortures Of The Pope In Exile...*'

always be people and I guess they'll always be nauseating. In a more personal sense I think it's more to do with your own subjectivity, coping with it, that's the interesting thing. Not 'what are people going to be like after the bomb?' that's a really dull idea, I don't really care.

JB: If you look at BBC documentaries about the survivors or whatever, they're going to be incredibly boring BBC actors with bad make-up, wandering around making cheese. (Much sniggering) That's not the life I want, I'd rather die with it all.

ST: That is a political concern that one, because politics is...

JB: It's people politics though.

ST: Yeah, but politics is an arrogance I think because it's sort of concerned with larger units. The arrangement and shaping of large numbers of people which I find totally heinous.

JB: People should be only concerned with about ten people in their immediate vicinity.

ST: Anything else is an arrogance.

JB: Otherwise you dilute it. You're either being arrogant or idealistically stupid, that you can bother to influence... Then again people amaze me in how much they want to be influenced by people they don't even know. Maybe everybody should die in the next cataclysm, for their own good... But apart from that we're quite cheerful really! Apart from wishing the death of the human race! As quickly as possible. Let's get the album out first.

ST: Doesn't look like we will. It could be released after the apocalypse.

JB: 'If it's not too late, buy this...'

ST: We'll have to release it on CD so it doesn't distort through radiation.

JB: It might melt though?

AB: Is there something else behind the LP besides the influence of the apocalypse?

JB: I can't really tell. What did you think it was like compared to *Scatology*? Was it very different or not?

AB: *Scatology* was more serious. This reminded me a lot of other situations I remember from outside music, like soundtracks... A track like 'Ubu Noir' would fit much more on this album than the other one. Though the other one is probably more diverse.

JB: This one's more together isn't it? It does link, all the songs link in some way.

ST: There's a continuation in sound between the tracks as well. Not just in theme but in actual musical style...

JB: We realised we had to make it more one thing. Like I said, there's a second album, *The Dark Age Of Love*. There's tracks on there, which are about — thematically — a lot of things we didn't manage to explore on this because of the material overlap. The other album links very heavily with the death of European monarchies... And it's absurdist, in the sense of absurdist theatre: it's very serious, but you can't be serious to the point of being po-faced. You have to put humour in because it's the only way people will take it, it's the only way you can manage to deal with it. Plus I think it's funny.

AB: That's very personal as well, because you use — on this album — it's very black humour...

JB: I'd like it to get even blacker. Pure black. But I don't think there's many other forms of humour which I appreciate... Slapstick...

ST: Slapstick's a difficult form of humour to pull off as well.

(John goes to answer a door bell)

ST: Any particular songs that you recall liking more than any of the others?

AB: 'The Anal Staircase' is terrific.

ST: And anything that you thought was...

AB: Two tracks I didn't like very much: the last one on Side A is quite long and doesn't have any vocals. And not the last one, but the one before it on Side B.

ST: The narration.

AB: The angels of death or something...

ST: (Addresses John re-entering the room) Those are the tracks he doesn't like, 'Penetralia' and 'The Golden Section'.

AB: It's like a parody of 'Message From The Temple'.[4]

JB: A parody? (Laughter)

ST: That's rather good actually. I remember, when it was being done, I think all of us were worried that it might remind people too much of that track.

JB: And the man reading it is a man from TV, Paul Vaughan, who narrates serious documentaries. So it's very tongue-in-cheek to use him to read something like that. We did think 'this does sound quite a lot like "Message From The Temple"...'

ST: I don't think we were intending to take the piss. Though the idea of doing that is actually a very good one. You've given us an idea for another track.

4 From Psychic TV's *Force The Hand Of Chance*.

JB: Mr. Sebastian asked us if we wanted to use him again on any records.[5] We said it's too close to that sort of thing, so we'll use somebody else doing the same. It's not a joke but it's probably more of an indulgence, the idea of it, but I like the music and everything in the background.

AB: The first track on Side B also reminded me of Marc Almond.

ST: 'Circles Of Mania'? One of the musical decisions, or aims, was to create something rather more elegant and coloured than what one has become used to in independent and alternative music. So much of it sounds as black and white as their cheap album covers. The music fits those horrible photocopied covers, the whole fanzine milieu of cheap looking and cheap sounding music. Part of the aim was to create something very elegant, and very opulent, and expensive sounding in a way.

JB: Then again, it was cheaper than *Scatology* to make...

ST: Billy Bragg was in at the same time and he probably spent more on one song than we did on the whole album.

JB: He spent over sixty thousand pounds doing his socialist agitprop-type music. He spent all that time we were in the studio doing the album, doing overdubs on one track.[6]

ST: While we mixed our whole album and yet we are far more likely to be called self-indulgent than Billy Bragg, which just goes to show how ridiculous the left wing is.

AB: Have you done any interviews for *Horse Rotorvator*?

5 Alan Oversby (aka Mr. Sebastian) was a major figure in the early development of body piercing in the UK. He featured on Psychic TV's first album and was arrested in the 1987 Operation Spanner raids on individuals involved in consensual homosexual BDSM.

6 Livingston Studios, London, during Bragg's sessions for *Talking With The Taxman About Poetry*. Coil used the studio for part of *Horse Rotorvator*.

JB: No major ones yet really.

ST: Because no one has had copies of the album yet.

AB: Do you know if people are expecting anything from it? I know in Holland they do.

JB: I don't care what they expect, they get what we're going to give 'em. (Laughs) I expected things from it and I'm more pleased with it than I thought I would be — I think.

ST: It's quite a long time since most of those songs were finished and a hell of a long time since they actually originated and yet I still listen to them and still enjoy them. But then that's always the case because I always get far more enjoyment listening to things I've done than from listening to other people's music. You hear artists who can't listen to their work after they've finished, I can't understand it, I always listen to my old stuff. I've got six years of old recordings and I love listening to them.

JB: People have said to us it sounds like the Butthole Surfers' *Rembrandt Pussyhorse*, the actual title. I thought of ours before I knew that was coming out, that's how old some of the stuff is on it. Because of Some Bizzare not being able to give us money, just the relatively tiny amount of eight thousand pounds, to finish the album we couldn't do it until now. We've got half of the other album done — tracks like 'Aqua Regalia' and 'Paradisiac' — stuff that'll probably not be used on that album, we'll do new stuff.

AB: When are you planning to release that?

JB: Easter next year, hopefully.

ST: Even as we speak it looks like the current album is being delayed past Christmas, so that means there'll be two albums coming out at one time, fairly close together.

AB: It probably also depends on how much the next album is going to sell...

ST: Well, no doubt the third one will come out no matter how much the second one sells, it's just a matter of how much you can spend on recording it. But it will be released regardless.

JB: It should sell.

ST: The problem with promotion, the whole thing is usually thought of as helping the sales of a record. Probably, I think all of us are starting to find the whole promotion circle ridiculous, rather silly and difficult to deal with.

JB: I've always felt like that. It gets tedious. I mean I actually like talking to people I like about the things but having to set up interviews with people who aren't really interested and persuading them that they are interested. Being Coil, today, you have to put your John Balance head on and be him and you think, 'god almighty, I did this eight months ago and I'm fed up of talking about it. Thinking about it let alone talking about it!' And it's not that I don't like the stuff we've done.

ST: My enthusiasm for the music is sort of as high as it's ever been, if not higher, but the whole circus of music biz promotion and garnering interest — even though we do very little compared to a lot of people — it's tedious.

JB: You shy away from it anyway!

AB: I have no idea how the English press reacts anyway.

JB: They're very good with us, or they were before. They were very good, we're quite good friends with people who count — I've slept with most of them! No, but if you have it helps. But I haven't.

ST: We're working on a movie soundtrack at the moment and personally I find that a huge relief because the only thing you're

worried about is the music and the direct opinion of the people you're doing it for. You don't have to do interviews, nobody wants to do an interview with the person who's done a film soundtrack...

JB: We've done interviews already for the soundtrack!

ST: I know, but only because we're a band already. Only because the people that buy the records, because we're a rock band and involved in the rock world, want to know about us. If we solely or only recorded soundtrack albums then we'd never have to get involved in all that silly question and answer business. I'm sorry but talking about what you do, it's not as if it's not sufficiently intelligent to find anything to say about, there's plenty of things to say about it, but the act of discussing it with someone from a music paper then reading the way in which its treated constantly. What is it that Derek says? 'Popular music trapped in perpetual adolescence.'

JB: I wish I was!

ST: I wouldn't mind being trapped in a perpetual adolescent! You think it's good fun to do an interview for a while, but I gave up on the music press a long time ago.

JB: I read *Sounds* and felt quite ill. But I have to read them because they might mention us somewhere.

ST: I've dropped out of youth music so much now that when I read youth newspapers there's a constant stream of interviews with new bands I don't know, I've never heard of them, and they sound dreadful. And they're going 'hey, the new discovery!'

JB: The new thing of a thing I've never even heard of either.

ST: I'm so far behind all that now, so far away from it, that even the people that they're compared to are people that I've

never heard either. The Mighty Lemon Drops! They appear to be well liked in the music press but I haven't the faintest idea what they sound like and I don't want to hear them either because there's nothing interesting about the vibe you get.

JB: All I know is that we almost used the drummer out of Stump on one of our tracks but decided against it for some reason.

ST: It's always there though. I went through eighteen months where I didn't read a music paper at all because I never buy them and I didn't know anyone that did either. Then just recently I've started reading them again and it's like I've moved but they haven't, it's still happening the same old way but I've become more cynical to it — not in a bad way but in a sensible way. I've become more adult about it, I'm no longer an eighteen-year-old who rushes down to the shop to buy his copy of NME to find out what's happening in the music business because, frankly, it doesn't matter.

AB: It's even happening with Coil. When I go to Amsterdam — I'm not living in Amsterdam luckily — and I meet people who have written to John, for instance, they try to impress me with the fact that they know you have a dog named Khaos. And I'm like 'I know Khaos because the last time I was here he tried to fuck me while I was asleep.'

ST: What can you say in those situations? Especially when you're actually doing the music yourself...

JB: I can't believe that people are ever going to talk about our dog.

AB: It's unbelievable. They know every detail about Coil and even Current 93 records.

JB: It's unbelievable in a genuine sense of the word. They know more about us than I do.

ST: That's why it's so difficult to talk about what you do because you know you're entering into a silly relationship...

JB: But some people do know, there are a few people that keep you going, you do it because you know a few people will genuinely get it for the right reasons. My mum isn't one of them.

ST: I'm not sure what the right reasons are.

JB: They change from day to day anyway. But you have to assume them, you can't just be this nebulous mass of cynicism... Like Mark E. Smith.

ST: I think he's got the right way of approaching it because he totally cuts himself off from the audience altogether. Somebody like Mark Smith has made his audience frightened of emulating him.

JB: Who would want to emulate Mark E. Smith?

ST: They're frightened to do so anyway, or even to approach him...

JB: ...All running around looking for blonde American girlfriends now...

Cassette Side B

ANTHONY BLOKDIJK: Would you make music just to make some money out of it?

JOHN BALANCE: No... Well, I'm thinking about it... No.

STEPHEN THROWER: It depends what you would do with the money. Whenever I get money I always put it back into recording anyway.

JB: We're doing a live album, *Live At Bar Maldoror*, and that will basically be expensive to buy and it's being done to make

money.[7] But it's not going to make such a huge amount of money that we're going to dilute what we do. We'll do exactly what we want to and then charge a lot of money for it.

ST: I work with Possession as well, my band. So far all the money I've made from other projects like Coil and little bits of acting that I've done here and there whilst I've been down in London, has just been ploughed back into recording with them because the rest of Possession have no money at all so I pay for all that.

JB: That's how you get to be the leader. (Laughter)

ST: So, sure, I'd love to do something to make lots and lots of money but I'd only end up spending it on doing more records anyway so I'm sure I can be justified in that, if I need to be justified.

AB: I'm worrying in Holland about my being on the dole for about a year and they're complaining that I don't want to get a job — they make me write letters all the time and I refuse to write letters. They're having a conversation with me once a month.

JB: I got thrown off the dole in England, it's really hard to get done but I did, I got thrown off it. They offered me a job in a dole office — which is their usual ploy — it frightens you to death. So I didn't want to do that, so they cut me off completely.

ST: I used to work in a dole office.

JB: Yeah? See? You got offered it and you took it.

ST: No, I didn't get offered it, I mean I did it soon after I left school — voluntarily. Actually it's quite amazing, when I did the interview to get into this civil service job, this sort

7 While Current 93 released an LP called *Bar Maldoror* in 1985 and Nurse With Wound issued *Live At Bar Maldoror* (featuring John Balance) in 1991, Coil never released their own entry.

of government post, I did the interview and the reason I got the job was because one of the things that got me the job was defending Peter Sutcliffe. Because it was the time when Peter Sutcliffe — the Yorkshire Ripper, a mass murderer in England — he'd just been caught and during the interview they said to me, 'what particular news item over the last few weeks has caught your interest and for what reason?' They wanted to know how I could express myself on any particular subject and if I was aware of what's going on in the world. So I started going on about how all these people were baying for Peter Sutcliffe's blood outside the courts and how they were just as bad as he was, except that nobody was saying so, because there they were vowing to kill him if they could get their hands on him. I said it just shows there's psychopaths everywhere and they're going scot-free while that poor guy is locked up for it just for being more demonstrative. (Laughter)

JB: Having the courage of his convictions!

ST: I got the job, Jesus... Two-and-a-half years...

JB: You Sutcliffe's brother or something?

AB: How's Mother England looking toward Coil because of its homosexual background... ?

JB: I don't know. Probably half of them don't know.

ST: Coil have been silent as a commercial entity for quite a long time now so I don't know our audience, I suspect that because it's two years since *Scatology* came out...

JB: They've all gone hyperdelic!

ST: They're all sort of having *Scatology* as just a white spine in their record collection until the next thing comes out, so god knows what they expect of us. We've probably been filed away in

their minds because we haven't really released enough stuff for them to be hanging on desperately waiting for something else...

JB: A dribble, we've released a dribble of records for them...

ST: Speaking of dribbles...

AB: So you're not getting a problem?

(Thrower exits the room presumably for a toilet break)

JB: Maybe if we went on tour or something we might get beaten up and things. But Bronski Beat, they're raving homosexuals — half the bloody charts are if you know people in the music business!

AB: And you're not hiding it or anything...

JB: No, we don't hide it, but neither does Freddie Mercury or Elton John — even though he's married — and all those people.

AB: My sister wouldn't recognise Freddie Mercury as homosexual, or Elton John.

JB: Yeah, but part of their songs and their repertoire, if you are gay then you know that they are. Like, basically, I argue with my mum, she still doesn't believe Freddie Mercury is gay. I can't believe it, how anyone can see he comes out and says, 'here's Queen, for all you queens,' and his stupid in-jokes, and nobody knows. It goes over their heads. But either we're brave enough or we make the mistake of dealing with things like AIDS head on and for that we probably will get more flak, or more reaction, but I'm prepared to put up with that sort of thing.

(Stephen re-enters)

ST: What's that?

JB: Dealing with AIDS and things, the sort of difference between us as a 'gay band' and Queen — or Freddie Mercury specifically because the others aren't — and how he can get away with being gay, or Elton John, and people will argue in his defence that he's not.

ST: People don't want to believe who he is basically.

JB: You just get shoved in as 'pop personality', 'theatrical', but we're not like that anyway. Although Steve's been trying to make me: 'Dress up as Freddie Mercury!'

ST: I think that's what we need, a good frontman.

JB: A charismatic frontman. We got one really good hate-mail letter, a really good one, a very vicious one. But a lot of people, and obviously these are the people who count, we get letters from people in America who have got AIDS saying how much it helped them. They can't stand people not being direct about it. You can't treat people like that. I don't treat death in any way preciously.

ST: Once death becomes a part of your personal reality, as it does to people who have got AIDS, then it must be very irritating for people to be circumspect about it. It becomes part of their day-to-day experience and for people to be so nervous about talking about it is ridiculous.

JB: It's just wasting time for them as well. We've had letters from people associated with John Giorno in America — AIDS Foundation people — who've had really good reactions. They've actually shown groups of people with AIDS, counselling groups, our video for 'Tainted Love' and said that it had a really good reaction. I'm not sure what we actually intended to do but we get a good response back, we transcend it somehow. I don't know, you can't really explain... I can't

interpret people's reactions, who've got AIDS, to it. But there's been quite a good favourable response back to us, I mean they actually make the effort to write, that says something.

AB: Have you actually reached a new audience with it?

JB: I think so because the video got shown in clubs throughout America. A club distribution network bought the video. It was on cable TV which had a potential audience of thirty million — maybe two million watched but it had a potential audience of thirty million. And it's in the Metropolitan Museum Of Modern Art in New York actually, as an exhibit, so it's next to Max Ernst's pictures and things. Which I think is great! So they must have seen it somehow, it obviously got around.

AB: Is it the only country where it's been shown? America?

JB: I'm not sure, I really don't know this. I don't think it got shown. We never distributed it across Europe or in England so I think it was just America. It was made on money mostly coming from Stevo's TV programme, financed from America for America, you see? It was shown in Italy in clubs and things but not widespread at all. It's available, well, it's not available is the trouble. But if anyone wanted to distribute it we could make copies available.

AB: I can try to, then it'd be shown on Dutch television.

JB: There's nothing terribly offensive in it, mainly it's the directness of it.

AB: I think the point is money, you'll still see returns from it.

JB: In theory, but we haven't been paid the royalties on it yet. It's still coming, the money is still coming. You always have to wait usually a year or so. We've still got to be paid the money and when it does it'll go to Terrence Higgins. In America, John Giorno's recently organised things, he wanted to put

all the royalties from his label to go to AIDS and we said yes for 'Neither His Nor Yours', that track's going to go to AIDS research in New York.[8]

AB: I think on Dutch television people are working on some programmes about AIDS.

JB: I get sick of watching them, I really do actually.

ST: There are a lot of TV programmes about AIDS. We're going through the second AIDS boom in this country at the moment. There was the first 'shock horror' boom and now AIDS has gone heterosexual...

JB: ...They're concerned. It's ridiculous. Two years later about ten heterosexuals have got it and, of course, the government are acting immediately with fifty million pounds or whatever. And really stupid prudish things, Victorian things, like 'yes, we're considering that you can advertise Durex on television.'

ST: Apparently they reckon that in America, where they're about five years ahead of us on the AIDS scale, one of the lowest risk groups in America at the moment is the homosexual community because they've got better education now.

JB: West coast. West coast is completely different to New York. LA was quite good.

ST: Straight people are at the biggest risk now because they haven't lived with five years of gradually escalating fear of it. Homosexuals stand watch and it might actually become inverted. If there is a massive AIDS apocalypse then the people that survive will be the well-educated homosexuals. (Laughter) Doesn't bode well for the future of the race I suppose.

8 'Neither His Nor Yours', recorded 5th May 1985, appeared later that year on Giorno Poetry Systems' *A Diamond Hidden In The Mouth Of A Corpse* with proceeds going to AIDS research.

JB: No it doesn't. Marys overwhelming the land...Another vodka? Want some, Steve?

(Sound of door opening as, presumably, John goes to find the vodka)

ST: The name of the film is *Hellraiser*, directed by a man called Clive Barker who's famous mostly for a six-volume set of short stories called *The Books Of Blood* which he wrote, and a novel called *The Damnation Game*. He's principally a writer but he decided to direct one of his own stories because two film adaptations of his stories had already been made which hadn't really worked and he decided that, because he had experience working in theatre as well, he decided that it would be a good idea to direct the film of *Hellraiser* himself. I met Clive through working at a shop in London that specialises in film-related merchandise and found out that he was a big fan of *The Angelic Conversation* and when I mentioned that I'd been involved in the soundtrack he said he was very enthusiastic about the music and really liked it. I played him a few tapes of other things and he asked us to do the music for *Hellraiser*. Unfortunately it's being financed by New World which is an American film company...

AB: They did *The Boys Next Door*.

ST: That's right. It used to be Roger Corman's company, in the 60s and the mid-70s he was the head of it. They liked the Coil stuff as well which is quite surprising, the idea of an American film company boss liking Coil is quite odd but they were very enthusiastic.

AB: What did you let them hear?

ST: We made a cassette of a few tracks from *Scatology*, 'At The Heart Of It All', bits of the *Angelic Conversation* soundtrack...

Not structured songs like 'Panic' or 'Godhead=Deathead', which obviously aren't very good for film music, but the more ambient sort of things that have got better application for film. We made a tape of various bits and pieces of those. (John re-enters the room, the tinkle of glasses) Originally the film was going to be financed by Virgin, half by Virgin and half by New World, but fortunately Virgin pulled out.

JB: They've pulled out of films altogether.

ST: For a while, New World wanted us, Virgin wanted a Virgin band, and Virgin in particular were pressing for XTC, who they were apparently trying desperately to relaunch after a period of inactivity. Both Clive and New World were very against that and wanted us and when Virgin pulled out it was quite good for all concerned because I think XTC would have been a very bad move for a movie soundtrack. I think it's obvious from listening to our music that it does have quite blatant movie potential. There are moments when it's quite apparent that the sounds would be very effective when married to film. Plus all three of us — particularly with Sleazy working in video — have got a particular interest in film anyway. It's a far more mature medium as well. It does have its fair share of comic book intellects — Steven Spielberg and people... But, in general, there are more artistic heavyweights working in film than there are in popular music. I'd be hard pressed to name more than three or four people working in youth music who I could honestly claim to be anywhere near approaching a genius.

JB: It's a more visionary medium isn't it?

ST: It demands much more from people as well. Film's much more of a total experience.

AB: You're also working on a ritual soundtrack like 'How To Destroy Angels'?

JB: We haven't done it yet but there will be another follow-up to 'How To Destroy Angels'.

ST: 'How To Destroy Angels 2: The Other Side'.

JB: 'How To Destroy The Other Angels.' No, it's called 'The Gate'... I think. And it's about Cthulhu mythos, we love the classic Cthulhu mythos and how it's magically quite correct and relevant at this point in time.

ST: How do the lyrics go now? 'Niggur shoggoth n gai...' The beast with a thousand young...[9]

JB: I've done a song called 'Radio Cthulhu' but never even showed it to anybody.

ST: In fact, it's such an obscure track that even I don't know about it! True actually, I didn't know that...

JB: Yeah, I've got the lyrics upstairs. Kenneth Grant and everybody, all that lot, you have to be an inner member of the OTO before you get the genuine information but me and Tibet and people like that believe we've got it anyway. We don't need to bother with them.[10]

ST: What's that? Is there a serious connection between the Cthulhu stuff and...?

JB: Oh yes, that's what the main aim of the OTO now is, space marking, making an astral gateway in space for the Great Elder Ones to come through. (Giggles)

ST: Oh, wonderful.

JB: Seriously. It's quite serious. Very serious. Dangerously serious. Sirius.

9 Derived from Lovecraft's chants honouring Shub-Niggurath: The Black Goat Of The Woods With A Thousand Young.

10 Kenneth Grant was an influential author of occult books and founded the Typhonian Ordo Templi Orientis.

ST: Is that a clue? The positioning of the gateway?

JB: That's why in the scratching on our record it says 'you cannot be Sirius.' Didn't you know that?

ST: No, I didn't know that.

JB: As in 'Dogstar, oh oh oh...' I don't know what order these things are coming out in. Or what form they will take. Or if they will even come out in this dimension... We're supposed to be doing a 10" single with someone in Holland. I'll play that track to you later on, 'For Us They Will'.[11]

ST: Is that still around? Have you got a tape of that now?

JB: It's on Betamax. It's one of my favourite tracks.

AB: Have you ever had contact with people like Kenneth Grant?

JB: Not direct — Tibet has — but, at the risk of sounding, what's the word? Not irreligious but... They're old fogies, they're old men. Although they may be very well-meaning old men they're making themselves redundant by being so insular. You can hardly even get hold of them. So pompous, just like the Freemasons! There are, obviously, people who are interesting in that circle of people — so what? I really do believe that most people... Or a very few people — most of them I think are my friends — are actually far more in tune with what is serious and what is important in that area than they themselves are now. Talk about 'bringing in the new Aeon' or whatever, they should go out with the old one! They're all tied up with Crowley so much that they feel that they're sort of ambassadors or press officers for Crowley — and he's dead! He'd probably think they were pompous old fools and kick them out his front door.

11 Balance is parodying Psychic TV's 'Godstar'. 'For Us They Will' emerged on *Gold Is The Metal (With The Broadest Shoulders)*.

ST: Not particularly generous to his followers was he?

JB: No, he would never suffer a fool gladly either. Not that they're fools but they're stuck in their ways so much, they're like Great British institutions: secret societies, such an old English tradition. Not that I'm being particularly disrespectful because I'm sure they'd admit it themselves. But in that way it could be a defence because they get on with their job, whatever they find important they're actually doing and this may be a good smokescreen, a cover. I respect that, that's why I leave them alone, let them get on with it.

AB: You experienced something similar with the Temple Ov Psychick Youth, Psychic TV...

JB: Well I didn't feel they were doing anything particularly important magickally. They were dabbling. Once Tibet had left I refused. I didn't want to give them my information in the end — and Tibet certainly didn't — because they didn't use it properly, they just did it sensationally. Magick people get on with what they want to do, what they have to do, regardless of whatever. No way do you go broadcasting it in your public bulletins. You keep it. You go to the greatest lengths possible to keep it a secret, because only that way can you keep it pure.

ST: The current position of Genesis P-Orridge is as a media entertainer, which says quite a lot about his earlier intentions.

JB: One of Gen's quotes is 'I wouldn't mind being thought of like Elton John or Liberace.' Anyone who can say that and really mean it is well fucked. He means it!

AB: The only thing I like about Psychic TV still is that he's openly confessed to what kind of sexual pervert he is but he's reaching channels like Sky. I think that's quite important.

JB: He's introducing colour into people's lives.

ST: He's no more important than Alice Cooper.

JB: Alice Cooper is more important! No, really, he is. It's the same mentality.

ST: I don't think you can use that word about anything that goes on in the pop music circuit. I don't mind. I don't criticise Gen for what he's doing, I can understand after fifteen or so years toiling away in the avant garde circuit he must be heartily sick of it.

JB: He must want some brightness in his life, I can quite agree.

ST: All well and good, but certainly there's nothing important about it.

JB: It's like having a birthday party, lots of blancmanges and jellies and whoopee cushions.

ST: Good luck to him, I don't have any particular criticism of it.

JB: So long as he's got enough money, keeps him off my back.

ST: Perhaps those phone calls will eventually stop when he makes enough money.

JB: Trouble is he owes us about six thousand pounds.

ST: I wish somebody owed me six thousand pounds, I'd have my hands round their throat at this very second! That's one of my favourite quotes, I can't remember who said it but some American murderer that had just gone and shot loads of people in a shopping mall, said: 'I wish the whole world had one throat and I had my hands around it.' Such a brilliant line, worthy of Oscar Wilde.[12]

12 Serial killer Charles 'Carl' Panzram, prior to his execution in 1930, rejected interventions by opponents of the death penalty, telling them either 'I wish you all had one neck and that I had my hands on it,' or 'I wish the whole world had one neck and I had my hands around it.'

JB: You got any other questions?

AB: Maybe tomorrow. You could put it off if you want to.

ST: Have we already done one side?

JB: It's nearly finished actually.

(Someone burps divinely)

JB: That says it all. (Laughs)

Following Morning

PETER CHRISTOPHERSON: Didn't you do one last night or yesterday?

JB: Shut up, you weren't here Sleazy!

PC: I was hoping you'd finish it.

AB: What's the connection between Coil and the IRA?

JB: Ah well, my dad, he's in the RAF... Actually, we once stayed in a house in Northern Ireland, in Downpatrick, and it was blown up the week after I was there by the IRA. That's the connection.

AB: There was something with the cover as well.

JB: Oh! And there's another one there. Sleazy?

PC: Our album cover was designed by somebody that's in the IRA.

JB: No it was not!

PC: It shows a picture of something that was once blown up by the IRA.

JB: And they blew up the horses in Horse Guards Parade in... Regent's Park?

PC: Hyde Park.

JB: Yeah, they blew up the horses, and in our minds there's a link between that and the Horse Rotorvator. The first manifestation of the coming of the Horse Rotorvator, the act of blowing up the horses, not that we advocate blowing up horses. It's just a surrealist image for us we've taken and used for ourselves. It's that the cover... it looks like you can see many things happening in it, even though you can't see them. It's like you've seen the shadows of past actions. It's a very laden image. Sort of like the ghosts of those who have died in the past, but it's the ghost of the violence. It echoes.

AB: You mentioned something surrealist, you could say Coil has become far more surrealist — it has more theory in it.

JB: We don't set out and think 'these are our theories,' we borrow the things we like and obviously we stick to our beliefs.

AB: I think *Horse Rotorvator* is far less obvious than the first one.

JB: Yes, deliberately, apart from the small bit of writing on the front to explain slightly what the Horse Rotorvator is, there's nothing like all the sleeve-notes and things. We wanted to do almost the opposite. We're not having a lyric-sheet so people will have to work it out themselves. Whereas before we gave them quite a lot of information, it's good to give them even less and hope they can work at it. Having given them something to go on from the last album.

AB: Did you decide to be more vague because of bad experiences?

JB: Vague? Not really, I just find it boring for me to have to explain everything in detail, though I'm quite prepared to do that when we talk about things. People should work at it, I thought perhaps one of the things on *Scatology*, which we now think might have been a bit easy for people, is that we gave them too much information. People like to not know things,

I guess it allows symbols to have more meanings whereas we perhaps tied things down before. The sleeve-notes were partly to complete a tangent to what was actually on the record — it just pointed out in all directions. This time we're leaving people floating in the black humour of it all.

AB: I think, on the first album, you've got to tell people or else they'll have never heard of Alfred Jarry. You didn't put quotes from Burroughs or Crowley on there.

JB: We did. (Laughter)

PC: They should have been so obvious that they were not necessary to mention.

JB: We did it on purpose, we mentioned Crowley, Burroughs, Manson... In fact, Jim Jones we didn't, but we deliberately pissed around with people's expectations, partly went toward what people thought we would do — but we were taking the piss. People might never even realise it, but we did.

PC: For our own sake, you know?

JB: But there were good reasons for every one of them.

AB: Did you think that putting out a 12" of 'The Anal Staircase' would scare off loads of people?

JB: I don't think so, it should do the opposite. It got played last night in that club I went to. People felt a sort of nervousness in the air, it quite grabbed them. I thought it was good, a really good reaction I thought. People were almost dancing, 'what the fuck's this? It's a little bit weird...' Because it's very jittery, the whole thing sort of moves and waves in not a normal way.

PC: I don't think there's anything very scary about it, is there? Apart from the title.

CC

JB: It's like a rollercoaster, quite a slow rollercoaster, it exhilarates.

AB: How are the lyrics then? For me it's quite difficult to hear them.

JB: It's just about pleasure...

PC: Extremes of pleasure isn't it?

JB: Yeah, it's rollercoastering, you know what I mean? Helter-skelter. There's a lot of pleasure in how you always end up at the bottom. 'Measure the extent of a dizzying descent, down the anal staircase.' The anal staircase is backward kundalini, kundalini in reverse, the 'anal staircase' being the spine, a ladder upwards, there being a tantric thing about kundalini. And the 11th degree of the OTO is anal sex, the reversal of everything. It's just throwing those images around, ups and downs of pleasure, magick reversals, tunnels, that's what the anal staircase is — inside the body. The opposite of being about buggery or anything, it's the last thing that came into my mind. I think it'll attract people, it's quite a catchy sort of song.

PC: The other songs are more, sort of, thoughtful aren't they? Maybe they're more frightening as a result, but there's more information perhaps than in the other ones.

JB: There's a lot of information in all of them, there always is. 'The Anal Staircase' is probably one of the more direct ones, it grabs you more. A chance to meet me half way in some respect.

AB: What were you trying to do with 'Ostia', the basis of the song you recorded in Mexico? To me, it reminded me of postcards you get, probably like a remembrance, you recorded that song to remember a holiday in Mexico.

PC: Although portions of it were recorded in Mexico, the actual song is about something that happened in Italy. But they're the same kind of place in a way.

JB: It's about the death of Pasolini, the film director. And it's about a friend of ours called Wayne, who jumped over the white cliffs of Dover. He was a heroin addict and killed himself by jumping over the cliffs of Dover. That's all mixed in. It's about ritual deaths, like the Grail myth, how the king must die in water like in... *The Tempest* is it...? The king dies underwater. We've got a track called 'Aqua Regalia' which is about the same, you've got this drowning baby Nero, it's about the death of kings, drowning in water. Bad King John lost all the jewels in The Wash, did you know that? One of the old English kings he escaped with all the crown jewels, the original Saxon crown jewels, in Lincolnshire up in the beginning of northern England. There's a huge great marsh, a big estuary, which you can sometimes cross — it's full of quicksand and things — and escaping across there he sank into the mud, into the water, and lost all of the crown jewels and they're still there somewhere. Out in the North Sea. All these images came into it, drowning kings, underwater jewels and things.

PC: That's on the other album isn't it?

JB: Yeah, but that's tied in with this: the drowning of the king, the Grail myth, the Fisher King, how you sacrifice somebody in order to bring the harvest to fruition so everything will grow. It fits in with Mexico perfectly because of the Aztec ritual where they had to sacrifice someone every day to make the sun rise, and it wouldn't rise unless they killed them. That's where the line 'killed to keep the world turning,' comes in. And I think Pasolini's death, in many ways, had a deeper meaning than the fact that a man was murdered. For me, the word Ostia, which is the place where he died, it's on the outskirts of Rome, it's called 'Rome By The Sea', it's like a resort town... Which is why it's weird how you say it's like a postcard because a friend of mine actually sent a postcard from Ostia with all these

notes about it. And the death of Pasolini is interesting in that he was killed by one of the working class boys who he always hung around with and filmed and...

PC: Fucked.

JB: Yeah, and fucked, and generated a lot of his art from reacting with these people. And he eventually died at the hands of one and it's like the death he would almost have wanted.

PC: He described it!

JB: He described his own death like that and it came true.

AB: Where did he do that?

PC: He wrote a novel called *A Violent Life* — that's what it was called in English anyway. And it was a story about an older man who died at the hands of these teenage hustlers.

JB: Which is exactly what happened. They beat him over the head with a plank and then rolled over his head with a car — in Ostia. And the word 'Ostia', in Italian, is the word for 'the host' that you receive in the Mass. And it also means a sacrifice. It couldn't be better. Plus he died on a beach, very near to the beach. And Ostia, it doesn't actually mean it in Italian, but Ostia, the word 'osti' — I don't know where it comes from, Latin? — it means bones, an osteopath is someone who deals with bones. An ossuary house is where you keep all the bones after they're dead. So there's so many things in there. And the Mexican thing fits in. The beginning was recorded at Chichén Itzá, which is one of the main sacrificial places in the Yucatán, in the Mayan peninsula. We were actually walking down the road recording and there were all these dead dogs in the hedgerows and the stench of death.

AB: Like the march you recorded...

JB: We just liked they were really drunk, a drunk Christmas march, completely drunk.

AB: Can I expect that behind every song there is a story like this because it's quite a full story.

PC: Some of them are fuller than others.

JB: 'Ostia' is particularly full.

PC: Yeah, it's one of the more full ones. The instrumentals are more just sort of, pictures.

AB: Where did you come up with the idea to record 'Who By Fire'?

PC: We wanted some light relief. So we decided to record a song that's about methods of dying and suicide. Just for a bit of relaxation from the real meaningful lyrics.

JB: I like the idea that the lightest spot on the whole album is one of Leonard Cohen's songs — he's renowned for his gloominess. But Tibet got quite friendly with him when he came over. I think he's got Coil's album and Current 93 albums. And Tibet, at the time, said that we might do it, to him, and he said 'that's great.' He really liked the idea. Having said that, we'll probably be sued when he hears it.

PC: We have a tradition, don't we? Or we've established a tradition, of doing one cover version...

JB: ...About death.

PC: Isn't that dreadful? What's the next one going to be?

AB: I don't know about tradition, 'Tainted Love' is the only other one...

PC: It's a short tradition. But it's a good one, isn't it?

JB: That's about death. Wasn't originally, but we made it.

PC: What's that Johnny Cash song? (Murmurs a lyric)

JB: 'I fell into a burning ring of fire...'

PC: 'Ring Of Fire'! Yeah, that's a good song. We might do that one.

JB: We've taken bits of that: 'I fell into a burning ring of knives,' on 'Circles Of Mania'.

PC: It is better if you don't tell people...

JB: ...Too much. It ruins it. I like to know a bit about things but usually after I've heard it.

AB: When I heard *Horse Rotorvator* for the first time I kept thinking of Kate Bush. After a while I mentioned it to Geff, he said that you actually wanted Kate Bush to produce the album. It was quite strange.

PC: I don't know if that's a good thing or not.

JB: Getting her to do it? It was just this idea we had at the time.

PC: I meant that he was thinking about it before.

JB: I think it's good. I think she does good records. This album is, in some ways, the most commercial we're going to get. it's like we're playing around with almost pop songs, not quite though.

PC: Well not really, because the only song really that possibly could be a single has got an obscene title. So it's not something that we do playing around seriously — it is serious playing around but it's not...

JB: It just came out like that. I intended this album to be very much more violent and heavier than *Scatology*, but it just turned out this way.

PC: I think it is violent and heavy, it's just in a sophisticated way.

JB: Subtle, yeah.

AB: You say this album and the next album are like two pieces?

JB: They're linked very closely, yeah.

PC: The style of some of the pieces that are not on this album is similar to this album. They're probably a bit more frightening I would think. More violent in an orchestral sort of way.

JB: Sounds from a classical type orchestra, some of the sounds are like that, but it's the way we've gone about it that you can't tie it down to any sort of style. I think it's timeless. That's what we're trying for. This one, the next album certainly... (Appears to glance at the TV, mention of Federico Garcia Lorca on screen) Garcia Lorca? He tried to bugger Dali. (Turns TV right up) That was supposed to come out early spring wasn't it? That was *The Prodigious Adventure Of The Lace-Maker And The Rhinoceros*? Unfinished. 1948.[13] He had a narwhal tusk, did you see that? ...Where were we?

AB: I think it's time. Are you planning to do more films? You actually want to end up specialising in films?

PC: No, I think it varies.

JB: I'd like to get extremely large amounts of money for doing a film soundtrack.

PC: I like to do anything that seems to be interesting.

JB: Much in the same way as the dog does.

PC: Wish I could lick my own arse.

JB: Don't need toilet paper do you Khaos? Get your tongue round it.

13 *L'histoireprodigieuse De La Dentelliere Et Du Rhinoceros* was an unfinished film worked on by Salvador Dali and photographer Robert Descharnes.

" You're only ever _WHAT you ALREADY_
told *kNow* "

To TONY ABRAHADABRA

WITH BEST wishES & MoVEMENT

tOWARDS the GREAt EXtREMe.
in the YEAR of the HORSE RotoR
-VATOR

" We All GEt the
Gods We
DESERVE " —

Best wishes
Peter
Cliff

1 : II > 86ev ♂

London

The Dark
Age of Love

1986–1988

'It Could Be to Kill The Audience!'

Maelzel, February-May 1986

Maurizio Pustianaz

I was 18 in late 1984 and starting to redefine myself, experimenting with music, and then in early 1985 I started two fanzines: *Snowdonia*, with my brother Marco, and *Maelzel*, which I did alone. I was a member of the Italian branch of Thee Temple Ov Psychick Youth which was headed by guys from the band Rosemary's Baby. I owe thanks to Aldo Chimenti, a music journalist for *Rockerilla* and a local DJ on Radio Torino Popolare, who played tracks from *Scatology*: my introduction to Coil. I was hooked by the way they conveyed both melody and harshness inside a single song. I decided to write to them.

Given how slow communicating through letters was, I could create one issue of *Maelzel* per year and I was delighted when John wrote back. He kindly answered my questions and also asked if I would send him copies of *Maelzel*, he said that it was frustrating to spend time answering questions to never see the result.

I had Coil's address so when Massimo Mantovani of Thelema went to London I asked him to take copies of *Maelzel*'s second issue. John must have been impressed when a 'special postman'

all the way from Italy arrived because he started to send me their promo material. He was extremely kind: I would receive all their bulletins and postcards, and he sent me everything from the *Hellraiser* 10", to the 'Scope' 7", even the special clear edition of *Gold Is The Metal With The Broadest Shoulders* with the 'Wheel' 7".

Out of the blue, John proposed that I release a Coil 7". I wasn't working and I certainly didn't have the money so I had to decline, but I proposed that I do a special Coil/Non booklet instead. He gave me Boyd Rice's address after making me promise to keep it private. I wrote to Boyd and he responded saying he was interested... But it seemed he was more interested that I could get him Italian militaria and Rita Pavone records. I sent him one of her LPs and the third issue of *Maelzel*... Unfortunately Boyd never replied. John kept asking if I was interested, but everything was on hold. I knew Boyd had moved so came to doubt he received my package. In time John stopped writing, lost in his own 'Dark River'.

Bringing everything full circle, in 2017 Boyd played in Bologna and we met. He told me that he had indeed received the Rita Pavone LP and he had brought me the original 7" of 'Pagan Muzak' which he had intended to trade me in return. In remembrance of John we took a moment and marked it with a photo together.

'St Anthony, the patron saint of visions, and mental patients — illness in general. We have a particular fondness of the story of his life, and his life-long torment by demons that he saw all the time.'

Interview

MAURIZIO PUSTIANAZ: What were the motivations for starting your Coil project?

JOHN BALANCE: As a vehicle for our personal investigations and obsessions. A peculiar desire to irritate — inspire — create and confuse. We aim to bring about total dis-credit to the world of reality!

MP: What do you think of the control of the mind in our society and how could deprogramming work in this context?

JB: Sometimes I wonder what would be the result of everyone having so called 'freedom' and 'control' of actions, etc. which appears to be the ideal circumstance — goal! I believe that you can divide society up into controlled and controllers, the led and the leaders — I don't necessarily refer to obvious political or state or media controllers. Society — the majority of people would not be able to function — would not feel secure or correct unless they were controlled. They willingly allow responsibility to be taken by others. This is their desired situation. On the other hand, there are people who do want freedom, but have difficulty in obtaining and maintaining such a status. It is a constant struggle. As we quote Crowley, 'the price of existence is eternal warfare', we attempt to strengthen ideas and ideals in individuals' minds by example — by being — by demonstrating a functioning, creating entity in which we explore and express liberating views. This is our view. We don't preach! We actively discourage an organised following — at this point in time. We modestly attempt to provide a turning point, a trigger by which people might feel to have benefitted from a dose of Coil.

MP: I think *How To Destroy Angels* was meant to be a performance of ritual music. How would you define it and in what ways can ritual music influence people (e.g., accumulation of sexual power)?

JB: Our debut one-sided 12" album, *How To Destroy Angels*, was ritual music, music created with a particular purpose and personal function. We can't say how it will affect people in practice! That is a purely personal interaction between the musick and the listener's consciousness. We can attempt to do certain things, but cannot presume a specific result. Too many factors have to be taken into consideration! We always base our music and ideas on our experiences and our perceptions. We create for ourselves, that way we remain pure, true to our beliefs. Then we set about presenting it, once it has been recorded.

All our music has a function. It could be entertainment! It could be to kill the audience! In this sense it is ritual musick! The definitions and reasons are different for everything we do.

MP: All your records tend to draw the listener into the music, bringing about different states of mind. Is it something you are consciously trying to do? Are you going to follow this up?

JB: Of course! As I've said it depends from one thing to another what specific thing we aim to achieve. We generally aim to give something enlivening, invigorating, energising, and liberating in some way. A musical vacuum cleaner to clear rubbish away!

MP: *Scatology* was quite different, on a musical level: was it entirely your own choice or did Some Bizzare play a part in this? What about drafting Clint Ruin in as a producer? Sound-wise, the LP was very close to other Foetus records...

JB: *Scatology* was how we wanted it! Jim Thirlwell was a valuable contributor, the sounds were 60% done before we asked him to produce it so preconceptions in the ears of the listeners are finding easy solutions as regards Coil sounding like Foetus records. We admit to wanting a powerful punching sound — the strength is the link in the sound. Some Bizzare had nothing to do with the choice. Jim is a friend regardless of a label identity. We do exactly as we want.

MP: Any particular reason for calling the LP *Scatology*? What's the exact meaning of the image of the black sun?

JB: We could write a book about all the meaning of the black sun symbol. Here are a handful: Black Sun is a Chaos Magick symbol. Also seen as below. A surrealist image. A negative-outsider viewpoint. Reversal of excepted normality. The Chaosphere. Illumination of the irrational. Eclipse.

MP: How essential are your references to Manson, Crowley, Burroughs, and so on?

JB: Can I ask any readers if they have Salvador Dali items they might send me. Any books, magazine articles, videos of documentaries, etc., etc. I will swap or negotiate a reasonable price with them. Anything considered!

These people you mention have had an influence on us, of course. Spare through his precise and genius-like exploration and defining of subconscious territories. He developed through his personalised 'Alphabet Of Desire' a potent, working system of shamanistic magic. Crowley is important as a teacher, a catalyst, as a figure with purely 'human interest', a rare type of personality. But again he demonstrates a model for life for an extraordinary heightened philosophy and attitude, a continual search for knowledge, for reasons, for what he believed was TRUTH. The correct path for him to

follow, this is the 'true will' concept that actions are justifiable to a higher, often hidden cause, intelligence even. He exalted the post-Christian man to the original pagan status, 'every man and woman is a star.'

We have been researching the works of the French biologist and mathematician René Thom who put forward a much maligned 'theory of catastrophes.' He proposes that natural events such as the point at which a wave breaks on a beach, or the place where a leaf, or even a fjord, might bend in, are operating under calculable laws, that there is some sort of order in previously considered chaotic events. This, of course, has far reaching consequences which extend to thought processes, evolution, geology, microscopic structures up to the shape of the galaxy even. His books are hard to get now but we will be reprinting the basics at a later date.

Also the works of René Crevel, an original member of the Surrealist group, who committed suicide (like his father before him) in 1935. His friend Philippe Soupault wrote: 'he was born a rebel as one is born with blue eyes.' Coil have done a song called 'René Crevel' to further illustrate our interest in the man.

We have done a track based loosely on the legend of St Narcissus of Gerona, whose body did not decay after death. It smelt of perfume instead in the tradition of someone completely pure of heart, blessed by Heaven. His left leg issued forth an army of flies, to drive away an army of invaders attempting to enter the city. He is the patron saint of flies as a result. Mosca: Lord Of The Flies.

St Anthony, the patron saint of visions, and mental patients — illness in general. We have a particular fondness of the story of his life, and his life-long torment by demons that he saw

all the time. He hid in a church and devils tried to claw at him through the broken windows of the church.

Matthias Grünewald painted the Isenheim Altar for a hospital dedicated to St Anthony in France. This picture shows Christ in the most degraded physical illness form — luminous with sores and open wounds. It is the most remarkable and shockingly powerful image painted by Grünewald who himself saw visions all the time and who believed himself tormented by demons on occasions in his life.

We did the song 'Godhead=Deathead' on *Scatology* which was inspired, in part, by these ideas, these people. We will continue the themes of medieval sickness — the divine sickness of genius! — in the next album and 12".

I also have borrowed an obsession — taken it over — from Dali, of the Angelus by [Jean-François] Millet.

'Having Been Corrupted it's Uphill From There On'

The Sound of Progress, 2nd and 3rd July 1986

Alexander Oey

It was in the London offices of Some Bizzare in 1985 that I met Coil for the first time. Peter and John agreed to contribute to a film I was planning: *The Sound Of Progress*. They did, however, have one condition: they would only be in the film if Psychic TV wasn't. I told them that I had no intention of including Psychic TV — that I was talking to Foetus, Current 93 and Test Dept — so they didn't need to worry about that. I asked them if they were ever going to perform live and Peter said they were thinking about it but were reluctant because they didn't want to be just another band performing the songs from their albums. They wanted it to be something more, but they hadn't found the right path.

From that moment on, I would call them once in a while, and I'd always ask if they had figured out how to perform. Peter or John would always answer that they had not. I wanted to film them performing live, but it never happened so, after a year, I told them I wanted to film something more than just an interview with them so they agreed to work something out.

Alexander Oey

This became the decadent dinner scene. I was hesitant to ask questions during the dinner, so we did an interview the day after while they were in a studio recording *Horse Rotorvator*. Peter was absorbed in playing with the, then revolutionary, new sampler, the Fairlight CMI. While he worked, I interviewed John and Stephen in the courtyard outside. They didn't finish anything that day, so they promised they would give me a recording of a song later in the week. A few days after, they let me know I could come and pick it up at their house. They weren't in when I arrived, but a plastic bag was pinned to their front door. The tape inside had a first mix of 'Restless Day'.

I never did film them doing a gig, though John had played the Chapman Stick with Current 93 at a show in Hamburg in 1985, so he can be seen on stage in my film. Years later, I learned he had died in a fall. A few years after, I spoke to Peter over the phone and he asked me if he could have copies of the raw footage from *The Sound Of Progress* in return for a 'goodie bag' of Coil stuff. I thought that was a pretty good deal so we agreed to follow up, but I never heard from him again. It was only years later, when Justin Mitchell and I agreed to release my film on DVD, that he told me Peter died in 2010.

Note: the text below is excerpted from the full transcript which contained a lot of dinnertime chatter and general chicanery.

'Did you know that there were 102 Catholic saints whose bodies didn't decompose naturally after death? ...their bodies turned into this stuff called Adipocere, which is like soap, an ammoniacal soap that's what they turned into. They don't really dry up at all. Sometimes bodies found under water do the same, their fat turns into this weird soap which keeps them preserved.'

Dining With Coil — 2nd July

ALEXANDER OEY: Are you going to make a video with the record or not?

PETER CHRISTOPHERSON: We probably will do with one or two songs. Just because it'll help to sell the record, not because it's art. I would always rather make a film first, then make the music afterward. But before you can make a film you need money, a script, some way to sell the film. Because I always make films after the music, it becomes very difficult to make them for yourself. It's a stupid way to do it. Normally the music is made just to sell records, while we make music because we like the sounds, which is not quite the same thing... Doing film music is actually very satisfying because it's a way of attacking the subconscious much more directly. In experimental music at the moment, a lot of things that are said about subliminals and... Do you know this thing back-masking, they talk about now? In America they claim that records have messages from the devil, they've recorded it backwards — they call it back-masking. It's total rubbish, total bullshit.

AO: Like if you listen to a Beatles song you can hear them saying 'Paul is dead... Paul is dead...'

PC: Well, with film, you can attack the subconscious directly because people's attention is taken toward the pictures and if you're looking at the screen you don't really hear what's going on in the music at all. So you have much more scope for getting into the brain without people realising. It's the same with TV commercials or TV programmes, because if you ask people about the music for a commercial...

JOHN BALANCE: There's a big difference between the musical subliminal and the visual subliminal.

PC: I don't think there's any such thing as a visual subliminal. If you remember any TV commercial that you've seen recently, it's really very difficult to remember what the music was. It's virtually impossible unless the total soundtrack was only the music and it was something you recognise.

JB: Adverts? So that's Satie, and you remember that because it's Satie.

STEPHEN THROWER: It's easier to remember when it's from a source that's already known.

PC: In England, there's that one commercial that you can remember, then you can remember, perhaps, Coco Pops or something. Most of the things you can't remember because they're just an accompaniment to the picture, the sales pitch, and so...

ST: And yet they have an effect, because if you took the music off they'd be a failure.

JB: I've always thought it would be good to do an advert with no music because it would stand out so much.

PC: There are some...

ST: Usually those sort of used cars, 'Johnson of Sheffield! Used Cortina dealer...'

JB: Those are good though aren't they? They flash the car in and out.

ST: In Yugoslavia, when I was over there, they're a step down from that. I thought that was the lowest form of advertisement but they go one worse by having totally silent still cars as the adverts in between programmes. Just a car with writing over it, no music, no voiceovers.

AO: Yesterday, my friend showed me two very old American adverts for Chevrolet...

PC: On the TV? Oh, we saw those too. (Turns to Balance) You remember that Clive James programme? It must have been on blue-screen, it's really good... It's old quality so maybe they could hide it...

AO: And the song was pretty good.

PC: Yes, it was! (Laughs) I think it's much more interesting to have the scope to write music for visuals that exist already, than to do the reverse, to write visuals for music that exists already. That's the way it always happens, but it's an inferior way to do it.

ST: Images become very histrionic when you put them to music, there's a tendency to go really over the top, whereas if you went really over the top with the music...

AO: It'd be nice, hey, make me a nice video, we want to make some music...

PC: Us three are lucky because we do both. There are not many people who do music and who do videos — and we do. There are a few rock musicians who now make films like Godley & Creme, a few other people. But there's not very many. So it's interesting to see both sides of the fence, both sides of the way the system works. It's much better to do the films first. But if you say that to a rock musician, 'I'm going to do a video, please will you do the music to it,' he'd be very offended... Generally. It's a reflection on his lack of understanding of the way that the art works.

JB: And an art it surely is.

AO: In your work, to some extent, it's commercial?

PC: Yes, I do commercials and the music also to go with them.

AO: First commercial and then music?

PC: Because normally the commercial is written by the agency or...

JB: Split-second timing on those things though, isn't it?

PC: Yeah, and the music has to be done later. But that's better. I prefer it that way.

ST: I've got this excellent Tex Avery cartoon on tape, this cat takes potions to make him grow bigger. He gets enormous. The last shot is this enormous cat and this enormous mouse snatching the bottle off each other and getting bigger and bigger and bigger until they're stood on the world, this enormous cat and mouse balancing on the globe. It's about ten minutes. Sort of an expressionist cartoon.

JB: There was a cartoon the other day where Hitler was being caricatured. He got electrocuted and every time they turned the (inaudible) on he'd go 'zap!' and turn into all these Swastikas.[1]

AO: When I talked with you earlier, about this feeling of the corruption of the west, is that what you're partly reflecting in your music?

PC: I think we embrace it...

JB: ...While reflecting it. No, I think we do.

PC: Yes, I think there's only corruption that is honest and the resistance of corruption is dishonest...

ST: Other people's corruption is a bit of a pain in the arse but one's own corruption is doing what you feel.

JB: I always get pissed off if I don't get offered to be corrupted. I don't want to miss out on corruption.

PC: And I think we were all corrupted at a fairly early age...

1 Tex Avery's *King-Size Canary* (1947) and Warner Bros.' *Russian Rhapsody* (1944) respectively.

JB: We're like Bambis. Baby Bambis.

PC: ...So, having been corrupted it's uphill from there on.

JB: You just use it. It's completely true that the whole world is corrupt, it's whether you use it or not.

AO: You don't choose to escape from it?

PC: In a way we're being silly because the kind of corruption that, perhaps, you're talking about is different from the corruption that we're talking about. I think that we're really talking about corruption in the sense of moral corruption and deviating from the normal.

JB: Which isn't necessarily corruption. So we embrace that sort.

PC: Whereas corruption in a business sense...

JB: ...Or a political sense... Has such widespread and huge hypocrisies that, firstly, you can't do a thing about it, because it's out of control — your control. And it's completely widespread isn't it?

PC: And it's not something that we support, obviously, at all. But I think, in a way, that if one is going to make records and be an artist — as hopefully we are — it's not the place to express politics. There are a lot of people that say it's important...

JB: And it's a very, very, very dodgy tightrope to walk if you do and very few come out of it... Sound. Come out of it not seeming a prat in some way.

ST: Politics is about the controlling and shaping of certain sections of the populace, of society. I think it's rather an unpardonable arrogance. To imagine that one can specify what should happen to a large number of people. I mean, we're more interested in internal, personal, things. But there are those people who say

that the internal is political as well, but only if you put it in a larger social context which, again, is an arrogance. I personally have no interest in social arrangements or structures at all, only in as much as trying to avoid them as much as possible.

JB: Because they were there already and therefore don't suit the person. You have to fit yourself into the existing mode and that's obviously wrong. It's a zen-anarchy.

PC: The best way to put across a political or a moral message is just to live that way yourself and if you do so in public, and people see that you live in a certain way, then it's inevitable that it follows that that's the way that you approve of. And if people have any respect for what you're doing then maybe that'll rub off. It's much better to do something by showing somebody than by telling somebody what to do.

(Phone rings)

ST: It's for you-ouuuu...

PC: Would you be interested in doing a Gay Pride benefit?

JB: We found ourselves marching on the anti-Apartheid march.

PC: By mistake.

ST: What? Try telling that to the press... 'Coil Demonstrate Political Conscience.' You shame me!

JB: 'Coil: What do they mean to us? Summer nights, warm greasy evenings, a copy of *Scatology*, "Ubu Noir", that effervescent opening tune...' Mind that lampshade!

(Christopherson pops a champagne cork, champagne cascading everywhere.)

PC: One of the things that I've noticed with a lot of people that are supposed to be experimental is that they seem to be polarising

into two separate camps. One is the camp of those that are actually going to sell records and make a living and pay a mortgage, and the other is the one that, basically, want to be unlistenable, to do things that are more extreme and more outrageous and more difficult than ever before. And I don't think there's very many people in the middle, apart from us. We always strive to do things that are completely different from anything that's gone before, not because they're different, but because to us they're refreshing, we've always tried to do music that we liked. It's not to make money and it's not to be difficult because I think that our music is accessible.

AO: Did you say you wanted to talk about saints or something?

JB: I have an interest in the incorruptible bodies of the saints. Did you know that there were 102 Catholic saints whose bodies didn't decompose naturally after death? They stayed totally incorrupt, they even exuded fragrant perfumes.

PC: Does it just go to prove that the Christian Church was right all along?

JB: No. But their bodies turned into this stuff called Adipocere, which is like soap, an ammoniacal soap that's what they turned into. They don't really dry up at all. Sometimes bodies found under water do the same, their fat turns into this weird soap which keeps them preserved.

PC: So why should it happen to saints?

JB: Well, just because of the sanctity of their soul apparently. And they do exude this perfume...

AO: Maybe it's the place they store it in?

JB: It's very different to the bog people that they've preserved because of the peat, the minerals preserve them, and it's

very different to the ones that have been preserved as in the manner of the saints.

ST: Geff's a closet Christian. I should point that out right now.

JB: Well, I'm interested in these sorts of things.

ST: Geff is on route for a miraculous death bed conversion, allowing the lord to enter his spirit...

JB: My backside!

ST: ...Moments before he dies.

PC: I thought we already did that?

ST: Personally, I think that any interest in any aspect of religion, apart from a sceptical one, is unhealthy. (Balance hits Thrower in the face with food scraps.) If you allow any form of credence to enter into your opinion.

JB: I believe! I believe! It's scientifically proven, that's why I'm interested.

ST: The first thing that pops into my mind is that who's to say that the people who have mentally, sort of authenticated this, aren't Christians themselves and have a vested interest in making claims like this.

JB: Yeah, well, there's definitely a vested interest in making things saints and miracles.

ST: I don't believe it for one moment. Certainly not that it's a miracle occurring.

JB: You cynic! You cynic!

PC: But it's only saints actually whose bodies they continue to look at century after century. There might be all sorts of other people who are also miraculously...

JB: They've been there since the 14th century and every year they drain off two inches of this fragrant oil from their coffins and dip the relics in. It's morbid. It's very fascinating. I'd like my body to exude fragrant oils when I'm dead, you know? I'm sure you could.

PC: What I'm saying is that there's probably lots of people that exude fragrant oils and worshipped all sorts of other deities.

JB: This is what I'm looking into, this is an early research phase. I'm still not sure whether... I mean, it's very different to being actually preserved, having preserving fluids put into your body, it's very different. I mean, Lenin, he decomposed and they stuck a wax effigy in his place.

PC: I read somewhere that it's actually a replacement, someone else that had died and they found the body and put it in his coffin.

JB: Yeah, I read that. And his ear fell off.

PC: Nobody's perfect.

Outside the Studio — 3rd July

AO: What's the meaning of this project, to bring new views to it not the old people who like you anyway?

JB: I mean, to a certain extent, we're often preaching to the converted because we've got such a specialist market I think. But people are interested, we do take time to explain these things sometimes. In interviews, when people come out with Charles Manson, control, Burroughs, and you just turn off because we've been interested in those things since the age of 11 in some cases. And it's not interesting to us anymore either.

ST: It seems bad as well that interviews should consist almost entirely of second-hand information, sort of a repeating of information that you've gathered from elsewhere, books that you've read and that sort of thing.

JB: But it can be other people's second-hand information, it's our second-hand information because usually people are talking about *Scatology* which came out over a year-and-a-half ago now. I don't mind talking about that because people still haven't picked up on all that was in that album, I don't think. They pick up on the words 'Charles Manson' on the cover, they don't pick up on the theories which Manson himself used about holes in the Nevada desert and things — they're the more interesting parts. We very rarely get time to explain because it's so long, so thorough, and people never ask either.

ST: People are more interested to know why Geff and Sleazy left Psychic TV than they are the lyrics. It can be a bit of a problem.

JB: Standard gossip. That happened, I don't know, it must be three years ago when we left. Just total history to us, we haven't seen Gen for two years except for a couple of meetings. History regurgitates.

AO: Would you like to explain, talk about what you haven't talked about yet?

JB: Well there's so many things because I think we're... It's not that we're intelligent or, what's the word? Verbose or literate. We're not. The way we do things we do them straight off the cuff, it's not a punk mentality but it's a spontaneous mentality and it always has been. But underneath that there's a huge body of intuitive knowledge and things we feed in, chance elements.

ST: It's fine to draw on material from elsewhere, so long as you're actually doing something with it when you've collated

it and so long as you're using it in an imaginative way once you've put it all together. So much of what passes for the avant garde in this country and music, just consists of dumbing it down. Like you've got a section of text and that's it, there's no treatment of it. The people who did it aren't putting anything into it, it's just like a bit here and a bit there. It's terrible.

JB: This is why I do think we, as a group, stand out — with a few other people like Current 93, Nurse With Wound, Boyd Rice, etc. We do stand out because we support the individual rather than a cause, this post-industrial heap of shit, because it's just a phrase coined for convenience, it doesn't mean a thing. It never did.

ST: The idea that a band has to have some kind of manifesto which it can wheel out any time people want to know about the sort of music you're doing is pretty crazy really. The whole post-industrial thing, a lot of tags, it's a terrible thing.

JB: But we've got two faces because on one side we preach the beauty of stupidity, where you just go out and do something straight off the top of your head. We're arrogant enough to believe that what comes out of the tops of our heads is superior to 99% of the population and what comes out of their heads usually. Except for a few examples and exceptions. But, then again, we've also got this body of knowledge. I'm not saying we've got anything special which we can impart to the public but we do research things and we don't just pick on names and ideas and things and use them. People do that still.

AO: What were you afraid of yesterday? You seemed afraid of the interview, you were afraid of something?

JB: Yes, because it's sort of being packaged with other people, I wanted to have an opposing image to them even at the cost of appearing stupid or drunk or loutish — I didn't give a shit

about that. Just to stand apart from the other people, though those particular people we don't mind. You have to spend so much time filtering out what you get given. We get sent records which I never listen to, cassettes which I never listen to, people assume you want books of Manson clippings...

AO: Do you have to care very much about your image?

JB: Not really, to a certain extent, but I don't really give a shit because you get into the popstar thing of 'I can't go out because I haven't got my special black jeans on and my hipster belt, my snakeskin boots and things.' We don't care about that. The mental process isn't the individual vision which I think we might be able to project at times. And all the people we admire as individuals are isolationists, almost like hermits, they stand apart. Austin Osman Spare; the occult painter Ralph Chubb is another painter we like.

ST: If you take a writer like James Joyce or someone, they would never have submitted to the indignity of an *NME* interview or that sort of procedure. They'd never have dreamed of going on pop programmes if they were involved in music.

JB: This is the first time we've stood in front of a video camera and said these things. We've had numerous opportunities to play huge festivals in Holland and in America — we've been offered to play the Palladium which is the biggest nightclub there at the moment — we just say no.[2] We get this perverse pleasure in turning these things down in a way. We don't want to dilute what we think we have by either compromising it in a live situation or becoming just another little marker in the marketplace.

ST: There's definite laziness in the way in which supposedly experimental bands present their music live...

2 The Palladium nightclub on East 14th Street, NYC, formerly The Academy of Music.

JB: Disgusting laziness! Just brainlessness, they don't think.

ST: I think most live cassettes of purportedly experimental bands in Britain particularly are totally unlistenable. I won't mention any names but... No doubt they defend it by saying 'oh, well, it's spontaneous, we just felt like we had to do...'

JB: There are things to be said for it in a certain respect.

ST: There's something to be said for spontaneity...

JB: We're not condemning outright every contemporary or peer.

ST: One starts to wonder, though whether they could get it together if they tried. Perhaps the reason that they always do these improvised spontaneous concerts is because they actually don't have the wherewithal to do it properly.

JB: And the sad thing is the unthinking public go for it anyway. You have shallow minds accepting shallow goods. There's no quality to it at all.

ST: You could guarantee that if you released a booklet, an accompanying magazine with an album, the majority of the people that bought the album would probably file it away next to their Cabaret Voltaire booklet, and their Test Dept booklet, this shelf full of magazine cadavers.

JB: A collector mentality. They end up sort of drowning under the weight of all their post-industrial badges. If they fell in a river they'd sink to the bottom because of them all cramming them on.

AO: Is it difficult to survive in all that? To retain some freshness?

JB: It's difficult to maintain a separate identity. We admit it, we're not saying we're unique and special and we have this amazing talent and everyone else should listen. We're not saying that

at all. In a sense we're being tarred by our own brush in this condemnation, but I'd rather have that and have the ability and have the time to work in isolation. Get on with what we really believe in. Everything gets diluted nowadays.

ST: I think the music is sufficiently unusual to stand up and to defend it. I think there is something special there even if that sounds big-headed or something. I think it's fairly interesting.

JB: But if anyone wanted to look for a message in our music, an overall sort of thing, it would be that you just have to go for individual visions whether they be Hitler or Bosch or Bruegel or something. It's only by ploughing into yourself I think, that you can get anything worthwhile, turning away from outside influences. You spend so much energy shutting out and filtering everything — records and TV and that. I can't listen to the radio, it makes me feel physically ill.

Current 93 share these things, it's good there are common linkages. We go back to, we ignore most contemporary sources and go back to, like, the Surrealists. What they were dealing with was the subconscious on a personal level and expanding it and plumbing the depths of it. That's just a very simple act that takes a huge amount of effort and has amazing consequences if you can do it. Unleashing something. People don't know how to do it. That's what we're aiming for in some respects.

ST: People seem to think it's sort of egotistical and introverted to take such an extensive interest in your own mental workings and capacities. I don't think that's true at all. I think it's more of an arrogance to believe that you could ever understand someone else...

JB: ...How are you ever going to know anybody else's? I don't know my own particularly, I want to know more about it.

You can never really know what other people are doing, except by shallow aping which we're on about. This is why we keep dream diaries and things. I've kept a diary of all my dreams, of every night, for the last five years. I'm not sure quite yet what purpose it serves but it's a unique record as far as I'm concerned.

ST: If only as a source of imagery as well, for writing.

JB: Yeah, you couldn't even say you got to know yourself better through it because it churns up such strange things. You just can't make sense of it. That's what I like. We utilise the chaos, we propagate and generate chaos — not in a sort of punk-anarchy way, but mental chaos. As we were saying before, we believe that states of delirium and self-induced madness, whether it be from LSD or schizophrenia which you invoke and make worse, I actually believe you can strengthen yourself through those things by putting yourself through it.

'Circles Of Mania, Pestilence and Temptations'

Rockerilla (#79), March 1987

Vittore Baroni

These letters were excerpted for an article in *Rockerilla* (issue 79, March 1987).

Interview

VITTORE BARONI: How did the Clive Barker *Hellraiser* connection come about?

JOHN BALANCE: We have known Clive Barker for about a year. Steve Thrower first got in touch with him and they got on well. Steve introduced Sleazy and myself and we've exchanged ideas on and off. I think Clive Barker first heard Coil when he saw *The Angelic Conversation* and got in touch with Derek Jarman to ask who'd done the music. We were then asked, and agreed, to produce a score for his self-directed feature film — which was financed by Roger Corman's company New World Pictures for three million dollars. Unfortunately we realised that things were becoming more and more as the American

'But as the saying goes: "how random is random"? We believe that we become, in ideal situations, vessels through which a greater whole, a complete energy, can come through us — we are merely instruments ourselves.'

money men wanted and it was being reshaped, with scenes being changed and reshot, to suit U.S. audience tastes.

Consequently, and inevitably, it reached a stage where Coil's music — which Clive had seemed to support 100% all the way — was suddenly judged to be too, I quote, 'cool-detached-weird,' for the mood of the picture. So Coil pulled out rather than be contracted to deliver a 'normal' emotional-type conventional orchestral score. So, basically, we are not now doing the *Hellraiser* music. So many ideas and original decisions were reversed, compromised and gone back on, that we couldn't go through with it. The New World Pictures company offered us a really lousy deal: fifteen thousand pounds for everything; to pay Coil's wages for the months October through February; the entire recording costs; the session i.e., orchestral musicians' fees; everything to come out of the fifteen thousand pounds — which was awful. But we originally agreed (a) because we liked Clive — and also wanted to work with him (b) because it was likely to lead to other such commissions. But we are glad it eventually worked out this way, we now have about an album's worth of nearly completed instrumental music which we very much want to complete and release. We did go on set! It was good, messy fun!

VB: And how about the film and soundtrack, *The Angelic Conversation*?

JB: The film was released in the U.K. and still shows regularly in U.K., I don't know about Europe. I do believe that someone has just bought the distribution rights for Europe so maybe it will be seen more next year.

The video release has been talked about a lot, but as yet, no plans have been finalised for its release.

It was shown on Channel 4 TV here in the U.K., which was well received, and we received eight hundred pounds in broadcast royalties so I hope they show it again — real soon!

The music will not be released as a complete soundtrack LP. We plan to release several sections of it, remixed because it needs to be adapted for record as it were, the film version is deliberately 'ambient' — it matches the style of the whole film — (and) I want to change the musical emphasis on certain sections. We have titles for a few pieces, i.e., 'Never', 'Escalation' and 'Cave Of Rose'. The more definite set pieces will be remixed for LP releases as part of an album we plan, *The Sound Of Music*, which will also include the unused *Hellraiser* themes and developments. At present we are planning to release a limited edition 2,000 or so copies of this album, to be followed later on by a more regular 'trade' edition on our normal label outlets in the U.S., U.K., and Europe. The first 2,000 we want to put out on our Force And Form label direct.

VB: I'd like to ask you more about your various collaborations and how they connect...

JB: It's hard to say. Each collaboration seems to make sense at the time. We don't feel any special need to do things with other people, but we like to include new ideas, new energies, into a project. Each person we've worked with we've really enjoyed. There are many more links and associations between these groups you mention than many people might realise. Jim Thirlwell has worked with Matt Johnson, Orange Juice, Marc Almond, The Virgin Prunes, Coil, etc. Marc Almond has worked with Coil, Matt Johnson, and many, many more. Coil are due to work with Gavin Friday on his first solo album due to be recorded in January-February — mostly cover versions of Brecht and such cabaret songs. I think there is a certain common vein that runs through the work of these groups. But it is really impossible, and perhaps pointless, to try to identify what it is exactly. It's a mixture of shared visions, ideals, and long-term friendships, and the 'spur of the moment', 'what

the Hell! Let's do it!' attitude that it takes to go into a studio — a certain kind of chemistry has to be present! We've been approached by many people to work with them but have declined eighty percent because you want to be sure about your personal and group integrity.

VB: What do you think regarding AIDS and how it has been treated by the media and government?

JB: It has taken until this year, last month, for the government to finally take the subject of AIDS seriously and to act to stop the spread of it. It has taken until heterosexuals have become a concern, potential victims, for them to act. I find this dangerous, disgusting, and typical. They could see the U.S. situation, could have seen it five years ago, but did not act! What else can you say?

VB: Who would you really like to work with?

JB: Well, we've always said we wanted Kate Bush to produce an album but she is always too busy doing her own stuff! I'd like to work with Jim Thirlwell again in some capacity; Marc Almond again; Gavin Friday again... But new people? Maybe the Butthole Surfers, especially Paul [Leary] the guitarist! And Gibby [Haynes]! There are plenty of film directors we'd like to get friendly with: [Lucio] Fulci, [David] Cronenberg, [Dario] Argento, etc.

VB: How much importance do you place on planning a recording, on the concept, and how much on the musical arrangements?

JB: I work out lyrics and many ideas — themes — and also musical ideas beforehand, often many months beforehand. But it is often a case of when we get into the studio, that we do something completely spontaneous. 'At The Heart Of It All' on *Scatology* was done straight off, as an improvisation.

We pre-set certain echoes, which we could play off, and did it. We do have certain backing tracks, rhythms, etc. that we base things on — but we never rehearse and very rarely play any song more than once. Most things, except for my vocals, are first takes, we plough straight on, partly because of the time and money situation and partly because we like to combine detailed programmed electronic backings with raw, unrehearsed guitars and noises. A nice mixture we feel. We allow for detailed, extremely well researched ideas and pure random chance. But as the saying goes: 'how random is random'? We believe that we become, in ideal situations, vessels through which a greater whole, a complete energy, can come through us — we are merely instruments ourselves. I feel this particularly when writing lyrics. I have about 20 books completely full of random notes, quotes, cut-ups, and automatic writings. I do trance experiments when I write things I have absolutely no recollections of having done later on. I like to use these a lot: 'ghost writers in the sky!' I also use bits from my dream diaries where I write down all my dreams for about the last three years.

VB: What do you answer to people who object to your music on account of the stress given to sexual perversions, death, sadomasochism, and obsessive themes?

JB: I don't usually talk to people who display such a polarised viewpoint. I am an obsessive, I love other obsessives, and I find it hard to relate to non-obsessive people. I hate half-way mentalities. This is why I love Jim Foetus, Boyd Rice, David Tibet, Marc Almond, Gavin Friday, etc. They live their dreams, they push to their boundaries, the borders of taste — often straying well over into the realms of indecency, but we should all expand, expose, explore, explode, explain, excite, and advance! Life is sex and death, guilt, fear, and ecstasy. The

in-between dilutions of these satisfy most people because they know no better. Because Eden has a barbed wire fence around it, most people shy clear of it. But to me the barbed wire is a beacon, a provocation, a challenge, and it shows that on the other side is something, someone somewhere does not want me to see. So I go! It's my nature, and to an extent Coil reflects and contains these principles. We are never as severe, as brave, as complete, as condensed, as I would like us to be. But we are getting denser, tougher, stronger — most hallucinatory and dangerous!

Clues and Confusions

'Circles Of Mania' had a working title of 'Twister' which we decided against because it was, perhaps, too close to Psychic TV's 'Twisted' track title.

Our track is the narrative of a martyr from the point of view of someone in the centre of a wild orgiastic, Dionysian, blood-feast. He is Christ hallucinating on the cross, he is Joan d'Arc burning alive, he is the cannibal's victim, the fly being sucked by the spider — all is sexual death-linked frenzy, Dionysus incarnate. These peasants are crazed on ancient witch potions: ergot, belladonna, mandrake, mercury/quicksilver, muscaria, fly agaric, psilocybin, etc.

It is the Black Widow/Praying Mantis devouring of the sexual partner.

It is the giddy vortex of hallucinatory sexuality. Goya and Hieronymus Bosch, [Matthias] Grünewald's paintings of the Isenheim Altar that decorated the church of Saint Anthony, the patron saint of diseases and mental disturbances. Saint Anthony himself, throughout his life, was tormented by visions of demons, and has inspired many pictures called

Vittore Baroni

The Temptations Of St Anthony by such artists as Max Ernst, Salvador Dali, and Grünewald himself, elsewhere in the church.

The title ('Blood From The Air') came from a Surrealist poem by Philip Lamantia, an unfortunately mostly unknown writer. The track is about a view of the world as seen through the eyes of a madman, a psychotic character, but he also possesses a very fundamental, dark, existential view of the world and life. It is depressing, cold, bleak, and is probably the darkest vision we present on the album. Arctic/Antarctic darkness, the North Lights, snow covers the murderer's tracks.

'The Dark Side Of Sampling'

Keyboard Magazine, Summer 1987

Mark Dery

I remember the '80s.

I remember reading about the New Romantics, sniggering at French-poodle quiffs and the geometric maquillage that turned nightclubbers' faces into Russian Constructivist paintings. I remember leafing through cover stories assuring us that Haysi Fantayzee, or Blancmange, or Rip Rig + Panic was — yawn — the 'next big thing.' I remember wearing a silver sharkskin suit, blindingly white Capezios (smudges retouched with White-Out) and a pink leopard skin tie to Depeche Mode's first LA gig, doing that electro-pop dance move everyone was doing then: cheeks sucked in like a mirror-shaded model in a Nagel poster, arms bent at the elbow, swivelling from waist up, feet nailed to the floor, while the band played 'Just Can't Get Enough'.

I moved to San Francisco in summer of '82, wrote for little magazines, and shuffled home, through late night snowdrifts of X-rated fortune-cookie slips disgorged from loosely tied trash-bags, after tending bar at a performance art space. I arrived with that deep-space alienation from being the only kid

in high school who loathed jockdom and the bong-erati, who'd rather sit in his room listening to *Radio Ethiopia* than go to the homecoming dance.

Before the Net, magazines were the catacombs of cool, a subterranean network connecting kids, marooned in tract-home desolation rows of suburbia, with subcultural trends and weirdos like themselves. In Re/Search Magazine's *Industrial Culture* issue, I discovered a world where insurgent intellect was cool, where forbidden knowledge was coin of the realm! The industrial aesthetic had come to kill hippy dead — and not a minute too soon in a state that, in 1982, still reeked to heaven of patchouli and Spiritual Sky incense, and a city awash in toxic runoff from the Summer of Love.

Between insinuating my starstruck self into the Re/Search inner circle; interviewing John Giorno in the legendary windowless basement where William S. Burroughs had lived; and summiting a Kilimanjaro of cocaine with Nick Rhodes — Duran Duran's impossibly pretty keyboardist — in a nightclub bathroom stall, I also managed to finagle an interview with Peter Christopherson. Ridiculously enough it was for the gearhead trade magazine *Keyboard*, but I simply had to interview a man nicknamed 'Sleazy'. We met in the Broome Street Bar in Soho, New York City. He was soft-spoken, diffident, with a coruscating intelligence and a sense of humour dry as bone dust. With his talk of sex magick, blood sacrifice, and tape recordings of '...this little kid laughing and saying things like, "My legs are starting to sweat..."' I found him genially, discreetly depraved. Which, then as now, impressed me no end.

'...the basic loop is a section of "The Rite Of Spring" backward and upside down, and at a quarter of the pitch. Somebody actually once told me that they recognised it.'

Mark Dery

Interview

Long before the verb was coined, Coil keyboardist Peter Christopherson started sampling.

As the tape player for Throbbing Gristle, Christopherson used a jerry-rigged one-octave keyboard to trigger Sony stereo cassette decks. With it, he added shadows to such Throbbing Gristle tunes as 'Persuasion' (20 Jazz Funk Greats), in which taped voices of kiddies at play underscore flatly intoned lyrics about a man who's 'got a little biscuit tin/to keep your panties in.'

'It was a box that Chris Carter made for me, to my design,' Christopherson recalls, 'that basically switched on and off — through inputs on tape recorders — six cassette machines, the output of each going to a different key. Many of the machines I used in Throbbing Gristle were cassette machines that were stripped down and altered to play backward and forward and four tracks at once, the speed variable by flywheels. The very first sampling device there ever was, as far as I know, was manufactured by Mountain Hardware for Apple computers. It was designed to reproduce voice samples, and had a very limited selection of pitches. I was using that onstage in '79 or '80, which was before the first Fairlight was used commercially. So I've always had a soft spot for sampling.'

That soft spot popped up in Christopherson's work with Psychic TV, after Throbbing Gristle split up, and has become almost a raison d'être in his current project, Coil, which formed around 1983. Strictly a studio band, Coil comprises himself and lyricist John Balance, who sings and plays Chapman Stick and some keyboards. They get an occasional hand from Stephen E. Thrower, who mainly plays drums and brass.

Coil's latest, *Horse Rotorvator*, hodgepodges Fairlight brass, sniff-clank percussion, Gregorian choirs, and lyrics about

CCL

death, sex, and divine cannibalism. The real star, though, is Christopherson's sampling. 'In "Ostia",' he informs, 'there's a recording of some grasshoppers that we made at Chichén Itzá in Mexico. Chichén Itzá is a pyramid that was used for the sacrifice of young men. Blood flowed down the steps of the pyramid and made it impossible to climb up.' The murmuring insects add atmosphere to the song, whose jumping-off point is the life and death of Pasolini, the Italian film director who was murdered by a rent boy in Ostia, Italy.

The story behind the background scuffles and squeals on 'The Anal Staircase' is equally odd. 'A tape was sent to us by a guy who's sort of a fan of ours,' Christopherson says. 'It's the sound of him playing with his son. But because of the title of the song and the rather explicit nature of some of the lyrics, we thought it would be interesting to counterpoint the tape's harmless sound with a lyric that had other overtones, to see if it would change the listener's perception of this little kid laughing and saying things like, "My legs are starting to sweat." Immediately one begins to think that there's something going on, some sort of torture scene.' As if that weren't weirdness enough for one song, Christopherson adds with a chuckle, 'the basic loop is a section of "The Rite Of Spring" backward and upside down, and at a quarter of the pitch. Somebody actually once told me that they recognised it.'

Making Stravinsky turn backflips might sound a little theatrical, but that's just the point. Coil strives for what Christopherson calls 'a "big movie theatre" ambience': a spacious, symphonic sound that echoes to the soundtracks of Arthurian romances, biblical epics, or old Steve Reeves movies. 'We've always liked movies about Turkish prisons and Roman galleys,' Christopherson says. 'Most contemporary music draws its imagery from the past 30 years, going back to the 50s.

But there's a whole wealth of imagery from earlier times that's fascinating to draw from.' Such Coil songs as 'Slur', 'Ostia', and 'The Golden Section' — with its clopping horses, voiced-over narration, and chanting galley slaves — are straight out of Cecil B. DeMille.

Balance's lyrics are also cinematic. Some songs were pieced together imagistically, like movie storyboards — such as 'Blood From The Air', a musical evocation, Christopherson says, of 'something John read about a schizophrenic who lived in Alaska.' The song was 'constructed by us just imagining a film in our heads about somebody walking through a very cold landscape and occasionally having mental attacks.'

Theatrics aside, Coil's music has some decidedly down-to-earth aspects — namely, the hardware Christopherson uses. 'Apart from the guitars and brass instruments and some live strings mixed with Fairlight III strings, everything else on *Horse Rotorvator* is artificial,' he notes. 'Quite a lot of those sounds were created using an Emulator II function to destroy the original sample and produce something else. I used the VCAs and VCFs[1] to do real-time modulation of the original sample.' The Emulator II also played a starring role in the song-writing. 'The initial sequences consisted of multi-tracked sample combinations done on the Emulator,' he explains. 'In most cases, what I did was download those sequences into a Fairlight by means of the MIDI output. You can edit much more easily on a Fairlight than on an Emulator.'

To avoid the android stiffness of sequence-based song-writing, Christopherson and company 'try and con the machines into doing what we want, even though sometimes the machines weren't designed to do that.' For *Horse Rotorvator*, the conned machines include a Fairlight II and III for sequencing and

1 Voltage Controlled Amplifiers and Voltage Controlled Filters

editing, Emulator II as the main sound generator, Yamaha DX7, PPG Wave 2.2, and an EMS Synthi for the heavy, distorted sounds. 'The Synthi,' Christopherson says, 'was like a portable version of their VCS-3, from '72. It has a collection of VCAs and ring modulators. The way you connect the oscillators and filters is via a matrix board, where you put pins in to make the connections.' Additional artillery included 'a few old Woolworth's-type flangers and distortion pedals.'

But don't be fooled by all the bits and bytes. Coil are not master musicians. 'I can't really play properly,' Christopherson asserts blithely. 'None of us can really play in the conventional sense.'

For once, that old hokum about players 'painting with sound' rings true. An artist whose bread and butter comes from directing TV commercials and pop videos (spots for The Firm and The The are among his recent credits), Christopherson composes Coil songs visually rather than musically. 'As long as I can remember, I've approached music from a visual point of view,' he says. 'Any technique that you can apply to a film, you can also apply to a piece of music. Our tunes that start off with a sort of film script or filmic picture are much more successful than the songs that start with a riff or bass line or conventional musical cue.'

Let other bands write songs; Coil makes ear movies.

'We Avoid Comparisons and Contrasts, We Isolate Ourselves...'

1st October 1988

With thanks to Claus Laufenburg, the piece here is excerpted from an apparently unpublished letter to an unknown recipient.

Interview

(1) The need to work on my own ideas has always been present, regardless of whoever I was officially linked with or who I am involved with. This made Coil of importance to me in about 1982, at which time I had joined Psychic Television and was contributing to both that group and especially to the ideas that formed the first incarnations and first presentations of Thee Temple Ov Psychick Youth, circa 1982-1983.

Coil were originally going to appear in some format at an event in 1982 called The Equinox Event. We would have been

'The world of man and
everything within, without,
and between is as minute as it
is infinite, as complex as can
be imagined but built from as
simple a formulae as can be
produced to represent it.'

a line-up of two people. John Balance and Jim Thirlwell (of Foetus). We didn't appear for various reasons.[1]

Coil began recording around this time, on solo material. The song 'S Is For Sleep' was a product of this formative, primitive era, as is the track 'Red Weather'. Inevitably, as we work closely together and live together, Sleazy became involved and Coil became a permanent duo when we both felt compelled to leave the Psychic TV group and Thee Temple Ov Psychick Youth in early 1984. The appearance of Steve Thrower at the time we worked on *Scatology* produced the three way collaborative unit that is still existent now in 1988. He is a permanent member, as is Otto Avery who joined us in 1988. Officially.

(2) We can really only list the groups that we variously enjoy to listen to and also those types of music that we admire in ways beyond mere entertainment. We tend to like music that is a product of a long and complicated system of thought and ideas. It may be a raw, rough, end-result but we generally admire hidden structures, humour, new ways to gain access to ancient emotions and transcendent states. So we use music much more than just listen to it which implies a passive response. I like to interact, act on and even change what I'm listening to. We like/have liked The Fall, The Residents, Captain Beefheart, Faust, Can, Butthole Surfers, Velvet Underground, Non, Bongwater, Nurse With Wound, Acid House — at the extreme end of it all — Kate Bush. Film music especially Nino Rota, Morricone, 50s/60s spy themes, John Barry. Tom Waits, Scott Walker, Eric Burdon, The Birthday Party, music by friends — i.e., Marc Almond, Current 93.

1 Jim Thirlwell confirms: 'Geff and I were going to do something together prior to my work on *Scatology*. I don't believe we rehearsed for it, but we did have a show lined up. In the end, maybe because Geff thought it was dodgy, it never happened. Across the years I used to call him occasionally, encouraging him to "take care" of himself. He was sometimes willing, but it was never quite enough.'

Classical music, especially (Igor) Stravinsky, (Josef) Suk, (Krzysztof) Penderecki, (Tomaso) Albinoni. So called 'ethnic musics', especially Tibetan and Afghan and Persian music, Mongolian vocal music, Thailand folk music and modern teen pop music. All sorts. As you can see.

We don't listen to many contemporary so called 'difficult' music groups. We avoid comparisons and contrasts, we isolate ourselves from all but a very few groups.

...Otto Avery was in a group called Fourteenth Century Spit (C14th) before he wrote (an) abusive letter to us last year. He has since provided an essential contribution to the new Coil materials we've produced since the *Gold Is The Metal* LP, which he also helped compile incidentally. He plays evil tricks on us all, provokes us when we least need it and reminds us of how futile it can all seem to be. He plays guitar and effects my vocals as I do them, i.e., real-time manipulation of my guitar and voice also. He cannot read or write. He doesn't know who his parents are — and hates all Americans except the Butthole Surfers and the cartoonist Tex Avery, who he believes may be his real father! He is not Austrian. He likes Acid House music and goes missing for days on end.

...(9) Yes, *Scatology* is banned by a whole chain of WHSmith owned Our Price record stores in the U.K. and so is 'The Anal Staircase'. Luckily we haven't had too much adverse reaction. But we certainly don't attract attention to ourselves in the way that many groups deliberately engineer as publicity stunts.

...Briefly, we admire to a degree the personality and vitality of Crowley and find admirable the complete conviction that he pursued his personal vision with and the way that his beliefs were totally inseparable from his lifestyle even when it seemed to go against all rules of self-preservation and to continue seemed

like financial and social suicide. I can't wholly admire his life, his treatment of friends and his friends' money, trust, and wives. But he, overall, presents an infinitely more interesting, dynamic and more complete character because of his faults and his weaknesses. He accepted, incorporated, and even valued his flaws and shows how the human spirit can potentially impress a useful, functioning magick order on its surroundings. He shows a triumph of will and only his aims, his methods, and his results need to be questioned. If one is looking towards Crowley for any degree of guidance, this is not a practice I'd recommend because time and a lack of understanding into his background, his learnings and his teachers, and the age he moored in, and the relative naivety of the majority of people he both met and influenced.

The ideas Crowley spread are nowadays commonplace if one has chosen to look for such things and mostly the ideas have been refined, mutated, reattributed to their original owners. Crowley passed a vast body of works off as his own and was able to do so because of the general ignorance of the origin of such things. For example, he was responsible for introducing many yoga ideas into the west, as well as Tantric ideas (but via Allan Bennett and others who have remained overshadowed by their more media-interesting acquaintance).

It's an unfair and unfortunate fact that history is created by those who write it (i.e., historians) and not by those who actually live it, who are that history. And that a knowledge of propaganda techniques and how to successfully suppress knowledge can be more valuable and important than truths. Truth is unattractive in its natural state and is often overlooked, passed over in favour of attractively presented nothings and diversions. Another characteristic of the way things are. Perhaps the truths are attempting to remain unabsorbed and wear such dull clothes as a form of protective

camouflage. They resist absorption because to be absorbed, circulated, will change their essential being. Perhaps they are very particular about who or what idea they come into contact with. Choosing what to mutate into, or become part of, involved with. In this way, Coil choose to remain outside of general areas of thought, of beliefs. The Shaman's way. Always in opposition, against and to act as a shadow to the main body. Without the shadow, the whole has no substance, no strength or no evidence of existence outside of itself.

Austin Osman Spare was a modern-day sorcerer shaman who demonstrates a system of highly evolved, personalised magick that was highly potent and highly fluent. He was a superb draftsman, a mathematics prodigy, and an inspired artist with a degree of style and execution that can be breath-taking in its skill and almost fluid artistry. He was lucky enough to have both access to the shamans' deep-seated world of the psyche, sorcery, and artistic symbolism and images witnessed in the astral worlds in his role of psycho-sexual traveller — and the artistic ability to report and record a vast amount of these paranormal and mediumistic-like phenomena. Most people have one or the other gift. The combination is rarely given, even less rarely achieved (by way of extreme personal sacrifice and immense effort and discipline). Again, I don't recommend one copies Spare's results — although they are far more interesting than nearly all other occult documents. But that one gets to know how and why he evolved what he did, and one can then apply his 'formulae,' a mathematically precise system of symbols that both correspond and allow access to certain mental and psychic states and experiences, which he called the 'Alphabet of Desire', the 'Zos Kia Cultus.'

Thelema remains a temptation to me, but the strict adherence to a small notebook of prophetic type verses —

that Crowley himself admitted to understand only the most simple of — seems a particularly stupid and unthinking way to harness one's faith and energies to. I admire the methods and the madness, I mistrust the message, especially when it has come via a commentator. I fundamentally feel that only certain things can ever make sense, in life, in different combinations, to everybody. And a synthesis of learned ideas, first hand life experiences, and progressive scientifically strict trial and error experiments with whatever you've learned, what you instinctively know, and what you have faith in — only these things can begin to produce a valuable and meaningful effect on one's life and one's perception of everything and anything. Chaos magick — or Khaos as I prefer to spell it as it includes, for my personal amusement, both the letters A-O-S (for Austin Osman Spare) and K, for '11', the number for sexual magick, the same K as in magicK. It's also the correct Greek spelling. The CHaos also reveal symbolism but I've yet to check this out — throws all the old references up into the harsh winds of the times we live in and introduces science, pseudoscience, neurosciences, shaman-medicine, state-of-the-art computing, dayglo, acid house, hallucinogenic drugs, polymorphous perversity, black humour — plus a healthy distrust of anything and everything that exists or could possibly exist — an acute sense of place, time and purpose; of fatality, mortality and vitality of energies and synchronicities; of the powers of language, image and human nature; tricks, traps, strategies, camouflage, procedures. It plays with expectations, responses and biological inevitabilities and search for shortcuts, short circuits, confrontations, new ways to produce of primal, first hand, direct experiences. Khaos magick is a charlatan that pretends to be what it is not, in order to get to the very heart of what it is truly attempting to discover! It's that

complicated and it is that simple. Only the fool can show the king that he is the king. Loki working with Odin.

True magick finally gets down to the business of living in the here and now. False magick leads to self-deceptive patterns that self-replicate and spread like false rumours, luring innocents and damaging the practitioner and distorting his image and self-image.

I personally practice magick every single day of my life to some degree. Peter has certain beliefs and tricks and techniques to help maximise his lifestyle and help along the way. Steve rejects any such apparently medieval concepts and starts out on the barren path of the modern existentialist being, which I can relate to but cannot envy. Because to try and remain isolated in one's experiences and absolutely miserable state of existence is not an enviable state to be in. I'd sooner go through life clothed in useful illusions and interesting textures and deceptions that I'm aware of and make work for me, than face blinding, barren, interpretative facts about man and the uncaring nature of the universe. I personally suspect that ruthlessly to adhere to such a style of belief is a form of deeply romanticised and sustained unnaturally simple vision to maintain. The world of man and everything within, without, and between is as minute as it is infinite, as complex as can be imagined but built from as simple a formulae as can be produced to represent it.

(19) Stephen, I have briefly described. He came to live in London in 1984 while we were doing recordings for *Scatology* and he played a lot of woodwinds, especially saxophone and clarinets, on that LP, as well as guitar and percussion. In Coil we do not have a well-defined role to stick to. Generally speaking, Steve plays percussion and woodwinds. I do vocals, lyrics, FX, bass, Chapman Stick guitar, and some keyboards.

Sleazy does keyboard programming and FX. But all these roles are completely changeable if we can produce something in another way. No rules, keeps our interests up and enables us to create new things that would not occur if we had clearly defined roles in the group in the way many/most groups work. Of course, we each have things we do best and things we prefer, but that's the only thing that keeps a constant hold on us. i.e., Sleazy has no real interest in playing 'guitar' and Steve doesn't like to programme keyboards and computers. But the way we work is that as soon as Sleazy, for example, has produced a keyboard computer sequence, myself and Steve will take it apart, changing and adding, and in the end that sequence pattern will be clearly the result of all four of us, although Sleazy began it. You see how it works?

Clothed in Useful Illusions

1989–1992

'A Naked Man, Hung on His Cross, Sacrificing His Body'

Opscene, April-May 1991

Roy Mantel and Petur Van Den Berg

With thanks to Roy and Petur for permitting the inclusion of this piece.

Interview

After a long absence, the English band Coil is back with the release of *Love's Secret Domain*. A record of the *new* Coil. A switch? No, not at all. A change? Yes, it is. According to John Balance and Peter Christopherson, there is an old and a new Coil sound. About strange nights with strange people, the layering of sounds, puritanical toilets, spirituality, neurotransmissions and chaotic mathematics. 'I can press play, but it won't do any good.'

If all has gone well, the album *Love's Secret Domain* has now been released. '*Love's Secret Domain* is the same album as *The Dark Age Of Love*. But then again, it's not. If we had made *The Dark Age Of Love* three years ago, it would have been *The Dark*

'Sometimes we use drugs when we are composing. But only as part of our lifestyle. We also like vitamins and healthy food. Now we have a kind of fancy drug. It increases the amount of oxygen supplied to the brain and improves the connection of the left and right hemispheres, thus improving artistic intuition.'

Age Of Love. It's not really just that we changed the title. A lot of old material was just dumped. That just ended up on compilation tracks. We'll probably finish a few more. We're very conscious of the old and the new Coil sound. We just said: this is the old Coil sound, we'll leave it as it is. We only took what sounded new and exciting to our ears. But *Love's Secret Domain* is 99% new material.'

One striking element on *Love's Secret Domain* is the use of a didgeridoo. 'We saw a didgeridoo player in a television programme. I've always been interested in the instrument, but the way he talked through it, it fitted in exactly with what we were doing, only we were making those kinds of effects electronically. We did with a 24-track machine what he did with his tube.'

Another notable element of the new disc is the House influence. 'What we do is not House. What does interest us in House is the attitude, the thought behind it. It's a spirituality. That can mean many things, but what we mean by it is the freedom of the mind. We've been using Ecstasy since 1982. We knew you could do something with it, creatively speaking. We always did it quietly at home until 1987, when I think the scene started to come alive. It all started as a neat movement. We fitted in and kept it quiet. We didn't want to share it, you have to keep something like that small and confined to a small group of people. Finally, a year later, the whole country joined in. But we didn't want to make a House record. That would have been too easy. We would have felt like we were making money out of it. But in the end, we thought it would be stupid not to do something, just because of our "integrity" or something like that. The sound just crept in. We don't know how to make House, we make the music we want to make. With Coil, everything we're involved in is more or less conceived in

the music. And because we went through a time of strange days and nights, going to strange clubs, being with strange people and doing strange things, those experiences had a kind of spiritual quality. What was interesting for us, was the connection between that spiritual quality and the sounds themselves. The reason for the sounds is the associations we get with them and not specifically because those sounds are elements of the House.'

Also of value to Coil is the authenticity of feeling: 'Before, about three years ago, you could go to a club and you could feel the power dripping off the walls, you could see that people were connected in a way that I've never seen. Now people just seem to be able to mimic that. They do have fun, but it used to be about this freshness and an almost religious ecstasy. The only thing that is really interesting to us is the way that the music, the volume, the dancing, the drug, you can have an experience that is ecstatic in the old sense of the word. The drug was called that because it suited the feeling perfectly.'

That Balance and Christopherson are not averse to the use of hallucinogenic substances is obvious – the first letters of Love's Secret Domain form the abbreviation LSD. 'We first wanted all the titles on the album to be abbreviations of LSD, but that would have been stupid. The negative side of drugs is much more expressive than the positive side. You can use drugs as a kind of excuse for your problems, they can be bad for you mentally. But everything can be bad for you. It depends on whether you are lazy, or if you go out and research to find out what is available. We use drugs with good results, but it is difficult to recommend such things to others. Sometimes we use drugs when we are composing. But only as part of our lifestyle. We also like vitamins and healthy food. Now we have a kind of fancy drug. It increases the amount of oxygen

supplied to the brain and improves the connection of the left and right hemispheres, thus improving artistic intuition. In Thailand, you can get this drug without a prescription.

By the way, we shot our video for 'Windowpane' in the north of Thailand. It was on a kind of island in the middle of the river, where the various tribes exchanged their opium for gold bars with the CIA. A place with a very alienating atmosphere, even when you are completely sober. We found out later when we stood in the water that it was quicksand. But the cameraman told us to keep singing as we were sinking. The Thais told us about their friends who had drowned there. It was a dangerous place. We were also warned that the Burmese police would shoot at us, because many smugglers were active in that area. The policemen sat all day waiting among the trees, and if they saw anything moving, they would start shooting. We were told to wave money at them and they would come to us and take it, meaning they would stop shooting. So we really risked our lives for that video.'

To come back to the drugs: in the Netherlands you also have these kinds of drugs. They work on certain parts of your nerves and stimulate your neurotransmissions. There's also a drug that makes you learn faster. You take it, for instance, two weeks before your exams and it improves your memory. The stuff has been tested on American students. We use this kind of thing to make it all a bit clearer and brighter. You can then understand things better.

The key question is whether the unsuspecting listener should understand it and what he or she should understand. What's it about?

'Coil is autobiographical. It's not about conveying a big message in a political sense, but it's about things that we are personally

involved in. That can be personified within the music. It is an instinctive process. *Horse Rotorvator*, for example, had a lot to do with death. Really morbid and down. We were in a situation where a lot of our friends died. That was incorporated into our music as a matter of course. We were celebrating death. We didn't want to support the Western negative attitude toward death.'

'*Love's Secret Domain*, however, is more an album about brief moments of inspiration: fear, orgasms, pleasure and ecstasy. If it's possible to have a good time now, we should enjoy it now. Again, it's autobiographical in that sense. It's our life, a distillation of what we believe; what we want to believe.'

The homosexual orientation of the band members is also an element that pops up from time to time. In puritanical England, the press doesn't ask about it: 'We'd have to give them an answer they wouldn't be able to publish. It is not a problem for someone like Jimmy Somerville, who sells a lot of records. He sells his homosexuality. In our case, I don't think the editors of *Sounds* or the NME would be interested in it.'

It sometimes seems that there is some kind of strange censorship by the editors of such magazines: 'Nick Cave is said, by the NME, to have stated that we were very good, that it was only a pity that we were gay. Maybe he didn't say that, because I only believe things like that first hand.'

The amount of fan mail from like-minded young people is skyrocketing for Coil. 'We get a lot of letters from all over the world. A lot of people thank us and tell us that it was the first time they heard a record that stirred up their feelings in a certain way. Often they feel guilty. They wonder if Coil's records aren't actually a bit dangerous, because they've awoken something in them. There's a lot of mail coming in from sixteen-year-old kids. You're a mess mentally when

you're sixteen. I don't know if we should feel responsible for it or not. In a stronger sense, it is a compliment. When I was sixteen, I felt a kind of sympathy with writers like William Burroughs, because they wrote about things that I found exciting. I had the same thing with music and I think we can continue that tradition, a tradition of making a sound recognisable to people who feel like us. We don't make it an emphatic statement, we give them the power to be different. We need to do this for ourselves, but it's nice to receive so much feedback.'

Coil's work has a strong associative power. 'It evokes all sorts of things when I'm listening to it. With our music, you get memories of things you haven't really seen yourself. I'm not sure what it evokes, but they are very strong feelings. It's like the feeling that comes over you when you're in a place you've never been. Or in the future.'

The creation of those kinds of associations may have its origins in the way that Coil songs are constructed. 'We don't work in a way where we first compose a song and then perform it. We work by putting ingredients together, then seeing what happens and then changing it. It's a kind of building process. One layer on top of another. With the new record, there were a lot of things that were very prominent at first, but over the course of three years, they became more and more distant. It's a kind of archaeology, but in reverse. You have the different layers that represent the eras. The oldest things are in the lower layers, the most recent things are on top, so there's a lot hidden away deep down. We talked about "deep listening" in the press release. A lot of the important parts of the music are not in the top layers, you might not hear it the first time, nor the second time and maybe never. But it is there. Maybe one day, when you're listening with the headphones, the lights are

off and your eyes are closed, then suddenly... There's Satan's voice in your head, saying, "Kill kill kill."'

'No, it's not that, but something will enter your mind. There's a lot of material that's buried. And that's not meant to be subliminal messages for the subconscious. All that stuff about Satan whispering messages to you and telling your son to kill himself... It's just bullshit. In England they haven't tried to find Satanic messages in our music because we don't sell enough records. But in a song like "Chaostrophy" for instance there's a fourteen-piece orchestra. The first minutes you can't hear it. It's completely buried. It's completely distorted. In "Further Back And Faster" you can hear thousands of voices. They are many layers of tapes. Often we ourselves don't know what's in them anymore. That's because sometimes we make a recording, put it in a tape loop and then use it again under the next set of recordings. We then play the tape again, run it through a gate and you have a kind of rhythm. Our sound engineer works closely with us and uses tricks we don't know about. He sometimes leaves things out or puts things in. He knows what we want.'

People who know what the band wants, are the people they can work with. However, it seems a strange contrast to work with people like Marc Almond and Annie Anxiety. The former is a sweet romantic in the positive sense of the word, the latter is a political extremist.

'You'd be surprised how similar they are to each other as people: they're just individuals who express themselves in different ways. Marc is quite political. He has strong opinions on certain subjects. He has a very strong belief in personal freedom, which is at the heart of his work. He is honest about his homosexuality. He makes a kind of eloquent music that deals with taboo subjects. He manages to get across

to teenagers. Annie does it her way with Crass. They're both people who believe that the individual should prevail over society; they both have different ways of expressing themselves. And the fact that they are different only makes it more interesting for us. Differences between people working together make the combination all the stronger.'

In an old interview with the *NME*, the gentlemen spoke of the eroticism of Catholicism: 'A naked man, hung on his cross, sacrificing his body. Spiritually, it's a form of divine cannibalism. The ultimate sacrifice... Sex is a smaller sacrifice, isn't it? There are thousands of ways to say Catholicism is erotic. It digs right down to the pleasure and guilt caused by that pleasure. That's the core of Catholicism. That's why they have sacred objects, they're containers of guilt and pleasure. Only certain people can give you access to them. They have relics that contain centuries of guilt and pain, caused and controlled by a fabulously difficult man, that you just have to live with.'

Yes, listening to Coil gives the feeling of a religious experience. 'It's the state that people should be in. It's a state we strive for. Most religions pop up and say, "Here we are, do it my way." It would be much more useful if people worked out life in their own way. It's the fight of paganism against the church. Because Paganism says that every man and woman is themselves God and therefore has the power to overthrow old structures. That's why the contemporary English church sees it as a threat. They want only their system to exist. Friends of ours with occult bookshops are fire-bombed and bullied out of the country.'

When you say everyone is their own God, isn't that the same as saying there is no God? 'There are as many gods as there are people. God is believing in yourself, fulfilling yourself, expressing yourself — and all that as fully as possible. You

don't need anything else. It's not like many Westerners think: "There is an us and there is a them." All is equal, there is no I and there is no you. Everything is a whole. Separate aspects are of lesser importance. It is wrong to let other people talk you into some kind of subdivision. It's simple and complicated at the same time, because it immediately creates problems. People want to relate to other people. People want to distinguish themselves and keep the others separate.'

'Then when people are in groups, they're a real threat. In London, you need permission from the police for a gathering of several people. The rules about the routes you can take with a demonstration have also become much stricter. There are permissible routes from one park to another. So there have been protest marches that no one has ever seen.'

Another wonderful example of the English mindset on social issues: 'English music stations have no desire to play records that can be associated with the Gulf War. They don't want to hurt anyone's feelings. On television, for example, all planned war movies, films about the desert and that sort of thing have been cancelled. Anything with camels in it is gone. On the radio: all the acts whose names might have something to do with the war. Like Bomb The Bass and Massive Attack, had to change their names. It's absolute madness that people in power think that it is better to protect the population from the truth. What people need is information. People need the truth.'

The current economic state of England doesn't leave Balance and Christopherson indifferent: 'Perhaps it finds its echo in our music, which is simply the reflection of what we feel. But it's usually better to support your allies than to fight the opposition. *Love's Secret Domain* is for people like us. People who are almost like us, or people who are not like us, but could be like us after listening to the album. And that's why we do

it; if we want to fight against a situation we do it in a different way. The title track is an angry song and there are references to William Blake's poetry: "*Oh rose, thou art sick.*" The English are traditionally repressed.'

'For example, if you've taken a shit in the Netherlands, you can look at your shit, it stays on a kind of platform. In England, it falls straight into the water and you can't see it. That says it all. In England, it's all gone before you can do anything with it. We shit on puritanical toilets.

'I wonder what will happen in 1992, when all the countries of Europe start to harmonise their laws. In the Netherlands the laws become more and more logical and humanitarian, while in England they make them worse and worse. They are now working on a law that makes it impossible for two men to stand still and talk in the street. That is absolutely absurd! They might talk about having sex later. There is no reason for that kind of fear. There's not an increasing number of people who want that but they increasingly want to suppress that kind of thing, before Europe gets too big a stake. They develop ridiculous laws.

'We have friends who do piercings, putting rings through different parts of the body. Recently, eleven of them were prosecuted. The police claimed that the people had assaulted themselves. There was no victim at all. It sounds like a joke, but the judge was serious: if it was for decoration, he said, it would not be a problem. But it was for fun and that was the worst crime he had ever seen. Those people were locked up for five years. Just because they had rings attached to their dicks. One boy had driven a nail through the dick of his regular boyfriend. They had taken pictures of it. It was considered a victimless assault. I mean: a sexual assault is an attack on someone's body against their will, whereas here it

was something his friend had done on request. That boy had to serve five years in prison.'

The English media also show a certain unhealthy diffidence when it comes to subjects not quite in line with Victorian standards. 'They do not, and will not, show a condom on television and say, "Use this because this will help prevent AIDS." They've improved the adverts since, because they realise that the financial impact on the health service is considerable. We're outraged by that kind of situation. That's why we did 'Tainted Love'. We've been seeing this kind of thing happen since 1984. Have you seen the video of that song? I can't watch it anymore because it's come true. It's even gotten worse. But our government still does nothing about AIDS. They don't give a penny to it either. They would rather spend it on bombs for Baghdad. This also has its roots in the British tradition: the Crusades in the 16th and 17th centuries. They're used to going to the Gulf and looting oil, money and carpets.'

There is a song title on the new album that seems to be a reference to the conditions in English society: 'Chaostrophy'. The elements chaos and catastrophe fused together into a word that seems to have a cause and effect relationship. That turns out to be too far-fetched, although the members of Coil do have an association with the word chaos. Chaotic theory appeals to them.

'That's a system we're both terribly interested in, but never worked out. The basic theory of small events and big consequences. Unfortunately, like acid house, it's become a kind of fashion. Chaos theory describes how nature works. For the first time, mathematicians devised formulas that described the leaf of a tree. Or the formation of a coastline. It's a very important breakthrough in mathematics because nature doesn't really have many straight lines. They now

think they have found a way to imitate how, for example, the natural lines of a tree are formed. The inference is that with a computer — working in a very logical way with the binary system — a chaotic mathematical process can be imitated. For example: you get computers that work like the human brain. The first major application of this kind of technology is in flight simulators. In America there are already pilots who have been trained in a flight simulator that displays images of deserts 100% realistically. Perhaps in about five years' time, you will have a kind of helmet that you have to put on in order to see an imaginary landscape; a landscape that moves very naturally. You could then, for example, play games in a sort of three-dimensional environment. It would be possible to go to business meetings without having to travel. Everyone has a kind of helmet on, which simulates the place where they should be. The computer then provides the reality, you don't have to be somewhere to experience, to react. You wonder what is reality and what is not. Perhaps in twenty years or so, Coil will participate in this kind of "landscape gardening." Perhaps we would rather do that than make music. Or a kind of musical landscape that contains all the elements we want to play. Perhaps it will even be possible for us to perform live to an audience wearing helmets.'

Because performing with the current equipment is not something Coil want to do, despite the many requests they have had. 'The music is in about four computers, and I just sit there doing nothing. I can press "play", but it doesn't do any good. I would much rather be doing something real.'

'You Let The Future Leak Through'

Justin Mitchell & John Eden, 16th May 1991

Introduction, John Eden

16th May 1991: Justin was nervous. I took the piss out of him — we were only going to have a chat with three men... But this was bluster to calm my own nerves. To say we'd both been listening to Coil since the mid-80s did not do the situation justice. There are few casual Coil fans and back then their slim discography sucked you in like a vortex, engulfing you in a world with its own iconography and geology, a world of sounds that became etched into your subconscious. We'd pored over interviews, sleeve-notes, traded obscure tracks off compilations, while lunging awkwardly though many doorways Coil opened for us. Immersing ourselves in Coil's cosmology was a glorious escape from suburban life, but now we were going to meet them — we just hoped they wouldn't think we were dickheads!

I was 21 years old and this was the first interview I had ever been part of. Justin organised it and I eagerly tagged along. I'd bumped into Justin three years previously in Holloway Tube while we each tried to find a Temple ov Psychick Youth squat event. We were both covered head-to-toe in Psychic TV regalia and very much lost... In quite a number of ways.

Since then Justin had been carving out a niche with his Cold Spring label. He'd also started a column called Pure focused on weird music, for a short-lived paper called *Spiral Scratch* — essentially *Record Collector* for goths. I, meanwhile, moved to London and immersed myself in matters occultural instead of studying for my degree.

We were shown into the front room and stammered through our questions. The three people we were clumsily interrogating took on different characteristics. Sleazy was pre-occupied with a man who had come to fit a carpet and hardly said anything. John Balance was as helpful as can be, straining to answer even my most stupid questions. And Stephen Thrower was bluntly Northern and very funny, even if it was at our expense. Listening to the tape again is agonising but feels remarkable for being an almost perfect conjunction of our obsessiveness and the group's generosity.

That evening was the Current 93/Death In June concert at the Venue in New Cross. To more than a few people, I not-so-casually mentioned that I had just interviewed Coil. I briefly reacquainted myself with Balance at the bar and apologised for being nervous earlier while he remained gracious.

Across the '90s, I grew more politicised and became weary of transgression and music that was overloaded with iconography: for a while, Coil were the baby I threw out with the bathwater. But that didn't last. 29 years later, Coil's ubiquity has endured and my critical distance from their work has only underlined the vitality of the doorways it opened.[1]

1 Excerpts of this interview featured in *Spiral Scratch*, *Der Gurtel* and *Minotaurus*.

'I hate clubs. I hate the people, I can only stand two or three at once. If I see large numbers of people enjoying themselves, I automatically start having a bad time.'

Interview

JOHN EDEN: So are there any underlying ideas behind the LP?

JOHN BALANCE: The press release says 'electricity and drugs'...

JE: Oh, I didn't get one.

JB: Well, it is that: energies. We started off three years ago. We had the idea of going back and, you know Tesla? The inventor? Of doing an album as if he'd done one in Weimar Berlin or something. Like a decadent early electronic cabaret album. It was a weird idea but it started like that, then it evolved. We've been recording on and off for about three years, but it's not that it takes that long, it's that we've had no money to finish it, we've messed around and things.

STEPHEN THROWER: It's changed titles about three times... There's about three times as much material as is actually on there because the other two-thirds we got completely sick and tired of and threw away, we got so fed up with it.

JB: When we did *Horse Rotorvator* we had almost enough for a double LP and we left the other material and we were going to do one called *The Dark Age Of Love* that was deliberately like a twin or a follow-up to that. Time passed and we changed our minds and ditched most of that and started new things.

JUSTIN MITCHELL: Going back to the early days of Psychic TV when you and Sleazy were members, you had Coil going then didn't you? What was the dissatisfaction in being part of another band that made you leave Psychic TV?

JB: It was personal things between us and Gen. The turnover that group have had since, it shows where the source of dissatisfaction is. It all came to the head when we did that

World Detour in America and found out Gen's real aims — i.e., he'd get all the money first then pay us a pittance.

JM: So his accusations that you've made vast amounts of cash from bootlegging — or Sleazy, Chris and Cosey bootlegging or giving permission to bootleg — Throbbing Gristle...

JB: Is that what he's said? I don't know what he's said but, as far as I know, he's done all that. I did one bootleg — *Assume Power Focus* — with his permission, he chose the track-listing and did the sleeve notes so it had his consultation... His approval. It wasn't with Chris and Cosey's approval, it was the other way round.[2]

JE: It seems like, as Coil has progressed, you've picked up another member every time you've done a record. Like, it started out as pretty much just you, and then Sleazy came on the scene. Looking at the picture on the new LP there seems to be another bloke?

JB: Another person who isn't here today, yeah!

JE: So who is he and where's he from and what's he doing?

JB: I don't know where he's from and I don't know where he's going, he's called Otto Avery. I'm not sure how old he is, about 18 I think? He's a mad acid kid, he sort of appears, he doesn't do anything on the record. He was there when we did it and he wants to be a member so we let him — he photographs quite well. But he's disappeared again so if I wanted him to do something I don't know what he will do. He's probably in prison or something.

JE: ...Was it like a spiritual thing?

2 Elsewhere Balance stated that neither he, nor Christopherson, ever received payment for live LPs issued by Psychic TV containing their performances. He also claimed they were due payment for selling their share of the rights to the name Psychic TV to P-Orridge.

JB: Well, we just thought we needed a younger person in the line-up so we just grabbed the nearest one.

JE: Talking of acid, I noticed that *Love's Secret Domain* is LSD...

JB: Oh really?

ST: Gosh, it is isn't it? (All laugh)

JE: And it's a pretty acidic album basically, acid house influences are pretty obvious.

ST: I think even the tracks without what you might call acid beats are actually best experienced in a state of complete mental drug derangement...

JB: It was made in that spirit and is designed to be listened to in that spirit.

ST: Although it was just cups of coffee...

JB: ...And Guarana.

ST: Sort of like a spur to our endeavours.

JB: The whole album hallucinates as far as I'm concerned. I'm not quite sure what I mean by that but it does, it bubbles and warps every time I listen to it.

JE: It's a really deranged album, it's different every time I listen to it. The first time I heard it I didn't like it at all...

JB: A lot of people have said that. It's a grower. Do you like it?

JM: Yeah, I like it, it's not what I expected.

JE: There's a lot more going on, it's very dense.

JB: That's partly because of us reworking everything, it's deliberate. This is what I mean by 'psychedelic', something that's got more layers and interacts with the listener. All the

best psychedelic music does that, you have to work toward it, it doesn't come and get you immediately. All these 60s revivalist groups now are just copying a style and I don't think that's psychedelic at all. Psychedelic music is something that expands and you expand with it. I think it's in the spirit of Can, or the early German groups, and a little bit like early Throbbing Gristle as someone said earlier today. It's just that we were experimenting, going back and using old tape techniques, like cutting up quarter inch tapes and everything we felt like using.

JE: Like Burroughs' cut-up techniques?

JB: Yeah, you let the future leak through is what they say. You let things in which you're not sure about, you know you're just opening the door and people are coming in.

JM: So, perhaps, you haven't got that psychedelic foundation in any other recordings, and if there isn't then is it because of the resurgence of interest in the 60s that you've...?

JB: No, I think this time we let our influences be felt more, not just acid house, I mean, we were doing Ecstasy back in 1982 when it was legal. It's just that we've never bothered to be so obvious about it and having explored slightly portentous, not pretentious, but more solemn music in the early stuff like *Horse Rotorvator* — big funeral echoes and stuff — we decided on more raw sounds, much rougher...

JE: ...It's a lot more fun as well.

JB: Yeah, fed up of being doomy and gloomy.

JM: A lot of the bands are doing this as well, Psychic TV, even Neubauten are starting to be a bit less noisy to listen to...

ST: Do you think this album is easy to listen to?

JE: No.

ST: It's more diversified than anything we've done before. There are things there that are easier to listen to than anything we've done before but there are also things on there that are completely broken up and fragmented.

JE: It's a really diverse album...

JB: As usual. That's partly the thing, because we work for a year or so and we have a lot of ideas and they all happen to go on one record, so that's where this diversification happens.

ST: There's a problem with some bands who try to absorb acid house influences, that they tend to get absorbed by the format rather than them absorbing the format. What's left is hardly recognisable as them at all, whereas I think with this album there are bits of it that bear absolutely no relation to anything happening in any club I've ever been to. We've kept control of it, it's not controlling us.

JE: Have you been getting into the house scene?

JB: That's a bad question for Stephen, I know he hasn't.

ST: I hate clubs. I hate the people, I can only stand two or three at once. If I see large numbers of people enjoying themselves, I automatically start having a bad time.

JB: But we did. During the making of *Horse Rotorvator*, around that time, three or four years ago, I started going to Confusion, then I went to Shoom which is the one everyone mentions — but Confusion was going on at the same time and was far wilder, Shoom was full of people from the West End with more clothes than sense as far as I could tell. Confusion was really raw, people having a good time — there were a lot more black people there while Shoom had hardly any — it was more

enjoyable. So, during *Horse Rotorvator*, I was going out to things like that then coming back and making music. So, after a while, it isn't that it wears you down, but you just want to reflect what your interests are. I mean, we haven't gone totally house, there are only a few tracks where we've let it... 'Dance.'

ST: You could spend your whole time on the dancefloor. You listen to Cabaret Voltaire and you could be forgiven for thinking they get up in the morning and they sort of... (rave impersonation to much laughter)...As soon as they get out of bed and that's all they do for the whole day. There's no trace of the other things they used to do in their work.

JM: And Marc Almond is singing on this new album, is that just because he's a friend?

ST: Yeah, he's a crap singer but he's a friend so we let him do a song.

PETER CHRISTOPHERSON: I like his voice.

JB: He wants to sing on more things but we won't let him.

JM: Do you see Marc a lot?

JB: Yeah, unfortunately. (Laughs) Once a week. Comes round for his tea on a Sunday.

JE: Annie Anxiety's on it as well, I'm trying to think if she's the first female singer on a Coil record?

PC: No, Rose was.

JB: Yeah, Rose is on it as well, on 'Windowpane.'

JE: How did you meet Annie?

JB: She's been hanging around for ages. I've known her since the Crass days. All these people are like, really early on. Marc

we've known since *Non-Stop Erotic Cabaret* — he worked with Psychic TV and things. When you come to do something you look around and see who might be interesting for us to use, I mean, Marc was — again — interesting: he played guitar on one of our tracks before called 'Restless Day', it's him playing feedback guitar on it, and he's done vocals before. We've had lots of ideas about projects, we were going to do a mini-album with him, it just happens that he fits in, I wrote the lyrics for him and he liked them. It was just interesting for us to use a female vocalist, Annie, as we know her and knew what she did, we got her in and gave her the brief of the ideas: it was sort of like a shell-shocked Nicaraguan woman or something, and she played off that, it was improvised in the studio.

JE: Are there other influences given there are magickal groups on the sleeve notes...

JB: Magickal what? Groups?

JE: Yeah, like the Illuminates of Thanateros (IOT) and Esoteric Order of Dagon (EOD)...

JB: Yeah, just anything with initials I put on there.

JE: I don't know how close you are to them, magick obviously plays an important part in what you do and you've got a pentagram round your neck...

JB: ...Well I must be into magick then, mustn't I?

JE: Must be, couldn't just be one of those gothic poseurs could you? (Laughter) I mean, I found 'Windowpane' has gold... Alchemy... I'm probably going completely up the wrong track here but...

JB: I mean, I like gold, I like the idea of gold and how it's a symbol. 'Windowpane' is, again, another acid song. You get

'windowpane acid' and I saw a guy doing it in a club and I thought it was a good idea because the visions he'd have came through seeing through his eye, and 'the eye is the instrument to the soul' as it were. I was just playing off of all of the words and how he might see the sky as gold and power, energies, it all comes back to energy and electricity again.

ST: Like what you were saying about doing a more positive album as well, 'golden sky' is a really positive energy isn't it? Inspiration and everything, less miserable...

JB: And it's not done in a sentimental way either.

ST: No, it's quite intense.

JB: I don't deliberately think 'oh let's put an alchemical reference in,' it's probably because I've read all the books and that's the way my mind works and that's the images I'll pick up on.

JM: On the liner notes I saw it says 'no thanks to Stevo and Some Bizzare,' how come everybody left? Everybody apart from Neubauten...

JB: Neubauten have left really, but they've sort of gone back again, I don't understand that — maybe they're contractually obliged to? Because Stevo claims to go on trust and everything's on trust there and you don't have a contract — well, in fact, half the people do — and basically Stevo's betrayed that trust. He's fucked us over to the tune of about twelve thousand quid and won't let us release our own records and back catalogue to anybody else. So he's on the top of my hated list at the moment.

JE: So now you're on Torso...

JB: ...They're in Holland.

JM: Have you played in Holland?

JB: No, not yet, we're talking about it — which is all we're doing. Having been around for about eight years I think we might get it down and do something live.

JE: What kind of deal would it be?

JB: Dunno. It'll be good. And it won't be to backing tapes like Front 242, etc.

JE: More danceable stuff or...?

JB: I don't know, it'll be more up-tempo, I'm not sure it'll be absolutely 'dance', baggie kids dancing around and stuff, but it'll be — well they can do if they want, I'm not going to stop 'em! It'll be more beat-orientated, more physical, I'm not sure what that'll entail. I don't think we'll go for the pastoral quieter bits because that's not for live.

JM: Do you have any idea what your audience is?

JB: Only when they come round to our house and stuff. I've got a vague idea, but it's not up to me to find out what they look like or what they want. Last time I met Psychic TV people, strange. They used to be miserable 'industrial' people then they got a bit nicer — in America they were nicer — but they've all changed again, they're all sort of multi-colour rainbow children now.

JE: Does it bother you who listens to your records or do you just want the music to be released?

JB: I don't target an audience at all, we don't say 'let's aim for 14 to 20 year olds with an income of so-and-so', you know? We've always just done what we want to do.

ST: We occasionally pass people in the street and say 'I wouldn't mind aiming my product at that person there...'

JB: You can't tell really. You just do it and hope that people like it... Is that... Sincere? (Laughs)

JE: What sort of methods do you use to compose material? Is anybody trained to play keyboards proficiently?

JB: No, Stephen can play a tune on something but we can't.

ST: Well not much more than that really...

JB: Well, we say we can't but when we get down to it we find we can — to our horror. What happens is you just do little bits then you go into the studio and improvise around it usually...

ST: ...You improvise, then you study the improvisation, and you extemporise around that...

JB: ...And you build on it...

ST: ...And then you think about what you've just done and take a bit off.

JM: The new album, it sounds more as if you've left a lot of improvisation in, and lots of bits coming in and out, and not really as structured as *Horse Rotorvator* which didn't have much room for improvisation.

JB: *Horse Rotorvator* was as near to 'songs' as I ever wanted to get and I had that deliberately in my mind, I said no way were we going to have verse-chorus-verse-chorus this time. So it's more open-ended and more... Pop Concrète or something.

JE: There's some press saying something about 'the accumulation of male sexual energy'...

JB: I don't understand this, that's an old phrase of ours... So, it isn't. Basically. I'm not sure what to say about the album really, there's so much in each 'bit', it's hard to sum it up. It's deliberately for people to work out and get into, more so than most records I think.

ST: There's a lot less specific pointers on this record.

JB: Every time we came across something specific and obvious we'd cross it out or we'd fold it up or harmonise it or flange it and fold it in again.

ST: The trouble is you do a record like *Scatology* with extensive sleeve notes and quotes from all sorts of sources...

JB: ...Which were ironic...

ST: ...And then you do another record where you don't actually want to point to the sources as much, and everyone goes 'well, what's this one about?'

JB: 'Where are the sleeve notes?' For the first time there are actually tracks on this album when people say 'what's that about?' I can proudly say, 'absolutely nothing.' I like that and that's deliberate. You tell me.

ST: It means what it is.

JB: Or does it?

JE: Well I won't ask you questions about it then! (Laughs) Can I ask you about where the samples of voices came from on 'Further Back And Faster'?

JB: From *Performance*, the film...

ST: Some of them do...

JB: Some of them do, the first bit, he goes 'electricity pulses.' Some of it's from Andrea Feldman, one of the Factory, Warhol's crowd, who jumped out of the window and committed suicide shouting 'I'm going for the big one!' She's the only person who was clinically addicted to LSD, which is an impossibility, but she managed it, actually needed it, and it's her going 'I need acid...' in the background. There's a lot more I can't remember...

JE: There's the 'tattoo'...

JB: Oh right! There's a film called *Night Of The Hunter*, it had Robert Mitchum in, which is sort of black and white, American gothic kids' story — a really good film. And it was directed by Charles Laughton, who was the hunchback in *The Hunchback Of Notre Dame*. It's his voice narrating on a record of the film.

ST: He only directed one film, his sole directorial thing.

JB: He was a gay actor who ended up living in Bridlington or something, with a 16 year old boy. But he was a really good guy and it's an amazing film, so it's sampled off the record of the film. It was taken almost by random when we were completely off our heads and tried to make sense of it. It was an agonising process. I had like 15 fingers trying to play the keyboards with these samples on. Heavy going.

JM: Did you write *Scatology* and things like that in the same frame of mind?

JB: We were speeding I think, more when we were angry young men.

ST: We were speeding this time as well...

JB: Oh shush! Shush...

ST: I'm still an angry young man!

JM: What other artists and writers influence you these days, do you have any influences outside...

JB: We have influences, food mostly.

ST: Outside of what?

JM: Outside of psychedelic substances...

PC: Smart drugs!

JB: Yeah, smart drugs, what are they called? Cognitive enhancers, that's what we're into.

JE: Do they work?

JB: Yeah, have you read about them?

JM: There was a thing on the television about them, The Shamen are really into them.

JB: They're pussies compared to what we're into! (Laughter) Battle of the smart drugs with them. We swap smart drugs with The Shamen, they're always phoning up saying, 'we've just got some vasopressin,' and we say, 'give us some!' And they say, 'it's gone already!' You can buy these things legally so you get them shipped into the country.

JM: Is there any obvious conscious effect?

JB: Absolutely. But it's not a high of any sort, it's over a long time. In Thailand I was taking piracetam — it's called a nootropil. Just everything works better in your brain, you're clearer, you wake up, you feel it — you're probably not — but you feel it. You talk better and think better and you remember better, you remember things from your childhood, it all seems to flood back and you think 'God, I haven't remembered that person for ages,' so they do work. Placebos wouldn't do what these do I don't think.

PC: There's no reason why chemicals shouldn't have that effect on your brain considering the chemical basis of your brain. If you just find the right chemicals you could do anything.

JB: It just speeds up the working of your mind by 10 percent, or 20 percent, and you can take other sorts that work on different parts of the brain, like memory. Vasopressin works on the process of memory, so on vasopressin you remember things much better and it stays in your mind as well.

PC: They all work by increasing the blood flow between the two sides of the brain...

JB: Well not just that, though that's basically it.

ST: That's basically it, increasing the amount of oxygen that actually gets to the brain cells.

JB: But it works between the hemispheres and that's where creativity comes from, between the two. It enhances that considerably. It's really good for working and I'd love to get some more for the next album.

JE: Is it expensive?

JB: No, that one actually isn't. You can get a box for about eight quid and there's 60 in it. Take about three a day, it's affordable.

JM: Is it used for senile dementia?

JB: A lot of them are. There's one called arcalion that's used as well. I've got brain damage from all the other things that I've taken so they haven't done much for me yet, but it's repairing basically, 'fixing the holes where the water gets in.'

JE: So, is recording for you continuous?

JB: No, not really. It's a continuous sporadic process. You do it for a few weeks, then leave it for six months, then do three more weeks. I hope that's the last time it happens and the next one we're going to do is going to be ready by September or so.

JE: You said that last time... (Everyone laughs)

ST: Basically we do as much as we can afford and we can handle, then we have to wait until (a) we've recovered and (b) we've got some more money. That's the automatic pacing process that means we don't do an album in three weeks in the way that some people do.

JB: We've got aspirations toward it though.

PC: In terms of actual hours, it is probably four or five weeks continuous work, but we couldn't possibly do that in one lump.

JM: So, what sort of numbers are the records selling these days?

JB: I don't know yet as they've only just come out really. No idea.

JM: Well is the picture disc just sort of a marketing ploy?

JB: No, unfortunately we don't sell in sufficient amounts. It would be a marketing ploy if we sold in such amounts to make it worthy but it just happens that we've got some of those left and they went abroad, so as a marketing ploy to get into the charts it just wouldn't work.

ST: If Steve Stapleton releases a picture disc you could hardly accuse him of a marketing ploy...

JB: It's a marketing ploy for us to release a record at all.

PC: We like to do collectable items because people like to collect them.

JB: And we like to collect them.

PC: It's unfortunate that vinyl is so close to its demise.

JB: That's not what you said the other day. 'Death to vinyl!' and 'why did I keep doing these stupid picture discs...'

JE: Do you listen to stuff on CD or vinyl?

JB: I listen to a lot of dance stuff and that mostly comes out on 12". I like CD albums a lot more, it's better sound usually.

JM: That was your listening to influence the writing of the album, dance stuff, the things that you're interested in, going to clubs and so on?

JB: More going to clubs than listening to it, the whole experience, not just the music. And not all the music either because I hate lots of it. What other listening influences do we have?

ST: I don't know. I've stopped listening to music now. I used to listen to lots and you never used to listen to any.

JM: So you don't keep an interested ear on other bands?

ST: What other bands?

JB: Our so-called contemporaries? No. Nurse With Wound I do.

ST: Yeah, 'Journey Through Cheese' by Nurse With Wound is one of the greatest compositions of the last 20 years I think.

JB: Of the Twentieth Century.

JE: You're always lumped in with Sol Invictus and Death In June, Current 93...

JB: We're going to see them tonight.

JE: ...But I don't really see any musical connection...

ST: Well we hardly ever use an acoustic guitar, even when we do we don't 'play' it.

JE: Is it sort of like you're just friends with some of them?

JB: Friends with 'some' of them, yeah. I'm not enemies with any of them, but I'm friends with some of them. It's because of Psychic TV with Tibet, people still look back that far to 1982 or whenever it was.

JE: Does it bother you people harking back...?

JB: It depends how they hark back. If they've got a point to make then no, not really.

JE: It's incredibly boring when people keep going back to grey uniforms and Charles Manson and *Dreams Less Sweet* when things seem to have progressed so much — it seems retro...

JB: Yeah, who likes Charles Manson now? Still sending him grey trousers.

JM: Has he ever replied?

ST: Giving him the address of Stevo... Once he gets out on parole does he fancy coming round? (Laughter)

JB: There are certain philosophical threads between people like Boyd Rice, Current 93, and us. Tibet's renounced his Crowleyian interest but he still keeps up to date with it all and releases CDs of Crowley, his poetry...

ST: Who are our contemporaries? I really don't know.

JE: It seems like a lot of sections of music like Coil, I saw you mentioned in an interview with Napalm Death and they were quite into what you were doing.

ST: That's the kind of thing I like because you wouldn't immediately think of Napalm Death as very closely linked to us, and yet they like us and we like them. And yet we're a million miles apart.

JB: Mark Stewart likes us. That was a real shock for me to find out.

ST: I thought we'd be too decadent for the guy who wrote 'For How Much Longer Do We Tolerate Mass Murder' but there you go.

JE: There just seems to be two types of music, good and bad...

JB: Yeah, quite, and when you meet the people who make that music it sorts it out even further. There's shit people making good music still, so you just whittle it down and eventually collaborations arise and things happen.

JE: Are you going to be collaborating with anyone else in the near future?

JB: Which brings us to... Yeah. Tim Simenon of Bomb The Bass wants to do something with us, but not so commercial. He wants to remix 'Windowpane' for a start, which I think we'll let him do. And he wants to do something weirder, whatever that means for him. And we're going to do an album with Nurse With Wound, one day. We keep talking about it and Steve lives abroad now so it's quite hard to get hold of him but eventually something will come up of that. A proper collaboration, not as Coil or Nurse With Wound, a sum of the parts. Quite good for people to work out who did which bit.

JM: There was a time when you didn't have any label at all after Some Bizzare wasn't there? Why did you go with Torso, who are a Belgian label?

JB: Dutch. Because they had *Horse Rotorvator* licensed over there and they had enthusiasm, they filled a shop window up with album covers — even when it wasn't their product — for our records. They showed willing and were nice to us. I'm not sure they offered us huge amounts of money.

JM: Is the response to the music better, is it more positive in Europe than it is in the U.K.?

JB: Yeah, basically. Interviewers ask more interesting questions than they usually do here. (Laughter)

PC: Present company excepted, of course. (Laughter)

ST: He's so diplomatic.

PC: I think English people, in general, tend to be incredibly blasé and lacking in momentum, but once you get them going they're OK and will riot as good as the next man. But they

don't really generate their own enthusiasm for things in the way that Dutch and Germans and Belgians and French people do. Certainly we get far more letters from out of the country than we do from here.

JM: There seems to be a funny relationship between that 'English reserve' and this 'been there, done it, seen it,' attitude. There's a twisted relationship between the two qualities, the unwillingness to commit themselves with enthusiasm to anything — which is the reserved attitude — and now it's become that the excuse for that is 'been through it all, seen it.' Which is bollocks really.

JE: You hate living in this country don't you? (Laughs) What about the rest of you?

ST: I'm happy right now because I've just moved house.

JB: I don't know. You love it and you hate it. There are things about England I like a lot, and then you're stuck here basically.

JE: Could you make a living out of Coil?

JB: No, we could do if we really worked at it and prostituted ourselves.

PC: If we didn't live in such an expensive house.

JE: What do you think about the way the country is going? There seems to be a big clampdown on 'alternative' lifestyles...?

ST: I think it's clamped down on itself a lot actually.

JE: So they all deserve what they get?

JB: Well, people obviously don't deserve what they get in England, because what they get is far worse than anyone can deserve, as far as our moral climate is concerned. The English learned pleasure about three years ago, that was a nice thing, but it's

all dying down again. It's an ongoing battle partly to do with the climate, depression, all that shit...

ST: I was reading this wretched New Age magazine a couple of days ago where they were talking about sex and saying, 'sex is for evolutionary purposes and for love, and any lust driven animalistic drives are so 80s...' I thought, great, it's just like new conservatism sneaking through the back door again...

JM: The New Age is turning into fundamentalist Christians with different clothes on, different hats.

JB: If you go to one of those meetings, any New Age sort of thing, like the Festival Of Mind And Body, you walk through in black with any kind of pagan symbol on and they all completely freak out.

JE: Negative vibes man.

JB: Yeah, they just sit there with their finger cymbals.

ST: It's like John Waters said about the 60s: when everyone else was wandering around talking about peace and love, he was fantasising about starting the hate generation.

JE: England has always been a really bad place for sex, I mean, you can still get it but it's just such a negative attitude. Stuff like Mr. Sebastian, or other people you've been associated with, going up in the Old Bailey just for putting rings through bits of anatomy.

ST: It's mind-boggling. The more you think about it, the more depressed you get and the more ridiculous it is.

JB: The worst thing about that was the way the judge summed it all up. He said that because it was a pleasurable thing and not done for function that was the crime, if it had been any other thing they could have found an excuse for letting him off or

whatever. They are appealing. They went down for five years. There was so much police time and energy spent on it that they had to have a conviction, it was like a year and a huge amount of money and hassle.

ST: Consider how that even came to the attention of the authorities...

JB: I don't know if that's indicative of what's going to come or what.

JE: There was something in FF Magazine that instead of trying to ban each illicit substance as it appears, they're going to try instead to ban the state of consciousness, anyone caught in that state...

JB: So it's the category, the group, or genre of drugs, so anything that could ever be thought of in the future that could do this is also illegal...

ST: It's if you're found in a state of intoxication unrelated to drink or fundamentalist Christianity... (Laughter)

JB: They should go to a Christian meeting, everyone raving, and arrest them all for altered states of consciousness. You could arrest people for mouldy bread. These are all things we should worry about, I'm not sure what you can do about them, sidestep them or confront them, both are difficult things.

JE: You've done benefits before...

JB: Not actual live benefits but money for things, yeah. If we could play live then I'd certainly do lots of benefits, I'd do more. That's one thing I feel a bit, not worried about, but I'd like Coil to be more upfront about what they believe in and be seen to be believing it... We've got a new single coming out, 'The Snow' but five remixes. Sleazy did one, I did one, Jack Dangers has done two, and Meat Beat Manifesto — which are really sort

of hard, relentless. You know that club called Slimelight? It's aimed at that crowd... Leather shorts...

ST: Sounds like they should be slapping thighs and big tankards of beers...

JB: The Lederhosen unit.

PC: There's a rare collector's item that looks like the *Love's Secret Domain* CD but it in fact has German...

JB: it's called Schlager Musik...

JM: ...Beer drinking songs, thigh-slapping...

ST: Accordions!

JB: Someone apparently phoned up Vinyl Experience and asked 'what's happened to Coil?' They thought it was actually our music and stuff.

PC: If you actually find one of these things you should hang onto it because they'll be worth a fortune in due course.

JM: Speaking of collectors' items, can you justify the 250 pound, 54 copy, *Gold Is The Metal With The Broadest Shoulders* version?

ST: Well, we didn't charge 250 pounds! We sold them for 55 didn't we?

JB: Yeah, and they cost 50 quid each to make so we ended up losing money on them. We can't put 'do not resell for more than this' on them.

ST: I think it's nice to have special things and if I was interested in the group then I'd bloody buy them. Anything that we've sold has been value for money at the time we've sold it...

JB: ...As far as we can control it. Sometimes things, like the Shock label's single ('Wrong Eye'/'Scope') went out at a dealer price far

above what I would have wanted. It wasn't Stefan (Jaworzyn)'s fault, it was the shop — Vinyl Experience — again. He doesn't like bullshit but he's the nicest man you could ever meet. He has a nice attitude. 'I was there when noise was created...'

ST: One person's noise isn't quite the same as another person's noise.

JB: Well there's no new noises. I was hoping the Butthole Surfers would come up with an absolutely new noise and I had a dream where they did but they got halfway there and then they hadn't anymore. Which is what I hope we've done, I'm not sure if we've done new noises with our record or not, but it's what I always want to do.

JE: The didgeridoos were pretty cool...

JB: Didgeridon't.

'We do Dance Music for the Head'

Compulsion, 18ᵗʰ October, 1992

Tony Dickie

Like many others, Psychic TV were my conduit to industrial music, but during the late 80s it was the trinity of Coil, Death In June and Current 93 that most fascinated me. My interest had been piqued by the involvement of Paul Bee Hampshire, formerly of Getting The Fear, then part of Into A Circle who featured Rose McDowall. In this period, Bee and Rose were fellow travellers contributing vocals to releases from Death In June and Current 93. So too was John Balance. *Horse Rotorvator*, *Swastikas For Noddy*, *Brown Book* and *Assassins* became pivotal to my musical education.

The first wave of fanzine culture had long passed when *Compulsion* began, replaced by publications such as *Fractured*, *Music From The Empty Quarter*, *Impulse* and *E.S.T.* The music press were — as ever — chasing the next big thing, avoiding anything with substance. Even then, it felt interviews were either too brief, uninformed, or both. As I was on countless mailing lists and had access to a computer, photocopier and owned scissors and glue, I set about the first issue of *Compulsion*. For the inaugural issue, interview questions were mailed off to groups that interested me

alongside pieces on groups who were in town who might offer something of interest. Post-industrial music by default became the focus.

The Coil interview was originally intended as a mail interview but John Balance responded saying it would be more spontaneous if we did it as a conversation. Fair enough, but as someone quite young and in awe of Coil I was apprehensive. Conducted soon after the release of *Stolen And Contaminated Songs*, the interview was hesitant but wide ranging covering the period around *Love's Secret Domain* when Coil were embarking on numerous projects, most of which have now been released posthumously.

As each issue neared publication, I'd contact Coil for an update. Listening back to those calls, one with John, another with Peter who would often confer with John, they sound like mini-interviews. Sometime in 2004, when Coil were deep within their lunar phase, John got in touch, and while those emails are lost to dead technology, I still recall John's words: 'I've woken up, my juices are flowing!' he said, requesting a new interview and offering me a *Beast Box*. It would have been interesting as those *Musick To Play In The Dark* volumes offered new avenues to discuss far removed from when we first spoke. The interview never transpired, and that Beast Box never arrived.

'England is completely fucked up. It's all to do with the church, where everything is based on guilt here. You're fucked unless the church or society says you're not. In Thailand it is the opposite, you're free, and if you fuck up it's your own fault. It's a completely reversed system over there, the whole thing is about having enjoyment in life.'

Interview

TONY DICKIE: Regarding Clive Barker's *Hellraiser* what actually happened? Did Coil pull out or did the financial backers think the music was too weird?

JOHN BALANCE: Well, we pulled out about 10 minutes before they said we were going to pull out, anyway. The thing is we were in right at the very beginning of the project. Clive Barker was writing a screenplay and he came to our house and took away a load of piercing magazines and things — which is where they got all the Pinhead stuff from.

TD: Apparently, it was quite S&M orientated...

JB: Yeah, we saw some original footage which we unfortunately didn't keep but it was really heavy and good, like a sort of twisted English horror film. And then when the Americans saw this footage they thought it was too extreme and they also gave Clive ten times the original money.

TD: It completely changed then...

JB: Yeah, so then Clive sort of felt, because it was his first film and with Hollywood being involved, it was his gateway to the stars. So they changed the location to America, dubbed all the actors over and took out a lot of the explicit sex.

TD: Did you feel let down about this? It could have been your gateway as well?

JB: Yeah, it would have been brilliant but we wouldn't have carried on, because they were changing everything and they weren't being very nice to us, the actual film people. They were keeping us in the dark a lot. We said we'd had enough just at the same time they decided they wanted to use Howard Shore. They just wanted normal film music. They

didn't want anything too scary which is sad and ridiculous for a horror film.

TD: Are Coil still doing music for commercials?

JB: We haven't done any for a while.

TD: When you did do them, were they used to finance Coil projects or were they an integral part of Coil?

JB: Well, Peter does adverts and videos as almost his main job really and if he didn't do those we couldn't do Coil, but we don't do it to finance Coil, we do that anyway, but it helps.

TD: Peter does a lot of video work as well?

JB: He's done loads of videos.

TD: You made a video for 'Windowpane'. Did you enjoy that?

JB: It was really good, best video I think we've done. We've done about six in all.

TD: I understand you made one for 'Love's Secret Domain' in Thailand, it's supposed to be quite sensual...

JB: We made 'Windowpane' in Thailand as well. Yeah, they both are. The 'Windowpane' one we filmed in the Golden Triangle, actually in the water of the Mekong River. It means Laos and Burma meets Thailand — the original opium dealing areas. There was an area where the sun dipped down into the hill just at sunset, and we filmed it at sunset on this island.

TD: It was on (the music TV show) *Snub*, the visuals were really good...

JB: Yeah, really trippy.

TD: What about 'The Snow' video?

JB: It's a sort of... Not a collage... But a barrage of images. A couple of people threatening to dance, but it's done sort of mandala, the images go in and out, there's four of them basically. An image repeated that makes patterns, there's lots of stuff in it, actual snow flurries. It all looks like it was filmed in a snow shaker.

TD: Have you any plans to issue these commercially?

JB: Yeah, we keep waiting. When we do the next album we'll do a couple of videos from that album and we'll put them all out together.

TD: Do you think video is a good medium to get your ideas across?

JB: I do think so. Yeah, but they're not useful you see. We have to spend a lot of money on them, a lot of our money, and unless they can use them on commercial TV it's almost stupid for us to make them, but we still do. In Thailand we were actually filming somebody else and, because we were there with cameras and stuff, we managed to get two videos out of those for next to nothing. It's just juggling it all.

TD: In the *Music From The Empty Quarter* interview, you spoke of Coil making a film. Is this true?

JB: We keep talking about this project, *Live At Bar Maldoror*.

TD: What's it going to be?

JB: I don't know. (Laughs). We haven't started it yet. We've got lots of other stuff. I would like to make a 45-minute film or something. It will take a year to do it. Steven Stapleton (of Nurse With Wound) is doing one as well.

TD: What's that?

JB: *Lumb's Sister.*

TD: Right, some of the soundtrack's already been released...

JB: Yeah, in small bits. The film is about two hours long.

TD: What is it based on?

JB: Nature and magic around his house in Ireland. The whole area is about to be made National Heritage which means fuck all! It means a lot of trouble for him, they're widening the road so tourists can come up it.

TD: Moving on, Coil seem to have a low profile, little press attention, tracks on obscure compilations, and the mail order releases won't exactly gain much press attention. Do you think you should keep a higher profile?

JB: Yeah, probably. We sort of have to but we haven't got the set-up really. We have a much better profile in Europe. It's because we don't follow album releases with a single and keep up the pressure.

TD: You have a promotion company though...

JB: No, not any longer.

TD: But you had one for *Love's Secret Domain*...

JB: Yeah, we did, but we won't use them again. It's difficult because you give a lot of control over and we thought it might work, and it sort of worked, but it also backfired a lot.

TD: Is this why *Stolen And Contaminated Songs* was mail order?

JB: Yeah, to get money. We can double the money we get which isn't much but we need it all. We're going to do a thousand as lots of our friends don't have CDs and have missed out.

TD: In *Tape Delay* you stated, 'we're making a conscious effort to be isolationists.' Do you still feel this way?

JB: Yeah, I compromise, I watch TV and stuff, and it drives you mad if you have to spend 90 percent of your time getting rid of everything.

TD: Coil use a lot of symbolism, both aurally and visually. How important to you is this?

JB: Just the way we think. The Black Sun is a weird one, it's what I call the 'Millennial Emblem'. I've noticed it in a lot of other people's stuff. All About Eve's video ended with a black sun and The Shamen have been using it in weird ways. It's like this strange shape is appearing and I don't know why.

TD: Where did you take it from?

JB: Well, the one we used is taken from Aleister Crowley, originally. He drew it as a cipher for something. Then we used the chaos symbol which sort of dovetailed to the use of that in Chaos Magick. We are going to do a book expanding it all to see how many we can come up with. I'm going to get as many people in, just everything I can find on it. I've got a file on it, but I know if I ask as many people as possible it could go on forever. It will be out by the autumn or something.

TD: 'How To Destroy Angels' was designed specifically 'for the accumulation of male sexual energy,' yet so was *Love's Secret Domain*. In what way was this?

JB: This is like one of those weird press releases that was going around. It was part of this misleading thing, we never said that.

TD: *How To Destroy Angels* was an actual ritual piece, though...

JB: Yeah, it was. It was designed, if you break it down there was like five gongs we used and the piece was 17 minutes which was associated with Mars. There was lots of things with that

we couldn't do, on the original one as it had to fit in. When we did the CD, the new version, we've expanded it out a bit.

TD: Why did you decide to rework it?

JB: Because I thought we could do more with it.

TD: It's based on magickal structures and specific timing, how did you work it out?

JB: For Mars there's loads of numbers associated with it, and the metals and the colours, and we used male-orientated instruments, like gongs — that was the metal part of the iron — bullroarers which are used in male initiation rites, which we covered in blood and symbols and stuff and we didn't let anybody see them. The way you're supposed to use them.

TD: Do you think people actually listened to it in its required context?

JB: Well, that's beyond us. One of the best things is that people said it relaxed them in the bath. That's fair enough, you didn't have to keep women out of the room when you are listening to it, that certainly wasn't the intention. The idea was music with a function, once we've done that people can use it for anything.

TD: Derek Jarman designed the cover for the reissue, didn't he?

JB: Yeah, it's a painting of his, sort of two foot by two-and-a-half foot of gold on gold with smashed glass on a black background. He's doing a lot of art now. He does his painting in Kensington, in a friend's sort of room. He's doing massive canvasses now.

TD: The 12 inch was to be the first in a series...

JB: Well, we are going to do another one, another ritual one, on Mercury, which we'll be starting just before Christmas.

TD: *Love's Secret Domain*, like previous Coil releases, seems fragmented and disorientated. Is this the way you like to work?

JB: It's the way we are! (Laughs) It's partly to do with the fact we like a two-year gap between each one, as we do other things in between to pay the rent. From now on, we've decided to do things quicker and make each one more of a whole. Instead, we'll do different projects, each one taking an idea and expanding it.

TD: What's the best conditions for listening to Coil?

JB: Whatever you feel.

TD: Drugs?

JB: It helps perhaps. It'll bring certain things out, though I'm not advocating it.

TD: With *Scatology* you spoke of using 'alchemy in sound'. What did you mean by this?

JB: Literally, some of the sounds — shitting and toilets — were all raw noises. We were making good things from what is perceived as being, basically, bad things; dealing with subjects other people wouldn't touch such as rotting and death. That wasn't the total picture. We were touching on things and it seemed easy to say that to people. There was much more to it.

TD: It wasn't shit you were celebrating then?

JB: It wasn't shit we were celebrating at all but the undergrowth, the rotting vegetation type thing.

TD: What were you trying to convey?

JB: Back then? Too long ago. (Laughs)

TD: With *Love's Secret Domain* you seem to have dropped the references, leaving the music on its own. Any specific reason?

JB: Deliberately. Because if you look at all our album covers before they had loads of references, as you said, and I kept seeing other people's albums doing that. So I wanted to take away every pointer or reference people could have, including vocals. I took a lot of the vocals out of the mixes and just left sounds and fragments and stuff — that makes sense but not on the surface. We took away the sense and left sensation is what we said.

TD: What were the ideas behind *Love's Secret Domain?*

JB: Electricity and drugs. It's about sound sensations, physical sensations, and frequencies.

TD: Is that why you chose the sample from Donald Cammell's film *Performance?*

JB: Yeah, partly.

TD: Pulsating energies...

JB: Yeah, right, and they were on mushrooms in that part of the film.

TD: The vocals were via Tesla's wireless - going back so was 'Metal In The Head'. Do you like using recurring themes?

JB: Absolutely. Sort of the same thing. We don't look back as much as other groups do. I've toyed with the idea of re-recording some of our older songs to see how it would be.

TD: *Love's Secret Domain* saw a slight change in Coil. *Horse Rotorvator* was such a dark record, right down to the apocalypse quote — a death album maybe — while *Love's Secret Domain* was more uplifting, a life album maybe. What changed you?

JB: Well, you can't go much lower than that. It's like the wake after the funeral basically. We're seriously exploring pleasure now.

TD: Did people think you were getting too doomy and gloomy then?

JB: It didn't bother me. Lots of people criticised *Love's Secret Domain* for being too uppy and clubby. It isn't really that at all.

TD: Going back to that press release, it said 'deranged techno house compatriots'. Even though it's been overstated do you feel comfortable doing dance music?

JB: We don't do dance music.

TD: What about 'The Snow'?

JB: You can't dance to it. It's physical music but not dance music, I mean, we know how to do it but we don't want to, basically. We do dance music for the head. This is what 'deep listening' is about. We used the rhythms and the sounds of dance music to some extent, but it had meaning behind it, in a sense it's like ritual music again.

TD: What did you mean by 'trance as dance'?

JB: That was the press release again. (Laughs) It's giving me grief.

TD: Last time we spoke you mentioned the possibility of releasing some dance records under a different name. Any more on this?

JB: No, not yet. (Laughs) Still thinking about it.

TD: It would be Coil under a different name?

JB: Yeah, I think so.

TD: Considering people had said Coil had gone dancey, how did the Coil audience react?

JB: It confused them a bit. We never get enough feedback though some did say 'why are you doing this?' or 'I hated this,' specific tracks they didn't like. This was from people in Norway and it doesn't really mean the same to them.

TD: 'The Snow' contained a line of Crowley's poetry, why?

JB: I just liked the quote. Annie Anxiety says it at the end. You can't really hear it.

TD: How did the Jack Dangers (of Meat Beat Manifesto) remixes come about?

JB: We wanted to do different mixes and we knew him vaguely, so we phoned him up and he was into it. He's a really nice guy and we wanted to work with someone we liked. We could have given it to someone else who could have come up with something we didn't like. Something commercial, God forbid.

TD: What did you make of them? They were quite heavy...

JB: I liked it. I said make it as relentless as possible and he did.

TD: Tim Simenon was to remix 'Windowpane'...

JB: He was. I'm not sure if he's going to anymore. We've done a track with him for the new album which is called 'Damage From A Diamond'. In fact, we worked on the track together and he's releasing the track as Bomb The Bass and we're releasing it as Coil, as well. We're setting up a whole bunch of collaborations for the new album.

TD: You've been remixing Nine Inch Nails. How did this come about?

JB: He's a Coil fan. We got in touch with him to do a video and he said 'of course you can and, by the way, 'Tainted Love' by Coil is my favourite video ever.' So I said, 'do you want to work with us on some music?' and he said 'yeah'. So he said 'do you want to do a remix,' and he sent the tape and we chose one: it's 'Gave Up' off the new album *Broken*. It's to come out in a couple of months, I think. We cut all his vocals completely. It's really good actually. I mean that's commercial because the original thing is. It's got choruses and that and we tried to take those away.

TD: You cut up a lot of *Love's Secret Domain* didn't you?

JB: All over.

TD: You didn't mind that people thought this was an old technique?

JB: No, we wanted people to think it was old hat. We went back to actually cutting up quarter inch tape into one-inch pieces and taping it together. It took about three days to do it. We had two 40-foot loops across the room.

TD: What were the tapes of?

JB: A prison documentary, male rape, and Chinese girls banging percussion and stuff. Almost random, it wasn't chosen for any meaning.

TD: Do you do a lot of videos for other groups?

JB: Recently we've done Ministry — two videos, one with William Burroughs — Bjorn Again, and Gavin Friday, which is a really good video, though I haven't seen it on anywhere. Pete's done his last three as well.

TD: You seem quite inside the music industry, for Coil to be so far outside it, if you know what I mean?

JB: Yeah, absolutely. We haven't made a conscious attempt to get inside. Even to be perceived as being inside you really have to make an effort, go to places and meet journalists, and I'm just not up for that.

TD: How do you feel about still being labelled as 'industrial', as you were in *Indiecator* magazine's industrial article?

JB: Doesn't bother me. It's quite good as people who like industrial might buy it anyway. It means nothing to us. It doesn't influence what we do in any way whatsoever. They can call us anything.

TD: Do you think you've still got a deviant viewpoint?

JB: Yes, (laughs) always will have.

TD: Do you enjoy collaborating with other people?

JB: Yeah, we enjoy it more than doing it purely off our own back. It's just another person's energy. As we work as a threesome, including our engineer (Danny Hyde), once you've done that and done all your ideas, all the music, and done the work on the mixing desk, and then listening to it over and over, then the test pressings... You're just sick of it from over-exposure and if you've got someone else sitting in there making a triangle of energies it's really good.

TD: How did the Annie Anxiety collaboration come about?

JB: She's been on the fringe of our social circle thing for ages, ever since we knew Crass in 1978.

TD: Marc Almond is from your Psychic TV days. Does he enjoy working with Coil?

JB: He likes to work with us. I sort of ask him once we've finished a track, 'what did you think of it?' and he says, 'great!' that's all you ever get from him. I think he enjoys it because it's sort of different for him.

TD: What about Boyd Rice, from Throbbing Gristle times then?

JB: Yeah, we're going to do some more. He's coming over at Christmas as he's playing with Death In June live and hopefully he'll record with us, doing something similar to what we've done before.

TD: What's new in the collaboration front then?

JB: We're going to work with Diamanda Galás on the next album. She'll be doing vocals and piano and ideas. It will be an angry song. She wants to do our press release in America as well.

TD: It sounds as if you need someone new after what you said earlier.

JB: Yeah, right. (Laughs)

TD: What was this about a Ministry video with William Burroughs?

JB: A track called 'Just One Fix' where they had used some Burroughs samples and their record company made them take them off as they were scared of copyright infringement and William heard about it and he said, 'oh no, put them back on.' So we went over and filmed them all, William shooting and stuff, and while we were there we also did some recording with him for Coil.

TD: What is this going to be?

JB: Another track on the album.

TD: Spoken vocals?

JB: Well, I'm fed up of hearing him speak over other people's work so we got him to say a load of words, from which we'll do an original cut-up.

TD: That will be interesting as he, along with Brion Gysin, were the first to do cut-ups...

JB: Yeah, that's right. We're going to try and recapture what they were trying to do.

TD: You've met him before?

JB: Yeah, Peter worked with him on the *Nothing Here Now But The Recordings* (Industrial Records) album and we've been in touch with him and his secretary and right-hand man, James Grauerholtz, by post. We've been doing secret dealings and stuff but we're going public with them now.

TD: *Melody Maker* reported that Coil were to be involved in the soundtrack to David Cronenberg's film version of *Naked Lunch*. Was there any truth in this?

JB: Almost. (Laughs) We were sort of up for it at some point and in some way. There's things in the pipeline which we're far more in control with, Burroughs' texts and books, but that's like three years ahead. But we're sort of developing ideas and we've got full permission from Grauerholtz and Burroughs.

TD: Burroughs was working recently with The Disposable Heroes Of Hiphoprisy...

JB: I don't know how much he did.

TD: Did he mention how he feels about working with them?

JB: Yeah, he did. He obviously gets so many requests and James says 'look, do you want to work with these people?' and they've got good sense. If they meet the people and like them, they'll do it. At the moment he's doing loads of paintings, not just gunshot art but automatic drawings, some of which are brilliant. He goes for pure art and at the moment that is painting.

TD: What did you think of the film *Naked Lunch*?

JB: I didn't like it. I thought it was homophobic which was one of the weirdest things I thought about it. If it had been more caricature it would have been much better. I didn't enjoy it full stop. However good it was.

TD: Coil provided the soundtrack for *The Gay Man's Guide To Safer Sex*, how did that come about?

JB: The people who produced it were friends of ours.

TD: From the Terrence Higgins Trust? What did you do for the film?

JB: Yeah, it's like 45 minutes of new music. It suits the tone of it which is slightly new agey, a slightly progressive house-type thing. I wouldn't want to release it as Coil particularly.

TD: And the other one is *Sara Dale's Sensual Massage?*

JB: Same again, same production company, and that's even more ambienty.

TD: What's that all about?

JB: How to please your partner using kitchen utensils, oils, and stuff. (Laughs)

TD: Do you enjoy writing music for films?

JB: Yeah, I do. I'd like ideally to do brilliant films, a good project. These projects are interesting and we do get amusement from them.

TD: Is it a different process to writing actual songs?

JB: Yeah, absolutely, as you have to fit it into their timing and to their beliefs. You obviously can't go mad, you have to tone it down usually.

TD: More disciplined then. Ideas from them and you?

JB: Well, there are no ideas. You have the pictures and there's almost the music that is obviously for it. You can easily ruin everything by using inappropriate music.

TD: How do you approach song writing as, unlike guitar bands, you can't exactly jam in the studio?

JB: It's difficult. We just find sounds we like, I mean, we do jam, we jam onto tape. If it doesn't work, you take that part away. It appears but it probably isn't as spontaneous as a guitar-based band. Ultimately it's the same thing.

TD: What about playing live. You've been talking about it for years...

JB: (Laughs) Probably will talk about it for years. Not as Coil, I would imagine. If we do a different sort of thing with other members, like I've got this project — Black Light District. I couldn't imagine us setting up equipment to enable us to play live, as you couldn't cart all our equipment onto a stage.

TD: What is the Black Light District? I saw t-shirts a few years ago...

JB: It's sort of techno, but weirder. No releases yet but there will be through Threshold House.

TD: If you did play live, how would you tackle it?

JB: It wouldn't be a normal rock club, not a church either, we need technology, it's what we are about. A good high-tech club or something.

TD: You played before using smell as well...

JB: Yeah, we would do that and all sorts of things. Performances going on in the audience as well.

TD: John McRobbie of Mute's Grey Area approached you to perform live with some films, possible the Derek Jarman ones. Will you?

JB: I doubt it. Depends how much they offer us. It would be at the Scala Cinema so I doubt it.

TD: You seem to be spending increasing amounts of time in Thailand. What's the fascination with the country?

JB: Over the last six years we've gone every year. It's spiritual, it really is spiritual. England is completely fucked up. It's all to do with the church, where everything is based on guilt here. You're fucked unless the church or society says you're not. In Thailand it is the opposite, you're free, and if you fuck up it's

your own fault. It's a completely reversed system over there, the whole thing is about having enjoyment in life.

TD: Is Bee (Paul 'Bee' Hampshire, ex-Into A Circle) still living there?

JB: Yeah, right, and also Bee lives there and we go and stay with him. He's thinking of starting a studio in Bangkok. He was back over here recently.

TD: Is *Stolen And Contaminated Songs* more of a stopgap release than anything else?

JB: Yes, we said originally it was more ambient but... The tracks are longer.

TD: How much of it was reworked?

JB: There's only a couple. There's a different version of 'Love's Secret Domain', a rougher mix, and much of the rest is new or unheard anyway.

TD: The track based around the suicide, 'Is Suicide A Solution?', was this taken from your answering machine?

JB: We edited a few clicks out and that. We actually had second thoughts about putting it on or not. It is good. It was a friend of ours. We came back and it was on the answering machine, devastated me a bit, I couldn't believe it.

TD: Do you have a lot of problems in releasing records such as *The Sound Of Music*?

JB: No, it's our own fault for putting the titles out before we've even got the project. The next album should be out in March.

TD: This will be *International Dark Skies* I take it? It features those we've already mentioned, who else?

JB: Trent Reznor. When he comes over we're filming a video for him. He'll be doing lead guitar and vocals.

TD: Do you like Nine Inch Nails?

JB: I like the idea of Nine Inch Nails, that's my stock answer. I respect what he does. We listened to his backing tapes and it's all really well done.

TD: What about Nine Inch Nails namechecking Throbbing Gristle and calling themselves 'industrial?'

JB: Well, in a sense, Throbbing Gristle don't own their own history. I think it's good as it can only reflect well on the original industrial groups. I mean these people are stadium bands in America and they are genuinely into these obscure bands.

TD: Would you not like to think you have moved on since then?

JB: Oh yeah, we're doing something completely different and they're doing something different. It is college rock 'n' roll that they're doing.

TD: What's happening with the Coil/Nurse With Wound project?

JB: It's still happening. It will be an album. We tried to record some up in Yorkshire but it didn't happen so we packed up our bags and headed back to London.

TD: Are you writing together or covering each other's songs?

JB: Well, there was supposed to be a Clawfist single, which I don't think will happen now. I mean it might eventually come off the album.

TD: Aren't Coil doing music to accompany a graphic novel?

JB: Yeah, with Dark Horse Publishing. They do major league comics and we're involved with a couple of projects. We're

helping them with a Tattoo comic and the main one is called *Underground* which is a very adult novel, a graphic novel as they call them, and we're doing the soundtrack that you play while you're reading.

TD: Sounds interesting...

JB: It is very violent and very good.

TD: Have you seen the storyline yet, what is it about?

JB: It's about tunnels under a Futurist city where people play games.

TD: Tunnels under cities, that's you back to sewers again...

JB: Yeah, it is very much our thing. In the games they play people who collect ears, they play like computer games but with people.

TD: How did this come about?

JB: Through our Wax Trax contacts. We've been corresponding with the people at Dark Horse on magic and all sorts. They're very up on it, the writers.

TD: It will reach a whole new audience as well...

JB: Absolutely, and it will sell a lot, but the clever thing is we can incorporate Black Light District into the comic. So we would actually appear in the strip, not as Coil as a group, but as a theme running throughout it. I'm going to get Black Suns put in it too.

TD: When should we expect *Underground*?

JB: It's due out July next year.[1]

1 Jerry Prosser elaborates on the origins of *Underground*: 'Rich Shupe, who ran an alternative music magazine titled *Reflex*, came to Dark Horse with a comic tie-in project for The Residents' *Freak Show*. This was the seed of *Underground* which was envisioned as a shared-universe anthology featuring contributions →

TD: What else project-wise?

JB: The Black Sun book which will have a single in it. That's the main thing I want to concentrate upon. I want to get some good people to write articles and stuff.

From Melody Maker's True Stories column '...this allows us to neatly sidestep into a story concerning how Peter and John got laid up for several hours with blood poisoning after traversing the sewers of Brighton on a gay activist tour. Seems they survived that OK, only to be laid low when they started cleaning out their goldfish pool and got severe cuts.'

TD: ...So, what's the story?

JB: It's these fucking people again! (Laughs) We went down the sewers in Brighton as you can go on tours and then it's completely something else. I cut my hand on rosebushes and then went into our pond. We've got a big pond round the back with frogs and stuff and I got really bad poisoning. The scars went septic, though they've completely gone now.

TD: It's not as bad as it sounds, then?

JB: There was no gay activism in that thing. I got arrested for gay activism with Derek Jarman on a march though. (Laughs)

TD: Did you? Was that an Act-Up thing?

→ from a variety of comics talent and sci-fi authors. I thought it would be neat to have a "soundtrack" accompanying the book, like The Residents' disc with *Freak Show*. I was listening to *Love's Secret Domain* and thought something along those lines would work. I believe John Dennett who worked with Wax Trax was the connective tissue to Coil, but I could not swear to that. I sent them a fan letter and laid out my ideas, then went back and forth with John Balance about possibilities, as well as esoteric interests we shared — Austin Osman Spare, Fulcanelli, etc. — John knew a lot more than I and even sent me stuff. He seemed to like the idea and suggested it as an outlet for something called Black Light District...'

JB: Yeah, we got arrested, taken to the station, and cautioned.

TD: No further action?

JB: I don't think so. We're probably on their list, I was probably on it before. (Laughs)

TD: Do you get hassle from the authorities at all?

JB: Secretly, nothing hands-on — touch wood. As far as they know, we don't break the law.

TD: Is there anything that's interested you lately?

JB: Well, Terence McKenna. I did a course with him recently for a couple of days and it was pretty inspiring. We're going to work with him. Evolution, the label, are doing an EP with four or five tracks, each with different groups, and I think we're on that with Terence.

TD: What are the aims of Coil now?

JB: To do all the things we've said we would and keep us going. I want to do some more higher profile stuff. I would like to do a really good film soundtrack and, as I said, that's three years on down the line. Then I think the Burroughs influenced thing will appear.

TD: What about financial backing for the film?

JB: There are ways. You just get professional film backers. We don't have to put our money up for it.

TD: You don't want to compromise your ideas though?

JB: That's the trouble, finding the backers who will allow you. These French TV people, Canal+, finance pretty weird things. Maybe they will.

TD: This would be under your own names, not Coil?

JB: Yeah, it will be a more complex set up.

TD: Filming, directing, and writing?

JB: No, just about it, that's the hardest bit. I want to do everything.

TD: You've never helped on the Derek Jarman films?

JB: No, I haven't actually. We did the *Angelic Conversation* soundtrack. But helping out, no, I don't know why. Haven't even been in one, everyone else I know has. (Laughs)

TD: Did you enjoy the *Angelic Conversation*?

JB: Yeah, it's Derek's favourite film as well. People have said why don't you put the soundtracks out on their own, but it doesn't work. It is more than the usual soundtrack and is meant to go with the video. This is what *The Sound Of Music* will be eventually.

TD: Will that ever see the light of day?

JB: Yeah, probably. It'll be soundtrack stuff, slightly reworked to make it a bit more interesting on record.

TD: What about *The Side Effects Of Life*?

JB: That became *Love's Secret Domain*.

TD: And I remember another provisional title called *Funeral Music For Princess Diana*...

JB: (Laughs) Ever since the current scandal I thought maybe we should cash in and release that.

Born Again Pagans

1994–1997

'In The Talking Shop'

Opscene, August/September 1994

Edwin Brienen

One of the most important records of my early childhood was ABBA's *The Visitors*. The chilly synthesizer sounds and paranoid lyrics prepared me for when, in adolescent life, I encountered bands like Coil and Throbbing Gristle. Exactly ten years later *Love's Secret Domain* had a similar impact, this time transitioning me from 'dark alternative' to house and techno, which was very much a source of liberation at the time. The album offered everything I liked about experimental music, now sensibly inundated with a dark club atmosphere — more Hades than Club Tropicana.

I was offered a job at VPRO when I turned 22. Soon after, my boss, Gerard Walhof —formerly of post-punk art band Minny Pops and the subject of a song by Jim Thirlwell — sent me to London to interview John and Sleazy, the first interview Coil had allowed after a press silence lasting nearly three years. Gerard knew I was a huge Coil fan. I was bloody nervous. Not only were they my teenage heroes, all the weird gay boys were into Coil after all, I had also heard rumours about how much they hated

the press. My fears were unsubstantiated: they were the most charming men imaginable, and immediately made me feel at ease. Once I proclaimed my love for Pasolini and Fassbinder, the ice was broken. They invited me for dinner and that evening we listened to newly recorded Coil tracks. I felt relieved they sincerely liked me.

We kept in contact after that memorable day in London, and met again years later when they, surprisingly, returned to live performance. I recorded a series of new interviews with John and Sleazy, now mainly focusing on Aleister Crowley and their use of 'magick.' The live shows were all set up according to magical rules, with specially produced incenses and even an invocation to Pan. 'We want to draw people out of normality, show them a different reality so that they have a choice,' John mentioned in one of those interviews. 'We're not forcing anything, but we're suggesting everything.' Their strength was not having an attainable ideal about the perfect sound or look, it was all about change and looking forward. In retrospect, it's clear why they chose to spell 'musick' with a k. 'The way of Mastery is to break all the rules,' Crowley once said and it explains the pure magic of Coil: they showed us alternative visions, offered a summoning ritual to deal with all the chaos. And they provided solace, made you feel you were not alone in this dark, confusing place we know as 'the world.' Coil were an unrepeatable act of courage and ingenuity. Damn, they are sorely missed.

'It's a huge advantage to be gay! (Laughs) It makes you an outsider. So you're automatically beyond the mainstream, which enables you to see and do things that others don't.'

Interview

On a rainy afternoon in May, I took the underground from Heathrow to Chiswick, a dreary suburb of west London. It's hard to believe that this was the breeding ground for Balance and Christopherson's bizarre musical exercises. When I arrive at their eerie mansion, I am greeted by two growling monsters. The visitor has been warned. The acquaintance inside the house, while enjoying an English cup of A+ coffee, is much more amiable.

I tell the gentlemen that, in May of this year, Horse Rotorvator was proclaimed one of the most important records of all time (essentially the direct reason for this conversation). On behalf of VPRO and Nieuwe Revu, a handful of critics compiled a Top 100 Albums of All Time, not without drama called 'The Record Of The Century.' Coil's success, however, didn't extend beyond position 68, just ahead of Aretha Franklin, Allman Brothers, Pink Floyd, Steely Dan, Masters Of Reality and Queensryche...

PETER CHRISTOPHERSON: *Horse Rotorvator* is a very fashionable album in retrospect.

JOHN BALANCE: We wrote the album at a time when AIDS was first becoming fashionable. It sounds horrible, of course, but it was the reality. Some of our friends were told they would die of AIDS and we were surprised that no one gave any artistic response to that. For a long time I thought we were part of a scene that was 'wrong' and destructive then, eventually, we discovered that our whole life, and especially our way of life, had been shattered into hundreds of pieces.

PC: It's ironic that, nearly ten years after *Horse Rotorvator*, megastars like Bruce Springsteen finally dare to use 'The Plague' as a song theme. Finally, big money recognises that AIDS is an essential part of life. I call that hypocrisy: someone like

Diamanda Galás was ten years ahead of Hollywood. I find it curious that many musicians don't seriously engage with the seamy side of life. Maybe that's why *Horse Rotorvator* is still so popular; we express our deepest feelings regarding our friends, our generation. To this day, we receive letters from patients and those affected, thanking us for the positive nature of the record.

JB: The record offers an alternative. Not in the sense of taking your medication and being nice and content until you drop dead, but by encouraging the victims to take charge of their own lives without letting something like death stop them. In Western society one hardly dares to talk about death. In England it is almost impossible to express feelings in such a difficult situation.

Another striking aspect of Horse Rotorvator *is the pronounced homoerotic lyrical content.*

JB: It's good if people feel that way, the record was made for them. When I look back at *Horse Rotorvator*, the lyrics seem almost surreal. It's definitely one of our weirdest records. My strongest lyrics are on that record, they're unbelievably cannibalistic, almost sado-realistic. Where the inspiration came from, I don't know. It seemed to be transmitted from another dimension.

PC: Hmm, interesting. I had a kind of trance feeling myself. You feel driven, motivated. Maybe we were really sent by higher forces or acting as receivers. I remember Marc Almond going almost manic, or Billy McGee doing the violin arrangements. He'd burn himself up and we'd have to force him to stop. He looked like a tortured Christian, dishevelled, skinny and drained. We checked his hands every day to see if there was any blood coming out.

A common complaint was the morbid nature of the record. *Horse Rotorvator* is about 'The Plague,' a deadly epidemic, but also about loss in general, the loss of everything that stands for life. And, with all due respect, that's definitely morbid and depressing. But our message is that death is manageable and therefore that it doesn't necessarily have to mean the end. It's a shift in your consciousness, a transference to another dimension. People like Nina Simone, Johnny Cash and Leonard Cohen each treat death in a beautiful, poetic way: the same thing that we wanted to achieve with *Horse Rotorvator*. We simply saw things at that time that others overlooked in the moment.

Balance and Christopherson are obsessed by Italian writer and filmmaker Pasolini, whose last masterpiece Salo, Or The 120 Days Of Sodom *went down in history as the most controversial film of all time. Pasolini was murdered three weeks before the premiere by Giuseppe Pelosi, better known as Pino: a male prostitute who lived on the streets.*

JB: *Salo* is one of the best films ever made. I also found it impossible to immediately accept what I saw. The film brings out underlying fears in the audience. The first time I saw *Salo*, I hesitated between running away and calling the police. In the end, I found a hard-on in my trousers. Unbelievable! I'd never had a film stir such emotions in me. That man, Pasolini, was incredibly important. Derek Jarman was strongly influenced by Pasolini and adopted many of his ideas: sacrifice, redemption, etc. We knew Derek for over ten years, which was a great privilege. As an artist, you meet a lot of people with the same interests.

PC: It's a huge advantage to be gay! (Laughs) It makes you an outsider. So you're automatically beyond the mainstream, which enables you to see and do things that others don't.

You have to fight that little bit harder against society to get out of the closet. In England, you're still confronted with all kinds of prejudices, but someone like Pasolini benefited from his homosexuality; it was a weapon with which he could fight against conservative society.

JB: This was a very powerful part of Derek too. Which is not to say that gays are always creative and honest. Absolutely not. But sometimes it helps.

PC: The murder of Pasolini was a warning to the opponents of the arch-conservative power-movers. The sinister thing is that Pasolini described his own death in much of his work. It's even rumoured that he wanted to be murdered and so there are a lot of theories.

JB: But the point is not who killed him and why. We are focusing (in the song 'Ostia (The Death Of Pasolini)') on the fact that he felt it coming, that he poetically publicised it. In his diary, Pasolini wrote: 'I will be murdered by someone who carries such a dark, destructive feeling within him, that it's amazing.' In *A Violent Life* he even describes the exact spot where it happened. Derek, too, carried problems like that around with him. Derek was so moved by Pasolini that we really started to worry about him. After *The Angelic Conversation*, he asked us to provide the music for a horror film. He wanted to be killed during the shooting of that film, while he was sitting at his desk writing. Maybe that's the essence of the artist's life. It's damn hard to separate reality from fantasy.

Poor distribution is a barrier to success for the time being. This is one of the reasons why the band is unwilling or unable to say anything concrete about their long-awaited fourth album, an album that, according to insiders, has been over two years in the making. In any case, it is clear that Coil's problems are partly

their own fault and that the British indie-scene has dropped the band like a stone.

PC: The indie scene is a creation of the major companies. By referring to the so-called underground scene, they distance themselves from all those strange bands. That's the classic method of selling strange records. It's ridiculous that people see the value of a certain record, just because it's released by an independent. That's like saying there's democracy in Peru.

JB: I've got The Orb's new CD in the player at the moment, released by a major, Island. It's such weird stuff, even for them. Now tell me if The Orb is indie, or not...

PC: The so-called indie scene plays it safe with big names. Experimental bands are just ignored. In England, Coil is never played. At least not on the radio, maybe in the clubs.

JB: Like that time in the Torture Garden.[1] We didn't recognise our own music! Peter asked the barman what was on. When the guy yelled 'Coil,' we ran away in shame! (Laughs) Thank God we're not known here. It's strange, in America even the hotel porter recognises you, here in England nobody knows us.

PC: Maybe that's for the best. I do feel affection for the ideas of this country. England is still as oppressive as ever. The hypocrisy of the government gets crazier and crazier. Recently they made the claim that the government is allowed to lie in parliament, which makes you think, Jesus, what is going on here?

Three years ago, Coil told Opscene about the witch hunt in England for anything that goes against Victorian values. Several friends of Balance and Christopherson were arrested for S&M and piercing activities. They were given five years in prison.

1 A dance club in London with a BDSM theme.

PC: Those people are totally broken! Two of them committed suicide, the other three are still in prison. It was a horrible event. Nobody wanted to help them. I mean, you at least expect all the media to be behind them, after all this is about freedom of speech, not a morality issue. And this is still happening in 1994! The government doesn't give a damn whether people have control over their own sexuality or not, which was the issue at stake in the piercing case. That was just a distraction from real issues, such as poverty, housing shortage, joblessness, poor health care. If you can make the people forget these distressing issues by making a fuss about porno films, or homosexuality, serial killers, or children killing other children...Why not? The government motivates the tabloid press, so the important issues stay on the shelf.

JB: And, in the meantime, they undermine the school system while denouncing the morality of a six-year-old. England is rotten. That's why I think that European unity can only be positive for a country like England. These Europeans are a lot wiser than we are. The English scaremongering should be over and done with. It's high time that we also mastered another language. Americans too have their misguided ideas and fears. They have problems with Mexicans, they think that black people are a threat, and that takes the country further away from worldly unity. If there is any chance for civilisation, it has to come from Europe.

With an envious eye, the pair look at Dutch politics. At least, when it comes to drug policy.

PC: At the time of *Horse Rotorvator* we were pretty depressed... Love drugs helped us out of the crisis. During the 'Summer of Love' we experimented with all kinds of drugs. We soon got into the nightly house life for the sake of the atmosphere, the crazy energy that was released in those days. We were

interested in the people, not so much in the music. Still, *Love's Secret Domain* is strongly influenced by acid house, the dark atmosphere of strange clubs and bizarre nights. Later, we made 'The Snow' remixes to achieve total integration into club life.

With Throbbing Gristle we were already making electronic music without the intention that it had to be danceable. The same goes for Coil, we don't make dance music, at best it looks like it. When I listen back to a classic house record now, say the debut of 808 State, it has the same effect as six years ago. Your fingers tingle again, you feel yourself ascending to higher dimensions. A record like that is interesting to make. But not something like 'Doop'.[2]

JB: That's an easy target. We don't mind being part of the house and techno scene, but we won't compromise on it either. As long as we don't feel restricted, it's fine to be part of a movement. People like Orbital, Black Dog, and Richard D. James all turned out to be great admirers of our work. That was a big shock, because the respect is mutual. Nowadays, I also listen a lot to Brazilian music and we eavesdrop on phone calls through a scanner. We don't have money to buy all those records anyway.

A new Coil record often takes years to come out: Scatology *was followed by* Horse Rotorvator *within two years, but* Love's Secret Domain *was a five-year delay. The new album is also some years away. The wait is eased by a series of CDs with leftover material and film music. Where is the new album?*

JB: I once read this three-way split in a review: *Scatology* was heaven, *Horse Rotorvator* was purgatory and *Love's Secret Domain*, hell. And where are we now? Beyond Hell? I prefer the following

2 A reference to Dutch band, Doop, who scored a U.K. No. 1 in March 1994.

distinction: *Scatology* stands for the body, *Horse Rotorvator* for death, and *Love's Secret Domain* for pleasure. The new album is supposed to be about violence and destruction, an idea that unfortunately we have not fully worked out. But I think it would be great to experiment more with aggressive moods and vocals. We are obsessed with the multiplicity of sounds and tones, especially the effect that can be achieved with this.

A group like Orbital knows how to make use of certain sounds in an inventive way, and still achieve a certain literary level. That intrigues us. During the recording of *Love's Secret Domain* we were struggling with all kinds of ideas around the vocals. On our new album, we just use sounds: no lyrics, at most some intellectual philosophies. Maybe it's time for a modem album, when we have the guts at least.

PC: In the future, we want to get more involved with pagan ideas, paganism. Despite the presence of a religious atmosphere, *Horse Rotorvator* already sounded quite pagan. Paganism is very important to us, because it pretends nothing, it is pure. The fact that we incorporate religion and spirituality into our music is because it is an important part of our daily lives. Just like coffee and tea or condoms. Maybe that's a hippie mindset, but for us this is a clear-cut thing.

JB: It's terribly difficult to make a normal Coil album, because we have such high expectations of ourselves. Technology is so advanced these days. We just played something that you said sounds like it came from another planet. That is our main goal. That's why we never toured, the technology wasn't kind to us. In the meantime, that problem has been solved as well.

PC: (Indignantly) You're not going to say we're going to tour! We once did two gigs, and I found that quite embarrassing!

For a moment there is a chilling silence. Finally, it's John who calms the fire.

JB: By the way, did you know that this is the first interview we've allowed in three years?

'Wrapping Around Reznor, Hellraiser, Burroughs, and Spirituality'

Boing Boing, 1994

Jessica Wing

Boing Boing magazine, active to this day, was founded in 1988 and switched online in 1995. The author of this interview, Jessica Wing, was lauded by the *New York Post* as representative of a newly emerging 'cyberculture' for her eponymous website. Wing, tragically, died of cancer a few days shy of her 32nd birthday. In a packed life, she was an intern at *Wired* and music editor for *Boing Boing*; was part of the group Weird Blinking Lights while releasing solo compositions as Warm Blooded Love; and founded the Inverse Theater Company.

'We used to not like the word "ambient." We just discovered that ambient — ambiente — is Mexican slang for gay. So we decided that it might not be so bad to be in the Mexican gay sections of record stores.'

Interview

JESSICA WING: Do you see a psychedelic content in your music?

JOHN BALANCE: Some of it. Unfortunately, most people come across a sort of evil element in our music, and shy away from it, especially in a psychedelic context, unless they're up for a headfuck situation. People say they do like taking drugs and listening to our music. They love it!

PETER CHRISTOPHERSON: But it's true that most people perceive a dark side.

JW: Where does the darkness come from?

JB: Deep in our hearts. (Laughs) Well, we don't see any reason to be unnecessarily happy or jolly when sorrow drives most of the world, really.

PC: I think we live in times when the restorative power of tragedy has been ignored. Throughout history, tragic or dark or painful truths have always been part of existence and human life. In the past maybe 50 years, there's been a conscientious attempt, especially among middle-class, respectable people, to deny the positive and restorative power that these truths have. So now we have a society where it's very difficult for people to relate to death, or any of these perfectly natural things — pestilence, disease, or riot.

JB: The perfect Buddhist ideal is to face the pain, the suffering. And we feel that it's part of our duty, in the lineage of William Burroughs and John Giorno and Diamanda Galás, specifically with the AIDS crisis, to confront and occasionally frighten people into enlightenment.

JW: What is your next album going to be like?

JB: We have two albums running together. Coil has been around for about 12 years, and it's about time that we splintered and became different entities. One album is called *International Dark Skies*. It's... Well, we hate the word ambient, but it's sort of dark ambient.

PC: We used to not like the word 'ambient.' We just discovered that ambient — *ambiente* — is Mexican slang for gay. So we decided that it might not be so bad to be in the Mexican gay sections of record stores.

JB: We have stickers saying 'File Under Ambiente.'

JW: And the second album?

JB: I think it's either going to be called *God Please Fuck My Mind For Good* — which is, in fact, a Captain Beefheart quote — or *Backwards*. This is going to be more vocal, since I haven't done lyrics or vocals in a long time. And it's going to be more aggressive, more violent, more upfront.

JW: Peter, you've shot some videos for Nine Inch Nails. What happened recently with the 'March Of The Pigs' video?

PC: Basically, I did two. One which was a good video, but it wasn't exactly what Trent wanted to show in his return to the public eye. So we made the one which appeared in public, which is a one-shot video just of the band, because it represented the way he wanted to be put across more completely.

JW: What was the first one like?

PC: (Pause)

JB: (Cough)

PC: Does that answer your question?

JW: Excuse me...? (Now intrigued)

PC: Uh...

JB: Mmmmm...

PC: Well, I'm not sure if I really want to go into it. It just wasn't exactly what they were looking for. It was kind of interesting and weird and strange, but it wasn't exactly right and Trent has the habit of being a perfectionist, so we decided to try a different avenue.

JB: I think that Trent was torn between what the record company wants from him, and what Trent's mind wants for him, which is extremely extreme. We did video scripts for Trent involving rooms of meat breathing in and out, which he loved, but we couldn't possibly do them, because they would never be shown.[1]

JW: Tell me about your involvement with William S. Burroughs and the video for Ministry's 'Just One Fix.'

JB: We've known William for god knows how long — Peter's known him for almost 20 years. We got the chance to shoot him for the video for 'Just One Fix,' which was about heroin and also a metaphor.

JW: What was the metaphor?

JB: Well, it's no secret that Al Jourgensen was a heroin addict at the time, but it was also about society needing more and more and more. We went to Lawrence, Kansas and we had a great time, spending about a week there.[2] We also recorded him for a specific as-yet unreleased Coil track, with him doing magic spells, sort of a latter-day cut-up using computer stuff.

1 A couple of minutes of the unused video appear in Nine Inch Nails' video, *Closure*. While studio lighting is visible overhead, the set resembles a stomach with organic red walls and the band sloshing about in murky ankle-deep water.

2 Burroughs resided in Lawrence, Kansas from 1981 until he died in August 1997 aged 83.

CCCLI

We saw his paintings and talked to him about magic and how nature should take its revenge on mankind.

PC: We're developing a film project based on William's work, but it's in its early days as yet.

JW: What is Burroughs doing now?

JB: He's painting a lot. He's switched from the word to the image. He was always trying to eradicate the word, anyway; and now he thinks he's done that, and he's painting extraordinary automatic paintings.

JW: What are they like? Are there images, or are they mostly abstract?

JB: There are millions of images contained within what seem like random brush strokes. Sometimes they work, and sometimes they fail. I think each one is a magical spell on paper. I think he's trying to trap the spirits or the demons in the paint. They're fantastic, some of them.

JW: Does he sell them?

JB: Yes, he sells them. The major pieces go into exhibition now and again. He's got a stockpile of them; I don't know what he's going to do with them. Maybe he's scared to release all his demons.

JW: What is his house like?

PC: Well, it's in the outskirts of Lawrence, in a very pastoral, natural neighbourhood... There's running water and trees and...

JB: Tornadoes!

PC: He's obsessed with animals and nature. He's become a shaman. He stays in his back garden talking to his toads and his frogs and cats. He's not exactly in retirement, but he's, what, 84 now?

JB: He's 80.

PC: So he's taking life a little easier than the hectic New York of the 60s.

JB: But he can still shoot a target with a double-barrel shotgun, both barrels, and survive the recoil. He's a very strong, snake-like man. He may not be human, as he suggested all along.

JW: Peter, where did you first meet William S. Burroughs?

PC: I first met William in New York in the 70s, because I was a fan and I contributed a lot of photographs that I'd done to his archive; he was going to use them in an illustrated book of one of his novels. Shortly after that, my record company, Industrial Records, released an album of the early cut-up experiments called *Nothing Here Now But The Recordings*. This was one of the first publicly documented issues of the cut-up tape manipulation experiments that Burroughs and Brion Gysin and Ian Sommerville made in the 60s, which were the father, if you like, of the modern approach to sampling, cut-ups and also the MTV style of film-making.

JB: Their intentions were magickal, drug-induced, based in ritual. They seriously believed that through these processes they could dissolve reality. Brion Gysin's paintings did the same thing; they were intended as magickal gateways to new realities. In some way, we try to consider some of our songs as doing the same things.

JW: So there is a spiritual or supernatural element to the music?

JB: Everything is supernatural. Yes, there are psychic intentions behind a lot of the stuff, definitely. You need to be taught how to have magickal empowerment. Half the neuroses in the world are caused by people misunderstanding perfectly natural — so-called supernatural — events. Dreams are just

as important as so-called reality. It's difficult for me to talk about this, because my lifestyle is so wrapped up in paganism and animism and the spirit world that I find it hard to relate sometimes to what so-called normal people are thinking.

PC: Hopefully the imagery or sounds that we use draw on a much deeper well of the unconscious that is present in everybody; and if more people could draw on their own psychic imagination, it would make the world a richer place.

'Coil was Just Becoming a Rope Around Our Neck'

Convulsion, Late 1994

Dorian Fraser-Moore

I was first introduced to Coil as a schoolboy who spent his lunchtimes hanging around in record shops trying to work out how to spend his lunch money. One week, the staff of the shop having noticed my purchasing habits, I was handed a copy of *The Snow* EP — a conceptual leap in the music I was listening to. My next Coil release was *How To Destroy Angels* which really pushed my understanding of them, while further piquing my interest.

Four years later, my passion for music was strengthened by running clubs and attempting to write about music for *Convulsion*; Jon Bains, the zine's editor, decided to let me try and get a fresh perspective. That's how I found myself heading across London to interview Coil, who had become a somewhat legendary band in my mind. I was totally unprepared, with not a single specific question to ask, and certainly somewhat in awe.

The interview had a profound effect on me. They say 'never meet your heroes' and I went in trepidatious of how I would find Coil, scared I wouldn't find my words, but I left realising these masters were mere mortals. Speaking with them made

them human and that was something I wanted to get over in the interview, as well as being something that affected my work with artists, musicians, and models throughout my career. It also impacted the way I approach my work, making me more ready to re-appraise and explore, more determined to refine and improve — while ensuring I served myself lashings of self-critique, something that evidently affected John Balance throughout his life.

I think Coil sensed my nervousness and did their best to make me feel instantly at home in their cosy living room. They seemed more than happy to go for more of a fireside chat than an interview. The tapes are long lost and all that remains is this highly cut-up transcript, which is possibly a good thing as about a week later Peter contacted me to ask I didn't repeat quite a few things on the recording — nothing salacious, just perhaps things that would easily be misquoted and thus misunderstood.

Over the years I've seen Coil play live dozens of times, mostly accompanied by one of my longest standing friends, John Hawthorn, the man who first handed me that copy of *The Snow* EP. This interview is but a little glimpse into how Coil has affected my life and friendships.

'Most people are turkeys in pigeon-holes. You can't stick a turkey in a pigeon-hole, I don't care what people classify us as, as they try to enjoy or understand our music. Who cares what they call it... You know, that's what they do.'

Interview

PETER CHRISTOPHERSON: Eskaton Records is our new imprint. After 12 years of Coil we decided it seemed a good idea to fragment and just produce music. Coil was just becoming a rope round our neck, especially with people asking us for live gigs once a week — at five-thousand pounds each time.

JOHN BALANCE: After 12 years, like Cabaret Voltaire or something, you feel that you just want to do something different, so we just formed a new label and said, 'anything that we do, we will create a name for.' We've got groups like Trial By Music and Wormicide. Wormicide is our sort of hard acid stuff — spastic acid — which came out before Richie Hawtin did it. Black Light District was sort of soundtrack stuff. All these offshoot groups basically. Which we make known as Coil.

DREW MCDOWALL: It's just a chance to be really self-indulgent. Like the ELpH stuff that's playing now. We started listening backwards to Cluster and, I'm not sure I should mention, Tangerine Dream. All the German groups and all the really early system musics like Lamont Young. It just seemed refreshing again, I've been through a twelve-year cycle. I feel like a teenager again. When we were doing this stuff, it was like, we felt we were taking it too far, we were disappearing up our own arses.

JB: Safest place to be isn't it?

PC: At least you know where you are!

Coil have always been known for having an interest in cults, rituals and weird science, which for them is partly a spectator sport and partly inspirational.

JB: Eskatology is the study of the end of the world. It sort of ties in with Terance McKenna and his 2012 theory. Instead of

the Big Bang being the beginning of history, we are in fact being hurled toward an object or something at the end of history, and that end of history will be 2012. I don't take that many drugs anymore, but I feel there is something going on. Both me and Drew agree with this, that psychic abilities and coincidences are increasing exponentially, or whatever one of those upward going curves is. You feel that time is overlapping at times, we're actually reaching a spiral point.

DM:Things are getting weirder, people are having weirder dreams, there's more and more coincidences. It's escalating to the Eskaton.

Having been together for twelve years, and working in the 'music industry' for longer, they come across a lot of different music and perspectives. Influences are not noticeable in the records, but are they influenced by others and who?

JB: Musically, Atom Heart. I don't know, when people ask that, it doesn't influence me.

DM: Enthusiasm as opposed to influence.

JB: I would never try and consciously copy anyone musically, as I said, I like Lamont Young. Just the purity of it, I wanted to make sacred music.

DM: The Cluster stuff they did without Eno. The stuff they did with Eno was all right, but the stuff without him was brilliant.

JB: I want to do hardcore ambient. I don't like wimp-out ambient. Mention no names...

DM: But there are so many people doing good things...

JB: From, so called 'Eskimo Music' to....

DM: ...To the new LFO single 'Tied Up.'

PC: Autechre... Scanner — Robin Rimbaud — His records are nice, but... We know him.

A clunk on the tape follows as one of Peter and Geff's dogs, Khaos, kicks over the tape recorder... An apt name for the dog.

JB: Sort of meeting people at the Electronic Lounge, at the ICA, has been an eye opener basically because, I for one started to go out which I never have done, and meet people and remember them. It suddenly turns out we are going to work with Bill Laswell and other people. It's flattering and it's also ridiculous. We poked our heads out of this cocoon we built for ourselves, everyone's sort of — not paying homage, I wouldn't say that — but respect due, which is great. Well the tide's changed, it really has. Doing things quietly and without reward has finally paid off.

Live performances by Coil are very few and very far between. Initially Coil were against the idea of playing live due to its unfeasibility, but with the changes in the technology they are using, and the addition of an extra set of hands, the live performance arena may open up to them. At the time of the interview it had been rumoured that Coil were going to perform live in Brighton to perform a new soundtrack to one of Derek Jarman's films.

JB: They advertised it as *Journey To Avebury* with a live premiere by Coil. Now because of that we're not turning up, we're not even going to be there. Because to turn up like that, in that situation, people are just going to think we've copped out. We absolutely said that we are not going to play live, we're providing a soundtrack pre-recorded on DAT which you can premiere if you are willing. That was it.

So is there any scope for Coil doing a world tour, or one-off performances?

JB: We are talking about it for later this year. Not down here. Autechre, Sean, said don't play London, so I will take his word for it. The reaction of people north of Watford is like five times more enthusiastic and open, I will take Sean's word for that, having just been on a big tour.

Geff's attitude to going out, or not as the case may be, shows a great deal of insecurity.

JB: I don't feel secure per se. I've never felt secure — ever.

DM: Insecurity is our baseline, that's where we work from, basic insecurity.

PC: Insecurity is our bassline!

JB: It's where we get our low frequencies. No, I don't feel anything full stop. If Drew tells me to I do. I have urges, juices, splurges, glitches. We are doing an ELpH album which might be called *Worship The Glitch* sort of like following mistakes to their logical conclusions.

DM: She's such a genius you allow her to lose her way now and again, it's part of being a genius.

JB: It's like Miles Davis, he did crap albums as well. She's going through a bad phase.

Musically, Coil are quite hard to categorise, they have dismissed the 'A' word as too large a scale to measure things on, and generally try to remain Coil rather than anything else.

DM: We desperately do not classify ourselves. That's the trick, to avoid classification.

JB: Most people are turkeys in pigeon-holes. You can't stick a turkey in a pigeon-hole, I don't care what people classify us as, as they try to enjoy or understand our music. Who cares what they call it... You know, that's what they do.

The variation of styles makes them hard to place. Industrial, experimental, ambient, techno and many, many more categories spring to mind. However latterly they seem to have stopped working with as much lyrical content.

JB: We are going to go back to that. We are signed in America to Trent Reznor's Nothing Records — Nine Inch Nails' sort of personal label — and we're going to do a vocal album. I've got tons of books of lyrics, so it's going to be good. We've just been a bit more nebulous recently. So I'm having singing lessons and shit like that, would you believe. I've not started yet, but I'm going to up until the record. Maybe Tona De Brett — she's a hard task mistress. I did a Jill Purce course.[1] Her husband, Rupert Sheldrake, is the one responsible for this theory of morphic resonance. Basically he's saying, in a scientific way — which I don't think you need to do, that everything is connected. Jill does vocal overtone chanting, which sounds a bit new-agey, but when you actually go there it's like shitting your guts out. It's like having colonic irrigation, psychic colonic irrigation. I did a week course and at the end of the week's course I had a big bruise on my bum. Not from sitting cross-legged, I don't think, but from vibrating with everyone else. It was resonating my body. I would come home and I would have dreams about drinking lager and sort of having my head cut off and everyone scooping my brains out. And you would go back the next day and say this and she would say 'good, good, that's purification,' all these dreams of having a limb severed and fed to everyone else is purification. So she's good.

Their theories and attitudes towards religion and the occult have caused them problems over time, with problems resulting

1 Jill Purce confirms: 'Geff was delightfully challenging and fun to have in the workshop because he was wild and outspoken and I always love to dance with challenging people! Unpredictability is so much more interesting, and that he certainly was, but in a really good way.'

from the 1992 Dispatches *'Beyond Belief' programme still in their minds, they are very careful of what they say.*

JB: I've been more refined over time. Like Julian Cope said in his recent album, I was scared of the cross, but now I'm not. I've become not anti-Christian, I've come up with stuff like 'a faith worse than death.' I can't be bothered to pursue that, I think that Christians who have good intent are good people. So I've absorbed that, and grown up, and realised that currents take all sorts of form. I've become much more involved, personally, with the occult. But less involved with groups or Crowley worship or anything. Although I respect Crowley. He will never be knocked out of my pantheon because he is an interesting person. The man was a wind up artist, and that's it — but I knew that. On the new ELpH CD there is a little logo which just says, 'Born Again Pagans.' I want everyone to become Born Again Pagans.

How To Destroy Angels *was described, on the liner notes, as ritual music for the accumulation of male sexual energy.*

JB: Only male because we are male. I'm gay and Peter is gay — Drew isn't. So that was for us then, it wasn't misogynist — we just couldn't fathom female energy then. I actually think now we can, and I want to do something about the sea and the moon. I want to do a double album about the moon. I was only about 20 when I did that, now I'm 32 — 23 backwards! I'm really into Isis worship, I think if the whole world turned into Isis worshippers it would be a far more harmonious place, but that's another chapter. Goddess worship is fine.

Their studio, Slut's Hole, displays a coherence of hi-tech systems. Working with racks of synths and outboard equipment and a direct-to-disc recorder they seem to have a lot to play with.

PC: It's a series of what we call secret weapons. Which might be a series of Boss pedals on a board, or it might be something upstairs

which we are not going to tell you about. Basically customised equipment. Using the Mac we have a program which filters and co-filters and all sort of shit. You can time-stretch a second out to a minute and then gate and you have a huge symphony type of thing. It's just, like, about having fun.

If I can recognise it I don't want to use it, is the rule. I don't care about copyright. I want to hear something new, so I pull it and stretch it and warp it until I get something I like. There is living sound and there is dead sound, and most of what is around is dead sound because it doesn't evoke anything. The moment it evokes something strong and archaic and universal I am into it. I challenged them to find any sample Coil have used — except for one which I regret. It was a Renegade Soundwave sample which I didn't know because the engineer suggested it. I sort of blotted our copy book of that one thing, and someone wrote in and said, 'how could you use a Renegade Soundwave sample? And I didn't know, I was slightly embarrassed.'[2]

The whole thing could be blamed on coincidence?

JB: This is the thing about morphic resonance though, as soon as you think about an idea it is out in the ether. As soon as you've got an idea you've got to work on it right away. That's a good point. I think that Kate Bush has stolen ideas from me psychically while I slept. I did a lyric a couple of years which went 'punish the dolphin, cut off his wings,' and, of course, Prince's new video has, 'if I were a dolphin would you cut off my fins,' which is too close for me. I was broadcasting really strongly. It's true what Drew says, if you are off in the stratosphere, where the air is clear, you know, these things are flying around there. It's who pulls them down first gets the most money.

2 A sample of Renegade Soundwave's 'On TV' is used on *Love's Secret Domain*'s 'Further Back And Faster' and 'Cocaine Sex (Turbo Lust)' on 'Windowpane'.

'Sex=Death=A Cycle of Energy'

Omega, Early 1995

Thierry Jolif

For me, 1994-1995, was a special time, creativity exploding in all directions. It was a magickal time when the mailbox was a threshold connecting me to the entire world... Or, more specifically, that small part of it invested in esoteric music, art, and magick. I was working hard on the second album by my band, Lonsai Maikov, while getting ever more involved in writing, and in doing interviews with interesting artists. It allowed me to answer my personal sense of spiritual seeking. With this in mind, it was obvious that speaking to Coil was essential. At that time, they had started to explore and experiment with music and sound in a way that was intense, brilliant, and sent shivers down the spine. Given my particular taste in art and music — and while I believe all their creations are tremendous — *Horse Rotorvator*, *Love's Secret Domain*, and *Stolen & Contaminated Songs* (as well as *Unnatural History*) are their masterpieces.

Of course, I had to wait quite a few weeks before I received John Balance's intensely desired answers... And it was worth the wait! Opening the envelope to discover a hand-written letter

from John, accompanied by photos and images, was a beautiful personal moment. John answers, to my mind, were deep and sincere — precisely what one would expect if one had knowledge of his work. John wrote simply and clearly about his experiences of real life and of real magickal exploration; of dance, art, the body, and the spirit above all.

(Interview translated by Sophie Smith with thanks and gratitude.)

'We may well found an anti-cult, a cult of the Black Sun. Each member would become a point of the sun, an angle of the conceptual space which would be created thanks to the contribution of each member. ...An idea without end, open and without any limitation of any kind, no landmarks, no dogma — superb! And stupid!'

Interview

THIERRY JOLIF: Your music seems very inspired by sex, drugs and magic...

JOHN BALANCE: Yes, life is our inspiration, in all of its aspects: light and dark, rising and falling, even darker and deeper still, further forward and faster, ambient 'new age dark.' In short, like our Buddhist friend John Giorno, we believe in the usefulness of demonstrating all aspects of life. No taboos, only compassion for the context of actions and of art, is a weapon that we adopt on our life's path. Drugs, because there is no unmodified state, no convergence lines, no real sanity. Reality is fragmented, holographic. Magick is the means by which the invisible world intervenes and works. Sorcery directs this planet. It isn't a question here of superstition, it's the awakening of a world of spirits intertwined with ours. The spirit, our thoughts, create multiple realities with varying degrees of actual foundation. Sex=death=a cycle of energy, of transformations. Death is velocity. Life is a very slow dream compared to the speed of the alternative that our spirits traverse when our physical form decomposes.

TJ: Death appears to play a major role in your music. What do you think of this quote from Hagakure: 'if you die in your thoughts each morning, then you will no longer be afraid of dying'...?[1]

JB: Dying every day... That's the only way to reduce the moments of fear that interfere with life on Earth, in this place.

TJ: The sensations that emerge from your music are very sensual and carnal, thanks to the electronic instruments. It's paradoxical...

1 Hagakure is an 18th century collection of Japanese warrior epithets and commentaries also known as *The Book Of The Samurai*.

JB: Electricity is Energy. Energy is Eternal. 'Energy is eternal delight.'[2] The vibrations, as well as the sequences, create forms and emotions guide these forms. Sensuality is delightful. F.E.A.R.=False Evidence Appearing Real. See you in the light.

TJ: The record cover for *Love's Secret Domain* is a perfect representation of your music. Why did you choose Steven Stapleton to design it?

JB: Steven Stapleton created the cover of *Love's Secret Domain* because he's our friend and we like giving our friends the opportunity to help us. He loved the record, we loved his painting. It was painted while he slept on a gloomy mountain, painted on a toilet door found on a damp Irish meadow. The more deeply you look at it, the closer you get, the more detailed it seems. At a certain distance I saw the figure of a lion with a nave... Steve didn't set out to create an animal like that.

TJ: Marc Almond sings on 'Titan Arch'. Despite the differences in your music, it seems that you have sex, drugs and magic in common.

JB: Yes, Marc Almond has been a close friend these past 12 years. We've shared numerous decadent episodes — many, many, maybe we will write about some of them. I wrote the lyrics for 'Titan Arch' and thought they would suit Marc more than me. I like the song a lot. A version exists with 100% feedback — a very heavy sound. I wanted a Lovecraftian atmosphere. Actually, some phrases were borrowed from H.P. Lovecraft and altered, but the best are mine: 'under shivering stars...' I'm proud of the song.

TJ: Looking back, what do you think of your previous records?

2 A quotation from William Blake's *The Marriage Of Heaven And Hell*.

JB: We don't like to look back and study them. Some don't sound as if they were written by us. I like that feeling: to forget your past. Why should we remember each of these recordings? ...We have too many future plans to pay attention to. Too many projects and ideas. Some sounds hate things (?), but not as much as you might think.

TJ: Could you tell us more about the Black Sun?

JB: The Black Sun. Our symbol. A star of Khaos. 'Soleil Noir'. An anti-sun. Keter.[3] The emblem of the underworld. A dream darkness that leads to the district of the Black Light. It's an ancient symbol of Odin. The crow. Harry and Caresse Crosby lived in 'the Shadow of the Sun' under this symbol — and had a publishing house called Black Sun Press, a decadent and beautifully presented series of limited editions.[4] We are finally going to publish a collection dedicated to the symbolism of the Black Sun. We may well found an anti-cult, a cult of the Black Sun. Each member would become a point of the sun, an angle of the conceptual space which would be created thanks to the contribution of each member. We would make plaques that indicate that they represent one corner of the anti-temple of the Black Sun. An idea without end, open and without any limitation of any kind, no landmarks, no dogma — superb! And stupid!

TJ: Why did you decide to make *Stolen And Contaminated Songs* containing remixes or unreleased versions of songs?

JB: We constantly have unfinished bonus tracks that time and money stop us from including on actual records. They are

3 Keter (or Kether) is the highest sephiroth on the Kabbalistic tree of life.

4 An intriguing couple who founded Black Sun Press and published many important modernist works before committing joint suicide (or perhaps it was a murder/suicide) in 1929.

often purer in a way, even if the sound is rougher. I like alternative versions and, at the same time, it puts a stop to bootleg or pirate versions.

TJ: Aleister Crowley says that sex, dance and drugs are the best way to reach Enlightenment. Do you agree?

JB: Aleister Crowley... has said a great many things. I don't think that sex is so good — now with AIDS and other even stranger diseases of the soul — the sun and the sea are as important. I've recently become single (celibate or was this a temporary split?) and sex scares me. I search for consolation in images of sex, that is to say, pornography. Knowing how far I can detach myself from it intrigues me. Nevertheless, my orgasms are still used in magical ways. I never waste an intense burst of semen. I make stars into seeds, growing my magic antlers like a deer, like a reindeer. Energies driven out across the astral world. Dancing, yes. Since 1987 dance has been a way to reach new kingdoms. Before 1987, I never danced. I didn't know how to let myself go. I was too cautious to take part in such events. Now I see them as vital for our survival and to re-paganisation. Regenerated pagans.

TJ: Was it a deliberate choice to make dance music on *Love's Secret Domain*?

JB: We had secretly been recording dance tracks since 1988, unreleased, under the name Black Light District. Drew McDowall worked with us on acid house tracks in 1988. We thought it was too late to convey the excitement we felt in the clubs at the time. It was better to make pleasing experiments than to copy the music. With *Love's Secret Domain*, we only used 'dance' type sounds: drum machines, etc. Why should this come as a surprise? 'The Anal Staircase' followed the same process a long time ago. Violent rhythms.

TJ: What do you think of techno? It seems to have inspired you...

JB: Techno. Old stuff maybe, the earliest acid tracks. I was there from the start, listening to that music, getting involved in the English scene with clubs like Trip, Love, Confusion, Strawberry, Sweatshop, etc... I like music that unleashes deep feelings and ancient energies. Now there are a few ambient things I like, as well as some older German electronic groups. Peter Namlook's Fax label, ESP, Atom Heart's CD Orange (*Monochrome Stills*). We love that record, as well as Autechre, Black Dog...

TJ: Some songs on *Love's Secret Domain* make me think of techno reinvented by Coil...

JB: We systematically take what surrounds us and make it ours. We pervert sounds. Absolutely all of them. That's why Nine Inch Nails' Trent Reznor gave us four of his songs to remix. He loves our sonic perversions. We twist and inflect things with our ideas and golden disease.

TJ: You don't often play live, why is that?

JB: There's no reason for us to do it. We don't play well and aren't trained for that kind of situation. Creating our sound is a long and complex process. We can't reproduce what we've done before. Perhaps one of our groups will play live in the most simple and straightforward way.

TJ: What are your current plans?

JB: We have two half-finished Coil albums. One of them is electronic and called *International Dark Skies* — a dark and deep dream world theme. The other, *Backwards*, sounds a lot more like the old Coil, more aggressive, with a lot of lyrics and vocals about anger, hatred, blood and sexual perversion. We still have a lot of aspects to reveal to our fans. We also have Wormsine, an acid group, it's fast and aggressive but

intelligent. Black Light District, a side project, is dark and rich with an album that should be out soon. We've just started a new label — Eskaton — for future electronic projects. The first disc is coming soon. Eskaton 001 Coil Vs. The Eskaton 'Nasa-Arab' and 'First Dark Ride'. 'Nasa-Arab' is a new version we've remodelled and embellished. We have a very special sound system. It's three-dimensional sound called 'sidereal sound.' It adds an astral element to the sound. It allows the spirit to penetrate the structure of the music. It's real. It's not a joke.

murderwerkers

we can stare
into gala's
eyes

we are giddy
dull boys

37

'Threshold House and Café Freedom'

Auf Abwegen, March 1995 and 19ᵗʰ March 1996

Till Kniola

In 1992 I started *Auf Abwegen* as a vehicle to find out more about artists whose work intrigued me. True to its name — which translates as something like 'off the beaten path' — the magazine's content expanded from covering EBM and Dark Wave to more experimental, free form music and all kinds of strange pop (and beyond) the staff liked. Somewhat belatedly I came across the 'industrial' scene and a whole new universe of noises opened up for me, artists occupying the ground cleared by the first wave of sound experimenters. A lengthy stay in London in 1994-1995 enabled me to make direct contact with groups and labels operating out of the capital, among them Coil. I bought the 'Nasa-Arab' 12" and used the email address on the sleeve to contact them. I remember John Balance replying in a lowly tone — Coil's friend Leigh Bowery had just died but I could come round to do the damn interview if I didn't bring a camera.

Thus one cold evening in March 1995, over two bottles of red wine and a generous exchange of gifts, a charming conversation ensued. I left Threshold House surprised, impressed and touched

by John and Peter — and we stayed in touch. They gave me a track for the CD compilation that started off the aufabwegen label proper and, later, I was fortunate to work with some of the other members of Coil, organising concerts for Drew McDowall, Thighpaulsandra and Stephen Thrower in Germany. I last saw Sleazy in Cologne, when I invited him in 2009 to perform with his new project SoiSong. He was in good spirits and seemed more interested in meditation than music, but was still the friendly, somehow reserved, Sleazy many fans knew him as. John was much the opposite, a very warm, vulnerable and open man. I last met him by chance in the summer of 2004. My wife and I were on holiday in Manchester. On our way to our hotel we passed a crowd gathering outside a gallery when I heard someone call my name. John. He greeted us with kisses and introduced me to his new partner Ian Johnstone and invited us to join the gallery party. We sheepishly declined as we felt like intruders. A few months later, he was dead.

It would be stupid to claim to have known them as human beings. But it is through the personal encounters, and the memories that accompany them, that their music has kept its power and relevance for me. I am grateful for the way they pressed their hopes, fears, interests and beliefs into their music in such a natural manner. I believe we should consider it a special gift to have been allowed into their sound world.

'I honestly cannot determine what I've dreamt and what is real. For me, they're the same thing. I'll wake up in the morning and a dream will take me for a whole week, to either get rid of, or act on.'

Interview Part One

TILL KNIOLA: So, what's new then, for you? The latest thing I knew was this 12" with the black cover...

JOHN BALANCE: That's 'Nasa-Arab' and 'First Dark Ride'.

TK: And I think on that cover it said something about an album to come up. Has that been released yet?[1]

PETER CHRISTOPHERSON: No, no, no, no, no... (Laughter)

TK: So that was the latest thing you've had...

JB: No, we've had a CD single, which is Coil vs. ELpH. What's ELpH like? Sort of, like I said, Cluster. So you have to look up Cluster, they're a really great group. Very quiet, not ambient — we don't like the word ambient. It's more electronic textures, almost like Stockhausen. Very pure electronic tones.

TK: So you took one track from the 12" as Coil or...?

PC: The Coil track is actually an old Coil track but it hasn't been released.

TK: So you wanted to put both things on that but in the future you will separate these?

PC: We got to the stage where we've been doing Coil for so long that we felt like we wanted to do different things. It's better to call them something different rather than confuse people that like Coil and expect one particular thing.

TK: But don't you think this will be kind of consequent for you to do in Coil whatever you feel like? And not be shaped by other people's expectations or whatever?

1 The label stated: 'Coil are currently working toward completing their next album *International Dark Skies* — a collection of electronic based "astral soundscapes."' It mentioned intended collaborations with Autechre, Scanner, David Tibet, the Sentrax label, Schaft, plus Nine Inch Nails.

JB: We'd rather have it this way. It's like we do some music and if it's sort of hard acid-y music then we've got a group called Wormsine, as in sinewave, the musical tone. After 12 years, 'cus our music is getting so different, each time somebody buys something it's so different for them it gets confusing. Better to have a new group.

TK: So it's confusing for you as well?

JB: Yeah.

PC: Kind of.

TK: Because I had the feel that with the latest releases you've been losing the straight-line for Coil anyway, that it wasn't so much a concept or whatever.

JB: It's true. But we still will do Coil, for America for Trent Reznor, for his Nothing label. We're going to do a proper Coil album called *Backwards*.

TK: And that's on Nothing?

JB: Yes, in America, it'll be for America. All the other projects... The ELpH CD sold out at its first pressing which would be a thousand copies... Well it sold out before it was released really.

TK: Just through mail order?

JB: Through World Serpent distribution.

TK: I'm going to meet these guys, I spoke to Alan (Trench), I want to do a little portrait of how they started and stuff.

PC: They're very successful.

TK: Especially in Germany. Some people view this as being the big rip-off now but...

JB: I personally do wish they'd keep their prices down when people order. I really do. I don't think people should pay over the odds for anything. It's not their fault all the time but when I see our records marked up to seven pounds for a single in the shop I get very angry because... Why? I wouldn't pay that. I'd be very annoyed if a group... Well I paid through the nose, there's another German group who's one of my favourite groups at the moment called Atom Heart...

TK: It's Uwe Schmidt from Frankfurt, right?

PC: We're mutual fans.

JB: Yes, I faxed him and I couldn't believe he said 'oh, I know your work!' He's one of those groups, everything he does is interesting.[2]

TK: He's been releasing tons of albums.

JB: I hope we'll work with him. We haven't said we would but I'd very much like to. Enthusiasm for music, strangely enough, happened again.

TK: So there was a period when you felt you didn't want to be part of it anymore?

JB: About two years ago. But now we're doing all sorts of things.

TK: And are they the old plans? You have this habit of announcing albums. (Laughter from Christopherson)

JB: Everything we announce, it will come out!

PC: Eventually.

2 Uwe Schmidt recalls: 'we were in very brief contact via email, perhaps half a dozen messages if I recall. The conversation broke off rather suddenly, I don't remember how or why.'

JB: I've always said that. Even things I said like 12"s I mentioned ten years ago — like 'Silence And Secrecy' was one, it's going to come out. They will all come out.

PC: Eventually.

JB: Eventually. *Funeral Music For Princess Diana...*

TK: So this one is coming out?

JB: Oh yes.

TK: I wrote a few down actually, so they're all going to come out... 'Damage From A Diamond'?

JB: 'Damage From A Diamond' is a track we did with Tim Simenon. He's already put his version out...

TK: That's Bomb The Bass? Is that on the new album?

JB: No, there's two albums: there's one called *Clear* and then he's got another album and what I call 'Damage From A Diamond' is going to come out on that. It's now called 'Dial 'U' for Ubu' and its Gavin Friday doing vocals on it. So he's releasing a version of it and we're releasing our own version.

TK: And that's on the next album?

JB: I don't know where it'll turn up that one.

TK: And then there was this *International Dark Skies*... That's going to be the next album then, or not?

JB: That's going to be our next English release, through World Serpent I think.

TK: And you won't have any double material that's the same on the American release?

JB: I don't think so.

TK: Do you have any schedule for this yet, or...?

JB: Not for that one. It's half-finished. It's all on tape, or the pieces are on tape. Maybe late summer for that one.

TK: And will you still do *The Sound Of Music*?

JB: Oh yeah, that's nearly finished. We've just finished a ten-minute soundtrack for a Derek Jarman film, *Journey To Avebury*. It's a Super-8 film he did in the 70s and we know his management and we know the people who own the Super-8 rights and I said 'I want to do this film soundtrack,' so we spent a weekend and we finished it off.

TK: So that album will be this piece and also outtakes from *The Angelic Conversation* or...?

JB: No, there are no outtakes from that. There's some more from *Hellraiser* and...

TK: Which wasn't on the 10"?

JB: Which weren't. We found about 20-minutes more. And we'll do a couple more soundtracks as well. We might remake the *Journey To Avebury* film ourselves now after nearly 25 years later, we'll go to Avebury and make this film again and do a soundtrack for it. That'll be on it. So that's actually nearly our next release.

TK: And do you have any time when this is going to come out?

JB: Couple of months? What are we now? February-March-April... Yeah, about Easter. Nice that it'll be an Easter record. It'll be a double CD.

TK: And what happened to Threshold House, is that still going?

JB: That's still going, yeah.

TK: I was a bit confused with the 12″ being Eskaton.

JB: Eskaton basically was meant for single releases of electronic music.

TK: Just your music?

JB: Not necessarily. There is no other band yet but if Atom Heart or someone, if we work with them it would come out on it. Threshold House is Coil, old material.

TK: So you definitely keep that one.

JB: Yeah, there's no reason to close it down.

TK: And you always have this really nice symbol, this house, for Threshold House.

JB: Designed by Peter Smith.

TK: And what's this from? Is it based on a building that exists actually?

JB: No, well, this IS Threshold House — but don't tell anybody. It's a sort of Lovecraft, you know H.P. Lovecraft? That's why there's the tentacles coming out of the water. You don't like him that much?

TK: No, not really. Sorry!

JB: No, I don't, he's not my favourite. I like this guy called Clark Ashton Smith, I've got his books up there. It's meant to be a sort of temple of abomination or something.

TK: It doesn't make sense to me?

JB: Abomination is sort of things you can hardly talk about because they're so strange and evil goes on. Not this house! This is what the picture represents.

TK: I have one question that goes back quite far, so if this is too far just...

JB: I'll remember.

TK: This has to do with Zos Kia, I never really understood why a band that uses Coil material can go on without you. Did they have permission from you or...? It says they use Coil material.

JB: They didn't need permission from me. With Zos Kia, originally, we did about five concerts, very small, and also we did the Berlin Atonal Festival. There were three in Zos Kia and I was Coil at the time and Peter was doing some of the sound mixing. At one point the material we were doing was the same and then John Gosling, who is now Zos Kia, carried on.[3]

TK: I just met Raymond Watts who does Pig the other day and he said John Gosling is doing a new album now as Zos Kia. You don't have contact with him?

JB: Yeah we do, he's a nice guy, a really nice person.

TK: And what about Danny Hyde?

JB: He's our engineer who we need and love.

TK: I thought he was more a member of the band? Is that so or...?

JB: Yeah, it's difficult when you say actual members of the band, he's never in the photos — we don't really take any photos. What Danny's done for us and with us has made our sound. He's very important to what we do. But we can live without him, we have done stuff without him.

3 Extract from a Coil/Zos Kia fact-sheet Balance sent to Will I. Stasch dated 11th May 1984 (used with Will I.'s kind permission): 'The Berlin gig was the last one we played together in that form. Zos Kia was Min and John Gosling. When we played Berlin, we used the backing tapes of Coil material and played Coil songs. Zos Kia have since recorded a single which uses "Here To Here". It is a version of "Violation" from the live cassette. I did not play on it, they used my backing tape instead.'

PC: ELpH doesn't have him on.

JB: ELpH he's not on, just Coil. But we prefer to work with him, he's a very good engineer and having worked with him for ten years we don't really need to use anyone else. He's got his own band, a band called Sample Nation which we don't have anything to do with. Not because we don't want to, it's just his own project. Very sample-y and sort of ethnic music, electronic ethnic.

TK: Ethnic brings me onto a point: you once contributed to a Sub Rosa *Myths* kind of thing and there was a ritual piece which was actually recorded in the field...[4]

JB: In Burma, yeah.

TK: Can you talk a little bit about this? What did you do, you just went in there...?

JB: You know animism, spirit worship? There was a temple, there's a place called Pagan in Burma, with a field of temples, there must be ten thousand temples. They're Buddhist now but they were pre-Buddhist and there's a mountain there which I can't remember the name of and you have to walk round it on this spiral with all these statues of animals and you touch each one as you go up and at the top there was this monk singing and he was a Buddhist monk but he was singing these ancient hymns that were pre-Buddhist. So we just said 'can we give some money to the temple and record you?' And he said yes, so he carried on. No objection, why should he? We went there in the right spirit of it, the place. It really was a recording you couldn't get anymore because the military in Burma now are so heavy and they've destroyed villages.

4 *Myths 4: Sinople Twilight In Çatal Hüyük* compilation (Sub Rosa, 1989). Coil's contribution, 'Another Brown World' contains vocals recorded at the summit of Mount Popa, an extinct volcano.

TK: So when was this, when did you do it?

JB: I can't quite remember but about two years before the record came out. (Sound of door opening) Hiya! Come in.

NEW VOICE: Hello, am I interrupting you?

JB: Terribly interrupting. (Kisses exchanged) Hi, how are you?

NEW VOICE: Fine thanks, how are you?

PC: Do you want a cup of tea or anything?

NEW VOICE: I'd love a cuppa actually — seriously. Milk in first for me please. Then sugar.

JB: Till? This is Marc Almond.

TK: Yeah, yeah, I know! Hi!

MARC ALMOND: Nice to meet you. (Brief pause in the interview)

TK: You have a tendency to do some special first issues of records, I heard there's a special release of *Gold Is The Metal* with some artwork? In Germany people pay a thousand marks for it. There were like 50 copies...

JB: (Having fished around on a shelf) It looks like that, but this isn't it. Inside it has a special gold leaf.

TK: I thought it had a painting with it.

JB: Oh it does, everything's handmade. There were 55 copies and I don't know where they've all gone.

TK: And I believe there was also a first issue of *Stolen And Contaminated Songs* on LP, is that true?

JB: No, we said it would do, but it didn't.

TK: But it had a CD with no tracks listed?

JB: That's true. Have you seen that one?

TK: No, I've just got the second one.

JB: I'll give you one, there's quite a few upstairs still.

TK: So what was the purpose of those, were they not finished...?

JB: No, it was meant to be a sort of mail order only thing. Numbered. It was always meant to be a small release and stupidly enough we didn't think people would bootleg it. It didn't actually happen, we don't think, but we heard from two people that they were going to do it.

TK: Couldn't you just stop them if you know the people?

JB: You can't really. Once it's out 1,000 to 2,000 people have bought it. So we reissued it and changed the cover.

TK: And there was talk of doing a remix version of the whole album, did that happen? *Stolen And Contaminated*. The people at Rough Trade said it. No, you never intended to do that?

JB: I don't think so.

PC: We have occasionally felt that it would be good to do two completely different versions of an album, but we haven't done it yet.

TK: And with *Gold Is The Metal*, you give people insight to your work process in a way that I felt you put out some sort of rough mixes... Doesn't it also put pressure for you? You give away the song before its actually finished...

JB: No, we give away the song after it's finished.

PC: Usually we do the finished version first and then we release something that has some of the notes and the ideas that led to the finished version.

TK: And sometimes you have two versions of a song that appear under different names...

PC: We have done. There's 'Penetralia I' and 'Penetralia II'. We don't do that in order to confuse people, we do that because it seemed like the new version was so different it wasn't really the same song but...

TK: ...It started from the same idea.

JB: I think it's quite nice to do. It's nice for us having spent like ten weeks, overall, working toward a finished album which every song has to be important and mean something on a record — it's got to be 'the one.' Each one could be a hit single or whatever. The pressure on that is just so horrible that to do something just totally off the wall with the material is such a great release that it's fun to do. What's wrong with having fun? We do.

TK: And maybe it's also a nice document for you that you have actually manifested what the song was like at that time and it goes on.

PC: It's the closest we can get to spontaneous performance of things.

JB: The way we work often is very spontaneous, it just happens. Some of the early tracks like 'At The Heart Of It All' on *Scatology* is live, it's the way it happened in the studio and that quite often happens but once it's on a record people imagine you spent ages overdubbing and stuff and it's not always the case. The rougher ones, after a while, they may sound wrong — the sound may go up and down or whatever — but they're more interesting to me.

TK: I really like some of the songs on *Gold Is The Metal*. Especially the one in the Thai boxing stadium.

JB: Yeah, I think it's a good album. That was just something we never quite finished and then decided, 'well let's not finish it. Let's just put it out.' There's videos to go with that as well.

TK: You plan, eventually, to put it out? A Coil video compilation or...?

JB: Nothing Records want to.

TK: It's a bit of a shame really, you do so much video, Coil...

JB: ...For other people!

TK: ...But the only one I know of is 'Windowpane'.

JB: We've done about six proper full videos.

TK: Most of them around *Love's Secret Domain*, that album?

JB: No, there's 'The Wheel', 'Tainted Love', 'The Snow', 'Love's Secret Domain' — the actual title track — a couple of others. Although there's lots of videos here but most of them are pornography, we don't have copies of our own. We have a mental block about showing people our own videos. I don't mind people seeing them, I like people seeing them.

TK: I just got a taped copy of *Love's Secret Domain* and so I listen to it quite often on headphones on my Walkman and I think it's actually quite a good album to do this, it has this interactivity, like you listen to it on the tube and you often hear other people's conversations actually going in, it really works quite well.

JB: We did that deliberately, we spent a long time folding things in so what sounds like percussion is in fact vocal speech chopped up and made into percussion. We spent a long time and we were doing a lot of drugs — we were doing LSD and Ecstasy and Speed and things. We've stopped now because I went

CCCLXXXIX

mad at the end of doing that record, so I laid off everything. But it was all folding in on itself, every time we listen, every time I listen to it, there's new things. The 'Windowpane' single we recut it recently and to listen to it again it sounded really fresh and interesting.

TK: Is it going to be remixed by the guy from Bomb The Bass? Still not decided?

JB: I hope so. Tim Simenon said he would do it about two years ago and we're, hopefully, just waiting for a phone call just to ask him as a favour. He's a good friend of ours, we've known him for a long time, so it depends how busy he is.

TK: There was one track on *Love's Secret Domain* that had heavy voice samples, this one guy says: 'tattooed fingers, look at the fingers…' Where's that from?

JB: It's a film called *Night Of The Hunter* with Robert Mitchum. It's a very strange film about two children who know where some money's hidden. It's got Robert Mitchum as the evil man. It was directed by Charles Laughton who was Quasimodo in a very famous version of *The Hunchback Of Notre Dame*. He was an extremely brilliant actor.

PC: But that's not taken from the film it's taken from a record the actor made of the story…

JB: The words are taken from Charles Laughton narrating *The Night Of The Hunter* on a record. We took the samples and played them on a keyboard and rearranged it. Our minds were totally scrambled at that time. (Christopherson sniggers) You'd gone home by then.

PC: I was asleep.

TK: But you still felt you were in control of this during this time?

JB: Yeah, otherwise I wouldn't have released it. We do loads of things we lose control and then we just don't put out.

TK: So you have actually like a pile of stuff that you...

JB: ...Not so big actually because, as I say, we tend to use most of what we do. We get pretty far out but we're still in control most of the time.

TK: And what is sidereal sound?

JB: Sidereal means sideways on.

TK: Like stereo effects?

JB: Not really.

PC: It's actually used in art and graphic design, it's not normally used in music.

JB: I collect the art of Austin Osman Spare — do you know about him? That's two pictures by him there and that's one by him as well. For Spare, sidereal means, geometrically, being twisted on its side. So we take sidereal sound to mean the same thing. As opposed to a picture, it's taking the sound and twisted it on its side.

PC: And the reason that we use it is because we use a lot of computer processes now with sound that affect the sound in a way that was impossible before.

JB: You can actually turn the frequencies of the sound inside out so what your brain is listening to is something that it's never been able to hear before.

TK: So it's kind of like an implosion?

JB: Very much so. But a very slow implosion, turning things inside out very slowly. Like we do very quiet music but it sounds loud.

PC: And vice versa. If you imagine the shape that a body makes in sand on a beach, when the body leaves there's an impression made of the body. So you can see the shape but it's of something that's not there. With a computer now you can do the same thing with sound, so you can subtract one sound from another sound and you no longer can hear the first sound because it's subtracted, but you feel the shape of it.

JB: It's all digital.

TK: So you try to pull the strings of the subconscious?

JB: Well that's our intention, it's done very mathematically. You have a sound and you subtract a certain frequency so there's a hollow where there should be a peak. It just sounds very peculiar which is what we've always tried to do.

PC: it's not like a box that we've made, it's an approach.

JB: It's the way we approach it, yeah. It is a series of boxes, it's definitely a mechanical thing, it's the way we try and approach it.

TK: And was it actually set up by you?

PC: Yeah, we won't sell it to anybody else, for sure. We're not in the business of making audio equipment...

JB: We don't believe in sound copyright at all. Everything is 100% recycled sound and if people want to take our sound and do something with it, that's OK with us.

PC: At the same time we're not going to tell them how we did it. (Laughs)

TK: I think that a lot of this also went on the recent 12".

JB: Definitely. It went through all our boxes.

TK: I felt that this, the 12", actually had quite a druggy feel to it.

JB: We've stopped drugs, we don't do drugs anymore. (Some sniggering) Well we didn't do drugs for it.

PC: As it happens, I don't think we were taking drugs when that was actually recorded.

JB: We don't need to do anything like that to make the sound. It's more fun to make them when you're normal and then you get the strangest thing. We've just done two remixes for Scorn, a track called 'Dreamspace', we've done two versions of that track. One's 11 minutes and one's about four. The short one's very hard and the first one's totally psychedelic, but we didn't do any drugs, didn't do anything — I was slightly drunk maybe but... I like working with sound, with frequencies.[5]

PC: I think the drug experience helps you to realise what sounds would be good.

JB: Having been through it!

TK: But maybe you lose some of the fun of it because doing the music, the actual process is the fun. Maybe if you're not fully conscious or whatever...

PC: It's not generally possible to do them together. You can do them separately and they both will make a contribution to the other experience but it's difficult to do it at the same time.

JB: I admire people who can take drugs and make music at the same time, but we can't. *Horse Rotorvator* was heavily Speed induced. It doesn't sound like it at all but once you take such huge amounts of Amphetamine Sulphate you start hallucinating and weird things happen. We don't do that anymore, we're too old. I just drink red wine.

5 'Dreamspace (Coil — Shadow vs. Executioner Mix)' on *Ellipsis* and 'Dreamspace (Coil — Unstable Sidereal Oneiroscopic Mix)' on *Gyral* respectively.

TK: What is actually the *Horse Rotorvator?*

JB: It was a dream I had. Instead of the Four Horsemen of the Apocalypse riding down and spilling death and war and famine and pestilence on people, they actually kill their own horses and they took their jawbones and made a great machine that ploughed the earth up. A rotorvator is a machine for digging very deep earth. A big plough.

TK: And maybe this was a good indicator for what was going on?

JB: What's going on! What's going on! This was pre-destruction of the rainforests, well maybe not quite before but...

TK: I meant also in a metaphorical sense that out of yourself you bring what is hidden, what is dark, you bring it up.

JB: I always do, unfortunately. (Indicates Christopherson in background) He has to live with me, he lives through this. I honestly cannot determine what I've dreamt and what is real. For me, they're the same thing. I'll wake up in the morning and a dream will take me for a whole week, to either get rid of, or act on.

TK: I don't know whether the theories we have about dreams are really right, I mean, we regard dreams as something not so meaningful but other people can take it just as a state of life and don't even consider it to be unconscious.

JB: I agree. It's certainly not unconscious, it's something else. We prefer Jung. I like the way Jung said it, 'I don't believe, I know.' That's it for me.

TK: I think that when you did *Love's Secret Domain* and later came *Stolen And Contaminated* and you put on there a few original versions that appeared in different versions on *Love's Secret Domain*. So, one could see, I thought, you were actually, on *Love's Secret Domain*, destroying some of the

songs in the sense that you made them sound not song-like, like what you did to the lyrics. For example, with 'Love's Secret Domain', which in its original version is more or less a plain song, you're singing quite clearly. On *LSD* you've really messed around with it. And you also use, quite often, backward stuff on *Love's Secret Domain*...

JB: I don't like the sound of my own voice really. I always think people should work toward listening to an album and if you give them something that's obvious and just there then it's no fun for anybody. It's not fun for the person who made it. Fun is probably not the word, not with our music anyway. They should work at it!

TK: And how was it working with Derek Jarman?

JB: Brilliant. Derek really is a saint.[6]

TK: A saint of... How do you pronounce it?

JB: Dungeness, it's where he lived.

TK: I'm just reading the books, the autobiographical ones.

JB: We're doing a track called 'At Your Own Risk' — 'AYOR'.

PC: Derek is more interesting as a person than as a phenomenon or a filmmaker. I didn't really like many of his films, but his personality and what he did and the way he did it was extraordinary.

JB: If you met the guy, even when he was dying you'd go into a room and come out humbled and say 'my god! How's he got so much lifeforce coming from the guy?' It was wonderful.

6 In September 1991, Jarman was canonised by the Canterbury branch of the Sisters Of Perpetual Indulgence who declared him Saint Derek Of The Celluloid Knights Of Dungeness. 'AYOR' is a reference to Jarman's book *At Your Own Risk: A Saint's Testament* (1992). The title 'Disco Hospital' was re-used for a composition on Jarman's album *Blue* (Mute, 1993).

TK: I liked very much to see that he could still have this humour or sarcasm or whatever.

JB: What else have you got left at that point, really?

TK: I also like your contribution to *Blue*. Was 'Disco Hospital' actually the same as on *LSD*? It's a scene in a hospital, it comes on as he leaves the hospital.

JB: It was just the title which was the same. He asked us to do a piece of music that resembled the feelings of people who had AIDS via a disco — which is a very heavy thing to do. So we made it slightly 70s disco, then suddenly this huge noise like the scythe of death coming in. He loved it! When it was shown at early screenings, before it was finished, he'd stand up and clap, 'this is fantastic!' So I feel it's a good piece.

TK: I got the single and I was disappointed it was so short.

JB: We might do a longer version for *The Sound Of Music*. It was just meant to be a small little piece for the film ... The dog's farted.

TK: Do you actually think it's important to be presented in a gay context, for you?

JB: Well, when we're being gay. Me and Peter are gay. Drew, who's the other member of the band now, isn't.

TK: It's not the husband of Rose McDowall is it?

JB: Yeah. He's been a friend of ours for a long time. Now he is a permanent member of Coil because he's a beautiful person and we need him.

PC: We get irritated when they have reviews of supposedly gay groups and we get missed.

JB: For a long time we were the most out on a limb or experimental gay group, for sure, in England — for the last ten years. We've

been existing as a gay group, when Steve Thrower was in the group we were all gay, all three of us, and that was it.

PC: And we were the first group to do an AIDS benefit. We would never consider that we promoted a gay lifestyle particularly, in the way that some do but the thing is we deal honestly with the things that are important to us.

TK: Do you think it is crucial for a proper understanding of your music, to be gay?

JB: No, of course not. Absolutely not. That'd be really pigeon-holing. I'll tell anybody who asks me, or we would tell anybody who asks us, but it's not crucial.

PC: I can't think of hardly any song we ever did that was specifically a love song where the identity of the relationship was important because all of our songs are more complicated than that.

Interview Part Two

TK: You mentioned Stephen Thrower. He's now in a band called Put Put with the guys from the These Records shop. Why did you get rid of him?

JB: We didn't get rid of him. We had philosophical differences basically. He doesn't believe in anything whereas we believe in everything.

TK: It's as simple as that?

JB: Well, as simple and as complex as that. And I don't mean to degrade him at all because he's a very intelligent person and we very much respect his input.

PC: And a very good sex... (inaudible quip)

JB: You're just being flippant! He was a very important person when he was with us but we grew out of each other after eight years or so. He was always an irritant, which was a good thing! I don't mean that in a horrible way, but he was always an irritant and it provoked a lot in me and I suddenly realised I don't need to be irritated anymore. Maybe I've gone soft and he's on the right course, but good luck to him!

TK: I thought that, especially on *Horse Rotorvator*, the oboe playing or whatever that was really added something, especially to the slow pieces...

JB: Actually, listening back a while ago, I realised he was doing much more than I imagined. It's unfair to pinpoint what he actually did, it was a combination of people and after all that time we were very strung out, a far distant planet, and you can't keep that up for so long so we decided to change.

PC: We need to have a third person to stop us killing each other!

TK: I imagined it would be easier for you two to work as a close unit because you're together anyway so you can exchange...

PC: We're too close.

JB: No, we need people to stop us killing each other...

TK: So, sometimes you have two distinct ideas and you feel you can't really put them together or...?

JB: It's like Burroughs said in *The Third Mind*: however many people you have working, there's always a sort of overview that's happening. It started to get slightly poisonous and destructive so we stopped with Steve. And Drew didn't replace Steve at all, it just sort of happened that we said 'let's work together' and things have happened again.

TK: How did you meet this guy because I thought they were living in Canada? Or you knew them?

JB: We've known him since the Strawberry Switchblade days. Rose is married to someone called Robert — he's Korean stroke Canadian. But Drew has been around 12 years.

TK: But Rose McDowall is on the recent 12", or is that Drew?

PC: On the recent one, it's Drew. Rose is on 'Windowpane'.

JB: Rose is going to work with us as well, we're going to do a Christmas single with her.

TK: I've always thought it's funny, you've been involved from quite early on with Current 93 and also Death In June but they, on the other hand, never went quite so strongly into Coil as guest vocals or whatever.

JB: I don't know, me and David are doing an album together which will be totally both our things. Me and Steve Stapleton are going to be doing an album. It's happening. I've done several ghost vocals on their things.

TK: And you, in the *Fist* magazine interview, you talked about *International Dark Skies* and you said that it should be easier to watch the stars again, so to dim down the light. Have you developed a theory for that?

JB: It's not my theory at all. International Dark Skies is a movement to reduce street lighting, so you can see the stars again — it should go down and not up. We spent a holiday in a place called Ardpatrick, in Scotland, and there was no lighting at all apart from the house we were in, a very old house. We'd be watching the clouds then suddenly you would see what I thought was a UFO, this light would suddenly go woosh and shoot across the sky! And you'd realise it was a car about 12

miles away, just the headlights of a car coming around the corner. People are so desensitised to what should really be seen. My ideal place would be with no sounds apart from the waves and animals, and no light apart from... Well, waves and animals. An occasional car but not anymore. I have a terrible problem living in London because I don't like it at all. After 12 years of enjoying getting objects, like books and things, I don't want it anymore. I want to go.

TK: If you think this further, what does this tell you about society or how do you perceive society? What should be changed? I mean, it had some misanthropic phrases in it...[7]

JB: I stand by them all. I don't think humankind... It's a bad animal. My dog is behaving today, but when people breed animals and they go wrong, they take a choice and decide not to breed them anymore. And I don't believe in that because I think nature should take its course, but man is a bad animal. It has bad habits, it doesn't care for the planet. I've been aware of this since I was about ten.

TK: That's right but I still don't think it gives someone the right to say other people...

JB: Of course not, I would never...

7 In Fist #5, Balance stated 'We should have clean rivers and air and not so many kids. When I turn on the telly it's full of programmes about... blocked fallopian tubes, cot deaths and babies. There are very few shows that talk about contraception. I've thought about going onto one of those programmes and saying that you should keep the kid you have and care for it. Don't have any more and tell your friends the same thing. This is why I think Gays and Lesbians are radical as they don't have kids. They've opted out of that genetic trap. People think, if you don't have kids then you don't believe in human life... It's totally the wrong way round. They do care so much, they've decided not to have children.' Asked if he was misanthropic: 'Not really, because the people who are here, I care about. I just don't want any more.'

TK: ...Like birth control or whatever.

JB: Birth control, yes!

PC: Not for a selected group, for everybody. The difference is in Fascist states is that they choose who should live and who should die... We believe everybody should die. (Sniggers)

JB: No, not everybody should die, but everybody should have only one child. If everybody had only one child, then if that died have another child, but if they only had one child then it's just possible that the planet might be able to survive and sustain. All it's to do with is the quality of life. I don't care about race or anything like that, everyone has an equal right to survive — the total opposite of Fascism. And if anybody ever accuses me of being Fascist then they're either completely stupid or I will go and shoot them. It's just not what I'm into! But this planet can only sustain so many people, I'm the opposite, I'm about caring for other people.

(Break while Balance takes a phone call)

TK: I just wanted to ask about the graphic novel that's coming out...

PC: It's not happening. We didn't complete what we were supposed to complete for it and, at the same time, the CD side of it didn't appear. And the so-called novel actually turned out to be more of a comic which wasn't as interesting as it seemed like it was going to be.

JB: It was like typed stories, there was no graphic novel.

TK: And you also talked about putting together a book with all the Black Sun symbols. Will you still do this?

JB: That was what I was talking to the guy on the phone about, John Coulthart. He's an extremely good graphic artist. He did

something in the recent H.P. Lovecraft book. But we want to work with him because he's an extremely brilliant artist. I don't want to do something so shallow as an album cover with him, I want to do something more important. (Shows Kniola something) See, this here was designed by me and Peter Smith. They used this without permission and I got really pissed off with them — Creation Books if you'd like to mention them in print. They really fucked me over. John is very into magic and things, an extremely good artist.[8]

TK: So, you haven't set a deadline for this book yet?

JB: No, of course not. With collaborators it's like, they've got their own lives to lead, we've got our own lives to lead, and when it coincides, it's good. You can't push people. I know from experience you can't push us. If you ask us things and push us, we don't do it.

TK: I pushed you to do an interview. (Laughs)

JB: And we did it. That's OK!

TK: I thought Peter was doing much of your graphic work for Coil?

JB: Were you Peter?

PC: Sometimes. Not always.

TK: So you'd rather get somebody else to do it then?

JB: No, we do it. We do it together. It's because of Hipgnosis, Peter is seen as the... Most of the graphics on the album covers are my ideas then Peter realises them. Most of the time he doesn't know what I'm talking about... Until about eight years later.

TK: You also announced a 'queer disco album' with William Burroughs, is this still going to happen?

8 Check online for more detail on the bizarre tale of Creation Books.

JB: Oh, *Keep This Frequency Queer?* Who knows?

TK: Are things a bit difficult with William Burroughs? Or with his agent? He seems to be spreading himself around a bit...

JB: No, not with us. And everything William does is obviously his decision but the options offered to him are often quite different to what might possibly be the best for him. But it's his life. William would never do anything that he didn't want to do — full stop. If you've met the guy, he wouldn't.

TK: I believe you did actually collect some talks of his?

JB: Yes, we've done a couple of tracks, talking for a couple of tracks that haven't come out yet, called 'At War With Words'. Not William just talking his text, we asked him to speak words so we can do anything we want with them, rearrange them into magical spells or whatever — it's good. Better than most of the things that just take William speaking and put music to it. We actually gave him a piece of paper with the words we wanted on and said 'William, will you say these please?' And he did. It's new. It's going to be a Coil thing.

TK: You mentioned magic. You're also very fond of Austin Osman Spare and of Crowley I believe?

JB: Yes, Crowley is in my background history...

TK: How far does this reflect in the way you do your music?

JB: I don't know about the music but in my life, Austin Spare and Crowley — my own magick, that's all there is. If music happens from it that's good. I'm, sort of, negotiating with Kenneth Anger as to how we can sort of follow on what Kenneth Anger started as a film-maker and celebrate Crowley. There's a magickal current that runs through us all. It's not our responsibility but — change that, it is our responsibility.

It's our total responsibility to carry it on. Even if it ruins your life, which it quite often does, it's not Crowley's spirit, it's just the spirit, of what they were doing as well. You might call it decadent or left-field or whatever you want to call it. Kenneth did it through film, we did it through film slightly — mostly through music.

TK: I was just thinking in terms of those people who lay out some rituals or who describe what they did. Do you adopt some of the practices?

JB: I do rituals. I'll cut my arm and let blood flow or whatever I feel is appropriate. But I've never been a member of the OTO or all those groups, although I think I could have been. It's because I don't believe in groups. It's the Groucho Marx thing: 'I'll never be a member of a club that would want me to be a member.' I don't see the point. All my heroes did what they did on their own, without the help of most other people.

TK: You used the bull-roarers in 'How To Destroy Angels' and they're a magickal instrument...

JB: And they were covered in blood. We actually said, and this'll sound sexist, but it was a male thing so we didn't let women in the studio at the time. If we did a moon-orientated thing then only women, maybe not even us, would be allowed in — it just depends what we're doing. We're certainly not sexist. It's the idea of ritual, you have to have parameters for ritual, otherwise it isn't a ritual. You have to have boundaries so you can focus on what you're doing. Doing moon rituals you have to focus on the moon, not anything else, everything else is irrelevant even if there's a war going or flooding.

TK: Do you actually feel your music can serve as a ritual?

JB: Not for us, but for other people. It's part of why we exist. Every piece of music we do, is done with other people in mind. It flows through us. It's not our music almost.

TK: Do you see yourself as being a catalyst?

PC: Putting out those frequencies.

JB: We're *something*. Shamanic in some way. I spend half my life in bed cowering and being scared of what I see and feel and hear. Only in the music can we get any sense of normality. I really do suffer, basically. I don't want to be a martyr, but I can't function most of the time in the modern world. It's what I was saying about having no light and having no sound. That's my ideal situation: I want the sound of nature to come back and not the sound of humanity.

TK: So when you're on the tube you go mad?

JB: I don't go mad, but I see the possibilities of how you could go mad... And very occasionally I do go mad. I don't stab anybody but I feel very uncomfortable unless I'm in a strong mood. I can see people's faces changing into animals and all sorts. It does happen.

TK: You've mentioned before that you felt a strong connection with your ancestors.

JB: What else is there? Ancestors and animals, totally. I see ghosts. I think ghosts make up the fabric of human existence. Everybody recognises their ancestors in other people, this is why we get guilt trips and why we feel racial identity and stuff. It's because it's ancestors and the same with animals. Some people are called monkey, some people are called vipers, snakes and stuff. We are all the same. That's it. It is weird, it's scary sometimes.

TK: Do you actually believe in being reborn?

JB: Of course. Reincarnation, totally.

TK: This theory has a danger of replacing the responsibility for people's deeds, like 'we didn't get around to what we wanted to do in this life, so we do it next life...' or 'everything will be alright in the next life,' or whatever.

JB: Compare that to Christian things where you can do anything you want in this life and on your deathbed you say, 'please forgive me, I repent!' and you go to Heaven. It's a complete pile of crap. If you have responsibility for your life and you care about what happens to you in the next life, you will care about what's around you at the time. That's the way I see it. Christianity is a very stupid religion. A faith worse than death! It's the opposite, it's taking responsibility for what you do in every moment of your life that makes you a pagan. But if you do something like plant a tree in your garden, if you plant a cherry tree so it blossoms and looks beautiful, what are you doing? As opposed to people who, in Christianity, you can do what you want and collect as much wealth as you want and then as you die you just say 'I'm sorry!' and you're forgiven.

TK: That's maybe more to do with the Church than Christianity.

JB: I agree actually because Christians, if you can get right back to the root of Christianity, they're fine. It's the Church.

PC: The age-old principles of Christianity were originally pagan rites anyway, they were just adopted.

JB: Of course they were, it's just rebirth and death. It's so twisted now.

PC: Most of the Christian saints have antecedents.

JB: Everything is sacred and everything has a soul basically, to my mind, and I've found it works and no one is ever going

to persuade me any other way. Everything is sacred. That totally eliminates Fascism or racism or anything. I may have preferences to what I want to go and live with, I'd rather not live in South Africa particularly, but that's because I'm English. Or Irish, rather. Or Scottish. I'm Celtic. I don't particularly want to interact with other people, but I respect their beliefs and that's that.

TK: Yeah, but what you say 'that everything has a soul,' you see that in other contexts, that things are thought of as being 'animate,' like a dagger or whatever.

JB: It should be! Because that's the truth of it. Everything has an importance.

TK: But that's also, I think, maybe the only form of material good or whatever, for which this still holds true in the western world is maybe art.

JB: Art and money and sex.

PC: I think most people, even in the art world, would think that art was really just a commodity.

JB: I'm not so sure. I think real appreciators of art — or money or sex — would realise that all those had power. They're all symbols of power, but I don't like power at all. I think things should just 'be.'

TK: But would you say that, for example, music has a soul?

JB: Yes. Definitely. After all the work that we put into it, it better have. And a power to transform as well, which is one step beyond what we're talking about. Things have got their own inner grace and being, but our things have an intent to change everything. Which makes us dangerous, or it makes us stupid, or whatever you want to call it but it happens.

TK: And how analytical are you about your music? You construct a sound and you have a broad outline and you say, 'OK, there could go piano...' How do you actually place a sound in a certain position within the song? Sort of evaluating the effectiveness of a sound...

JB: I don't know, it's a good question! Instinct.

PC: It's only instinct, very difficult. It's true that we are very careful about what we do, but it's impossible for us to say how it is. I frequently don't remember recording whole albums. I can't remember very much of the recording of the albums because we go into a different state.

TK: I thought that, especially with the new material it has at the same time this druggy feel — infinite — while, on the other hand, it seems to be really laid out in a scientific way. Really carefully...

JB: That's because we work at it.

PC: I don't think that's a contradiction, you can have both of them.

JB: Psychedelic doesn't imply that you lose control, in fact the opposite for us, it's that you have total control. It's just getting the balance right that you're controlling totally psychic states. You're asking very deep questions!

TK: Is this actually why you call yourself John Balance?

JB: No, John Balance just came into my head one day.

TK: I'll try to finish this OK. I wanted to ask about some films that were mentioned in this *Compulsion* interview... I thought they were gay porn, is that probable that you make music for this? *Sara Dale's Sensual Massage*?

JB: That wasn't gay. We did *Gay Man's Guide To Safer Sex*, which the single 'Protection' came from. *Sara Dale* is sort of a massage video. They were full length features.

TK: He talked about that they went through the Terrence Higgins Trust...

JB: *The Gay Men's Guide* one did do.

TK: So it was a kind of sexual education type of thing?

JB: Yes, a safe sex video. It's why we called it 'Protection', the theme from it. *Sara Dale* is more of a heterosexual erotic thing. They paid us and we did music to order and we might release a few of them.

TK: What is this Clawfist single? This one. Is this new material or old?

JB: No, old. About two years ago. 'Is Suicide A Solution?' And that was with a new 'Airborne Bells'. A friend of ours jumped through a window listening to Coil. He was on LSD at the time. So this was a tribute to him. And that was the view from his window, it was like 14th storey. It was in London, that's like streets and stuff. (Referring to the single cover)[9]

TK: What do you make of this, that he jumped out while listening to Coil?

JB: Well, it's not our responsibility that he jumped but there's a connection. It had an effect on us, completely freaked us out. I'd never say it's our fault, he had lots of things going on in his life anyway, including having tattoos of wings on his ankles. So, that might make somebody jump out anyway.

TK: And will you do an *Unnatural History* Volume Two of all the other stuff?

JB: Yes, quite soon.

TK: And *Black Light District*, is it still happening or has it all gone into ELpH now?

9 The single 'Is Suicide A Solution?' was a revision of 'Who'll Fall?' which had appeared on *Stolen & Contaminated Songs*.

JB: No, it's still going to happen.

TK: And this will not include Peter?

JB: Oh, I guess it will. (Laughs) If he's good.

PC: I might be too busy.

TK: Have you laid out any plans for this?

JB: *Black Light District* started in 1988. When acid house started in England and we decided we were already bandwagon jumping so we didn't want to do it, so we left it alone for a long time and then we sort of decided to reinstate it.

PC: All these other projects may happen — we don't know. It's just more exciting for us to have the possibility of doing lots of different things.

Café Freedom Interview, 19ᵗʰ March 1996

TK: Can we go back to this *Frisk* thing you were telling me?

JB: I don't know so much about it. We gave the producers of *Frisk*, the movie, a load of music which eventually turned up on the ELpH *Worship The Glitch* album. I haven't seen the finished movie.[10] We gave them the music because we liked the novel. We didn't know much about the film at all... (Interruption)

TK: On *Unnatural History II* there's this gap then this song from this Virgin compilation. What's the song called?

JB: 'The Hills Are Alive'.

TK: And with the CD for the Nothing label, is that still going ahead, can you say how far you have gone with this?

10 *Frisk* is a 1995 movie based on a novel by Dennis Cooper. 'Bee Has The Photos' (aka 'Damage From A Diamond') was used.

JB: I think we're going to go over to New Orleans in the summer and record at Trent's studio.

TK: And is it still going to be called *International Dark Skies*?

JB: For now, today, it's called *International Dark Skies*... We haven't got anywhere with it. We haven't started it yet. We started an album about two years ago and we've got about eight tracks, I think one of those is going to become one of the other tracks — 'At Your Own Risk', 'AYOR'. It's a homosexual term for if you go cruising. You might get queer-bashed.

TK: Is that referring to the book from Derek Jarman as well?

JB: It's a common phrase. If you get a gay guidebook or something, it'll say 'don't go in the bushes because it's AYOR.'

DAVID TIBET: Any bushes?

JB: Keep out of bushes.

DT: What if you're cutting a hedge?

JB: AYOR!

TK: So while the two of you are here, what's this thing you've planned: John Balance and David Tibet...

JB: We don't really talk to David Tibet anymore.

DT: Because he doesn't know any words long enough for me to understand, that's why.

JB: It's the same with the one I'm doing with Steve, this trilogy! It'll happen but if we keep talking about it, because we see each other every day, every other day, familiarity breeds... What is it? Contempt?

TK: I think that you have interesting moments where you integrate field recordings. I really liked 'Another Brown World' and also 'Airborne Bells' which sounds almost like Gamelan drumming.

JB: Thank you. But that's not field recordings, that was all electronic.

DREW MCDOWALL: ...Off of Gamelan recordings!

JB: Strangely enough I did ask Tibet if he had any Gamelan records last week, but that's about the first interest that I've had for a long time.

TK: In your house you kept this pointing stick, you have some ritual objects?

JB: I've got an African pointing bone but I have it pointed away from everybody in the house because it's like a gun, it's going to go off. If you point it at someone and you do the right curse, in South African or wherever it came from, it's supposed to kill people.

TK: And with *Black Light District*, I haven't heard it yet, is this more going in an ambient type direction? Is it anything comparable to ELpH?

DM: It's more like German 70s stuff like Neu. It's not ambient, no.

TK: So more monotonous then?

JB: Yeah, it's hideous... Monotonous... Tedious... Hypnotic...

TK: Has it got beats?

DM: Some of it, but they don't sound like drums, nothing that sounds like drum machines...

JB: ELpH was deliberately out there and alien and not very listenable because it was an experiment with a particular way of doing things sound-wise, using new electronic equipment. *Black Light District* goes much more toward how Coil used to, originally, record when we did it all in a very short space of time. About one month wasn't it? Over Christmas. And it's tranquil and it's quiet and it's got vocals on it so it's not ambient.

TK: Did you use sidereal techniques?

JB: Yeah. There's certain pieces of equipment we've got will do three-dimensional stereo-panning along with other things we use, special little gizmo boxes... Was that a yawn, Tibet?

TK: And with your Spare collection, do you intend to do an exhibit or is it private? You're collectors?

JB: Very private. It's an obsession. The thing with Spare pictures is because he's such an intelligent artist and has such a vast scope of styles, you could carry on collecting and each one would have a different feel. While Louis Wain just painted the one cat again and again.

TK: Didn't Spare used to do portraits for people, he had a space and people from the street could come in and buy him a meal and he would paint them?

JB: Yeah, he was a very prolific painter. I'm not sure how many survived because he worked in the war years so a lot were destroyed including his studio. He did exhibitions from home and each one had three hundred or so pictures in.

TK: And is he more famous for his writings or...?

JB: Ten years ago, for his pictures, but now because some books have been published and people are re-evaluating him as a magician and philosopher. There's been about four books come out in the last year. Good books.

TK: I tried to get hold of a book in German, a good introductory work, but...

JB: You can't really have an introduction to Spare, you either grab the whole thing or...

DT: Well, Semple's book just came out? That's the only introduction...

JB: That's true. What's it called? *Zos-Kia: An Introductory Essay On The Art And Sorcery Of Austin Osman Spare*. A book by Gavin Semple has just come out and it's very good. It is a limited publication so it might be expensive.

TK: And is there any other project going on with Coil, film-wise? You're doing some other soundtracks? On the internet has been quite a few mentions but I can't keep track... There was *Seven*, the remix...

JB: Yeah, we did a press release because we were pissed off with not having a credit in the actual movie, at the end, like I think we should have done. It just happened to be that the remix we did for Nine Inch Nails about two years ago, 'Closer', ended up being used. Which is very good for them because they get paid, we wouldn't have got paid anyway for that and that's OK, but we could at least have had the credit so people hear the music and then see who did the music at the end. Which didn't happen and we complained through press releases and the film releasers are getting back to us.

TK: So maybe in the video edition they might change that?

JB: Oh god no, they won't do that. Never. Hollywood is a scum city, I'm not interested in working with mainstream Hollywood stuff.

TK: Isn't that where Peter works? You're not involved with any of his videos?

DT: Private ones. (Laughter)

JB: I help him ideas-wise, but he's extremely professional and good at what he does so he goes over and does his thing, he's

technically brilliant behind the camera and with lighting, he always has been. I can't do that, but what I can do is I help write the ideas with him. I haven't done recently because I got bored with doing it. I'm fed up with having my ideas... What happens is you do some ideas then they'll turn up in a Guns 'N' Roses video — as has happened. You do the ideas, write them all down, and send them to all the groups and they just steal them from you.

TK: So there are other soundtracks?

JB: There are a couple of things coming up but, like Tibet and me's project, the more we talk about it the further it gets from actually happening.

DM: There was that *Journey To Avebury* thing...

JB: Just before Derek died we talked to him about doing soundtracks for a lot of his Super-8 work and there's one in particular I wanted to do called *Journey To Avebury*.

TK: You were saying in the last interview that you are trying to re-film this?

JB: We did the soundtrack and it got shown at this Brighton festival by a bunch of wankers. We're developing it again, we're going to redo it as a 20-30 minute film with a new soundtrack.

TK: And is *Black Light District*, will it come out on vinyl?

JB: Yeah, soon. Test pressings not in yet are they? In a couple of weeks, yeah. They'll have like a double gatefold. Clear vinyl.

TK: Has it got any extra tracks on there? Remixes?

JB: Yeah, it has got one, no remixes. Tibet asked us to do a track on behalf of Bevis (Frond), called 'The Lost Rivers Of London'

and there's an instrumental version of it on the vinyl version of *Black Light District.*

DT: You know *Ptolemaic Terrascope?* The magazine? It's a benefit compilation for them.

JB: What's the title, do you know?

DT: *Succour.*

JB: Is it coming with the magazine?

DT: No, it's a double CD. It's coming out in a couple of weeks. Coil, Nurse, Current, Bevis Frond, someone from R.E.M. — Peter Buck.

TK: is this magazine famous?

DT: It really concentrates on psychedelic, hippy, 60s-70s stuff. Current did a track — they always give away a free 7" so we did a track for them. They normally do about two-and-a-half to three-thousand magazines. It's quite a cheap magazine so they're not getting enough money to make it viable. Nick Saloman does it with his partner and they put it out together — a hobby, labour of love. It's why they need this compilation. They'll upgrade the magazine. It's got interesting articles about people who you might not like or have heard of but it's always fascinating to read. Bits of gossip about hippy groups from the 60s that only did one 7" then all died of drugs.

JB: Tibet asked me to do a track for it and I did lyrics and vocals based on some Tibet faxed me over, so it's the first track by Coil that's got proper vocals for a long time. It's a nice little intermediary piece going on to the next album. I did it about three weeks ago.

TK: And how many tracks have vocals on *Black Light District?*

JB: Five? Some of them aren't mine. We used Scanner, you know he takes things off the airwaves and telephone calls? We've got a friend called Scanner. So they're found vocals. He got a name for doing it and we got him back by doing it again, and Sleazy did it originally for Throbbing Gristle — he used bugs, microphone bugs.[11]

DT: They didn't have scanners then!

JB: CB radio? Come in rubber duck convoy! (Laughter)

TK: Are you possibly doing something with Robin?

JB: He came round while we were recording the album, we took a day off and said come round. So he turned up with his computer discs...

DM: ...And they didn't work.

JB: His things wouldn't slip into our slot. He went home again. We were not compatible. We'll do something again.

TK: I might meet him for an interview tomorrow or the day after...

11 Robin Rimbaud recollects, 'Geff bought a radio scanner at my recommendation, as did Aphex Twin, and a host of others inspired by this rather playful and voyeuristic work of mine. I visited their house a couple of times in London to have a play around in the studio, but not much of value came out of it unfortunately. We had countless conversations about a special kind of mix collaboration between Mixmaster Morris, myself and Coil, but these ideas sadly never came to fruition. *Black Light District* was interesting: I gave Geff a DAT with recordings of scanned phone calls, with all manner of conversations on it. At the time using the radio scanner was rather like switching on a tap. You had to be recording to ensure you didn't miss out on something amazing. Just listening wouldn't work, as you might simply miss something spectacular. So this DAT was 90-minutes of live scanned voices that I passed along, and these kind of scanned voices appear within the context of some of the tracks. It always felt a little like a tribute and I was touched at my thank you in the credits.'

JB: Wear silver! Silver jumpsuits.

DT: He dresses in silver.

TK: And how's your Scorn connection going? Was it just a one-off those remixes?

JB: Yeah, Mick Harris has gone quiet, not because we've fallen out or anything but he travels around and he works with Bill Laswell in New York a lot. I'm trying to remember who he's working with at the moment — he has a lot of bands.

TK: Because it's just himself now isn't it?

JB: Yeah, Mick was the original drummer from Napalm Death, he works with a lot of people, he's one of these travelling musicians...

DT: He's a minstrel.

TK: You're going to do another ELpH album as well? With ELpH, I felt it was...

DM: ...Awful?

TK: No! Very dark but not so scary as some of the Coil stuff.

JB: It was cerebral or intellectual, it was meant to be sound manipulations a bit like Pierre Boulez, Stockhausen or something. It really was musique concrète, we tried not to put our personalities into it.

DM: It was to see how much music you could actually take away and it still means something.

TK: It sounds very stripped down...

JB: ...Which is how we wanted it.

TK: I'm just wondering, how much of you is actually in there?

DM: It's what you're left with when you take all the music away, you're just left with us.

TK: I felt it was like the complete opposite to *LSD*.

JB: After the fact, people have said it's like we were channelling an alien entity. We go along with that.

DT: Wasn't it you who said that?

DM: No, no, the alien said it... They told us we were channelling them.

JB: We felt like that when we were doing it, we did it really quickly over about a week and it felt like the sound was coming through us which was not derived from drugs. When you listen to *Black Light District* you'll find that it's much more personal and much more gentle and... Human. Compared with ELpH.

DT: I thought they were both excellent. I liked *Worship The Glitch* a lot, I said to Balance its uneasy listening but I still think it's fantastic. It's more a mood piece. *Black Light District* is more a collection of pieces which are excellent, but because there's vocals on some of it, it cuts the mood up a bit. I'd listen to *Glitch* more because I find it really good to sit and drink wine to. It builds a beautiful, a very impressive atmosphere into the house, it seeps into the walls of the room and changes the energy in the room. *Black Light District* doesn't do that so much because the mood shifts a bit, there'll be an instrumental piece then a vocal piece, like 'Blue Rats' which is brilliant but it shifts your attention again. You focus on it differently, whereas *Glitch* is just seamless. I much prefer what they're doing now to *Scatology* and *Horse Rotorvator* — which I liked a lot at the time but what they do now is really light years beyond that. On *Scatology*, the atmosphere couldn't really get through because it was too packed, it was too tight.

JB: It's true, on the first two albums we used to dump down three years of experience and ideas onto one album and it ends up being as David says. Are we ever going to do this *Haunted Air* album?

DT: We'll do it this year, at the end of the year.

JB: David and myself will do this *Haunted Air* album... We're trying to find some hurdy-gurdy players.[12]

TK: You kept the title *Black Light District*, did you have this original idea for the comic in mind while you were doing this or was it just because you had this idea of the title so you wanted to stick with it?

JB: Boyd Rice had the idea of the title in 1982 and it stuck around. At the time, I said we're going to use this and he said fine, yes, let's do it. And it just turned up. The underground comic thing, that must have been five years ago, we were working with this guy called Jerry Prosser from Black Horse and between us, we were faxing each other, he wanted me to do a whole cosmology and symbology of these underground tunnels and write the stories with other people and it would be an illustrated comic book. What happened was it all fell through really and we got uninspired by it. Some of the ideas, including the *Black Light District*, may or may not have run through the comic. That's what happened to that.[13]

12 The phrase would reappear in the song title 'Magick In The Haunted Air?' on the *'Jhonn,' Uttered Babylon* album (The Spheres, 2012) by David Tibet and James Blackshaw under the name Myrninerest. In a note written that year, Tibet commented that the album was written 'in Hastings during November 2011 as Jhonn came softly to me in Haunted Dreams and Haunted Airs....'

13 Jeremy Prosser elaborates on the demise of *Underground*: 'My plans began to unravel. I proposed a budget and timeline, got push-back from the powers that be, thought that I had the go-ahead, but then faced further hemming and hawing from bean counters saying the project was too expensive. I got approval for a modified version serialising the material in an anthology comic →

TK: Have you ever considered a Coil CD-ROM?

JB: Yes, but I haven't seen a good CD-ROM yet at all. They may exist and I've stopped looking.

DM: They all follow the same format, they'll give you four channels of music where you can do some limited remix of the track, biogs of the band — but they're boring. I hate CD-ROMs.

JB: Yeah, I hate them as well...

DM: I mean 'band CD-ROMs.'

JB: No, any CD-ROMs! I don't like the idea. If you're going to — for instance — have a museum on a CD-ROM, why not just go to the fucking museum and see the objects in reality?

DT: Because you might be crippled. Housebound.

JB: Yeah, but I'm not crippled...

DT: ...And not very compassionate either! (Laughter)

JB: David is my heart and soul... Today. On loan.

→ format. If those books sold well enough, I could collect it all, add more, and possibly include the CD. In the end, *Underground* ran for four issues and didn't continue. I tried to keep Balance in the loop but, at some point, told him things were not coming together as I'd hoped. We kind of drifted apart and I was gone from Dark Horse not long after. It was a weird boom time in the comics market with expectations that were likely too high. Today, if a book sold *Freak Show* numbers, folks would probably be happy.'

All the material contained on this cassette is previously
unreleased.Thanks are due to all the groups/individuals
concerned;Master tape processed and produced by Chris at
the Western Works,Sheffield-May/June 1981.Rema Rema have
deceased and have risen as Mass,The El-Trains and parts
of Adam and the Ants.The 2 tracks included were recorded
live at the Acklam Hall,April'79.The Eyeless in Gaza was
recorded especially for this cassette as was Chris Carter
,and A House.Culturcide are from Texas,USA and have had a
single released on their own Infomation label.A C46 tape
of futher material may be released on White Stains in the
future.Climbing'is one of two versions of the same song
recorded on sunday,9th March'81.A long cassette of A House
is planned for White Stains'release in the near future.M.
A Peacock lives in Sheffield.It is her first official re
lease.For futher info.contact Stabmental C/o Rough Trade,
202,Kensington Park Rd,London WII. white stains 002

STEREO:DOLBIED.

the men with the deadly dreams

white stains tapes 002

"Yes we on the Psychik TV.

'5

1	Christopher R Watson	News Cut-up 2/5/81
	Rema Rema	Why ask why ?
	Eyeless in Gaza	Pale saints
	Culturcide	Land of Birds
2	Chris Carter	Climbing
	Rema Rema	Christopher
	A House	Words From a Radio
	Richard H Kirk	Powermad
	M A Peacock	Voices

artwerk—murderwerkers

'Trouble Distinguishing Sleeping Dreams From Waking Dreams'

Brainwashed, 5th May 1997

Jon Whitney

In November 1990, I had an advance tape of *Love's Secret Domain* and was floored: it was miles ahead of anything Coil had previously done and defied every genre. It was the start of my correspondence with John and Peter and, when I launched Brainwashed.com in April 1996, I worked with Greg Clow to incorporate his *Light Shining Darkly* Coil discography and to make it interactive alongside news, photos, articles, sounds, text and other things. John and Peter were happy and soon after we worked with Dan Garcia at Hollyfeld.org to get a Coil-dedicated email list going.

Interestingly, by 1997, many people had forgotten Coil. It wasn't like the years where they had a sizable label handling promotion; there was no 'Coil proper' album; lore circulated about *Backwards*... If I mentioned them in conversation I'd get reactions like, 'oh, they still make music?' This was the background to my London vacation and my desire to conduct a proper interview with Coil as an 'exclusive' for Brainwashed.

On Saturday 3rd May 1997 at London's Union Chapel, I met John and Peter for the first time. The occasion was a Current 93

show. John performed a reading at the start of the evening, then played Chapman Stick during 'Christ And The Pale Queens'.

The following Monday I made the journey to the Coil house in West London on the Tube. Just a few blocks walk away, there was the house. In typical English neighbourhoods the houses are all in rows, connected, and homogenous. Coil's home was easy to spot: it was the only one with black windows.

Invited in, I made my way through the door featured in the video for 'The Wheel' — where the cookie reading 'EAT ME' slides through the letterbox. We headed up the stairs, the walls painted a dark green, to the kitchen. Drew was in the studio but came in and joined us. The dogs were a breed I had never seen before — African 'barkless hounds' — quite helpful if you're a musician. Nervous as hell, I sat down, and Peter let me use his tape recorder.

Note: the interview below is an excerpt — with Jon Whitney's kind permission — from a significantly longer and fuller interview on Brainwashed.com.

'...there's a place where the sea meets the sky, you can't tell which is which. The light just sort of shimmers, and there's a mist. You absolutely lose yourself in this place.'

Interview

JON WHITNEY: Is there a consciously thought-out idea when you sit down to record something or do things fall into place?

JOHN BALANCE: The first thing is usually an idea, if we don't have an idea, we can sit for two weeks making noises and nothing will happen. We need an idea and a deadline.

DREW MCDOWALL: Definitely works best with a deadline.

JB: I usually say 'I've got this idea for a track and I would like Drew to do something and Peter to do something' and sort of like horse-work them until the sound appears. Quite often the way we work. Once there's something to start with, I'll change it or we'll all change it... I have a bad habit of only working if I've had an idea and I have written a title down and try to come up with something that fits with it. These two could play me something brilliant they've been doing for a week and I'll say it's shit because it didn't come from me and I haven't got an idea to go with it, and six months later, once I've fixed on it, I'll say 'that was amazing, why didn't we use it?' I have notebooks all over the house. On the Nothing record, I'll have an idea, we'll do some music, and then I'll improvise. I took this course of self-hypnosis before we went over there to deliberately tap into subconscious stuff and give me the confidence to just stand in the monitor room and sing it in front of everyone. I just didn't care. Normally, I used to just be the coward in the corner, drunk and on drugs, trying to just squeeze a vocal out of me.

JW: Is your music an artistic representation of your feelings?

PETER CHRISTOPHERSON: I think that's all that it is. The thing is that with our music, we've never done our music to appear a certain way to others. Our music represents internal states because

it's totally personal to us and we've never tried to do records to be successful or to be dance records or to be any other record. It's why it's pure, why it retains that unique entity. In that sense, everything that has been in our experience has in some way influenced us. Whether it's a boring day on the train or it's the sounds and noises you hear while outside, all become part of the process.

JB: I seem to have trouble distinguishing sleeping dreams from waking dreams. That's what we do when we work, we sort of deal with the subconscious, and tend to keep it open all the time. It's a good thing if you can handle it but it gets to be strange sometimes. I've had a couple pivotal dreams which have shaped what albums are going to sound like. I had a kind of angelic visitation dream with the Butthole Surfers, before I had heard their music, after I had heard their name, where I was shown a vision, pictures of what their sound was, and it was like an early version of 'Comb'. There was a huge bit of pillars of fire and weird abstract things going around in my head, and I based a whole period of Coil, for *Horse Rotorvator*, on what I remembered of this sound. It was like being given a bag of snakes or something, and being told make some music of this. And that kept me going until it sort of ebbed away for a while before we did the latest album for Nothing. 'Fire of the Mind' is what it's called. I had another dream and it was Mark Stewart's latest album, but it wasn't, it was this other angelic visitation of noise and sound and again I had these visions of palaces with sinewaves going through them and all sort of stuff. And I still, if I need to know what music is supposed to sound like, what I want my music to sound like, I just have to see this image and it immediately puts me back on this strong visual power of what sound should be like. I think that's a gift from somewhere.

Jon Whitney

JW: What would your ideal living situation be?

PC: I think that the ideal image of a place to live would be the same as in the eyes of our fans. We've been recently looking for a house and the ones we've been looking at tend to be more eccentric and sort of old and weird. There is a schism where living in the city where you have access to all sorts of culture and transportation versus living in a totally isolated place. On one hand, you want the noise of other people, psychic noise (not audio noise) for stimulation but you also want separation from that noise. So in an ideal world we would have about four houses all around the world. One would probably be in New York and one would probably be in Ireland in an isolated area, might be one in London...

JW: Last year John, you've been in rehabilitation. Can you describe the extent of how bad it felt and maybe what kind of programmes you're on right now to sort of keep you sane?

JB: It was bad. A year ago it was really bad. Physically I was drinking so much. I had a complete nervous breakdown or else I was completely insane. I was six weeks in a primary treatment place and I did about six months of sort of going to AA and NA meetings. Then I stopped and I started drinking again a bit. I didn't do any more drugs cause it just didn't feel right. I've been drinking up until quite recently again. I was getting bad again, but not really bad. I just felt spiritually bankrupt, not physically, total destruction as it was. I suddenly decided, two weeks ago, that I had to get on with my work. Strangely enough I spoke to John Giorno, I phoned John Giorno, actually Sleazy phoned him, I wouldn't speak to him actually because I was hurting really bad. He eventually made Sleazy put me on the phone and he spoke to me about Allen Ginsberg. He just told John that he was dying and the next day after, he died. He sort of wanted to share that with me, that one of his best

friends just said he was going to die and I suddenly thought I was a real selfish cunt, basically. Just lying on the couch being miserable, just complaining about the whole world and with all these sort of dreams that had been messed around and forgotten and suddenly realised how miserable I had been to everybody. I just had to get on with it. I just had to get off my couch and my bed and just work. I've kept this in my mind and I don't think it's going to go away. You know, we're here to do, to share with other people. So that's where I am at the moment, if you ask me again next week the answer might be different.

JW: Do you feel you have an obligation to your fans or yourself?

JB: To myself first of all but then obviously, it's to share with other people. I have an obligation not to waste what I have, what we have...

PC: I think that anybody who goes through any kind of problem or any kind of struggle and that probably means everyone in the world going through childhood and adolescence and stuff, learns things that are going to be of aid and assistance to others who are going through that same thing. I think that people do have an obligation to help those people coming after them. Not so much to their fans particularly but to just everyone, I think it's part of the human condition to try and ease the existence of those that come afterward and give them a chance to achieve as much for their children or whatever.

JW: Was that phone call a wake-up call of sorts?

JB: Yeah. One of many really. I was just sort of thinking why actually I let myself, or that it happened, that I had a breakdown and stuff. What I do feel is that I shouldn't hide it, that everything's grist for the mill, being an artist or whatever. I find it strange when people won't admit there's something wrong because the only way it can get better is by sharing it.

JW: So what's a great day to you? What is an excellent day?

DM: For me, sometimes it can be the simplest things. A couple of months ago I was walking over from Hampstead Heath and I saw that it was sunset. It was the sort of mythical green flash that's you're supposed to occasionally see at sunset where the sky goes green. Have you ever seen that? I'd never seen that before, and I wasn't on drugs (laughs). And the sky went completely green and that just gave me such a major buzz. But I guess, on good days getting some good music done. Not committing to the temptation of doing drugs. (laughs) Oh, I get this weird British reserve, 'Eww, talk about our feelings! Horrible!'

JB: I like going up to Scotland. There's a place in Scotland where we occasionally go, it's sort of up in the Hebrides, we hire a bit of a house there, a wing of a house. There's a place there that you can look out to Jura, one of the sacred islands out there. And there's a place where the sea meets the sky, you can't tell which is which. The light just sort of shimmers, and there's a mist. You absolutely lose yourself in this place. And there's a promontory of rock that points out into the sea. You sit on that looking, watching the sun set, or not even, just for the whole of the afternoon. You have no sense of time or place but you actually know you're in nature and you're fine and it's probably best to spend the afternoon there.

JW: Can you tell us of some of the things you've been working on recently?

JB: Yes. There's 'Sex with Sun Ra' — whatever it will be. There's one format I want to do, a double 7" pack. This year started out and I said what I'd like to do is a single for every equinox and solstice so we'll have four pieces of music out and I thought a 7" single for each one. Maybe a couple of others as well, Crowley's

birthday or Austin Spare's. It just sort of snowballed a bit. First of all I got really anal about it and said 'The single's got to be out on the Spring Equinox! It's got to be out at 10.35 when Taurus is in the...' And then I thought, 'no, let's record then and get it out whenever.' That way it will remain pure, the idea, instead of just going for a deadline that's a commercial thing. So, we did this piece of music and sort of extended and extended. Bill Breeze, who is the head of the Ordo Templi Orientis* [*a magical organisation once headed by Aleister Crowley], came and did some really good viola on it and it has sort of taken it somewhere else. We're going to do a version and Steve Stapleton is up for doing a remix or a mix of it which will come on something else. I just like the idea of using springboards to go with a new aspect.

JW: Then is *The Sound of Music* completely shelved or is that still around?

PC: That was done under an alternate name. Everything that was going to be on that just came out on different things. It's not like *The Sound of Music* was unreleased, it's just that the format didn't happen.

JW: Is there anything you want people to know about you?

JB: A lot of people seem to be worried that Trent's all over our new album.

PC: Yeah, and there is no influence whatsoever from Nine Inch Nails on the new album other than the fact that they're songs with vocals. The majority of the songs are anyway.

JW: You spoke about taking vocal lessons — how has that influenced your vocal work?

JB: It wasn't singing lesson type, traditional stuff. I did a course of chanting and basically it teaches you how to explore your voice more.

DM: It's a more spiritual thing.

JW: Has it given you more confidence in the studio?

JB: Yeah, a lot more. Which resulted in stronger images and lyrics.

DM:It's really significant — how powerful your voice in New Orleans was.

JW: Do you think your environment has anything to do with recording?

DM: You can't help but be influenced by it.

JB: Especially New Orleans.

DM: It was an incredibly powerful environment. I found it almost suffocating. I loved the place.

PC: I don't think we would have done a Zydeco record if we'd been anywhere else.

DM: (laughs) Yeah, did you know that? It's a Cajun album. It's all accordions and fiddles.

JB: And a flange slider.

JW: Did you enjoy the flying cockroaches down there?

DM: Oh those are weird, yeah, those cockroaches.

JB: We taped them. They're on the album. Something up a tree's on the album anyway. It sounded like someone just strapped a synthesizer to a tree and just left it playing.

The Key To Joy

1998–2002

'The Gloaming, The Liminal, The Dusk'

Descent V, June 1999

Tyler Davis

Descent magazine originated in the mind of Mr. Stephen O'Malley — of Sunn O))) fame among numerous other endeavours — with its first issue emerging in 1994. In its initial incarnation it was primarily focused on Black Metal, but that began to change when I became more prominently involved in 1996 with the third issue. From that time on, we filled the pages with a widening spectrum of extreme, dark, or otherwise 'uncomfortable' music.

Our ethos reached its zenith on the fifth issue, which we christened 'The Death Issue.' It stemmed from this idea in our heads that all the good magazines we knew had reached five issues then imploded — so we decided we'd go out with a bang! In hindsight, *Descent* V was a really stellar conclusion featuring Blood Axis, Der Blutharsch, Brocas Helm, Darkthrone, Genocide Organ, Mayhem, Orplid, Boyd Rice, Sleep, Turbund Sturmwerk... And COIL.

At so many years distance, though I know it was most likely via snail mail, I can't recall exactly how the interview with John was conducted. What I do remember is our intense focus on

making the fifth issue a true grand finale and my own feeling that securing an interview with Coil would bestow a genuine sense of completion, at least for me.

As stated at the start of the interview, the concept behind it stemmed from my reading of *Pharmako/Poeia* by Dale Pendell, an utterly brilliant book filled with poetry, wit, wisdom, and experiential assessments of the effects of a variety of plants. Pendell subsequently wrote two more books in the same series, *Pharmako/Dynamis* and *Pharmako/Gnosis*, both equally as explorative, expansive, unique and inspired/inspiring.

I had been susceptible to the work of Coil for quite some years, was aware of their interests, and gathered that John was potentially familiar with Pendell's writings, all of which led me to decide on this new way to approach 'the interview'. Being honest, I felt we needed something special and that this was likely the only way he would agree to be part of a very-much-under-the-radar magazine, catering to music he may not have appreciated all that much. Hence I came up with a list of words and phrases gathered from *Pharmako/Poeia* and described the approach to him, that I hoped he would be willing to provide a reaction or response to each phrase (a sort of Rorschach Test), then I settled down and awaited a response.

To my delight, he came back to me saying he loved the idea for the interview and kindly provided the words reprinted here. I no longer recall if he wrote anything beyond what you can see in the pages that follow. Tragically, too many memories are lost to time and dust.

'Colour — Colour-Sound. Oblivion.
I write with mauve ink and I always
keep my toe-nails painted Gold. My
Grandad used to tantalise me with
the idea of Sky-Blue Pink.'

Interview

ANIMAL — Man is the animal. The only bad animal.

ARCHETYPE — The Wanderer.

AUTHOR — Millions now living will never die. I read to live and live to read.

BODY PART — I love the nape of the neck. And beautiful small ears often do it for me too. Erotic.

CHORD — Hmmmmmmm. There is a good chord sequence in Albinoni's famous funeral music (*Adagio*). I don't know the correct title off the top of my head. Tim Simenon of Bomb The Bass is great with chords... hear 'Manchild' by Neneh Cherry.

COLOUR — Colour-Sound. Oblivion. I write with mauve ink and I always keep my toe-nails painted Gold. My Grandad used to tantalise me with the idea of Sky-Blue Pink.

DAY — May day, May Day.

DIMENSION — I get a little anxious about the idea of Alternity... The multi-verse. I'm constantly flashing between a multitude of them, you see. It all seems very, very frenetic and I need to keep grounding myself in this physical plane. I'm often off on the Astral. Professionally I work in the dimension of sound.

ELEMENT — The element of surprise.

FORM OF ENERGY — Teenage Lightning. The energy given off when two teenagers are rubbed together.

Either that or 'Electricity' by Captain Beefheart who is himself a force of nature. I am so sad about him being ill and pray every day for him and his wife. The man is beautiful, man. I'd love a drawing... a doodle by him, or a signed photograph or an autograph or monograph because he's a monolith.

When I was little my mother bought cheap nylon sheets and pyjamas and I a) used to amuse myself by getting under the covers and causing cascades of static electricity by pulling the sheets apart quickly and also by rubbing my legs of my pyjamas together so that they lit up under the bed and b) I was absolutely terrified of the strong summer storms that swept across the Harz mountains in Germany, where we lived for a time, and I refused to sleep in the bed because I thought I would be electrocuted.

FORM OF IGNORANCE — Let me count the ways. I think... FEAR because...

GEMSTONE — Topaz.

GOD — Better an old Demon than a new God. I tend towards associating with PAN. Every non-targeted, non-sigilised drop of my sperm tends to be propelled in the general direction of PAN.

GODDESS — I say 'thank you Goddess' before I eat every meal. She is more precisely ISIS when I need comfort and strength. Austin Osman Spare drew on Isis similarly. It was he who taught me this path of solace. Sri Mookambika Devi when I am concentrating on synchronicities. The author Rupert Sheldrake, whose wonderful wife Jill Purce is a friend and vocal teacher of mine, came across the shrine of this Goddess in India. She has since become the Goddess of Morphic Resonance. I wish I had my books here but anything by Rupert is worth finding and reading.

HISTORICAL AGE — Wow. I would have loved to hear the sound of the world ringed with the rumbles, squeaks and songs of the dinosaurs. Like the Cetaceans, the whales and the dolphins I think the animals of way back then were extremely vocal, communicating by deep waves of song. The whole planet

would have been heard from space. The air would be thick with a resonant sludge of multi-chordal bliss. I'm very interested in the High Mayan cultures too, centred around Oaxaca in the Yucatan. And here in the U.K. I'm obsessed with stone circles and especially the Avebury complex in Wiltshire. You could say I'm a Silbury Hill-billy.

LANDMARK — The sky.

LANDSCAPE — The chalk and flint hills of Wiltshire, England. Or Bryce Canyon, U.S.A.

METAL — Guru.

MINERAL — I would like to have an obsidian mirror. Black Aztec scrying mirror like the one used by John Dee and Edward Kelley for their Angelic Conversations. I also have an inscribed amulet made of meteoric iron. The ancient Egyptians believed that this material was the bones of the pharaohs come back to this world transmutated. That it came from beyond the stars. In fact meteoric iron comes from within our own solar system, and it is the rarer organic mixed compound meteorites that contain materials from beyond it, from the stars. So I'd better get another amulet made up.

NUMBER — Pi.

ONOMATOPOEIA — Plop.

PLANET — Janet.

POISON — See William Burroughs for interesting discourse on poisons. Sarin is pretty hip isn't it. I prefer traditional ways out like Laburnum, Hemlock and Alcohol.

POPE — I'd hold him upside down, of course, and shake him until the key to the secret Vatican library fell out and then go and liberate all the hidden books they have. The handful of Mayan

Codices that they didn't burn, for instance. The remainder of the books from Ancient Egypt saved from the burning of the library at Alexandria. The wealth of Arab teaching they are suppressing so it seems that the Christians thought of everything when in fact the Arab cultures had already worked things out centuries before.

SEASON — Perpetual Autumn.

SENSE — Non-sense. I love all the senses...

SEXUAL POSITION — Vacant, at present.

SIN — Synergy.

TAROT KEY — The Magician.

TASTE — I haven't got any.

TIME OF DAY — The Gloaming. The liminal. The dusk. The time when light and dark fuse into a mythological hypnagogic purr of pleasure and terror. When myths and legends and stories and Ancestral connections are at their most accessible. When stories were created. Where creativity can creep out and not be shrivelled by the sun or lost in the ludicrous Post-Christian fear of darkness.

URBAN MYTH — I used to be terrified of the one about the escaped lunatic on the roof of the car... know the one?

VIRTUE — Persistence is all.

original
ART (ha!.)

F Bolam Ee
23 IV 86

'Bad Behaviour'

Hello Culture, 2001

Ian MacMillan

Hello Culture was the follow up to a series I had made for Channel 4 TV with my friend, art critic Matthew Collings, named *This Is Modern Art*. 'TIMA' had been a huge success, winning several awards including a BAFTA, and so we had an unusual degree of freedom to make this somewhat eccentric overview of themes we felt had hugely influenced creativity across the board, from nihilism and madness to, in this instance, 'badness'.

Coil's performance at Julian Cope's *Cornucopea* night at the Royal Festival Hall had blown me away, and completely rekindled my love for them, having been a fan since *Scatology*. It occurred to me that they would be perfect to talk about Aleister Crowley and all things culturally transgressive. I was staggered when they agreed straight away, and invited us to their Threshold House base on the English seaside.

I don't know whose idea it was for them to 'perform' (aka mime!) on vintage synthesizers on the rocky seafront, but it made for a suitably surreal intro to their section of the programme. As we set up, my initial nervousness about meeting Peter and Jhonn

(and Thighpaulsandra) completely melted away. They were charming, great company, easy to direct, and surprisingly funny.

I'd prepared Matt for the interview by giving him Ian Penman's magnificent piece from *The Wire*, and when we sat down for the chat it seemed to just sail along. There was a fantastic rapport between everyone, and the guys' deep sincerity, as well as their dark humour, really came through. It was a truly thrilling exchange.

Afterward we hung around with me playing with their dogs between cups of nettle tea. They were extraordinarily generous, giving everyone on the small crew copies of both volumes of *Musick To Play In The Dark*, *Time Machines*, and various others. Peter took me aside to thank me personally and handed me a package which contained the 'Industrial Use Of Semen' t-shirt, and one of the 'Musick Cures You Of Time' watches, which I still treasure.

As is the way of TV production, a finished film has to be approved by the channel's commissioner and I was nervous to see how they would react to the finished cut. Astonishingly, while there were some issues with various elements of what we'd put together, the sequence deemed to be the best was the Coil interview, which survived completely unchanged.

Jhonn and I emailed on and off for a while and when we lost touch I was disappointed... But in retrospect it was probably a consequence of his increasing issues with alcoholism. His last email was sent from Prague. It said: 'We are having a great time. Sadly our favourite gay brothel has closed down.'

Included by kind permission of Mark Bentley and the team at Oxford Films to whom a debt of thanks is owed for their valiant efforts to find the footage and their true kindness.

'...Most of it's happening in the early part of the 20th Century, when it was a much more repressed society. So shagging and drug-taking had a much more loaded meaning than it does now, where it's almost against the law NOT to do that.'

Interview

MATTHEW COLLINGS: What do you think... Crowley really means to you — now, as opposed to what you can remember of his story?

JOHN BALANCE: It's the way really that he integrated his life with his art and his work — and that's what we sort of try and do.

PETER CHRISTOPHERSON: He had a sort of disarming honesty that was what made him so unpalatable for the people at the time, it was that he did what he believed regardless of the consequences.

MC: People were afraid, they thought he was wicked and evil, they said he was the wickedest man in England. Do you feel you are wicked?

JB: No, no, we've never been branded as wicked... So far. He was branded by the press, particularly by *John Bull* originally — the magazine — and then by Lord Beaverbrook. It was because of what happened in Cefalu, someone died, Raoul Loveday died...

PC: Not as a consequence of what Crowley did particularly.

JB: No, I'm saying. But he died of gastroenteritis or blood poisoning or something. And Betty May came back and sold her story to the press and he became 'the wickedest man in the world.' But before that he had a huge body of work that was intelligent and important and esoteric and we've studied that and that's important to us. But the fact that he stuck to what he believed in originally. When he was 23, he joined the Golden Dawn and he adopted the magickal motto 'perdurabo' — 'I will endure' — and everything he did throughout his life he endured. He said his whole life was an experiment in life and not that many people these days can dare do that...

PC: As we try to do with ours as well.

JB: Yeah, I mean, most people don't have the space or the bravery to do that anymore; to live the same way as they say.

MC: Well what is the role of wickedness in Crowley?

JB: It's a Christian word isn't it? Wickedness. Is it the Frisson of naughtiness that he shagged lots of women and took loads of drugs...

PC: And men.

JB: He did sex magick with women and men, the men side is not very often emphasised but it was equally with men. And he would invite journalists round to his house, or important people in society, and he would shag his girlfriend or his wife on the floor in front of them, then they would take drugs in front of them. And this was completely shocking, but he did this because he wanted to break out of the routine of being an ordinary person. He was Plymouth Brethren...

PC: By upbringing.

JB: So a rigid Christian.

MC: ...Most of it's happening in the early part of the 20ᵗʰ Century, when it was a much more repressed society. So shagging and drug-taking had a much more loaded meaning than it does now, where it's almost against the law NOT to do that. (Laughter)

JB: Well that's probably how he's becoming more relevant, you see? Not particularly to us because we've done our drug-taking and... He attracts the hedonists and he attracts the so-called dabblers in the occult and stuff, but he also attracts the serious scholars. There's two levels to him and he presented two levels as well. He definitely sensationalised his life because he was beyond the pale. The thing is he was a child of

the 90s — the 1890s. He grew up in the shadow of the Oscar Wilde trials and he was gay up until his first wife, Rose Kelly. He had open relationships with men at Cambridge, especially a guy called Pollitt. It was the gay 90s! It was sort of OK to do that and as soon as the Wilde trial happened it became not so OK, but Crowley stuck to his guns and continued to publish quite overtly homosexual poetry and have sexual relationships with men and women. He sort of dived into society. He married Rose Kelly, the wife of a famous Royal Academy painter — in fact the head of the Royal Academy — so he was playing around with really high society and loving the scandal that he caused.

PC: He loved the scandal but I don't think that he would have set out to have taken the title of 'the wickedest man in the world' or whatever. Since it was thrust upon him he chose to go along with it. I think, generally, you can divide people who are bad or wicked into two groups. One is those that are doing it for publicity and the other is the people that are simply following their own path regardless of the consequences. And Crowley was obviously the latter, the fact of him doing all of the things that he did was simply because he believed that was the right thing for him to do.

MC: When you say 'following your own path,' I think of 'do what thou wilt shall be the whole of the law!'

JB: It's Rabelaisian...

MC: What does it mean now in a society that has certain relaxations and freedoms?

PC: You can be gay and nobody cares; you can take drugs and practically nobody cares; and many things are liberal about today's society... But many things are not. There are millions of people across the world who would like to be doing the things

CDL

that artists do: going to sleep late, getting up at four in the afternoon, painting paintings and taking drugs and being self-indulgent... But they don't because they're afraid to.

JB: Just being an artist is seen as indulgent.

PC: The whole thing of 'my kid could have painted that,' or 'I could do that in my sleep,' or 'what an appalling noise that group made,' or 'how is it that they get our tax money' — or whatever it is — 'to do those things,' are all expressions of people's desire to be that character that they feel that they can't because they've got to pay the mortgage or they've got to carry on with their lives in the normal way.

MC: Does Satan have a role or a reality now?

PC: For us, Satan has no role whatsoever except as something to goad Christians with. (Laughter all round) It's a meaningless concept to me, something that never existed.

MC: It's always an empty vessel which is filled differently according to the age. I mean, for Crowley, would it have been a very important and loaded signifier...?

JB: I hate to disappoint you, but Crowley was not a Satanist at all! If someone called him it, he would have assumed the mantle of it. It's more like Abraxas, where the divine god is seen as both good and evil in equal quantities. Whatever people project onto Crowley, or onto William Burroughs, or 'the artist' in general or perhaps onto us. We're seen as demonic because we deal with the serious core of these people's legacies. We don't see William Burroughs as a junkie, we see him as someone who's managed to crack and fragment reality to the point where people are absolutely terrified of him and the only way they can see him is as the cartoon junkie. It's a shame because there's so much more to him. We see him on a shamanic level,

casting spells with words and with pictures — he did lots of paintings toward the end of his life.

PC: And with sound as well.

JB: Yes, the sound experiments he did. Cut-ups.

MC: So you see him and Crowley more as curers of society rather than just destroyers?

JB: Absolutely. You have to crack open the rigidness of society and let stuff. That was William's sort of... What word to use? Pret A Manger...? What's the thing...?

MC: Raison d'être! (Laughter)

JB: that's what I think Crowley was intending to do. He wanted to change people's perceptions of what reality was. He wanted to expand society. He really had plans for society that were good.

MC: Why did he relish the role of someone who wanted to do bad?

JB: Because it attracted attention. He wanted devotees, he wanted people first of all — sorry, last of all, to pay money toward him to keep him in the lifestyle to which he was originally accustomed. He came from a very wealthy family and then he fell on hard times. So he always had that as a consideration, but he really did want a multicultural society that was liberated from the Christian yoke.

PC: It's very difficult, once you've been described as the wickedest man in the world, simply to say 'no, I'm not!' It's kind of naff isn't it?

JB: It's much better to say, 'yes, I am! Come to me, give me your money.'

MC: One thing that does come across quite soon when you start reading about Crowley is that he did very little that was actually all that bad... Never really anything Satanic and evil

and cruel or Hammer House Of Horror, yet there's a great desire on the part of the society in which he lives, to believe in a great evil which he stands for. They make a cartoon out of him, a sort of 'cartoon evil guy.' How do you think you fit into those two things, Crowley on the one hand, cartoon Crowley on the other? I mean, you wear black...

PC: Only for TV interviews. (Laughter) Normally we wear bright colours.

MC: Well, you have a few pieces of art around that reflect the dark side... Gothic touches.

JB: Sure, we do — and that's not the half of it. It's the inquiring spirit, that I think we have, is I think what Crowley had and what William Burroughs had and I don't really know about the Marquis De Sade — I don't really want to put ourselves in with that — but certainly with Crowley and Burroughs and Brion Gysin and Ian Sommerville... But particularly with Crowley and Burroughs, they put themselves beyond the pale because once you are beyond the pale you can get on quietly with your research basically.

PC: The thing about the cartoon element of goths and stuff is that they have an inquiring spirit too but they only get a little bit of the way.

JB: But aren't most of them just disenchanted youths? Disenchanted with society?

PC: Everybody feels drawn to things in their teens that have more meaning and more spirit and more resonance to them than the mainstream of what their parents were interested in. It's just that people who go for that particular cipher, if they only get so far, if they only get to the first step, then they end up wearing black and ridiculous hair and silly makeup.

If they were able to have the resources or the time or the enthusiasm to go further into that investigation then they would find out all sorts of interesting things about society and about themselves. It's just unfortunately they don't because, particularly in America, the goth thing is just like the simplest way to be doing something slightly different from your parents or from the jocks.

JB: I see it a different way actually, I give them much more respect in the sense that to dress that way you have to have a lot of guts and, in a way, you've taken responsibility for your own image. It may be that you are copying a cartoon or a cartouche or The Cure or Siouxsie And The Banshees. It really is the Addams Family, that's very true.

MC: But the point about the Addams Family is that they deliberately were the opposite of what was good. If it rained, they were like 'oh, lovely weather!'

JB: They were the opposite of the norm, of normality. They're obviously rebelling against the family but they were rebelling against society as a whole because I think society is bad. The majority of people these days are so scared of being seen to be alive and living and being vivacious and hungry for excitement and experience that they're dead — 99% of the people are dead, so I really respect the people who can break out of that even if it just means they're wearing black and strange makeup and hair... Goth music is often sort of melancholy and folk-tinged — we're far more hard-edged with our message and with the way we put it across. Live we're pretty intense. We do have goth tendencies slightly with some of the lyrics, but we deal with death and decay.

PC: And with life! And rebirth. And growth.

JB: Yes, but it's the same with Damien Hirst, he deals with corporeality, and for that he's pilloried and he's also worshipped — it's the twin pillars of where you place yourself.

MC: So when you're thinking about something that's rank and horrible and dead and dying, that's because you're interested in life?

JB: Yes, death makes life worthwhile, worth living. To study it decaying is really important. If you don't have putrefaction, without the compost heap, you don't have a lovely fresh garden. We're not scared to get our hands dirty. We're not scared to deal with blood and shit.

JB: ...Everything. Mental states, strange mental states.

PC: Any intense spiritual organisation, or spiritual school of learning — apart from Christianity — you'll find that monks and so on go through extended periods of living amongst dead bodies and studying those things, studying their decay...

MC: Why is Christianity so concerned to be washing its hands all the time?

PC: Because it's about denial of responsibility. Denial of personal responsibility.

JB: They worship a dead man on a cross, for Christ's sake! Oops, that's a bad pun. (Laughter)

MC: What's the thing they don't want to be responsible for?

JB: Their own life. They hand over their life to the church. Whereas we, on the other hand, take responsibility for our life now and that's what sets us aside and sets us against the majority of the population. And that's what makes us artists too, that's the sort of friction that causes us to create our work. I feel driven and always have done, since the age of seven or something, to react against something that I saw was a horrifying normality.

MC: So, for you, what united or runs through Crowley and Burroughs is their almost systematic anti-normality? They see normality as something almost evil, because it's so repressive and so denying.

JB: The banality of evil, yes...

PC: The evil of banality as well.

JB: The evil of banality: that is what they were fighting against and I think that is what we are fighting against. We have the slogan 'Persistence Is All' which is from Israel Regardie, who was head of the OTO at one point. Again, I intend it to be the same as 'perdurabo' — I will endure. We're going to do what we do for the rest of our life, it's not an act we put on, we don't dress up and go to work: we are what we do. We're following on deliberately from William Burroughs' researches into reality and how you can crack it and how you can jar people out of normality for a while.

PC: I'm sure you'll find that the obsessive doing what drives them and following their own path is what's different about John Lydon/Johnny Rotten, or any of those other characters, is that they're doing what they're doing because they feel driven to do it. It's quite easy, if you think about it, to see the difference between them and somebody like Malcolm McLaren, who's doing it because he wants to sell t-shirts.

(Break as Matthew Collings accidentally knocks his lapel mic off)

MC: Why do we want to believe that Satan exists and that there is wickedness?

JB: So self-righteous people can feel righteous.

PC: And sell newspapers.

JB: It is very much media driven. People are absolutely terrified of expressing themselves. People are terrified of people who have assumed responsibility for their own lives. Everything is segmented: the church looks after your spirituality, doctors and the health service and crematoriums look after the body, if anyone dares step outside that they're seen as taboo — they've transgressed. Like that guy who was making casts from body parts.[1] That was perfectly normal behaviour in the 18th century and 19th century, it was a craft almost. People have handed over so much responsibility now that anyone who, to any degree, is seen to be taking charge of their own lives could possibly be considered evil.

MC: Aleister Crowley, it's very clear he's a very stylish kind of guy, very creative, a very good writer and a good poet, a very interesting figure who lived life rather strongly all the way through. But, once he's given the chance to be 'Mr. Evil' he pretty much says, 'OK! I will.'

JB: Sure, well the option is to wither away and hide and he was not someone who would hide, he would face up to things.

PC: But, as you said, he didn't do anything really bad. He was a sweetie really.

JB: He crucified a frog once and he killed a cat and drank the blood — at Cefalu, there's no doubt about that. But these are two, sort of, silly episodes that he did to impress people. That was not what he was really about at all.

MC: Well, what do you think he was about? What is his book...

JB: You mean the actual book? *Magick In Theory And Practice?* It's a manual for reclaiming your own soul back from the church

1 Artist Anthony-Noel Kelly was given a nine-month sentence in 1998 for theft of body parts from the Royal College of Surgeons.

and society. That's where the evil thing is: the church would say 'only I can intervene on your behalf, only I can talk to god on your behalf.' Magick, as Crowley understood it, with a 'k' on the end — as opposed to stage magic — is all about becoming god-formed yourself: you are a god. That's heresy and that's where it's evil... I just want to go back to why Crowley's perceived as evil, particularly, is because he's articulate. There's loads of people who do bad things and are rogues and will shag women and do drugs — but they don't write about it. They don't write it in an important, articulate, methodical way through the whole of their life, and that's what makes Crowley dangerous. And so was William Burroughs, the whole of his life was a research laboratory.

MC: ...When you put that CD on today and the first doomy chord came along, what were you thinking then?

PC: The sounds that we make are simply the sounds that resonate with our philosophy and our beliefs. It's not like, 'oh, what can we do to achieve this effect in the listener?' It's about what we would like to hear now. It's as simple as that. And that could be a doomy chord, but it equally could be the buzzes and clicks of a computer breaking up or going wrong, or cables exploding, or whatever it is. It's simply complete self-indulgence, in the best possible sense of the word. And self-indulgence is one of the things that society frowns upon much more than anything else. You can commit any number of murders and go to prison for five years, but if you're self-indulgent, god! That's bad! (Laughter)

MC: Do a bit of spelling out what your philosophies and beliefs are?

PC: That's an even harder question! (Chuckling) We believe in personal responsibility, we believe in the through-line of

nature in the sense of the fact that mankind has grown up to where it's got to in the last 2,000 years and in another 2,000 years we'll be gone because we'll all be dead. So, nature has a through-line, after the time of the cessation of humanity, the trees will continue to grow and plants will grow over the buildings, and insects and stuff will continue to thrive, and the whole thing will start again.

JB: Our next album is called *The World Ended A Long Time Ago* and I really do believe that. Everyone's waiting for the end time and it's already been and gone. Now we're just sifting through the ruins, but we're making the most of it because we have spirits and there is spirituality and people need to be reminded of that and I think that is what our mission is.

MC: When you talk about you have spirits, what does it mean to you to possess a spirit?

JB: I'm not talking about spewing ectoplasm onto the table here! (Smiles) I'm talking about a higher soul. We're here for a purpose. We're here to teach each other that there's something better — whatever that takes, we will do it. If it takes huge loud noises and strobe lights going off for 15 minutes so people are absolutely terrified into realising that there's another state... I want to shake people out of their existence, out of their complacency, and the fact that they may think they know everything because they don't. Neither do we. What we want to do is present an alternative.

MC: There's a big fantasy about the Marquis de Sade, he's another figure who never really did anything on the whole. He wrote these incredibly long elaborate descriptions of all the evil things you can possibly think of — whether he could have sexual desire at somebody else's expense and thus be a sadist — but he just had a few floggings in his own life.

PC: There's always been crowds of people with burning torches ready to come and burn down the house of a neighbour because they had the wrong hat...

JB: 'She called her cat Grimalkin!'

PC: 'Burn her!'

JB: 'Burn her!' Duck her in a pond, if she drowns she's not a witch, if she floats then she is a witch and we'll torture her to death. There's always been that. That's just an awful part of human nature — I can't explain that. It exists, it always will exist. At the moment it's paedophiles that people are pointing the finger at.

MC: Why is there shit in your art form, in your idea of art?

JB: I shit every morning. It's manure, it's as sacred to me as blood, or piss, or shit, or spunk, or tears, or anything. My body is sacred. I'm not just a piece of meat.

PC: It's part of, basically, the Christian way of thinking is to abhor certain bodily functions — well, all bodily functions to a greater or lesser extent! And it's just crap.

JB: It's so ingrained that although... When I see Gilbert and George's shit pictures, I'm shocked — but I absolutely love them for having done it. What shocks me most and amazes and thrills me is they're so honest about it. Stunningly so. They've unnerved people so much they actually can't see what they're seeing, in a sense. Big shit pictures, big piss pictures, big globs of sperm — and they get away with it. It's fantastic! Because they're transparent in their honesty.

PC: It's very much a western thing though, isn't it? So much a European... I was filming in India last year and I was just doing a long shot of the side of a river and it was a beautiful sunset

and it was a great shot, everything was ready and people were ready to do their action, and I could not get the shot because people kept walking into the middle of the shot and taking a shit exactly where I wanted to shoot. Honestly, a dozen people came and by the time they finished shitting the sun had gone down. It was hopeless, but in other countries people will have a totally different perspective about these things.

JB: You go to Benares (Varanasi today) and you see the pyres crackling, skulls breaking open and brains spilling out, dogs eating the brains and running off with limbs, and it's part of life. The west, somehow, through Christianity and whatever, has just completely denied all this stuff which is what makes artists in the west so potent if they have the courage to deal with these things.

MC: Society definitely doesn't like evil or badness or wrongness, because it's got laws to stop it. But, for some reason, culture is slightly different. Culture rewards evil, or rewards bad behaviour, or rewards something a bit sort of over the top in the dark direction...

JB: Well it'll certainly pay money for it and that's a reward, yes, in a way.

MC: Why is culture so fascinated with it? Religion wants to have great big gods get rid of it, society wants to have plenty of policemen to stop it, but culture is saying 'mmm, let's have a go at that...'

JB: Or 'I'd like that on the wall.'

PC: ...People need somebody to do that stuff for them.

JB: It's a controlled repression. They say it's OK, we'll have a certain allowance of evil people and they'll be, 'Ooo look! He's evil and he's evil!'

MC: Iggy Pop, Lord Byron, the Marquis de Sade...

JB: ...Charles Manson, Marilyn Manson, Eminem...

THIGHPAULSANDRA: Coil. (All laugh)

JB: ...And we've chosen them because we don't... We're too scared to be evil. We'll buy bits of evil from them: i.e., our records, or our artworks, or Damien Hirst's artworks. They're buying artefacts from the artists who dared to live what they dare not live.

(Cut)

JB: You asked 'what 2001 means to us?' To me personally, I'm angry; this year I'm going to be angry. I'm torn between finding solace in nature and spirituality in nature — and utter nihilism. I feel like we're swimming in a sea of occidental vomit is the way I'd put it.

I'm sick of the west. I'm sick of the tyranny of the west and western civilisation and America and Britain and this colonial bloody shadow. It's payback time really. It's all coming back to us. Like pissing in the wind, it's all coming back to us now...

MC: On a different tack, with Aleister Crowley's paintings — no, his monogram actually, that phallic monogram and the OTO symbol, tell me something about that?

JB: the 'A' which is a penis shape? He's giving the paintings a magickal charge. In fact, there's evidence that he wanked on them as well — the same as Salvador Dali did. Dali would masturbate on his canvas quite often and get other people to masturbate on them as well. Semen is a magickal fluid, so it was imbibing and imbuing the paintings with his life force, his vitality. He lives on now, that's the whole point really.

MC: He said that he thought of himself as an Old Master because he painted dead souls.

JB: An Old Master-bator, yeah... When we did the Royal Festival Hall the first time, it was called 'The Industrial Use Of Semen Will Revolutionise The Human Race', paraphrasing Crowley who said 'human society' but we expanded it to be the whole human race.

(Cut)

JB: Our cleaning lady, I was going to mention her — Marilyn — she comes here and she doesn't really know us at all and she loves us.

MC: Does she ever ask you what you do?

JB: Oh yes, she knows totally. She says 'you can tell me anything.' She took the *Wire* article away and read it and went, 'mmm, I know now.' (Laughter)

PC: She's much better than your mum, because your mum just gets cross when she reads anything! I just think it's sad that the papers and the press make such a thing about... There isn't a paper here like there is in Mexico or Thailand that just shows pictures of dead bodies in car wrecks all the time.

MC: Give it a couple of years and there will be. It'll be Channel 5. There'll be a TV station that does it... If Channel 4 doesn't beat them to it.

JB: Death TV...

PC: It's better than *The World's Greatest Police Chases*, isn't it?

'Sounds Of Blakeness'

Fortean Times, 2001

Mark Pilkington

Film soundtracks were my first musical passion, so when I discovered Coil in 1987, via their *Hellraiser* EP, and then *Horse Rotorvator*, I was totally hooked by their dramatic, enigmatic and cinematic sound. I read everything I could about them, which wasn't much in those days, and eventually bought all their available albums.

14 years later, I was living what now seems like a charmed life, writing for *Fortean Times* and *Bizarre* magazines, making crop circles, DJing, putting on, and eventually playing, experimental gigs in London. The author Phil Baker had just been commissioned to write a biography of Austin Osman Spare (which SAP would end up publishing another decade on), and offered us a feature for *FT*. Via David Tibet we learned that Coil had a large Spare collection at their home in Weston-Super-Mare so off we set to view and photograph them for the piece.

It only occurred to me that morning that I could also take the opportunity to interview Geff and Peter. Luckily they were into the idea though for reasons that now elude me, only Geff

actually spoke to me. He was a long time *FT* reader and was quite excited to appear in it. Meanwhile, we spent a highly agreeable day immersing ourselves in their enormous Spare collection and left generously laden with Coil LPs.

Geff and I stayed in touch, and ended up speaking quite regularly on the phone, often for some time, trading books, magazines, postcards and music, and Coil played a one-off show at the Megalithomania event that Neil Mortimer and I put together at Conway Hall in 2002. By this time Geff and Peter had separated, and Geff was drinking heavily again; he almost didn't make the gig, which was a fairly chaotic affair, if unique and memorable, though I got the impression that not all the band enjoyed it.

I stayed in touch with both of them – Geff almost moved into my house at one point – and I got to work with Peter on the cover of a Mount Vernon Astral Tempel album released on their Eskaton label. The last time I saw them was at a Coil show at Ocean, Hackney. At the end of their set Geff spotted me from the stage, smiled and waved, shouting 'Thanks Mark!' into his mic. Three months later I placed a sliver of rock he had envied into his burial casket and said goodbye.

'My core belief is that instead of the Millennium Dome they should have planted forests, all the hedgerows should be restored. That's my magickal feeling at the moment, rather than anything ritualistic or Crowleyan — to restore the countryside is imperative. Someone accused us, after our first concert, of being tree huggers and I thought, what the hell is wrong with that? We will fight them in the beeches, as they say!'

Interview

MARK PILKINGTON: The album *Worship The Glitch*, is jointly credited to Coil and ELpH. Who or what was ELpH?

JOHN BALANCE: Coil work under a number of pseudonyms, Eskaton, Black Light District, etc., but when we entered into the ELpH project we felt compelled to do it... It was strange. Normally, we have a musical reference, we say: 'Let's do an album in the style of Cluster,' then we'll approximate it and go off at a tangent. But with ELpH, the three of us really felt that we were receiving extra-terrestrial messages and we just went with it. The sound was designed by whoever — or whatever — was coming through us. Throughout, the William Burroughs phrase, 'Stars splash the silver, answer back,' was behind the recording session. We did it in a week and, for that week, it was as if the transmission was in full flow. At the end of the week it stopped and we haven't got it back since, which is why we haven't done another ELpH album. We keep hoping that they — whatever it was — will contact us again, because we really want to do one. Maybe it was a one-off.

MP: Did you ever try to contact it through channelling or anything like that?

JB: I'm very wary of channelling, although, having studied magick, I do know how to banish and protect. I think channelling can be very dangerous, several acquaintances have had negative experiences with it... Having said that, I might consider it in the right circumstances.

MP: Perhaps your equipment was somehow picking this up?

JB: I don't know. It didn't feel like an electrical transmission at all — it felt very fluid. It could have been something earthbound, rather than extra-terrestrial. An earth spirit or something like that.

MP: Where were you recording?

JB: In Chiswick! The notorious Chiswick goblins at work!

MP: How has magick seeped into your music?

JB: Well it has, totally. I've always been into magick, using Crowley's 'k' to differentiate it from stage magic, and studied it. I tried to buy stuff by Crowley when I was young, but my parents refused to have anything to do with it and actively discouraged me. I wrote to Alex Sanders when I was 14 and he wrote back to me saying thanks for writing, I'm very pleased that you want to do this, but can you write back when you're 18? He wouldn't accept anyone so young into his coven. I used to worship the moon and I'd encourage other boys at school to do it too. I instinctively did things like that. It once got me into trouble. I was at school with the son of David Tomlinson, who was in *Bedknobs And Broomsticks.* The two of us were taught astral projection by a teacher and there was a scandal because they thought there was some homosexual relationship going on with the three of us, but there wasn't. I went to school one day and there was David Tomlinson's limousine outside. He grabbed me as I was coming off the school bus and asked whether his son and I had a sexual relationship with this teacher. From then on, all the teachers were watching me!

MP: So there was no specific point when you started practicing magick?

JB: No, even as a kid I used to do it. I was an only child, always talking to animals, fantasy creatures and spirits. I manufactured little plasticine gods and made offerings to them. I was just born with a pagan sensibility. I'm an animal, I've never been a human — there's no difference between animals and humans to me. I think that's one of the signs of a true pagan. I think some life experiences can jolt you into it. I had German measles

really badly — twice I think — and wasn't allowed contact with the light in case I went blind. Being shut in a dark room, that was like my initiation, I imagine.

MP: Was Alex Sanders your first contact with structured magickal techniques?

JB: Well, I'd say Max Ernst was, very obliquely — he was certainly shamanic. That's when I realised there were a few magickal people around. Up until that point, the only time I'd encountered witchcraft was when Anglia Television reported horror stories about covens being linked to people's disappearances. That's when I realised how biased the media were towards magick, but it served to push me further in that direction. Every time I came across an obstacle, I became more determined in my belief that this was the correct way to proceed with my life and work.

I went to university, but left after a term and joined Psychic TV. Through Throbbing Gristle I was introduced to William Burroughs, and the general concept of magick as a practicality in everyday life. Then in Psychic TV we all began to actively explore magick as a group, and play with it, provocatively and perhaps dangerously. Genesis is magickal, and has his own path to follow. He tends towards organisational stuff and likes to lead, but it's not our path. When that soured, divided, and became too complicated, I decided to do my own group: Coil. As soon as I discovered Austin Spare, I realised that we were loners, we practiced magick on our own. That's my style of magick, the shamanic way — and Spare was definitely a shaman.

MP: So there's a distinction to be made between the more ritualised magickal path of Psychic TV — perhaps more akin to the Western tradition of ritual magic — and your own more intuitive approach?

JB: Well, the core of people in Psychic TV were all shamanic — Genesis is definitely, concretising ideas from various traditions — but we assumed the mantle of organised religion, copying aspects of The Process Church, Jim Jones and actual clerical stuff. We came across as a cult, but we were, in fact, individually practicing sexual magick. So that was a camouflage, which eventually became a trap that we had to break away from. I felt very strongly that we had to get away from that.

MP: There was a lot of negative attention to the cult-like aspects of that scene. Was that something that you tried to evade, or did you play on it?

JB: We originally played on it, to be honest, and at that time you could play with that sort of thing. It was only later on — when Thatcher came to power and the government started introducing repressive law reforms and the 'video nasty' panic began — everything we were playing with became far more dangerous and serious to be associated with. For our own good then, Coil had to disassociate ourselves from all that.

When Gen got raided by the police in 1992, in which they took years worth of rare archived material, his response was to go to America. We weren't raided, but we lived in fear, as we had equal reason to be targeted at the time. We had to clear our house of anything which could be found in any way provocative. It was horrible, absolutely awful. I felt terrible for him, but Gen had a break and was allowed to move on, whereas we lived in fear for five years, never knowing whether the consequence of things that we did quite innocently and legally might rebound on us.

MP: It seems that there are regular resurgences of claims of 'Satanic ritual abuse,' but do you think those dark days have passed now?

JB: Well the focus has now changed to paedophilia, hasn't it? The pendulum has swung round to another target group. Satanists are safe for a while!

MP: You're accused of using satanic imagery...

JB: That's Pan, there's a huge distinction. I'm not a Christian, Satan does not exist in my cosmology. Not even on a rock 'n' roll Marilyn Manson level, or an Anton LaVey level — that's showbiz Satanism, I don't buy into any of that at all. Pan is certainly one of my deities, one that I find solace and power in. Pan represents zero, the void, and nature, both aspects. The wild side. It's hedgerows. My core belief is that instead of the Millennium Dome they should have planted forests, all the hedgerows should be restored. That's my magickal feeling at the moment, rather than anything ritualistic or Crowleyan — to restore the countryside is imperative. Someone accused us, after our first concert,[1] of being tree huggers and I thought, what the hell is wrong with that? We will fight them in the beeches, as they say! I've heard now that if you're a member of Earth First, you are labelled a terrorist, it's what MI5 are now spending their time looking into. It's insane.

MP: Can you tell us a little about your relationship with Austin Spare?

JB: Well, I have a very intimate relationship with Spare — he's my mentor. I communicate with him through his pictures and often ask his advice, as an ancestor. A lot of his beliefs were shamanic and to do with ancestor worship. I don't have a very close connection with my ancestors, my real family, other than my mother's parents, so I talk to Spare for advice. I think he still exists, in his art and in the aether. He's around as a

1 2nd April 2000 at London's Royal Festival Hall. Coil's return to live performance after 17 years was billed under several names: 'Coil Presents Time Machines,' 'Time Machines From The Heart Of Darkness,' and 'The Industrial Use Of Semen Will Revolutionise The Human Race.'

helper. Sounds a bit flaky doesn't it? ...Maybe I should couch it in cyber terms!

MP: I suppose the best art — painting, writing, photography, music, film whatever — acts like a time machine, transporting you to another mind, time or space...

JB: I'd view it as a magickal current. Austin Spare had people who came through for him, spirit guides, and there are magickal currents. He may have opened up a gateway or whatever, but now it's flowing in trickles, rivulets, even streams. That's why it's very important that we flash 'Zos Kia Cultus' and his images onto the screen at our performances, to energise Spare's current and put our own energies into it, to make it a living, breathing, energising, wonderful thing. By 'Cultus' I don't mean a cult, but a way of life, a philosophy, a code, which puts me in touch with what I really, truly should be doing on this planet. Like Burroughs, or Spare, we see no difference between our philosophy, our lifestyle and our art. This is what we do. We are what we do. What Spare did in art, we try to do through music. This is why we do sidereal sound. The way he twisted his pictures, so that the geometry appears warped, we try to do that, to produce strange geometries through sound, so that it comes out sideways. We do it with technology, with 3D devices, phasers, out-of-phasers, all sorts of gizmos. There's no one particular box that does it, we all do it any possible way that we can.

When we play our next gig, in France, we'll hopefully be using quadraphonic sound.[2] Spare used to do speaker battles, where he would project sound into the aether — which I think is a real physical thing, some kind of cosmic glue, a genuine substance or non-substance — to connect everything and allow unexplained things and ideas to be transmitted.

2 25th March 2001 at the Oblique Le Lieu Unique *lu Nights* Festival in Nantes, France.

MP: Is there a particular type of person who you find collects Spare's art?

JB: People with integrity. He really sorts the bullshitters out. You either get Spare or you don't. Although they're often decorative, the intention behind the decoration often hits you first. Most people who come into contact with Spare's work come away from it with something positive. There's a massive power there, he imprinted each picture with a power, purposefully. They resonate on a psychic level, some more than others, but they all have a power that transmits to you. You can commune with them and they change. Some of the chaotic ones, you look at them with one person and see certain things, and you look at them with another person and you see a completely different set of things. Every piece he did was magickal. There were some that were done for other people specifically as magickal spells, such as the stele or the magickal alphabet. But he lived his life as a magician and a stoic. He could survive for a week on a kipper.

MP: Psychedelics have become a more apparent theme in the more recent Coil material...

JB: And paradoxically we don't do them anymore! We were so busy doing them before that we didn't get any records out! After *Horse Rotorvator* we were completely psychedelicised for about five years, and hooked up with Terence McKenna — 'Coil rule!' he said in an email. It's a great shame about his death, though I'm sure he wouldn't see it in those terms, but as a transformation.

MP: He's with the Machine Elves now.

JB: The self-transforming Machine Elves.[3]

3 Some users of DMT have reported seeing spirits while under its influence. McKenna coined the idea that these were the 'self-transforming elf machines' or 'machine/clockwork elves.'

MP: Psychedelics must have transformed the way you approached sound, ultimately inspiring the *Time Machines* project?

JB: They did more than that. I was taking magic mushrooms from the age of 11 — a lot — until I was about 18, just at school, and they never did a bad thing, always taught me wonderful things. They taught me how to appreciate music and eventually told me to make music. As I've said before, I feel that I was brought up by mushrooms — they are teachers. *Time Machines* is explicitly to do with combining sounds and tones to create psychedelic effects. The Harmaline B alkaloid, like any other complex compound, is represented diagrammatically as a ring, but when you take DMT, Yage or Ayahuasca, you also hear a ringing tone, a psychic tone. And with DMT there's a kind of crumpling sound. So *Time Machines* was inspired by Terence McKenna's idea that time machines will only ever appear here once they have been made and will return to us from the future.

MP: Dennis McKenna, Terence's brother, he described hearing the sound of his DNA singing while using Ayahuasca.

JB: Yes, he's the one who went furthest out of that lot.

MP: So the intention was to create a sonic time machine?

JB: Yeah, but you don't have to be on the drugs mentioned on *Time Machines* for it to work. It's an attempt to recreate some of these psychedelic states using sound. And we did extensive research, testing whether these tones would actually transport you. The ones that did, we titled and put on the record.

MP: There were some drugs, like Hecate, I'd not come across before. Was this an Alexander Shulgin creation?

JB: Probably, though we got it off Spiral Tribe who called it DOET.[4] It's a very strange compound, we took it several times in Thailand. Once we were in Chiang Mai, a town in North Thailand, originally a walled city with a moat around it, though it's spread further out now, we were standing by the moat, alongside these old ramparts, probably 14th century. At first, we got the usual euphoria and heightened sense of awareness, of the luminous majesty of everything, then, as we took more, it all crumbled as the layers of time stripped away and the ground became bare fields again. So that's where the whole time travel thing came from. But if you went further on DOET you found nothingness, your sensory input would meet this absolute nothing, not even a 'void,' which gives it a name, it was just a greyness. Then you'd come back and it was an hour later. Very strange.

MP: A sort of a sensory overload, like white noise?

JB: Yeah, it was like that. We're tempted to do a five-CD *Time Machines* box-set, with a whole CD dedicated to each tone. The whole thing would be dedicated to Psilocybin. It's a very benign substance. I'm an admirer of mushrooms.

MP: A mycophile?

JB: A mycophiliac. But I haven't taken any of these things for ages.

MP: Do you miss them?

JB: Do they miss me? I don't know. It's like Terence McKenna said, once you've been there, why go again? I'm more tempted to go to Mexico and do Peyote with the Huichol Indians. I need to move my area of psychedelic learning to another place. If

4 Dimethoxy-4-ethylamphetamine. Spiral Tribe were a travelling collective who staged free raves. Members were charged after the Castlemorton Common Festival in 1992 but acquitted. Spiral Tribe subsequently moved to Europe.

I went to Yucatan or Palenque, and took mushrooms there with shamans, that would be more appropriate. I don't really appreciate England at the moment, and I don't want to learn anything psychedelically in this country...Did you see that programme on lemurs recently? One of them had a big poisonous centipede which it kept putting into its mouth and chewing. This lemur was clearly tripping out! Its eyes were rolling back and it almost fell out of the tree. It kept doing it over and over again... I wish William Burroughs had seen that — I'll have to tell him in a dream.

MP: On the subject of dreams, scientists monitoring sleeping birds' brains have found that they practice their songs in their sleep. How important are dreams to your music?

JB: I lucid dream all the time. Through astral projection I learned to do it at will. And now I don't astrally project anymore, but I reckon one out of three dreams I have is a lucid one. It's quite exhausting. I'll set myself tasks, like banishing dark areas, or just go around knowing it's a dream, but it's not like sleeping, you've just been round talking to all these people all night.

MP: I suppose in many ways you're not actually sleeping, because your brain is still acting as if you were awake.

JB: I'm not sure what the brain actually does. But I feel incredibly privileged. Then you also fly. I've had situations where I've been dreaming in my house and the layout is exactly the same, not distorted like in a dream. And I've asked myself, 'Is this a dream?', at which point I've leapt up into the air and taken off. There's a huge sense of euphoria when you start floating around. I like to show off like that in my dreams!

MP: Have you ever experienced precognitive dreams?

JB: No, but — and this is absolutely true — our first ever album, back in 1985, was going to be called *Funeral Music For Princess Diana*. That was based on a dream I had. I was sure she was going to die prematurely. I can't remember how she died in the dream, though I don't think it was a car crash.

MP: Your recent live performances at the Royal Festival Hall were powerful, both physically and mentally. How do you go about creating something like that?[5]

JB: We try to put magick in the music and we do a lot of preparation for that, from finding the right frequencies on the modular synthesizers, to using the right incense, or the right colours on the screen. We usually take stuff from Crowley's book of magickal correspondences, *777*, and mix it with intuition and research. It's certainly powerful, but we definitely don't aim to injure! In Thailand, we came across a drug rehabilitation unit that was also for psychiatric patients. They would use loud noises to exorcise the spirits, and basically they'd be amplifying buzz saws on either side of your head with big speakers and banging gongs and completely freaking people out, but they were doing it to banish spirits. So the last gig, we were attempting to do something like that. We're building it up and want to do bigger versions of it, to shake the bad stuff out.

MP: How does it feel now, having not played live for almost 15 years?

JB: Strange. I reached a point in my life where I've learnt a bit, I've absorbed a lot and I've got a lot of things, and now I want to put it back, put myself at the service of the current that we're living. If I'd approached it at an egotistical level I would never

5 19th September 2000 and billed as 'Persistence Is All' though Balance referred to it as 'Constant Shallowness Leads To Evil' during this interview, the title of their most recent record.

have got on stage. I'm really nervous and shy. I can hardly speak to people in shops, let alone on stage at the Royal Festival Hall. I just feel that I'm doing this as a duty.

MP: How about Electronic Voice Phenomena, have you ever experimented with that?

JB: No. What we do is buy old tape recorders and use the messages we find on them, which is different — I'm interested in found sounds, as opposed to found objects, like Burroughs was. It's a bit like people who pick radio waves up through fillings in their teeth, and they can, and nowadays everybody's brains must be completely scrambled by mobile phones. This is what we're trying to do in concert, almost, to blank this out through the use of white strobe lighting, white noise and video projections. Hopefully, we can provide some sort of safe area where all that is not going on, to allow people to be themselves in that particular time and space. Outside you just can't avoid it anymore, what with visual pollution from advertising, noise pollution, both audible and inaudible, microwaves — that's one of the things we're trying to negate.

MP: A lot of people would describe your music as dark, though it's less so now, you're letting in the light. Is that a conscious decision?

JB: Well it's partly age, though I'm not mellowing — I'm getting angrier if anything. 'A complete derangement of the senses,' as Rimbaud called it, was always what I was aiming for earlier on. I was much more into chaos, punishment almost. If I stayed up, I'd stay up for five days; if I did live performance, it would involve blood enemas and cutting myself up. And then I realised that it's OK to do that, but we wanted to make music that would take people places, be more constructive if you like, both for myself and others. I was literally destroying

myself in creating these things. Certainly, making the *Love's Secret Domain* album was very, very heavy, drug wise and in all sorts of ways. So we thought: let's try to do music that's more healing or holistic, but not in a New Age way, as it can still involve noise and abrasion, but the intention behind it is healing. It's just a different approach really, I wouldn't say we'd mellowed.

We like to think of what we're doing now as Moon Musick. When we lived in Chiswick, by the Thames, we became very aware of the tidality of the river, we'd go down there every evening. So we decided to move to the sea. We'd become lunar, switched into this lunar phase. The first thing we did, *How to Destroy Angels*, was a conjuration of Martian energy — male, homosexual energy. In fact, people claimed that it was misogynist, and Rough Trade almost wouldn't stock it — a controversy in a tea cup. But now we're in a lunar phase, very moon orientated. Arabic culture uses a lunar calendar, they have moon letters and sun letters, and the pre-Christian Celts also used a lunar calendar. It's so much more natural. I'm on a mission to put the moon back into perspective. So like Sun Ra came from Saturn, we, at the moment are at the Moon. Maybe we'll reach Saturn one day.

'It Imposed Itself on Me When I Was Eleven Years Old and Caused Me a Lot of Problems'

D-Side #4, 25th March 2001

Yannick Blay

I discovered Coil in 1986 thanks to an older friend of mine who kindly lent me *Scatology* and *Horse Rotorvator*. Being 15-16 years old, there are some records that mark you for life at that age. I was amazed by the sound, the symbolism and strange artwork, even the name of the singer: John Balance.

By coincidence, as a child I enjoyed playacting cowboy villains and conjured myself the name 'Johnny Balance'. It was a pun on Liberty Valance (a favourite western villain of mine portrayed by Lee Marvin) and on my own name: Yannick is 'Jean' in Breton and 'John' in English. Also, being born on 11th October I'd always felt my zodiac sign characterised me perfectly, hence 'Balance'. All this to say that when I discovered that name in the credits I felt I was in the presence of an English double of myself!

By the late 90s I was beginning a 'career' in the underground music press and was obsessed with the idea of interviewing Coil... Unfortunately without success. A few years passed then suddenly the magazine *D-Side* gave me the opportunity to meet them face-to-face. I jumped at the chance!

25th March 2001: Coil were playing in Nantes at an excellent venue called Le Lieu Unique, for a festival called Oblique *LU Nights* — their first French show. Before the gig, the organisers staged a press conference but, aside from a question by artist Black Sifichi and another from journalist Laurent Diouf, I conducted the whole interview. I was then lucky and delighted to meet them in a creperie afterward, a more casual chance to eat and talk with the entire band including John and Peter, as well as Thighpaulsandra and Simon Norris (Ossian Brown).

That evening, a white postcard was placed on each seat of the venue featuring a drawing of a Zos/Kia vulture-head and the inscription: 'Pay Your Respects To The Vultures, For They Are Your Future.' The scent of incense filled the room and Coil played dressed in what I can only describe as glow-in-the-dark psychiatric suits. I took photos on a disposable camera with the glow-in-the-dark preventing their faces and hands appearing when the images were developed. With John alternating between mad priest or human animal, the band fully occupied with their synths or playing with the lightbulbs hanging from the ceiling, the level of intensity just kept rising until, on their last song (from *Constant Shallowness Leads To Evil*), John was yelling 'Louder! Louder! Louder!' like a man demented or possessed. It was terrifying. Like nothing I've experienced outside of Swans or Sunn O))). God, it fucked my mind for good!

'Silence is sexy, yes, as Blixa
Bargeld says. But not with the
Berlin accent (laughs). In fact, we
have the most beautiful silence
in the garden of our new house,
sometimes altered by birdsong.'

Interview

YANNICK BLAY: Tell us about this famous magick permeating your work...

JOHN BALANCE: It's invasive. It imposed itself on me when I was eleven years old and caused me a lot of problems. It's another way of looking at the world. Coincidences are not coincidences, accidents are not coincidences. One can control and influence one's existence thanks to magick. We practice it every day of our lives. There are rituals, sexual in general, where I exercise my will toward a precise object or image. With Coil, we project this magick into our work, we practice music with supernatural powers in a deliberate way. It awakens the senses and changes the perception of reality just like a drug. It is certainly not 'wallpaper' music with a tendency to make you feel sleepy.

YB: Do you feel freer today?

JB: Absolutely, yes, and it's exciting. We are very enigmatic. For a very long time, we haven't given interviews and haven't played live. So we never really explained ourselves. As we approached the new millennium, we told ourselves that we had no more excuses, that we had to come out of our cocoon, explain what we did and what we were going to do. It's a kind of mission commanded by a higher — but not divine — force. We are born with a gift, a curse, or a vocation. Ours is the music we give back to people. And today we want to be less selfish, to come out of our seclusion for the purpose of being more available. So we tour, we talk with people, we clarify ideas or things in our music that perhaps weren't sufficiently clear in the past. The problem with being a magician is it's precisely to break certain addictions, as well as fears, and to explore or even explode these constraints of the mind. Constraints

that come from my parents, their religious upbringing, the industrial music that we are supposed to be a part of. We chose as teachers people like Brion Gysin, William Burroughs, John Giorno, Buddhists, some friends. And we have a duty, as well as a pleasure, to pass on this knowledge, to take over from people like Burroughs. Christians believe that it is by illuminating the world with divine light that they create peace. They are wrong; on the contrary, one must embrace one's own demons and even feed them. And this has nothing to do with Satanism. You have to explore the dark sides within yourself to better understand your own demons. Candlelight encouraged imagination, we told each other stories. The flame in the darkness, sitting next to a fire, fuelled creativity. Deeper things can emerge from it. This concept is played out a lot on stage.

YB: Coil has always been a group with a passion for symbolism. Did the Solstice and Equinox EP series mark the beginning of a new cycle and a new symbolism?

JB: At the start, my perception of the group was very solar. The music was burning me, destroying me, and probably the group itself. As a way of living it was too intense and destructive, given the constant use of drugs and alcohol. Our imagery back then was very dark. We had the Black Sun as our logo and the Khaos symbol adapted from Crowley's drawings. The Black Sun represented what we had in our hearts, in a surreal way. Today, we chose to change our mind and practice lunar music, to draw our energy from the Moon and all that it can represent, but also from its correspondence with the sea. We try to be more aware of natural cycles, without becoming hippies. We're set on seven-day weeks, and we try to break that. There is a movement that started in the United States, inspired by the Mayan calendar and its cycle of the thirteen

moons. This cycle is much more natural and appropriate, in my opinion, than the seven-day cycle.

YB: Are you trying to translate particular visions or images into music?

JB: Always, yes. That's how I work. But I can't answer for others.

THIGHPAULSANDRA: For Coil, I let myself be guided by John's fantasies. (laughs)

JB: And for Thighpaulsandra, it's obviously him who directs. When we work for him, we have well-defined and different pieces of music from Coil on which we do what he tells us to do. Our work together is magic, a kind of highlighting of a fluid and telepathic movement. For Coil, Thighpaulsandra, Ossian and Peter manifest what I feel. They illustrate my own visions and those of Peter.

PETER CHRISTOPHERSON: The main difference between the two is that Coil is completely visual. Visions, images or specific places are the basis of 99% of our compositions. We try to evoke an atmosphere and our work is quite similar to film music. Thighpaulsandra, on the other hand, makes strange and abstract places appear in his compositions. John and I have been living together for twenty years and share art books which are the source of our emotional and magickal imagery. Few people can penetrate and interpret these images. But Thighpaulsandra and Ossian do it very well.

YB: Is there a link between the visuals on stage (projections, staging) and the images behind your music?

JB: Yes, but what we project on stage is a kind of abstraction allowing the audience to get what they want from it. We want an interactive show so that everyone can have their own visual, auditory and even olfactory understanding given we

are burning incense. Incense is there to purify us as much as the audience. We also use a whole bunch of slogans with a very strong power of suggestion, but I won't tell you what they suggest so strongly. Our concert starts with 'Something', followed by two old songs, 'Blood From The Air' and 'Titan Arch', and then the music gets as intense as possible.

PC: First and foremost, we want our concerts to be memorable.

YB: What is that thing you're wearing around your neck?

PC: It's a symbol of Icelandic protection, which also has the power to help make your dreams come true. It's the same symbol that Bjork has tattooed on her arm. When I wear it, all my wishes are granted, but it also protects me from them.

YB: What do you think of the cover of 'Disco Hospital' by Matmos, the electronic duo that is working on the next Bjork album?

PC: I haven't heard it, but they're people I love. We spent time with them in Barcelona. They are wonderful musicians.

YB: And would you like to work with Bjork?

PC: Yes. I love her. We played with her in Iceland when she was sixteen. She was in Kükl and we were in Psychic TV. She didn't say a word, she just laughed.

YB: What music do you listen to?

TPS: Eminem! (laughing)

JB: Unfortunately I have to admit I don't listen to much music. I find much more value in silence. Thighpaulsandra and I love musique concrète. I'd like to do 'pop concrète.' Otherwise, I love music that makes me vulnerable or that liberates the mind like Arvo Pärt, folk music, ethnic music, especially Inuit music, Sun Ra, abstract electronics... Music that makes you

swirl. I also have to admit that I really love Eminem, unlike my comrades. I think there's something very strong coming out of him. His bigotry, his hatred, his fears are revealed in a very honest way, especially for an American mainstream artist. His homophobia is relatively twisted, as are his words in general, which reveal a struggle against oneself.

YB: Why did you leave London?

JB: Because of the smell. London is a terrible city and it's getting worse and worse. Any sensible person can only want to escape from London. There are so many beautiful places in the world, less polluted and above all less noisy.

YB: Is silence sexier?

JB: Silence is sexy, yes, as Blixa Bargeld says. But not with the Berlin accent (laughs). In fact, we have the most beautiful silence in the garden of our new house, sometimes altered by birdsong.

YB: What about the album you owe to Trent Reznor's label Nothing?

JB: 'Nothing comes from Nothing,' said Shakespeare. Trent has been very patient. The songs were recorded seven years ago and probably erased since then. We have the titles, the lyrics, some of the sound. We could make an album of silence for them (laughs). Or a *Metal Machine Music*.

YB: A word about Depeche Mode?

JB: We've remixed one of their tracks that unfortunately remains unreleased. Apart from that, they have very good producers and sound engineers that we unfortunately can't afford: Flood, with whom we worked with Psychic TV at one time; Tim Simenon; Mark Bell, who's afraid of us. The boss of Warp told us that he thought we were Satanists (laughs). Otherwise,

we are friends with Boards Of Canada and Autechre. They are lovely people. Yet I found myself fighting with the guy from Aphex Twin in the toilets. We were really drunk. We had been asked to make the video 'Come To Daddy'. We wanted to film grannies fighting with their shopping trolleys in a supermarket. But Chris Cunningham's work on this video is sumptuous.

YB: Psychic TV?

PC: We left at the right time.

JB: Psychic TV was a group of people who theorised and wrote together on common themes. Then Genesis began to take an interest in things that were far removed from our concerns and we left. Since then he hasn't stopped bad mouthing us, disgusted that we left him to his demons. But he seems happier today. I have respect for him because he taught me a lot, but some things have disappointed me a lot. And his music hasn't interested us for twenty years. We have crossed paths and we've changed, each to his own.

YB: Peter, do you still make music videos today?

PC: No. It doesn't interest me anymore. American television in particular is more and more aseptic and my videos would be considered too frightening. The pressure is terrible over there, really destructive. Marilyn Manson must be the only one to have so much control over what he does.

YB: Isn't it frustrating to be an influence for so many famous people like Autechre, Faith No More or Nine Inch Nails without having any real recognition, even if only commercial?

PC: Of course it is, but it's just as well because we are not under pressure. We can do exactly what we want.

YB: What are your plans?

PC: We are planning a concert with Chris & Cosey on the cliffs of Dover. We're waiting for a five CD box of *Time Machines* scheduled for Christmas, five hours of 'dissolved time,' a new Coil album called *Wounded Galaxies Tap At The Window*, a tribute to William S. Burroughs entitled *The Dream Machine*, another tribute to Brion Gysin, an album on Reznor's label, an album of Coil covers (including one by Trent Reznor), an album compiling the Solstice and Equinox EPs entitled *Moon's Milk (In Four Phases)* and the re-release of *Scatology* and *Horse Rotorvator* on Threshold House Records, remastered by Thighpaulsandra.

'Silence Is My Favourite Sound At The Moment'

Outburn #17 — January 2002

Lucasta

This interview took place in early 2002 and is included by kind permission of the team at *Outburn*. Unfortunately, despite extensive searching, no one could identify Lucasta. A low bow of respect is due for her thoughtful questions in what is one of the more meditative interviews of this late period.

'...it's only natural that there would be an influence of some sort from the moon on the way you feel or on some aspect of the way you're behaving. It seems absurd that science totally ignores these kinds of influences on people.'

Interview

LUCASTA: Should noise be considered music?

JOHN BALANCE: A lot of it has to do with one's intent. Sometimes the most horrible discordant sound can have its own beauty. What distinguishes the sound that we make from the sound that you might hear on a building site is the fact that we try and charge what we do with some kind of emotional intent and meaning. It's not random; it's made to be that way for a reason. And hopefully, even if people don't understand exactly what we mean, they'll have a proportion of the emotional feeling that we have.

L: Does that explain the cleansing purpose of your live performances?

JB: It's cleansing through noise. When it works and there's that total immersion of the human body, I think the vibrations that are going around and the magical intent can cause a schism or a detachment from your normal surroundings that shows you a different reality for a short time. Since we regard what we do as having a positive purpose, rather than a negative one, some of those feelings get picked up by the audience. When we create this total immersion of sound, you have a chance to zone out and actually discover a little bit of yourself in the experience. I think that makes some people uncomfortable with our music. They have, for the first time, an opportunity to see something in themselves that they're not comfortable with. Whereas for other people, it's a liberating moment. You do occasionally find people actually passing out.

L: How do you think the connection between the tide and the moon affects people?

JB: Subtly and profoundly... people are influenced by all sorts of things. But because they aren't part of the modern scientific canon, they don't really recognise or acknowledge them. The earth is two-thirds water... you have billions of tons of water that swing within this cycle and people are over 90% water. So it's only natural that there would be an influence of some sort from the moon on the way you feel or on some aspect of the way you're behaving. It seems absurd that science totally ignores these kinds of influences on people. Some of the *Musick To Play In The Dark* series is Moon music. And that is much more quiet, personal, and reflective.

L: What is the status of the new album to be released on Nothing?

JB: It has been completed... in the original incarnation. It has actually been finished for quite a while, but we just had some uneasiness with it. Somehow, we'd been a bit too influenced with our surroundings in New Orleans... especially in Trent's studio. It's not like he was hanging around and being demanding. He was actually almost invisible while we were working. I think we could have done with a bit of direction, because we were writing the songs in the studio, performing them in the studio, and I was singing the lyrics I'd just written in the studio. Then we mixed it there as producers, and it was all too much... I think we tried a bit too hard. It became too much of an expected thing, and therefore very difficult to work further on. When we go back to England, we're going to finish it and add some more up-to-date interests and sonic textures... like real strings and a few quiet pieces. We're actually going to deconstruct it and make some of it a little more out there. At the moment, it's called *The World Ended A Long Time Ago*. We're finishing it up, and it will be coming out in early spring... hopefully.

L: You often speak about spiritual things... what do you believe is the intent of these spirits?

JB: The room I'm in now, which is a seemingly empty room, is in fact swarming with spirits. I don't think they go anywhere else. They don't go to heaven; they don't go to hell; they just stay here, but in a different form. There's human spirits and then you have animal spirits, slug spirits, bird spirits, stone spirits, and water spirits... And spirits that there are no names for, because they don't actually ever manifest on the physical plane. And they're all here with us. Sometimes you can see them and sometimes you can feel them... And they influence.

L: Like when you were recording *Love's Secret Domain*...

JB: Oh, they were everywhere! We'd been up for about five days, and we'd been doing hallucinogens. There was that momentum, we had to get it finished. We don't like to spend lots of money when we record. We book a studio for a week and we work around the clock. And something just snapped, and all these strange entities started appearing, like Egyptian kings and queens and their families... They were all lined up around the room. The studio was only a block away from the British Museum. It may be they were from one of the store rooms in the museum.

L: Do you ever feel like escaping from everything in the world?

JB: Well, music is my way of doing it. But since it's my life and my career, I have to step back occasionally to review myself, and also review what's going on in the world. I like to have whole weeks off where I don't listen to anything but very minimal classical music. Tibetan shamanic music, or just silence. Silence is my favourite sound at the moment. The thing is, a lot of the things that we do now and what we did then imply a lot, but don't actually have the explicit content that people

think they do. We use the shorthand rather than the obvious. And that scares people and confuses them. They can't say 'oh, that's a pornographic movie featuring two mules and two Puerto Ricans, etc.' We sort of create a maelstrom rather than something specific.

'Sometimes it's Good to be in a Very Radioactive Place'

D-Side #10, 30ᵗʰ March 2002

Yannick Blay

I saw them again in Limoges on 30ᵗʰ March 2002 at the Artooz Festival. John, Sleazy and Simon Norris (now Ossian Brown) were warm and hearty and it was a nice encounter — Sleazy exchanged phone numbers with me. Coil played late, around 1am, and what I remember most is 'Slur' and John introducing it as 'a song about being sodomized in the ruined city of Marrakesh.'

'Last year in Amsterdam a couple wanted to get married during our concert. So they brought a priest! At one point the music was so loud that the woman fainted. We took her out of the hall to the infirmary, but when she woke up she wanted to come back shouting that she had to get married...'

Interview

YANNICK BLAY: What about the DVD of the concert recorded in Russia?

PETER CHRISTOPHERSON: We're still working on it. Technologically speaking, we've had some minor problems. It's certainly a rather long process. It should still be ready in one or two months and will be available on our website and also distributed by World Serpent. We intend to add some small bonuses in addition to the concert such as pictures from the previous tour and maybe some excerpts from the new one, from upcoming dates in Belgium, Switzerland, Italy, Germany or Holland.

JOHN BALANCE: In fact, we encourage everyone to film our concerts and send us a copy of the film as we plan to reuse the footage in the bonuses.

PC: Our policy has always been to encourage people to record our concerts and send us a copy so that we can market it. (laughs)

YB: How is this new tour different from the previous one?

PC: In its entirety. It's a different staging, new costumes, different technology and most importantly, we have completely changed the set list. There will be songs that are more accessible than the ones on the previous tour. In addition, there are two musicians we haven't played with before, Cliff Stapleton on the barrel organ and Michael York on the bagpipes. There are five of us on stage for a more organic show.

OSSIAN BROWN: We keep trying to reach people with as many different media as possible so that all five senses can be involved.

JB: It's less visceral than last time but maybe more aesthetically appealing.

CDXCIX

PC: Our concerts today are more lyrical and less abstract. But it's all instinctive. We don't try to manipulate people, though last year we tried to transport the audience to another space, a second state.

YB: Thighpaulsandra is not travelling with us this time...

JB: No. He's committed to his engagements with the group Spiritualized and is currently touring with them. Tom, the xylophone player, couldn't come either.

PC: But that's not a bad thing because it's what forced us to make some innovations in our stage performances and to move our music in another direction.

JB: But Thighpaulsandra will come back among us.

YB: Do you have a funny anecdote to tell us about the tour?

PC: Last year in Amsterdam a couple wanted to get married during our concert. So they brought a priest! At one point the music was so loud that the woman fainted. We took her out of the hall to the infirmary, but when she woke up she wanted to come back shouting that she had to get married...

JB: ...And she fainted a second time! (laughs) But she did finally take her vows.

YB: Maybe they came to conceive their child during the concert tonight?

PC: That would be great! (laughs)

YB: You participated in a project called CoH released as an EP. Can you tell us a few words about it?

JB: It's a Russian word which means 'dreams.' It's the project of an old friend of ours, Ivan Pavlov, who's passionate about electronics and computers. We did some very interesting things together.

D

YB: You seem to have a special relationship with Russia?

JB: The people are warm and the country is full of surprises and the unexpected. Their social behaviour is so different from ours, from the English anyway. We'd like to play there again this year. We love Saint Petersburg as well as Moscow.

PC: I would love to play Vladivostok. The atmosphere is very close to the city where I grew up, I mean this very industrial coastline. It's that kind of atmosphere that has forged the type of music we make. Today, we live by the sea, it's quiet and very beautiful, but sometimes it's good to be in a city where industry is still very present. In a large part of Europe, you can enjoy the green grass and beautiful trees and even when there are factories, everything is clean... Sometimes it's good to be in a very radioactive place, to find the good old polluted air. (laughs)

YB: Do you feel you belong in today's musical context?

PC: Music today makes me really angry, it's so shitty. When I see these clips on TV, I can't understand how record companies can sign such crap and how people can spend their money on it. I'm convinced that the charts are prefabricated, it can only be organised lies. In any case, we will never let the record industry get their hands on our music.

JB: Labels and media are a real pollution, an entity trying to take control of our minds, a bit like *The Remote Viewer*, which is the title of a CD-R we just made for the tour and which is inspired by the existence — or not — of a machine able to read and control your mind.

'Marc Almond Almost Killed Us!'

Laut, 4th April 2002

Daniel Straub

When Coil announced their Spring tour in 2002 it was like a dream come true for me. The previous years they had started to play live for the first time in almost 20 years, festivals mostly though. Now they embarked on a club tour that also brought them to Rote Fabrik, one of my favourite venues in Zürich, nicely located on the shores of Lake Zürich. And as if this wasn't already more than could be expected, the interview request I submitted, was approved to my surprise. I worked as a freelancer for the German online music magazine *Laut* at that time. And I was extremely excited about meeting Coil and getting the chance to ask them my questions. I've been following their music since the early 90s and they kept fascinating me all through the years with their beautifully haunting songs that seemed to come from some mysterious source. It was all the more astonishing to me that John, Peter and Ossian turned out to be vivid, curious and funny discussion partners.

'It's interesting how
you can fall in love with
a photograph and still
get an idea of someone's
personality. That was before
I knew the dark and evil
depths of his mind!'

Interview

DANIEL STRAUB: You started your European tour two days ago in Limoges.[1] How was the gig? How did the audience react to the new set?

JOHN BALANCE: It was a good gig, I think. But what actually happened in Limoges?

PETER CHRISTOPHERSON: Didn't someone shout something during the concert?

JB: No, I don't think so. You know, when you go on tour, you just lose your head. Everything works automatically. Someone says something and I often make up the lyrics spontaneously. Afterward, you listen to it and can't even remember it. So you have to think a little longer when you ask me a question like that. But they were both very good concerts.

DS: You haven't performed live in a long time. What was it that got you back on stage after almost 20 years?

JB: There are a few reasons why we did it. We've always said that we were waiting for the right technology to implement our ideas. We had very complex and well-developed ideas about how our music, the projections — we use live video projections — and the things we wear on stage should fit together into a coherent picture. And, until five years ago, it simply wasn't possible to implement our ideas live. So we didn't really need an excuse not to play. But some time ago I also realised how old we're getting — look at Peter and me!

OSSIAN BROWN: I'm still young, I'm only 36!

1 The Artooz Festival, Limoges, on 30th March, which was then followed by 2nd April show in Ghent.

DV

JB: That's pretty young. But, seriously, I realised that I wanted to give something back to the audience, the fans, and the easiest way to do that was to play live, even if I wasn't entirely comfortable. I was surprised how much I liked the stage.

DS: So, it was a good experience for you?

JB: Yeah, a very good experience.

DS: Are you going to play the same songs today as you did last year?

JB: No, there'll be other songs. We're playing a completely new set. Coil, on record, has so many different styles that we can play a different set for each tour. With our self-confidence, which has grown quite a bit — no, actually, a lot! — we can also do more subtle or refined performances. The first concerts were more of a kind of noise bombardment for the head, ears and body.

DS: Then will you be playing more melodical material today?

JB: Yes, partially. We have Cliff Stapleton on tour who plays the hurdy-gurdy.

DS: Is he related to Steven Stapleton from Nurse With Wound?

JB: No, no... And we still have Michael York playing the bagpipes. We only met him recently. Our other member, Thighpaulsandra, who is currently on tour with Spiritualized, has forced us to look for new people to work with. At first I thought this would be something terrible, a curse, and I hated him. But then I came to realise that this was a good opportunity to change again. So, now we're working with new people.

DS: So you're going to be using real instruments, not just synthesizers?

JB: Yeah, I've wanted to do this again for a long time — since *Horse Rotorvator* actually. Some of the melodies on *Horse*

Rotorvator were inspired by medieval Arabic and Andalusian pieces. So, pretty early music. And I always wanted to make something out of traditional English music combined with Arabic elements, but with the right instruments, not just with samples, and now we can finally do that.

DS: I'm just a little surprised because your most recent record, *Time Machines*, is synthetic through and through...

JB: We'll do that too, but now we can do both.

DS: Let's talk about the early days of Coil. How did the two of you get to know each other?

PC: I was playing in a band back in the 70s called Throbbing Gristle and whenever there was an opportunity to pick someone out of the audience and really confuse them, then I'd do it. John was one of the schoolboys who came to our concerts — I think you were 16 when you first went to a Throbbing Gristle concert?

JB: Probably 17. On the verge of legality! (laughs)

PC: That's how I managed to hypnotise him...

JB: ...So that I follow you everywhere and do what you want.

PC: Unfortunately, in the 20 years since then, he's managed to turn the tables. I work for him now!

JB: Now you do what I want! (Laughter)

DS: So it was more than just a shared interest in music?

JB: Yes, the interest in the other as a person. I remember buying a Throbbing Gristle record — no, I didn't buy it. The band sent it to me... It was *20 Jazz Funk Greats* with Peter on the cover and I thought 'there's something wrong here.' My girlfriend at the time, Lucy, said I'd turn his head — and I was thinking that I

felt the same way. It's interesting how you can fall in love with a photograph and still get an idea of someone's personality. That was before I knew the dark and evil depths of his mind! (Laughter) The chaos he creates, the order he creates... This is what happens when you live with someone for 20 years.

DS: I heard you guys are big art fans. What kind of art do you collect?

JB: Occult art, like pictures by Aleister Crowley, pictures by Austin Osman Spare. I also buy contemporary British art but we're very picky about it. Since we moved away from London we have gotten to know some famous people through friends, but to have real connection you have to participate in a social life, and since we no longer live in London that's difficult. That's why we're missing a lot. But isolation is good in itself.

PC: But you can also overdo it...

JB: Yeah, that's right.

PC: John hasn't left the house for three years.

DS: Are you kidding?

JB: No, really.

PC: A very shy person.

DS: Then what have you been doing all this time?

JB: Looking out of the window. (Laughter)

DS: In retrospect, London at the start of the 80s seems like an ideal place to make music. David Tibet is living there as well as Marc Almond, Genesis P-Orridge and others. What was it that drew so many creative minds to London?

JB: I don't really know what was so special about it. It was more that the rest of England was pretty boring at the time. It was

very demoralising for anyone with any artistic vision. People are always drawn to where they believe something is going to happen. And punk was only a thing in the big cities like London, Glasgow, Manchester or Leeds — where Marc started his career — after all, the record companies were there which was an incentive for many people to move to London. I moved to London because I wanted to be closer to the people from Throbbing Gristle and Cabaret Voltaire. There was also a lively scene around Some Bizzare with Einstürzende Neubauten, Matt Johnson, The The, Soft Cell, Psychic TV. I met Marc at the time because we hung out with Psychic TV a lot. You also mentioned David Tibet who moved to London at the same time as me. Steven Stapleton lived there before, he's from London. We met in a club where they played extreme electronic sounds like Whitehouse. There was an event in 1982 called Equinox and all the people who later got into making music themselves all met there. Jim Thirlwell was there, John Gosling, the Psychic TV people...

DS: Are you still in contact with everyone today?

JB: I'm in constant contact with David Tibet.

DS: With Marc Almond too I suppose...

JB: No, not so much actually...

DS: But there was a time when you worked together very intensively?

JB: Yes, we did a lot of things together and we're still very good friends, but he travels a lot and we travel a lot, so we only meet every now and then. When we lived in London we were very, very close friends, but at one point we had too many strange drug experiences. If we'd continued on like we did we would have killed Marc Almond — or Marc Almond would

have killed us! (Laughs) It would have been a double homicide or a double suicide. So we decided to keep a healthy distance from then on, at least for some time. But we would love to work with him again. The fantastic thing about good friends is that the door is always ajar.

OB: To have the confidence that you can come back, after a year without contact, without feeling that the friendship is missing something. You just start in a new place and build on the old experiences.

DS: Why did you start Coil? What did you want to achieve with it as a project in contrast to your work in Psychic TV?

PC: The freedom not to have to take commercial considerations, or the considerations that other people bring you, into consideration. To be able to ignore other people's egos.

JB: Whose egos?

PC: Just the egos of all the people we worked with at the time. John and I started Coil because we wanted to be able to do anything, without any limitation. The only limitations we've had so far have been either technical or creative, but neither are really limits. That's why we founded Coil.

JB: That's why we started Coil. Ever since I was a teenager I always had a vision that I would make music that I had never heard before, that was what I wanted to do. Back then I was listening to very weird experimental music and I wanted to do something that no one had heard before, something I could do.

DS: Was it about being in control of the music?

JB: No, not necessarily. (Peter laughs) One second... It isn't easy to analyse creative motivation. All I know is that I feel it's very much inside of me, we feel it very strongly within us.

DS: So it was more that basic freedom that you were looking for?

JB: Partly, yes. But I also had complete freedom on Psychic TV. But there, the ideas of many people were used without that input being appropriately acknowledged. That annoyed me, but it wasn't really why I started Coil because there was a time when Psychic TV and Coil worked perfectly together. There's no competition, it's just very different. Coil is what I want to do.

DS: Do you see Coil primarily as a band, or do you have another concept behind it, given you always work a lot with visuals?

JB: A friend and journalist, Ian Penman, who works for *The Wire*, once said in an annual poll about the tops 'n' flops of the year: 'top of the year: Coil. Everything else is just music.' That implies that Coil has always been more, a springboard for ideas, but not necessarily just for music. We use music and pictures and ourselves. On the other hand, we do want to do more fine art. Paintings, sculptures, objects that have a resemblance to the music of Coil. Coil records are all objects.

DS: On your homepage you write that *Love's Secret Domain* was the result of an 'MDMA fuelled' session. Do you think that drug experiences make it easier for the listener to get involved in your music?

JB: Hmmm, no, not necessarily. Really it depends on how people's brains work. My brain doesn't work the same way as Ossian's or Peter's because we all have our own 'chemical history.' I think everyone has a story like that. I took a lot of psychedelic drugs and Speed, Ossian did a lot of Speed. So every brain is polarised differently. We can't dictate or influence how someone experiences our music.

DS: So you didn't necessarily think of the listener when recording?

JB: Somehow, yes. But it's not like we're saying you should take this drug for this album and that drug for another album. Drugs are more there to get us going, to get creative. But sometimes drugs can also cause enormous blockages.

DS: You also remixed Depeche Mode's song 'Rush' — do you know why the remix was never released?[2]

JB: It's too good for them! (Laughs)

DS: Whose idea was it to ask you for a remix?

JB: We asked them because we got samples from Mute and we really liked *Songs Of Faith And Devotion*. We were only remixing Nine Inch Nails at the time. Everything was very new to us and we were just in the mood to do remixes. So we remixed Depeche Mode but I don't know why the people at Mute didn't like it. They always ask a lot of people and then only use a fraction of the remixes they receive — they can afford it. Plus, they always want to be up to date and maybe we're already past that.

DS: Do you feel honoured or acknowledged in your work when recognised institutions in the art world, such as the Museum Of Modern Art in New York, buy your work?

JB: Yeah, I wish that would happen more often! They should buy a lot more of our stuff. But we have a split relationship with the art scene. In the Whitechapel Gallery, one of the largest galleries in London, we were offered an installation commission for a week. We already had big plans for the show but, because of some stupid technical problem, it didn't work out. But maybe we'll get a second chance. Many of our friends find it easier to get financial support but we're not there yet because we are too busy with our work.

2 'Rush (Black Sun Mix)' from 1994 went unreleased until late 2004 when it came out via a secret site accompanying Depeche Mode's *Remixes 81–04*.

DS: Do you actually paint too?

JB: Yeah, but it's too crazy and messy to put on display, I just give them away to friends. Ossian has some too. I paint a lot of ghosts. Ghosts of animals, or trees, or tables, or pyjamas... Ghosts of everything. Or 'astral landscapes' as I call them.

OB: We paint a lot of pictures together. This works in a similar way to the automatic drawing or painting of the surrealists.

JB: We were once on vacation in a wooded area and in the evening we sat around the fire and painted with our eyes closed. That's how we connected with the spirits of the trees and the owls. Ossian continued painting the pictures I started and all with his eyes closed. A common automatic picture. Then we hid them for a while and then worked on the pictures again. It makes for a lot of fun.

DS: Are you also interested in electronic music like techno? Do you still go to clubs?

JB: No, not anymore. We loved acid house in 1987, before it got big in the newspapers a year later. By then we were dizzy or danced to death and by 1990 it was all over for us. The whole experience of reaching new states of consciousness on ecstasy is still very exciting, but the music got more repetitive from 1990 onward so we lost interest. We were listening to a lot of dance music around the time of *Horse Rotorvator*, but we always made sure that the two things were kept separate. What we listen to in private is very different from what we create.

DS: What do you put in your CD player at home?

JB: We had a year where we listened to a lot of musique concrète, things by Francois Bayle, Karlheinz Stockhausen, various people who were there from the very beginning. Lots of people

have told us 'you sound a bit like Stockhausen' and all that, that's why we got curious.

DS: Oh, you didn't even know Stockhausen and musique concrète?

JB: No, not before, not at all. Ossian had an earlier connection with it.

OB: Yes, I've heard that before too, but it was only in the last few years that we really got into it.

JB: Since I quit... I don't know how to say it, but you have to be very careful with what you let in your ears as a musician because everything can affect you somehow. We go to great lengths to be influenced as little as possible. The best way to do that is to find a genre of music that is a bit neglected, such as musique concrète, and surround yourself with that music. That acts as a kind of insulating layer against all the garbage that's out there. We also listen to classical music, or just crazy stuff... What else is there that you're listening to?

PC: Kind of acid dancehall...

JB: Acid-mutant-dubmonster-'Atari Teenage Riot meets Lee Scratch Perry' kind of things. It's great music. Every now and then you have to cleanse yourself with such things. We've always listened to ethnic music, world music, before it was even called that. We have a huge collection of Inuit music and stuff like that. Captain Beefheart always brings you back to reality.

PC: Back to his reality. (Laughter)

JB: We are part of his reality. But things like that are hardly reflected in our music. Pan Sonic, for example, are listening to rockabilly music all the time. Everyone has these secret music listening habits.

OB: I read that you're going to be releasing *Scatology, Horse Rotorvator*, and *Love's Secret Domain* along with a 12" of remixes. Is that right?

JB: Yeah, we're going to release it as a vinyl box-set with remixes from Autechre and Tony Child aka Surgeon...

PC: ...And some other remix that I can't remember right now.

JB: They're both acts that I really enjoy. Autechre took 'Panic' apart and Tony did... What did Tony do? I can't remember exactly but it was something extraordinary. There's also a very interesting band called Lefthandpath who are going to contribute a remix. I actually wanted to ask Boards Of Canada who we're friends with.[3] In addition to the tour we also recorded a CD-R called *The Remote Viewer* as a special limited edition. It's very psychedelic and repetitive but also very beautiful. We used the hurdy-gurdy as well as the bagpipes and shifting electronic sounds. And it'll be re-released after the tour with completely new music and new lyrics.

3 Anthony Child (Surgeon) made his remix of 'Teenage Lightning' available in 2012 and confirmed he had created it for 'a vinyl box-set edition which would include a 12" of remixes by Autechre and Surgeon. The remixes were completed and approved by Coil, but the project stayed on the shelf.'

'I'm Still Very Angry About Many, Many Things in The World'

Blow Up #10, June 2002

Gino Del Soler and Daniela Cascella

GINO DEL SOLER: I first connected with the music of Coil in the early nineties and was aware of their early years — *Horse Rotorvator* was a favourite — then I fell in love in a particular way with their 'entheogenic' *Time Machines* album — that was truly a trip to my ears. The first time I had the opportunity to see them live was at Sonar 2000 in Barcelona. It stunned me. They were in their 'Moon Music' period and the two volumes of *Musick To Play In The Dark*, to my mind, are their best work. Finally, in spring 2002, alongside Daniela Cascella, I had my first close encounter with John and Peter. It was an interview for *Blow Up* magazine, thanks to Enrico Croci their Italian promoter, on the occasion of their performance in the beautiful Teatro Delle Celebrazioni in Bologna. We met in the afternoon, just before soundcheck, on a calm and peaceful day. There was a very warm feeling to the meeting, like we'd been friends for a very long time. John lit an incense stick and stuck it in a banana! We went on to have a deep and intense conversation... Not to mention the equally deep and intense

gig that was to follow that night! Later the same year, I met them again in Fano, backstage and another Coil gig, and we hugged like long-lost friends.

DANIELA CASCELLA: In truth, Gino was the real expert on, and admirer of, Coil — I was invited along to Bologna because I was fluent in English and could support him in the interview, and I would, furthermore, have a chance to ask more questions. While I was not a Coil fan at the time, in retrospect the meeting with them was important because it led to me discovering *Musick To Play In The Dark Vol. 1 and 2* — each of which became a favourite record. It was also the first time I heard the name of Sir Thomas Browne, Jhonn mentioned him in relation to the song 'Batwings'. It seems he must have been sharing a premonition with me because, quite a number of years later, I became deeply absorbed — in a very different context — in Browne's books *Hydriotaphia, Urne-Buriall* and *The Garden Of Cyrus*.

'As you grow up, especially if you stay in the same city or country all the time and don't see other places, you forget how narrow the path is that you are walking on. It's only when you read a sign that says "don't walk on the grass" that you realise that the lawn exists, that it's very large and that you want to walk on it...'

Interview

BLOW UP: Your music is always full of contrasts, I'm thinking of the opposition between sensuality and immateriality and between the use of the most advanced technologies in sound production and the strong links with the occult tradition. Even your live shows are always different: the one at Sonar in June 2000 was very 'enchanting' while three months later, at the Queen Elizabeth Hall in London, I saw a very aggressive show, saturated with sound...

JOHN BALANCE: Tonight we'll show yet another aspect of our music. It's going to be quite a quiet concert, with plenty of songs but also with more texture. In addition, there'll be musical instruments played live and live electronics. There will be five of us: Ossian Brown on keyboards, myself, Peter Christopherson, Cliff Stapleton playing the hurdy-gurdy and Mike York playing the Breton bagpipes, which have a more melancholic and nuanced sound than Scottish bagpipes. Cliff and Mike usually play together at heritage music festivals and are really enjoying playing with Coil in such a different context.

OSSIAN BROWN: The music we make is not improvised in the way that free jazz is. The main element stems from a reaction to where we're playing: in Barcelona the concert was influenced by the lively, dynamic quality of the place, whereas in London it was certainly much darker.

BLOW UP: Will you also be using medieval instruments on the next album, or are you just experimenting and satisfying a curiosity by playing live?

JB: I love medieval instruments and sounds, we will use them on the new album too. We would have liked to use more in the past but it's very expensive, so we used samples. We love old musical instruments that evoke lost moods. For this tour we're

selling limited edition CD-Rs, 500 copies, which are work in progress for the new album. In the past, we've shared our 'raw material' after the release of albums; I think it's interesting to see sketches of a work of art or infrared images of a painting, which reveal the different layers.

BLOW UP: You promoted this tour with the phrase 'the key to joy is disobedience.' What does the word 'disobedience' mean for you today?

JB: It depends on what you are disobeying. Every situation gives you a chance to challenge it, not in a dishonest way but in a joyful way, you can fight it in the same way as you fight a tree when you shake its branches to make it drop its fruit. It may contain an abnormal element, a kind of imp or demon. A lot of people's lives are unhappy because they don't see these demons, these possibilities of deviation, they don't disobey, they believe that their path is marked by a series of predetermined steps to be carried out without looking around.

PETER CHRISTOPHERSON: We live in an age where we are seemingly very free but actually caged.

OB: As you grow up, especially if you stay in the same city or country all the time and don't see other places, you forget how narrow the path is that you are walking on. It's only when you read a sign that says 'don't walk on the grass' that you realise that the lawn exists, that it's very large and that you want to walk on it...

JB: In most cases, freedom is granted from above, it's not something you conquer or fight for. We believe that getting your own freedom is the best way. 'The key to joy is disobedience' is a line taken from Aleister Crowley's poem *Ode to Lucifer*: Lucifer was the angel expelled from heaven for his disobedience. It has nothing to do with the image of Satan, the origins of the

two myths are different, Lucifer was the morning star that brought light.

BLOW UP: Are you involved with the anti-globalisation movement? I ask you this because, immediately after the events in Genoa, John's 'symbolically' bloody face opened your website...

JB: I feel close to their motivation but, at the same time, I believe that direct action results in direct harm. We try to act differently. At some concerts, for example, we project signs that say: 'resist the things you can find everywhere' and this is the same message as the anti-globalisation movement, so you could say we are involved in our own way. We prefer to spread our messages from person to person, or else through the concert experience.

BLOW UP: How do you come up with your evocative lyrics?

JB: Our lyrical process doesn't start from the intention to illustrate, rather we try to evoke a mood through the juxtaposition of different images. For example 'Slur' in *Horse Rotorvator* is based on my sexual experiences in the ruins outside Marrakesh but that's only the starting point for a piece that becomes a universal love song, full of Moorish and Arabic impressions, and that also inspired by the abstract drawings used in those places as decoration on the walls, that have other meanings beyond ornamentation.

BLOW UP: There is a strong connection between your texts and certain paths linked to mythology, which have a long tradition behind them but, at the same time, are not widely known because they differ from the most widespread intellectual concepts...

OB: It's true, we often use certain images from traditional mythology alongside our own personal mythology. That's one

of the reasons why we take a lot of time making our albums. Sometimes we spend months investigating a certain topic, from mythology to history, from geology to science. We do it to enrich our music.

JB: I feel very responsible for the messages within our songs, so I think it's my duty to research, discover and document. I do it to learn from the past, to avoid the mistakes of the past, and to take a new direction. Do you know Austin Osman Spare? He was an English artist linked to occultism, a contemporary of Aleister Crowley, who died in 1955. He influenced us a lot. He created beautiful drawings halfway between Aubrey Beardsley and William Blake. He believed he could revive the spirit of Blake within himself. He worked in total isolation on magical themes. He developed a theory that he called 'Avatistic Resurgence.' He believed that our soul (or if you prefer our spirit, our personality) contained all the different layers of life forms: the Avatars, the gods, the people, the animals, the microbes. He believed that in order to progress intellectually, spiritually and artistically, one has to integrate these levels of existence, letting them all loose at the same time. In order to move forward you have to go backwards: that's why we wrote a new song called 'Backwards', which is about conquering and discovering the primordial forces within ourselves. In a way, we believe that we're all animals, without distinction...

PC: We often use a phrase that says 'what kind of animal are you?' A ferocious beast or a gentle animal? It also means that each of us has a 'totem animal' with which we are associated, just as the American Indians believed...

BLOW UP: Your *Musick To Play In The Dark* definitely seems to relate to the idea of an archetype, of an ancestral music. One night I was driving along listening to 'Batwings' and I said to myself: this is a song I would like to accompany my death,

not because it's sad, not at all, but rather it's a 'sacred' song. Like a litany for the passing away... Can you tell me something about its genesis?

JB: I was reading an English writer, Sir Thomas Browne, and I was struck by the language he used, an Old English that seemed like crystal, quite different from the coarse manner in which it's written today: every word used was very precise and had nuanced meanings. At the beginning of the song I read some passages from Sir Thomas Browne, changing them slightly and adding my own phrases; for the last part, the sung part, I thought 'here I have to sing as if it wasn't me,' so I arranged myself in a sort of Byzantine space in my mind and started to make some vocalisations which then turned into a kind of sacred music; there are also real words but for most of the piece they are blended in with a rather abstract chant, in which I repeat the single sounds like in a mantra.

OB: The genesis of this piece is an example of what happens when we work at our best: as we said before, it's not a question of improvising, but of finding a kind of attitude that has nothing to do with the intellect and that springs from other feelings.

JB: It's important to feel that the ego isn't involved and that you step outside of yourself and let a voice come through, a voice that isn't yours.

OB: Sometimes when we finish recording a new song we close the studio and go for a walk along the cliffs by the sea near our house. Then we go back into the studio and we don't remember what happened or the process that made us make that particular track; when something like that happens it's a very positive sign, it's like we've gone through some kind of meditative trance.

PC: For me the word 'trance' is fundamental, even if it has been destroyed by the club system, unfortunately. Trance, tran-scendence...

BLOW UP: Are you still going through your 'moon phase,' will you still make 'moon music'?

OB: We started composing 'moon music' after we moved, four years ago, from London to a house by the sea; every day we saw the tides going in and out and the moon reflecting on the water without being disturbed by the city lights. It's a change that influenced us a lot.

JB: I think our moon music has its roots in our London days, when we lived near the Thames, which, unlike most rivers, has very pronounced tides. If you look at a picture of the river from above, it looks like a huge snake going through the city, pulsating day and night. The power of the snake, the moon... I think there was a movement in South America that wanted to adopt a thirteen-month calendar, linked to the phases of the moon rather than the sun...

BLOW UP: You spoke earlier about Sir Thomas Browne's writing, which brings me back to another English writer, Shakespeare, and his sonnets that were used by Derek Jarman in the 1985 film *The Angelic Conversation*, for which you made the soundtrack. Shakespeare's sonnets are all composed around images of light, everything is minutely described through gradations of light and this aspect is also reflected in the film...

PC: We knew Derek from the Throbbing Gristle days, when he made *Throbbing Gristle: Psychic Rally In Heaven* for us and we later composed the soundtrack for *In The Shadow Of The Sun*. But maybe John can tell the story better...

JB: Derek wanted to make a film specifically for Coil, to collaborate with us. He brought us a video that we didn't like, and a year later he came back with some great images. The sonnets were put in later than the initial project. At that time the two guys you see in the film were both my boyfriends! During the shooting they fell in love...

PC: Anecdotes aside, *The Angelic Conversation* is a very personal film and Derek thought it was his best work. It was his favourite film. Most of his films contain a strong polemic or a strong political message whereas this film works in a similar way to our music, it conveys messages on a more personal level.

BLOW UP: *Time Machines* is another significant moment in your history. All those explicit references, right from the titles, to the chemistry of certain 'entheogenic' substances make one think of the theories and experiences of researchers who consider drugs to be sacramental foods... Terence McKenna for example...

JB: At that time we were hanging out with Terence and we were also planning to record with him. We did an amazing interview with him where he talks about the Black Sun and tells the secrets of the Mayan calendar and explains how the alignment of the planets will lead to a black hole in our galaxy...

BLOW UP: Was *Time Machines* really composed during an entheogenic experience?

JB: No, not during! It was a consequence of a series of such experiences. We had already taken a lot of those substances and then we decided to make the album. The titles were to show the kind of 'research' that had been done before the album. The music was the result of those experiences. The album was called *Time Machines* because when you take those kind of substances you're projected out of time, time has no

meaning anymore, so we wanted to make a form of music that was equivalent to the effect of those substances, which erase the feeling of time passing.

PC: People don't need to take certain substances to immerse themselves in the album.

BLOW UP: Do you still use them?

PC: As far as I'm concerned, they're part of my 'operating system', they're inside me like plug-ins inside a computer, which you don't have to install every time. You don't need to take the same substance over and over again, because when you open that particular 'door of perception,' it stays open forever. If you take the same substance repeatedly it becomes boring and not particularly interesting.

BLOW UP: Recurring names appear in your history, such as Aleister Crowley, Pasolini, Burroughs, Kenneth Anger, Nicolas Roeg: is there a thread that connects them all?

PC: Yes, there is something that unites all those names and many others. We try to reconnect people with those names and with a history of ideas that still live on even though many ties have been severed. That's why a cult is hidden: because the people in power want you to read their books and not those that put forward another kind of knowledge. All the names you mentioned are people who were outside 'normal' society; you always have to place yourself 'outside' to have a clear space around you, like a hermit living in the woods. Youth culture today, including contemporary music culture, doesn't contain any reference to this kind of information; it's not usually easy for 15-25 year olds to access esoteric knowledge. At the most (and in a superficial way) this happens with videogames, but even if they encounter the name of Cthulhu there'll be no one to tell them about Lovecraft... So, in some way, we think we

have a responsibility to give certain kinds of 'lost' information to new generations, for whom certain names mean very little.

BLOW UP: How did you get to know Pasolini's work?

JB: By not going to school! One morning I missed two hours of geography but I saw *Salò*!

BLOW UP: Do you feel connected in any way to the contemporary electronic scene? I'm asking because, for example, you took part, under the name of ELpH, in Raster's '20 To 2000' series, which in some ways marked an era...

PC: We receive a lot of tapes and CDs from very good young musicians, who tell us they love our work and want to collaborate with us. Usually, before we collaborate with someone, we have to meet them, we have to get along with people as well as appreciate their music. Sometimes in the past we have liked the idea behind a project, like with Raster. We get along very well with Boards Of Canada, for example, and we like their music.

BLOW UP: What do you like to listen to?

ALL: Silence.

BLOW UP: What do you think about the fact that many musicians who made 'noisy' music in the eighties are now working with silence in different ways, letting it become a part of their creations?

PC: It's definitely a phenomenon related to personal evolution. For us it also has to do with where we live and the different degrees of chaos in our lives. Now it's time to become more contemplative and leave the noise behind.

JB: Think of Aphex Twin: he's from Cornwall and his music contains very 'rural' elements but at the same time also has intense,

urban, nocturnal sounds, drug-related madness, and a strong 'spoiled teenager' element. Boards Of Canada themselves, who live in the country, make much more relaxed music. We still make very noisy music, like in *Constant Shallowness Leads To Evil*; I'm still very angry about many, many things in the world.

BLOW UP: Will the new album reflect the sounds we'll hear tonight?

JB: From a certain point of view, yes. We're always looking for rich, layered sounds. Nowadays it's all pre-programmed in the computer, people buy sounds that are inserted and programmed in computer factories and even use them all the time, they are fascinated by them. When we buy a new computer we always erase all the sounds in it and reset the programs to our liking.

OB: The next album will be very melancholic, half of it will be songs, still a lot of 'moon music'...

JB: We were thinking of calling it *The World Ended A Long Time Ago*....

'We Mostly Took Inspiration From Ourselves'

Ptiuch Connection, September 2002

Dmitry Tolkunov

Interviewing Peter Christopherson and John Balance was a remarkable experience for me given their impact and influence on my musical tastes. I associate their sound so much with my teenage years. Coil were very popular in the circles I hung out with, a soundtrack to the craziness of Moscow in the early 90s (though I confess I hadn't followed their later work). By the time Coil toured Russia, I was heavily involved in showbusiness and organising gigs for numerous western artists. I worked a lot with Marc Almond and, when I heard Coil was coming to Moscow, I asked Marc if he would put me in touch. He was happy to help and connected me with Peter.

The interview took place before the show at Tochka with Peter and John proving fascinating conversationalists. They told me afterward they were having a technical problem, that they had created a stage and image concept involving performing in white dresses... But some of the band's luggage had gone missing. I was happy to help and took them to an outlet a walkable distance from the venue where they were able to buy white clothing. A

personal friend photographed the interview and had come with us, so we all went back to his place where he offered the band a joint. It was also mushroom season and he had magic mushrooms he'd collected in a forest the previous week which he presented to the band. They were happy to accept them! I hope they had a nice trip after the show... Or perhaps during it? Who knows...

Editor's Note: credit and thanks for translation go to Alexander Slush — thank you!

'Then we were swept away
by the acid house revolution
that began around 1988, and
that's the reason that Coil
released almost nothing in
the late 80s. We were too
much into clubs and drugs.'

Interview

DIMITRY TOLKUNOV: You were among the first electronic musicians in the world. The first project you participated in was Throbbing Gristle, which emerged as early as the beginning of the 70s. How on earth, at that time, did you have this idea to create music of this nature? And what instruments and technologies did you use back then?

JOHN BALANCE: Well, I wasn't part of Throbbing Gristle, I was one of the groupies following the band dreaming about having sex with one of its members. Which I successfully did: Peter has been my boyfriend for 22 years. At this point we don't live together, we're more like friends or companions. I began making music later when Psychic TV was founded. So this question has more to do with Peter.

PETER CHRISTOPHERSON: Actually, the music I have created has always been an expression of certain ideas or outlooks on life. Its main purpose is the alteration of self through one's consciousness. For me, technology has never been the first priority. It might be a problem for me to create a track as perfect in its technical intricacy as one by Kraftwerk back in the day, or the kind of thing Autechre are doing now — I'm not as good with electronic instruments as they are. But it's not something I miss, I have other goals. As a matter of fact, I've had to work with very different technologies. I remember, in 1979, when I had my first Apple computer, I was thinking up methods for taking different non-music-related software, and using it to create music. And also, in the early 70s, I had to deal with eight-track — maybe you remember them from your childhood, huge cartridges, the size of modern VHS tapes. They used really big heads and it was possible to change and adjust the speed while recording.

DT: Who inspired you at the start of your career?

PC: Well, we mostly took inspiration from ourselves. Actually when, together with Genesis P-Orridge, we created Throbbing Gristle in 1974, it was initially conceived not only as a music project but as an art performance troupe. We were heavily influenced by the Beat Generation writers such as William Burroughs and Hunter Thompson. As for music... I was greatly influenced by Stockhausen then and, of course, my childhood idol was Captain Beefheart who I liked because he didn't resemble anyone else.

JB: As far as I'm concerned, the heroes who defined my whole outlook were Aleister Crowley and the great magician Austin Osman Spare. As a matter of fact, I'm a mystic on the inside. I've even had a spiritualistic contact with Spare. I feel that his inner emanations are so in sync with us that if this man hadn't died in 1956 he could have very possibly become a member of Coil. I was also profoundly influenced by the psychedelic revolution guru Terence McKenna. We even collaborated with him once, he recited his works to our music playing in the background, a sort of propaganda of psychedelic ideas. It's such a shame that this great man died a few years ago of a brain tumour.

DT: Currently there is a crisis of new ideas in the world of electronic music, don't you think? You can see it in the constant use of retro sound for the last five years at least, first it was lounge music of the 60s, then it was a return to the early sound of synth pop and electro from the 80s...

PC: Some people are probably experiencing this crisis. They get into that path if they don't have any ideas to begin with. If you go into music in order to follow the current fashion and limit yourself within a trendy genre, then you will definitely

face this problem. We've never had that issue. We've always stayed away from fashion and only got involved in what was interesting to us and what we believed in.

JB: Yes, a lot of people are now talking about the return of the early electro sound of Soft Cell and Human League... But it's not exactly the point, the fact that increasingly more music like that is being released, is down to more and more young musicians listening to their parents' old music and sourcing ideas from it. But these ideas mutate and go through certain changes in the hands of the new generation. We, on the contrary, have always been a phenomenon out of time and space. We were riding the wave sometimes, and sometimes not, it never bothered us much. We were just making our music.

DT: What kind of modern music are you listening to?

PC AND JB (ALMOST SIMULTANEOUSLY): Autechre and Boards of Canada.

DT: Are you going clubbing these days?

JB: No, almost never, compared to before. I escaped from London to a small seaside town not far from Bristol to be on the safe side. So much energy and health was put into the club life back in the day... How we managed to survive is quite unfathomable. We started frequenting clubs from 1981, together with Marc Almond, around the time Soft Cell released *Non-Stop Erotic Cabaret*. Then we were swept away by the acid house revolution that began around 1988, and that's the reason that Coil released almost nothing in the late 80s. We were too much into clubs and drugs.

DT: Do drugs have a big influence on your music? Do you think it's possible to write music like yours without a history of psychedelic experiences?

PC: I think that if a person can make their life more interesting with the help of a psychedelic trip, or by visiting a new location, or by having dinner in a new restaurant that's unknown to them, they should take the opportunity. I don't want to go to the same place for my holidays 20 years in a row, that's just boring. I consider it equally boring taking LSD on a daily basis. It only takes two-three trips to gather everything that the substance is capable of giving you. So I think that if people take psychedelic substances in order to learn more about themselves and discover new abilities, then it's OK. We've done that and of course our music was created largely under their influence.

JB: Drugs play as big a role in our music as they do in many other people's lives. I can say that I've always had a psychedelic mind and it had been that way long before I did drugs for the first time. Drugs only helped me in broadening and developing my mind.

DT: Do you consider it to be true that Coil is, to a significant extent, an ideological project and that its main purpose is to voice psychedelic ideas?

PC: That's totally true. Like I said, the music we play has a distinctive purpose. We aim to show people that their minds are much deeper and more multi-faceted than they tend to think. Most people happen to be complete jerks not because they are actually like that but because they choose this way under societal pressure. A big role in this ubiquitous numbing of the masses belongs to large record companies releasing music that makes people lose their ability to think. We on the contrary try to go against it as much as we can and to show people that there is an alternative path.

A Complete Derangement of The Senses

2003–2004

2003:
Balance Interruptus

Following what proved to be an exhausting tour, Balance took some time off from Coil to clear his head and be with his new partner Ian Johnstone. During this time Peter Christopherson spoke about him in a handful of interviews, which we thought were worth excerpting here.

PATTI SCHMIDT: ...Where's John right now?

PETER CHRISTOPHERSON: He's on his way to a little town called Cockermouth which is in the north of England, it's in Cumbria, which doesn't have anything very exciting about it at all except a kind of ragged beach where you can harvest seaweed and pull razor clams out of the sand and fry them with garlic. And he plans to spend some time growing organic vegetables which, as long as the salt in the air doesn't kill them first, I think is a good plan. John's basically spent the last two-and-a-half/three years experiencing an intense psychoanalysis at the hands of his audience very frequently and sometimes from one show to the next... John found, after two years, basically he couldn't really cope with that amount of intensity of experience and so he's taking a rest. But Coil will continue, fear not.

Interview with Patti Schmidt, CBC Radio, 16th May 2003

PETER CHRISTOPHERSON: [Balance] is at the sort of
 cutting edge of raw existence... He experiences
 life to the full and whether that's through an
 alcoholic haze or a haze of any other kind of
 chemical or a haze of religious, spiritual or sexual
 fervour, in doing those things without restriction
 you inevitably expose yourself to a large number
 of dangers and sometimes those dangers and
 demons can get the better of him. I think that
 he's planning to go into retreat for a year and
 recharge his batteries and consider which
 direction he wants to take...

Interview with Guy Strachan, *Terrorizer* #110, June 2003

PETER CHRISTOPHERSON: John told me to say that he's lying in a black bath in a clear spot. He's not doing any of the present series of shows because, as I said, the last shows were a bit too taxing... the direction the show takes is very spontaneous. Not so much in the way of like jazz improvisation, but in a kind of stream of consciousness, *Finnegan's Wake*, James Joyce kind of way. Some of the songs had fixed vocals but other times John would just go off into a speaking in tongues type of thing. And the more you open yourself to that kind of creative flow... the more you are exposed to the risks of opening up a Pandora's Box of inherent madness — basically. At the end of the last tour, John was spending more money than we were taking on mini-bars and trashing things and trashing himself and it wasn't a sensible way to proceed. He's still a part of Coil, very much, and very much a guide and friend to us and we will continue to record with him but he will not be participating in live things at the moment. Maybe next year.

Interview at Supersonic Festival, Birmingham, 12th July 2003

'Trying to Avoid Any Contaminants and Reach Something That's True'

Hot Press — 23rd October 2004

Paul Nolan

The following interview took place in Peter Christopherson's room in the Morrison Hotel, Dublin on the afternoon of Saturday, October 23, 2004, a few hours before Coil's final performance as headliners of the Dublin Electronic Arts Festival in City Hall. Upon hearing that the group were to perform at the festival a few weeks previously, I'd immediately put in a request to talk to them.

Although it was stipulated that Peter and his long-term collaborator, John Balance, only had a few short minutes before sound-check and didn't have the time or the inclination to do an in-depth interview, we ultimately ended up enjoying a lengthy and wide-ranging discussion, during which we touched on numerous phases of the group's career, and John and Peter talked candidly (and with great eloquence and humour) about many of their friends and collaborators.

Afterward, there were hugs from John and Peter, signed copies of the *Black Antlers* and *ANS* albums and an offer to stay in touch.

In return, I presented them with a couple of items I'd brought along as gifts; an early draft of J.T. Leroy's novella *Harold's End* and a copy of M. Ageyev's cult classic *Novel With Cocaine*. Fittingly, the show that evening was superb, a hugely enjoyable sixty minutes of audio-visual adventure which demonstrated that even after 20-odd years of ground-breaking music, Coil remained among the most vital and innovative of contemporary electronic acts.

Tragically, just over three weeks after the interview, John died in an accident at his home, leaving the music world without one of its most gifted mavericks. A long term sufferer of depression, he had returned from a lengthy drinking binge, only to fatally injure himself in a fall. John was one of the friendliest, and most humorous and intelligent, musicians I have ever interviewed. As his many friends and admirers testified after his untimely death, he will be sorely missed.

This interview has been excerpted from a longer version on the Hot Press *site.*

'I used to practice magic techniques that [Aleister Crowley] had laid out in books, just as a discipline to see what mindsets you could get yourself into.'

Interview

PAUL NOLAN: You seemed to be very resistant to the idea of playing live for many years. Why have you become more interested in that area in recent times?

PETER CHRISTOPHERSON: For the longest time we didn't want to play live because we didn't want to mime to a backing track; it's so boring when people have the tape running and are just going through the motions. We totally weren't interested in that. But the problem is that the kind of music we do is either electronic or an electronic variation on some other theme. So I think, for us, the answer has been to try and represent that approach in a live setting. For example, tonight we're going to have a hurdy-gurdy player, Cliff Stapleton, performing with us, and although on the surface it's a very traditional instrument, the way that we treat it is very non-traditional.

JOHN BALANCE: But it's the way he treats it as well. Cliff has worked in a very broad spectrum of folk music, but he now wants to show what's he's done. He's also done theatre as well, and from that he's got this incredible vocabulary of what the instrument will do; he's like the Jimi Hendrix of the hurdy-gurdy world. He's done stuff that people are shirking away from and are actually quite horrified at, but the sound he's got is absolutely stunning. It's similar to the way that we attack electronic instruments. If we can make something that they're not supposed to do sound good, that's what we'll use first of all, as opposed to more conventional material.

PN: Which live acts have impressed you down through the years?

JB: It depends what you go for really. I used to love the Virgin Prunes, I was following them from about 1980. Later on, the Butthole Surfers used to really do it for me, and Throbbing Gristle, although I only ever saw them live when they did the

Heathen Earth recording. But recently... I don't really know. My needs and wants have changed — I'm not a teenager or a young adult anymore, so I'm after something else. And when I listen to, say, Leonard Cohen, I think I kind of appreciate it and understand it in a different way than the manner in which I listened to music when I was younger. *Ten New Songs* was one of my favourite albums ever, but I don't think I'd go and see that live, because I get what I want from that record. So I don't really know what I'm looking for anymore!

PC: But you did go and see Nina Simone. You were very impressed with that.

JB: That's right, Nina Simone moved me to tears; I was really glad that I got to see her before she died. But, y'know, shows of that quality are few and far between.[1]

PN: What's the most recent Coil material you've been working on?

JB: We've been working on lots of stuff, but the most recent release was a very pure electronic album called *ANS*, but that's sort of a side project almost. We were investigating this instrument we came across in Russia. There's a huge machine in the basement of the Institute of Journalism in Moscow, which was designed in the 20s or 30s, I think, and [last?] used in the 60s* [*actually it was used on Edward Artemiev's soundtracks to *Solaris* and *Stalker* in the 1970s]. It's an astonishing thing, it looks like a fucking printing press, and we did a boxset of CDs based purely on our experiments with it. But it's an exploration of the instrument rather than a continuation of the Coil sound or ideas.

PN: How did you first hear about the instrument?

1 It's unclear when Balance saw Simone perform. The likely candidates are her two 1999 London shows or, less likely, her final U.K. performance in Exeter in August 2001.

Paul Nolan

JB: Well we've been to Moscow twice, and the first time we were over there, someone said to us that there was this instrument they thought we'd be interested in. But they couldn't find it or set it up while we were there, so a year later we went back and had a recording session with it.

PC: *ANS* is much more abstract than the stuff we're working on at the moment, which is more structured and song-based. It's a work-in-progress, currently called *Black Antlers*, and we've been selling CD-Rs of it at our shows. We're hoping to release it in January or February, and as I say it's more of a proper album, with lyrics and themes and so on.

PN: I've been listening to *Unnatural History Vol. 2* recently, and it's amazing how contemporary most of the material still sounds... You must be very pleased with the way that music has lasted.

JB: Yeah, we are. One of the reasons we never played live was that, unless you're very careful, you tend to fix yourself to a particular point in time, and we were always very aware of wanting to avoid that. I mean, there are certain sounds on our old records where you think, 'Oh my God, it sounds so 1983,' but some of it still carries through and has that timeless feel to it, which is a quality we always strive for on our records.

PC: We don't particularly take any notice of trends or fashions while we're working on our music, we tend to be quite reclusive, like some kind of weird hermits. Although we always make sure that the technology we use is cutting edge, because we don't really react to what's going on in the music business, the stuff we do generally doesn't sound like anything else that's around. I mean, there are some people that sound a bit Coil-like now, but we don't sound like anything else, certainly not consciously.

PN: One video I did see recently... was your long-form video for Nine Inch Nails' *Broken* EP. What was the idea behind the film?

DL

PC: Well, Trent asked me to make the heaviest video ever made, having made some quite heavy videos already. He'd already done 'Happiness In Slavery' with Bob Flanagan, which was a great video, but he said, 'I want to go further.' Because obviously that was too subtle. (laughs) They had cold feet, and understandably so, because, at that time especially, the ratings system had a very censorious attitude to visual media, and there was no way something like *Broken* was going to survive in that climate. I believe Trent said recently that the reason it didn't get released was because he was concerned that it would distract people from what he was doing musically, and although it was nice of him to say that, at the time I think I was actually rather foolish in getting so enthusiastic about those projects.

Everybody has to work in the real world, and, you know, material like that can put everybody at risk, including ourselves and even Trent, probably. Horror imagery, especially when it's that extreme, can have a deleterious effect on people's well-being, so you have to be very, very careful in how you present it. Particularly with something like *Broken*, so much of it is dependent on the perception of the person looking at it. Because I knew that we were making it up as we went along, it didn't actually bother me, but I can see in retrospect that someone who believed it to be real could actually be harmed by it. And in that respect I think it was irresponsible of me to do it.

PN: A friend of mine interviewed Will Self recently, and Aleister Crowley popped up in the conversation, in reference to the one of the chapter-opening quotes in *My Idea Of Fun*.

JB: Is that quote about Crowley crucifying a frog on a cross? Someone asked him why he did it and he said, 'it's my idea of fun.'

PN: No, I believe it was to do with the conservatism of mainstream society, and how he wanted no more to do with it than he would want to eat canned salmon.

JB: (Laughing) That's a very Crowley-esque quote.

PN: You've been a fan of his for a long time, haven't you?

JB: Yeah, we have a lot of friends in the OTO, the Aleister Crowley organisation, and some of them have worked with us, so that's a very direct link. But I've been interested in him and his work since about age 11, and I used to get in trouble over it in school quite a lot. I had my books taken off me several times, and I was told to stop astral projecting into other people's heads, ridiculous stuff. The teacher actually believed that I could do that! I think I believed it too. (laughs)

I mean, I used to practice magic techniques that he'd laid out in books, just as a discipline to see what mindsets you could get yourself into. I was also interested in the man as a social phenomenon, and how he'd been outcast, and continually came up against this wall of outrage in society. But he remained quite stoic in the face of it all, and he had such self-belief that you couldn't help but admire him. I realised that the only way you can travel through this world intact is to have somehow magically filled yourself with self-belief.

And you can be as humble and as quiet as you like, or you can be ostentatious and outrageous in the way Crowley was — he took a completely different path to the one I would choose. A lot of people who follow him think that they have to be like Aleister Crowley, but they don't; they can be as quiet and introspective as they want, as long as you're being true to what Crowley described as your 'holy guardian angel.' I just see it in terms of being true to your own beliefs, regardless of the changing tides of opinion that surround you.

PN: Did you admire William Burroughs for similar reasons?

JB: Absolutely; he knew what he liked early on — boys, drugs and guns — and he stuck to it. It was really fantastic to meet him. We did videos with him, released one of his records — in fact he may end up on the final version of *Black Antlers*. He did a magical intonation recording with us which we're still keen to use in some capacity.

PC: He was a very charming, quiet, generous little old guy.

JB: Thursday was the best day to get him on. That was when he went to the clinic to get his weekly methadone injection — he'd always be in high spirits after that. He was on inventive form during that last recording session we did with him, singing songs about astronauts and so forth.

PN: Finally, what music is exciting you these days? I'd imagine you're quite keen on people like Labradford, Pan Sonic, Aphex Twin...

PC: We listen to those things, but sometimes to be honest we do try and avoid them, because as we were saying earlier, we're always aware of trying to keep our music pure and free of outside contaminants, brilliant and exciting as they may be...

JB: Your ears become weary — my ears are weary anyway with the age I am. I've listened to an awful lot of stuff for an awful lot of reasons: I've listened to it for enjoyment; I've listened to it because I have to; I've listened to it to make sure we're not copying anybody; I've listened to it to see what excites me sonically. And your ears get tired.

PC: It's like when you get a package from a record company, or from Rough Trade or some other label, you've got this big pile of CDs to get through, and my first reaction is kind of (rolls eyes) 'Here we go...' These people are friends of mine and I've got to listen to them because, well, you know...

JB: You have to mention it on the telephone next time you speak to them!

PC: Yeah. And it's like, 'Enough already!'

JB: I like Nick Cave's new album a lot. Lyrically, it's superb. As I was saying earlier, that's what's exciting me more now, and that's feeding into what we're doing. I'm actually going back through my record collection, thinking 'What artists, male or female, can I listen to and get excited by lyrically? What great vocalists and songwriters have I missed out on?' For example, I like Will Oldham a lot.

PN: You look like him!

JB: Well, this is an accidental similarity! (Laughs) Trust me, it's not a homage.

'We Are No Longer…'

Stylus, Late 2004

Scott McKeating

I first became tangentially aware of Coil through Psychic TV. I had stumbled across one of PTV's *Dream Machine* pamphlets in an Aberdeen comic shop in 1992–1993, and then further fell down the rabbit hole via the first of the *Rapid Eye* anthologies. While much of PTV's music was, frankly, not that good, their sonics being the child-catcher's lollipop to the cult's message. Coil's music on the other hand, was rarely anything other than startling. The duo, and their shifting cohort of collaborators, were completely invested in both their musical output and their obsessions.

I stumbled across their 1995 release *Worship The Glitch*, a musically-other treatise on accidents and manipulation that's often lazily classed as ambient. Taking Eno's 'Honour thy error as intention' concept further than the usual repetition of bum notes, Coil co-credited the release to ELpH, an entity they blamed/ thanked for the fuck ups they used as this record's flesh and bones.

It was these lines of abstraction and Coil's queasy sonics that were their appeal. Investigating Coil's back catalogue, a thousand references were hinted at — doors of perception were nudged ajar to highlight strands of cultures yet to be held up to the photocopier light by the mainstream — subversive literature/cinema, queer culture, body modification and 'atmosphere' as end result. If a case was ever going to be made for Coil to have had a 'sound,' then it would have had to be wrapped in their sonic transgressions. Not many duo's musical journeys are reasonably classified as completely 'other,' even the harshest experimental noise artist will be working from a well-worn palette of cliché and posture. Coil were not a band in the traditional sense, they were a gathering of minds, friends and ideas.

Coil were never interested in putting together a canonical or traditional body of work. Their music was disparate, a series of drug, magick and literature expeditions down unconnected roads and headlong plummets into K/Worm/black holes. Physical formats were frustratingly difficult to locate, Coil's inclination to capture their music on a series of totemic, sometimes almost fetishistic, formats meant that until recently they were difficult to track down. The fact they never got around to releasing something on Trent Reznor's Nothing Records speaks volumes.

I emailed Sleazy out of the blue, asking if he would be interested in doing an email Q&A (he did offer to do a phone interview but I had no means of adequately recording the chat) — my overriding sense of him was that he was warm, open, and interested in communicating his thoughts. While his moniker always pointed intriguingly toward supposedly immoral sexual preferences, the man I encountered lived up to his reputation as a truly generous and friendly soul.

'The England that I grew up in, which was an inspiration to me for so long, has changed a great deal and I am no longer able to see any good side to it.'

Interview

SCOTT MCKEATING: You were recently in Thailand mastering some live Coil material, did you enjoy the trip?

PETER CHRISTOPHERSON: It wasn't so much a trip, more a relocation. I still have an apartment in Bangkok and plan to be there permanently as soon as is practical — maybe this autumn.

SM: What makes it such an ideal home for you?

PC: Most importantly, it seems to me that the barrier between the immediate everyday reality and the world of ghosts, spirits, and visions — a parallel reality that people in the West usually only glimpse using psychedelics — is much thinner there. You frequently pass between one and the other without realising. I don't know whether this is due to the latitude, lassitude, spicy food, oriental ley-lines or something else. I have no real idea, I just know that if you wander with an open mind, and receptive senses, you are regularly confronted by sights or visions as surreal, evocative, and gorgeous as any MDMA or DMT experience, without the need to take any drugs at all. In fact drugs just anesthetise you to the sensation, so are best avoided. Quite apart from the fact that they are heavily illegal and one should always have a healthy respect for local laws, if you value your own freedom and safety.

Next, I love the way the people look. Coming back to the U.K. last month the airport was like a scene from Doré or Dickens' vision of Bedlam: everyone looked diseased and deformed somehow. Not only that, but the Thais are — by and large — a truly sweet and generous race. You can smile at the scariest looking thug in a dark alley and, chances are, he (or she) will be flattered and flash you his (or her) most charming grin. And the food, what can say? I love it. Western food seems bland and unbearably heavy to me now.

More or less everything — food, rent, utilities, transport, but not
Apple Macs — is about a quarter the price of the West, especially
the U.K., so a modest Coil income goes four times further.

There are some things in Thailand that present problems
though. The main one for me is that in the U.K. it's easy to be
motivated to do a lot of work — or a lot of very expensive 'play'
— since there's basically nothing else to do! In Thailand there
are a million beautiful ways to pass the days, so motivating
myself to get things done there is much harder. The England
that I grew up in, which was an inspiration to me for so long,
has changed a great deal and I am no longer able to see any
good side to it.

SM: In what ways has this decline manifested itself?

PC: It seems to me that now virtually all artistic endeavour in the
U.K. is actually regarded simply as a means to an end; a means
of obtaining fame, a lifestyle, a flat-screen TV, an Audi or the
right flowers in the right pot. I'm including people starting
up as musicians, artists and fashion designers, the people
who will shape the cultural identity of the country in years
to come. Nobody seems to be doing these things just because
they are driven to, anymore. So their work is compromised.

TV seems to be shaping the tone of the nation, and is the No.
1 subject of daily conversation. Despite, or maybe because of,
the proliferation of TV channels, very few TV programmes or
programme-makers bother about quality any more. British
TV, by and large, is based on the principle of sneering at the
misfortune and, particularly, the ill-advised choices of others:
(i.e., interior design, partners, location of house purchase,
plastic-surgery, etc.) Even advertising is mostly based on fear;
the fear of what will happen if you do not have the product in
question and consequently people spend most of their time

flipping between being afraid what others think of them, or thinking badly of others.

And do I need to mention the foreign policies of the government or the fact that the opposition is even worse than they are? Of course my view is only from where I sit — I'm sure the U.K. has many excellent qualities I have somehow missed. The only other reason for staying in the U.K. was Jhonn Balance but, though we will no doubt continue to collaborate, we are no longer 'boyfriends,' and he seems to me to be attempting to turn into Oliver Reed.

SM: How do you stand with your Nothing Records contract?

PC: Technically we signed a deal memo, and not a contract. We still owe them a record and intend to deliver one, but in what form it will be and via what entity it will finally be available, we don't really know at this point. The whole structure of music creation and distribution is slipping uncontrollably over a 'chaotic event' at the moment. I guess they should never have released that butterfly.

SM: How easy was it to set up your imprints Eskaton and Threshold House, and how easy is it to run?

PC: Easy in so far as we don't really do anything, which is not that good for the artists concerned! Tips on running a label? Don't set one up! Instead set up a website which just recommends or introduces interesting artists or people to one another. All artists have to learn how to set up their own paid-download sites. If they leave it to labels they'll just go on getting ripped off for another 50 years… Links and recommendations are the only things that matter now.

SM: In these days of downloads, is it important to Coil — and you — to still create special editions of the work you do?

PC: The debate of the relative merits of ownership of special things versus the possession of special information will never die. I prefer the latter, but Jhonn the former. To be sure, the experience of holding an object, especially a hand-made object will not be equalled electronically for many years. I'd like to think Coil are weeks rather than months away from offering our work as downloads.

SM: How will Coil be manifesting itself live and have you retired those fluffy suits?

PC: The last few tours were very taxing for Jhonn, and I wouldn't want him to put himself at risk although this could make for a great show! I'm pretty sure I will be there, I have a lot of new ideas since having been away, so whatever it ends up being will be interesting. Regarding the suits, to be honest they are getting a bit stinky! I think the next Coil look will be something between Mary Poppins on Ketamine and the Funeral of King George VI.

SM: Will reaching 50 mean anything to you?

PC: It will mean living in a place where youth is not regarded as the equivalent of quality — in music, opinion, and wisdom, in anything in fact — and not living in the TV and magazine-driven West.

SM: How do you feel about the *England's Hidden Reverse* book? A few people I know who've read it felt that it made Coil a lot more human and less intimidating. Are you aware of people's perceptions of you, Jhonn and your work?

PC: (Laughing) I never meant to be intimidating! I hope the book does show us in a more human light, we're pretty normal really, it's just the world that's backwards. I felt that way about William Burroughs until that sunny day in Kansas

when Jhonn and I went shooting with him. I just forgot he was my No. 1 hero and just became a really cool and fascinating old bloke. I reckon it's probably better not to think about anybody in 'heroic' terms at all, but just be polite and, if possible, interesting to all the people you meet. Just treat everyone with the same generosity of spirit, and chances are they will do likewise.

SM: What was your best experience in producing videos?

PC: Actually I directed them, which is more about figuring out what it should be about and then making it happen in front of the camera when it is running — no mean feat sometimes. Whereas producing is about money and organisation both of which I'm hopeless at, but I'm sure you knew all that. I suppose the videos that were the most true to what Coil were about were the two Coil videos we shot in Thailand, 'Love's Secret Domain' and 'Windowpane', which we hope to release later in the year on DVD with a lot of other bits and pieces. Maybe also the extensive work I did for Nine Inch Nails, during the 90s.

The best adventure was probably shooting the Infected series for The The in Peru and Bolivia, though other shoots in Sao Paolo, Brazil (Sepultura) and Calcutta (Henry Rollins) were amazing too. It's really true what they say about travel broadening the mind.

In the end I gave up directing commercially for other people because it was rapidly becoming not enough to have talent, you also had to be some kind of tyrant or asshole just to get your ideas across. Nowadays you have to be a cunt in that business before people will even take your calls. Perhaps the tsunami that's hitting the record industry will wash away the video industry too and leave new, refreshed and fertile

ground and new distribution paths for talented people to bring out new and better work. I hope so.

SM: Your Threshold House site has teased people long enough, what exactly are we going to see on your DVD project *Wild Boys Of This And Other Worlds?*

PC: (Laughing) Well, I've got lots of ideas but none confirmed! More tease I'm afraid. I suppose, loosely, one could say that I hope it will do in moving pictures what Coil does in sound. As a solo project, it will not have traditional Hollywood resources although many of the technologies that cost a thousand dollars an hour five years ago are now available on my PowerBook. It will just take time to figure them out.

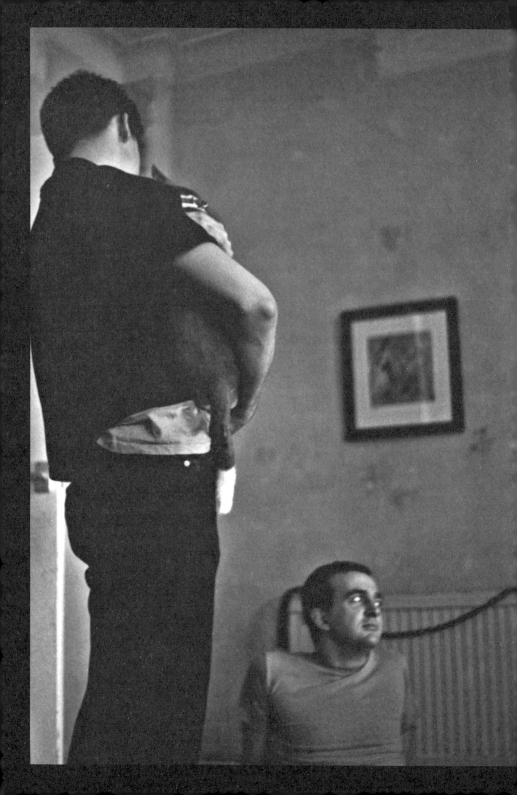

'Fermenting Moon Musick'

TYR, Late 2004

Joshua Buckley and Michael Moynihan

Introduction, Joshua Buckley

The decision to interview John Balance for the second issue of our journal *TYR: Myth—Culture—Tradition* was not an obvious one. First, music has never been the journal's primary focus and, second, the themes and interests that inspire Coil's artistic output might seem — on the surface — to barely overlap with those of *TYR*. The journal deals primarily with pre-Christian European cultures and mythologies. A major target of our inquest is the disenchanted, materialistic trajectory of modern civilisation. And here is the source for the hidden link: the bleak results of that ever-tightening modern constriction of the human spirit find their perverse, liberatory obverse in Coil's music.

But there are also reasons why John Balance, from his side, was so keen to do this particular interview, and to grant us permission to include a Coil track on the compilation CD that was included. Behind it lay a longstanding relationship of trust, as Michael had been corresponding with John since the early

80s. Decades later, when John obtained the first issue of TYR, he was insistent to speak publicly of his deep personal attraction to archaic expressions of paganism and sub-rosa elements of ancient religion.

Reading the short interview that John gave us is all the more poignant now, knowing this was to be one of the last he would ever do. Whether his genuinely upbeat outlook and the sense that he was winning the battle against his own inner demons should fill us with hope, or just more sadness, is hard to say.

But a matter beyond any doubt is the catalytic role that Coil's music could play in pulling back the façade of mundane existence — even if only momentarily. For Michael it was in Dresden at the end of the 90s, with *Time Machines* sonically ushering a small group of psychonauts through the doors of perception after the latter were thrown open via fungal psilocybin from the Bohemian Forest. Having regained composure after the entire surface of his skin erupted into a writhing carpet of tiny fluorescent-green worms, he led the cohort through the desolate, snow-laden streets of the city — firebombed and only partly rebuilt — where layers of real and figurative cultural rubble lay piled and patched together, awaiting spectral exhumation.

Coil's later oeuvre, with its hallucinatory penetrations of the personal and the transcendent, and its deep air of melancholy interspersed with skewed bits of humour, was the perfect accompaniment for such exploratory missions. It was almost as if John and Peter had written the soundtrack for their own final journey. It's hard to imagine two individuals more qualified to navigate the bardo, and to break on through to the Other Side.

'Now I'm out the other side of
this crisis and am full of joy and
am finalising my turnaround.'

Interview

TYR: You have said that you were born with a 'pagan sensibility.' You have also spent years exploring the possibilities of magic, psychedelics, and other tools designed to alter consciousness. What is the relationship between these types of pursuits and paganism? One can practice magic, for instance, without being a pagan — and vice versa. But as far as you're concerned, are these things all somehow connected?

JOHN BALANCE: Yes, they are connected — most definitely, both in plain sight and also in the most subtle ectoplasmic and tendril-like ways. There are countless definitions of magick and as many branches and paths that the pagan can travel down. I am a pagan.

I derive my inspiration and my life energy from the observation of, appreciation of, and intercourse with Nature: natural magick. Currently, I am deep into a year-long encounter with what I describe as 'PAN energy.' I am closely bound together in this with Ian Johnstone, who I met last year and who has been a central effervescence, guardian, and guide throughout the turmoils and trials that adhering to such a strange, rarely travelled path brings with it. This whole year has been one of new beginnings, dark echoes of previous events, and ghostly encounters. We have lived a raw-nerve procession of seasons. It is as if we are clearing dense, thorny foliage both for ourselves, and therefore in each of our personal lives, and also for others who come swiftly behind in parallel explorations.

As regards psychedelics, narcotics, and vegetable allies, I presently only have eyes for the beetroot.

Shamanism is the root and the branch and the leaf of my particular World Tree. Last year when Coil played live it seemed very much to be an ending of one sort of exploration

and mode of expression. I had a particularly lonely and hard winter and was thrown into a bleak place the likes of which I have never encountered before. A dark night of the soul. The worlds of politics and art and spirituality and of almost every belief and inner drive and enthusiasm for life and for living were tested until I nearly broke.

I think I did break, in fact, but was mended again over time with my friends' help and especially with Ian's help, for he never stopped believing in me despite the ugly distortions that I was creating and presenting outwardly, lost in the shamanic tangle. I became a 'shame-man', revolted to the point of acute rejection and illness by what 'Manunkind' was doing in the world and to the planet at large.

Now I'm out the other side of this crisis and am full of joy and am finalising my turnaround. Ian and I, along with Ossian Brown and others, are planning a printed project, or rather, series of projects, under the overall name of ONE. There will be a magazine (Pan-zine?) and printed posters and broadsheets, etc. I feel that to set into word and image the results and conclusions, the catalysing ideas and images that we have imagined and evolved and worked on, and most importantly lived this year, is the way forward. To make a mark and a difference we now have to publish and disseminate PAN ideas and beliefs. These include organic gardening and food production, growing and working with medicinal fungi, establishing and encouraging private press editions, public poetry readings, performances and events, reducing and making people aware of light pollution, reducing consumption of everything, buying locally, helping establish woodlands with native species of trees, reactivating old ceremonies and traditions. I don't mean that we ourselves will be doing all of these things all the time, but we will attempt

to inspire via *ONE* a sense of place and purpose. There is an excellent organisation doing this kind of work already called Common Ground. They are based in the U.K.[1]

TYR: One of Coil's most ambitious projects in recent years has been the *Moon's Milk* cycle of musical works for the solar/astronomical quarter days. Each equinoctial or solstitial piece appears to have been begun in one year and completed at the same time the following year. What led you to conceive this project, and how did you see it through to completion — did you make initial recordings on one equinox and then set them aside, only re-approaching and finishing them a year later?

JB: I was interested in exploring time in musick. And musick in time. I coined the phrase 'Musick cures you of time.' I was interested in the phenomenon of literally being 'lost in musick.' I wanted Coil to play continuously for a week, eating and sleeping where we played for a whole cycle of time, working in shifts to ensure the chain of events and expression was never broken. One person could play for twelve hours solo and then be joined by the rest for forty minutes. All sorts of combinations become possible. The individual becomes part of a much larger and boundless vehicle of sound. Moving to a larger house by the sea where the tides and their cycles can be seen from many of the windows deepened my sense of ebb and flow, of lunar rhythms and patterns and the whole procession of the seasons. When Sleazy and I lived in Chiswick, London, we used to take our two basenji dogs for walks down to the river Thames. It was a five-minute walk from Threshold House. The Thames has a high tidal volume and there were times when you could literally walk on the exposed riverbed. In these walks, and at this time, I became very aware of the moon and its power and influences and I decided to begin

1 Common Ground is a charity founded in 1982 to promote 'local distinctiveness.'

to call our work with Coil 'Moon Musick.' This meant that instead of working with preconceived and structured pieces, we would trust to chance and intuition. Nearly all the lyrics and vocal takes from the solstice/equinox series were one-offs. First takes. I didn't have any words or ideas written down in advance (actually I would have a vague notion or theme in mind, but this was deliberately left fresh and unformed until the recording of my vocal). The result is there to hear. Some of the words are sounds and impressions and are unformed, not finished, but that is how they are meant to be. I had to learn to trust to my own inner system of images and poetics. The same went for the majority of the actual sounds you hear — the musick was written live. Improvised. Bill Breeze's extraordinary viola parts on *Moon's Milk* were one-take performances. The only thing we did was to edit and select the pieces and sections that worked best for our purpose, and to shape the final songs from the streams and shards that the experiment became.

We did record at the correct astrological time to the best of our admittedly limited knowledge. If mistakes were made they are excused by the fact that we remained faithful to the spirit of the adventure. The bones are all shown there and they are all bare or partially concealed by after-work and tidying up. Yes, we did record passages and then set them aside until time was again right. They were left to ferment with Moon Juice.

TYR: Coil has always had a reputation for confronting the darker aspects of existence — chaos, violence, and deviant sexuality have been recurrent themes throughout most of your career. In recent years, however, you seem to have moved towards a more earth-centred type of spirituality (although not at all in the regrettable, New Age sense.) In the end, is this where the 'path of excess' has led you?

JB: Personally, I've found that the path of excess leads to the palace of excess, and to insecurity, neuroses, a profound disillusionment with almost everything, and an insurmountable depression. I have never been one to do things by halves and I have suffered as a consequence of my youthful adventures with the Left-Hand Paths. I ended up on antidepressants and found myself burdened with the ugly common yoke of alcohol abuse and addiction. I am currently free of these ordinary and dismal traps. I wish I had never gone onto antidepressants. They are a nightmare to come off of and my doctor, along with nearly all the medical industry, seems to want people on the fucking things. I recommend that everyone read the fantastic Feral House book *Pills-A-Go-Go*.

I was profoundly depressed. I needed a deep-rest. To be surrounded by Nature and natural things was the way in which I eventually walked away (well, with more of a lopsided hobble) a free man.

Now I find a time to be silent with myself every day. I exercise my voice and my body by chanting and singing. I am swimming more and most of all I'm going out into the countryside and just being there in it. Finding a deep spiritual drive and energy from immersing myself in the green and in the wood and in the water and the light that plays on the water. I'm in love and, of course, that helps enormously, but fundamentally being alone in Nature provides all the psychic nutrition my soul needs. Anything else is a joyful and heart-bursting gift. I still carry an intrinsic deviancy with me wherever I go — it's part of my askew take on the universe. I revel in the gnarly, the crippled, the liminal, and the sidereal. Distortions, outcasts, hybrids populate my crepuscular celebrations. Polymorphous perversions. All horned animals!

TYR: It would seem, then, that relocating to the British countryside played a significant part in your spiritual development...

JB: Indeed it did! We have a young oak forest right behind our house — in fact, the garden merges with it. We have an Iron Age fort directly above our house, and evidence of a very early goddess-centred temple in the middle of the woods. The local museum has a small white stone statue of what looks to me very much like Astarte that was found up in the woods in the 1890s.[2] The remains of a Roman altar were found in the garden next to ours around the same time. There is a place on the narrow steep peninsula that our house is located on where you can hear the sea on both sides of you, and it mingles with the sound of the dry leaves rustling to create a very special place.

2 A goddess associated with fertility and war, merging Canaanite, Cypriot and Greek precursors.

⑨

prior to
intercourse

⑬

⑥ take an older lover you
soon get tired of her

i get tired of lovers - suck off
suck out
lovers.
pychik vampires o i'll pop round later love [er

pop starts
thrive
vulgar upstarts
no roots in
thee ground / soil
sorry sorry sights...

⑩

siLence ___

___ blurred ___→

⑪

∞

⑫ life is a cycle like
painting thee forth bridge
once it's done it's time to
(s)tart again.

Gigography

With its remarkably detailed and entertaining summaries of each show — along with track-listings, photographs — the Live Coil Archive is the most extraordinary source related to any live manifestation of Coil. I recommend it without hesitation and would encourage anyone with recordings, pictures, or memories, to get in touch with the site.

1983 21 June, Tuesday — London Musician's Co-Op, London, U.K.
 (*Intended to be the inaugural performance of Coil, consisting of
 Balance and Jim Thirlwell, their performance was cancelled. Balance
 gave a 'non-musical performance' outside the venue*)
 4 August, Thursday — Club Magenta, Ritzy Cinema, London, U.K.
 24 August, Wednesday — Air Gallery, London, U.K.
 October 12, Wednesday — Recession Studios, London, U.K.
 3 December, Saturday — SO36, Berlin, Germany

1999 (*Peter Christopherson solo as* ELPH) 14 December, Tuesday —
XA Volksbühne, Berlin, Germany

Everything Keeps Dissolving

2000 2 April, Sunday — Royal Festival Hall, London, U.K.
17 June, Saturday — Mar Bella, Barcelona, Spain
19 September, Tuesday — Royal Festival Hall, London, U.K.

2001 25 March, Sunday — Le Lieu Unique, Nantes, France
30 May, Wednesday — Luchtbal, Antwerp, Belgium
1 June, Friday — Paradiso, Amsterdam, The Netherlands
3 June, Sunday — Agra Hall, Leipzig, Germany
21-23 June — Art installations and performances scheduled to take place at the Whitechapel Gallery, London, Sunday to Tuesday, are cancelled
18 August, Saturday — Irving Plaza, New York City, U.S.
15 September, Saturday — DK Gorbunova, Moscow, Russia
25 November, Sunday — *Teatro Duse, Bologna, Italy show cancelled after Balance had a suspected heart attack on Wednesday 24 October*

2002 *(Two shows planned for Belgium and The Netherlands cancelled alongside a five-six date spring tour of the U.S.)*
30 March, Saturday — Centre Culturel John Lennon, Limoges, France
2 April, Tuesday — Vooruit, Ghent, Belgium
3 April, Wednesday —*Show planned for The Netherlands cancelled*
4 April, Thursday — Rote Fabrik, Zürich, Switzerland
6 April, Saturday — Teatro Delle Celebrazioni, Bologna, Italy
7 April, Sunday — Muffathalle, Munich, Germany
12 April, Friday — Volksbühne, Berlin, Germany
13 April, Saturday — Alte Spinnerei, Glauchau, Germany
27 April, Saturday — Barbican, London, U.K.
7 June, Friday — Theatre Aan Het Spui, The Hague, The Netherlands
13 July, Saturday — Dour, Belgium
26 July, Friday — Corte Malatestiana, Fano, Italy
26 September, Thursday — Tochka Club, Moscow, Russia
29 September, Sunday — Vagonka Club, Kaliningrad, Russia
1 October, Tuesday — Royal Festival Hall, London, U.K.
5 October, Saturday — Ydrogeios Club, Thessaloniki, Greece
12 October, Saturday — Conway Hall, London, U.K.
16 October, Wednesday — Amager Bio, Copenhagen, Denmark
17 October, Thursday — Chateau Neuf, Betong, Oslo, Norway
19 October, Saturday — Fylkingen, Stockholm, Sweden
21 October, Monday — Tavastia Klubi, Helsinki, Finland

24 October, Thursday — St John's Church, Gdansk, Poland
25 October, Thursday — St John's Church, Gdansk, Poland
26 October, Saturday — Centrum Filmowe, Lodz, Poland
27 October, Sunday — Palac Akropolis, Prague, Czech Republic
29 October, Tuesday — Flex, Vienna, Austria
30 October, Wednesday — MuseumsQuartier, Vienna, Austria (*workshop/Q&A with Christopherson, Ossian Brown, Massimo Villani and Pierce Wyss*)
1-2 and 4 November — *Two shows in Italy and a ritual with Plastic Spider Thing cancelled*

2003 6 April, Sunday — Camber Sands Holiday Park, Camber, U.K. (*Balance did not perform during the May–July 2003 dates*)
29 May, Thursday — Metropolis, Montreal, Canada
21 June, Saturday — Casa Da Musica, Porto, Portugal
12 July, Saturday — The Custard Factory, Birmingham, U.K.

2004 23 May, Sunday — La Locomotive, Paris, France
29 May, Saturday — *Show planned for Athens, Greece, cancelled*
31 May, Monday — Haus, Leipzig, Germany
3 June, Thursday — Melkweg, Amsterdam, The Netherlands
11 June, Friday — Pergolesi Theatre, Jesi, Italy
25 July, Sunday — Ocean, London, U.K. (*Of personal note, this was the only time I saw Coil live. I remained glued to the front barrier throughout the show*)
October 23, Saturday — Dublin City Hall, Dublin, Ireland
November 12, Friday — *Show at the abandoned Aldwych Underground Station, London, U.K., cancelled same day*
3-5 and 6 December — *Performances scheduled to take place at Camber Sands and in Bilbao, Spain, respectively, are cancelled*

Selected Works

As any Coil aficionado knows, the Coil discography is awash with new versions, reprints, limited objets d'art, live records, demos, and archive material. My intention here is not to list every iteration of everything, but simply to capture the key releases and the overall chronology of Coil's musical works as an aid to the reading experience.

Transparent (Nekrophile Rekords, 1984) — Zos Kia/Coil
The Melancholy Mad Tenant (Vortex Campaign self-released, 1984)
How To Destroy Angels EP (L.A.Y.L.A.H. Antirecords, 1984)
Scatology (Force & Form/K.422, 1984)
'Panic'/'Aqua Regis'/'Tainted Love' single (Force & Form/Wax Trax! Records, 1985)
Horse Rotorvator (Force & Form/K.422, 1986)
The Anal Staircase EP (Force & Form/K.422, 1986)
'The Wheel'/'The Wheal' single (Threshold House, 1987)
Gold Is The Metal (With The Broadest Shoulders) (Threshold House, 1987)
The Unreleased Themes For Hellraiser EP (Solar Lodge Records, 1987)

Everything Keeps Dissolving

Unnatural History (Compilation Tracks Compiled) (Threshold House, 1990)
'The Wheel'/'Keelhauler' single (Normal, 1990)
'Wrong Eye'/'Scope' single (Shock, 1990)
'Windowpane'/'Windowpane (Astral Paddington Mix)' single (Threshold House, 1990)
Love's Secret Domain (Torso, 1991)
The Snow EP (Torso, 1991)
Stolen And Contaminated Songs (Threshold House, 1992)
How To Destroy Angels (Remixes And Re-Recordings) (Threshold House, 1992)
'Is Suicide A Solution?'/'Airborne Bells' single (Clawfist, 1993)
Themes For Derek Jarman's Blue EP (Threshold House, 1993)
The Angelic Conversation (Threshold House, 1994)
Nasa-Arab EP (Eskaton, 1994) — credited to Coil vs. The Eskaton
Born Again Pagans EP (Eskaton, 1994) — credited to ELpH vs. Coil
'PHILM #1'/'Static Electrician'/'Red Scratch' single (Eskaton, 1994) — credited to ELpH
Worship The Glitch (Eskaton, 1995)— credited to ELpH vs. Coil
Unnatural History II (Smiling In The Face Of Perversity) (Threshold House, 1995)
Windowpane & The Snow (Threshold House, 1995)
A Thousand Lights In A Darkened Room (Eskaton, 1996)
Unnatural History III (Threshold House, 1997)
Time Machines (Eskaton, 1998)
Autumn Equinox: Amethyst Deceivers EP (Eskaton, 1998)
Spring Equinox: Moon's Milk Or Under An Unquiet Skull EP (Eskaton 1998)
Summer Solstice: Bee Stings EP (Eskaton, 1998)
Winter Solstice EP (Eskaton, 1999)
Astral Disaster (Prescription, 1999)
'Zwölf' single (Raster-Noton, 1999)
Musick To Play In The Dark Vol. 1 (Chalice, 1999)
Musick To Play In The Dark Vol. 2 (Chalice, 2000)
Queens Of The Circulating Library (Eskaton, 2000)
The Remote Viewer (Threshold House, 2002)
Moon's Milk (In Four Phases) (Eskaton, 2002)
The Restitution Of Decayed Intelligence EP (Beta-lactam Ring Records, 2003)
ANS — one disc edition (Eskaton, 2003) and three disc plus DVD edition (Eskaton, 2004)
Black Antlers (Threshold House, 2004)
The Ape Of Naples (Threshold House, 2005)
Animal Are You? (Absinthevertrieb Lion, 2006)

Selected Works

The New Backwards (Threshold House, 2008)
Backwards (Cold Spring, 2015)

In terms of live recordings, a pretty substantial quantity of material was released during the life of John Balance and Peter Christopherson then extended thereafter:

Constant Shallowness Leads To Evil (Eskaton, 2000)
Coil Presents Time Machines (Eskaton, 2000)
Live In NYC August 18, 2001 (Mute Elation, 2001) — CDR/VHS release
Live Two (2003)
Live One (2003)
Live Three (2003)
Live Four (2003)
Megalithomania! (Threshold House, 2003)
Selvaggina, Go Back Into The Woods (Threshold House, 2004)
And The Ambulance Died In His Arms (Threshold House, 2005)
Colour Sound Oblivion (Threshold House, 2010) — 16 DVD live box-set
How To Destroy Angels — Coil/Zos Kia/Marc Almond (Cold Spring, 2018)
Live Five: Gdansk, Autumn 2002 (Retractor, 2019)
Live: Copenhagen 2002 (Retractor, 2019)

For those desiring a deeper dive into Coil-ian depths, numerous outtake and demo collections have emerged posthumously:

Recoiled (Cold Spring, 2014) — Coil/Nine Inch Nails
'Expansión Naranja'/'Ecuación De Las Estrellas' single (Mannequin, 2015) — Ford Proco/Coil
The Plastic Spider Thing (Rustblade, 2017) — Black Sun Productions/Coil
'A Cold Cell In Bangkok' single (Optimo Music, 2017) — one-sided picture disc
'Another Brown World'/'Baby Food' (Sub Rosa, 2017)
Astral Disaster Sessions Un/Finished Musics (Prescription, 2018)
Swanyard (Infinite Fog Productions, 2019)
The Gay Man's Guide To Safer Sex +2 (Musique Pour La Danse, 2019)
A Prison Of Measured Time EP (Old Europa Café, 2020)
Astral Disaster Sessions Un/Finished Musics Vol. 2 (Prescription, 2020)
Sara Dale's Sensual Massage (Infinite Fog Productions, 2020)

The most comprehensive retrospective has been the 14-disc Threshold Archives series released in two batches in 2015 and 2019:

Panic (T-ARCH 005 — Threshold Archives, 2015)
The Wheel (T-ARCH 006 — Threshold Archives, 2015)
The Anal Staircase (T-ARCH 007 — Threshold Archives, 2015)
The Consequences Of Raising Hell (T-ARCH 008 — Threshold Archives, 2015)
Wrong Eye (T-ARCH 009 — Threshold Archives, 2015)
Windowpane (T-ARCH 010 — Threshold Archives, 2015)
The Snow (T-ARCH 011 — Threshold Archives, 2015)
Airborne Bells (T-ARCH 012 — Threshold Archives, 2019)
The Sound Of Musick (T-ARCH 013 — Threshold Archives, 2019)
First Dark Ride (T-ARCH 014 — Threshold Archives, 2019) — credited to Coil vs. The Eskaton
Protection (T-ARCH 015 — Threshold Archives, 2019) — credited to Coil vs. ELpH
Heartworms (T-ARCH 016 — Threshold Archives, 2019)
I Don't Want To Be The One (T-ARCH 019 — Threshold Archives, 2019)
The Restitution Of Decayed Intelligence (T-ARCH 023 — Threshold Archives, 2019)

And, finally, for anyone just wanting to dip a toe into Coil, a two-volume greatest hits collection was issued by Russian label Feelee Records in 2001, released on Eskaton the same year as *The Golden Hare With A Voice Of Silver*, and was reissued by Cold Spring in 2020 as the two-disc *A Guide For Beginners: The Voice Of Silver/A Guide For Finishers: A Hair Of Gold*.

Index

Index

C

Index

F

G

Index

Index

Index

Index

Index

X

Y

Z

Strange Attractor Press
2023

Index

X

Y

Z

Strange Attractor Press
2023